Tori Talcott 1986

ART NOUVEAU JEWELRY

Vivienne Becker

ART NOUVEAU
JEWELRY

E. P. DUTTON

NEW YORK

For Rod

Acknowledgments

I owe a huge debt of gratitude to all the friends and colleagues who have contributed in some way over the years to this book, generously helping me to collect facts and giving me access to their collections. I am particularly grateful to Dr Joseph Sataloff and his family in Philadelphia for their help with illustrations, for sharing knowledge and above all the enthusiasm that started me on my study of Art Nouveau jewelry.

Special thanks, for help far beyond duty, go to David Callaghan, Helen Docherty, Sara Drake, Brian and Lynn Holmes, John Jesse and Irina Laski, and Geoffrey and Caroline Munn.

For sharing hard-earned knowledge and arranging photographic material, many thanks to Victor Arwas, Fred Brandt of the Lewis Collection, Fritz Falk, Peter and Debbie Gooday, Ulrike von Hase, Barbara and Lloyd Macklowe, Nicola Redway, the Decorative Arts Department at Sotheby's, and to all those who generously contributed photographs.

I am grateful to everyone who helped in my research, including Keith Baker, Shirley Bury, John Culme, Graham Dry, Martin Eidelberg, Hans-Joachim Fühner, Charlotte Gere, Susan Hare, the late Mrs Anne Hull Grundy, M. Manoukian, Edward Mürrle, Hans Nadelhoffer, M. Perinet, Maryella Piggott and her family, Evelyne Possémée, Penny Proddow, Derek Redgrove, Peyton Skipwith and Andy Tilbrook. I am particularly grateful to Judy Rudoe for her invaluable advice on makers' marks.

I would like to thank all my friends, both inside and outside the trade, and my family for their encouragement during this project.

VB

Decorations for the preliminary pages: designs by Alfred Roller, from *Ver Sacrum*, vols III and IV, 1900, 1901 (pp. 1–3); design by Ernst H. Walther from *Pan*, 1897 (p. 5).

First published, 1985, in the United States by E. P. Dutton
Copyright © 1985 by Thames and Hudson Ltd, London

Published in the United States by E. P. Dutton,
2 Park Avenue, New York, N.Y. 10016.

Library of Congress Catalog Card Number: 85-70804
ISBN: 0-525-24345-3

Printed and bound in Japan

USA&P

10 9 8 7 6 5 4 3 2 1
First Edition

Contents

Preface 6

Introduction *Jewelry Design in the Mid Nineteenth Century
and the Emergence of Art Nouveau* 7

1 France 41

2 Germany and Austria 105

3 Great Britain 153

4 The United States 181

5 The International Impact of the Art Nouveau Jewel 195
 *Belgium, Holland, Scandinavia, Russia,
Eastern Europe, Switzerland, Italy, Spain*

Notes to the Text 213

Biographies of the Jewelers 214

Checklist of Other Notable Jewelers 231

Guide to Identification 232
 Makers' Marks and Signatures 234

Bibliography 237

Index 238

Sources of the Illustrations 240

Preface

Curiously, apart from frequent mentions of Lalique and a few other major designers and jewelry houses, a close examination of Art Nouveau jewelry has never been attempted despite the voluminous and excellent literature on the Art Nouveau style.

In this book I have set out to give a broad panorama of international jewel design in the Art Nouveau style around 1900. The interchange of ideas – for example the connection between Scotland and Austria – is a fascinating and sometimes confusing aspect of the study of Art Nouveau jewelry. Artists and designers moved around a great deal, not only from country to country but also from one area of the arts to another, cross-fertilizing ideas and styles.

What I have considered of prime importance is to trace the convoluted roots of the Art Nouveau jewel and to provide an explanation as to why I think the jewels often took on strange and unprecedented characteristics. In this I became absorbed by the dramatic symbolism of recurrent themes and visual motifs which seemed to me to reflect the dying century and the profound changes that this implied. For instance, the developing role of women, their new freedom and the suffragette movement seemed to be a theme reflected in the many portrayals of women in the jewels.

The magazines and journals of the time, expressing the new spirit of the arts, with special emphasis on the decorative arts, echoed the frequently melodramatic tone of the jewelry in their high-flown language; these journals, which are unique documents of the period, have proved of the greatest interest and are an invaluable source of information.

The biographical list of makers at the end of this book aims to put all the information known to date together in one place, for ease of reference and for the identification of pieces. There is much work still to be done in this area, since it appears that almost every craftsman involved in Art Nouveau designed at least one jewel, although many were never heard of again.

Art Nouveau jewelry had all the vigour and intensity of youth and perhaps, too, some of its precociousness. It came and went quickly, only to be succeeded eventually by a style which, by comparison, was streamlined and mechanistic: Art Deco. It is for this reason that it has been said that Art Nouveau only provided beginnings. If this book serves its purpose, it too will hopefully make a beginning to the study of Art Nouveau jewels and their makers; but most of all I hope it will lead to the enjoyment and appreciation of a special form of beauty, craftsmanship and art in jewels.

VB

Introduction

Jewelry Design in the Mid Nineteenth Century and the Emergence of Art Nouveau

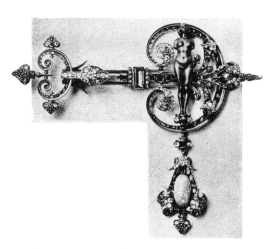

Renaissance-style brooch by René Lalique, 1895, using the female form

Decorations for this chapter: detail of a carpet design by Koloman Moser, from *Ver Sacrum*, vol. II, 1899, no. 4 (chapter title page); design by Otto Eckmann.

Jewelry was the most intense expression of the Art Nouveau movement. New interest in the decorative arts in general had brought jewelry to the attention of artists in many other areas, and it appealed to them for a variety of reasons. As a rediscovered medium, it offered great scope for new techniques, and the highly decorative, often opulent, nature of the Art Nouveau style suited the purpose of jewelry as adornment to feminine beauty. The jeweler's art could also forge the new aesthetic emphasis with the technical achievements of the nineteenth century, and the femininity that exerted a powerful influence on the age could be conveyed through the most feminine of ornaments.

By the late nineteenth century, jewelry design was ripe for drastic transformation: stagnating, robbed of artistic merit by the industrial age, it was long overdue for an injection of fresh talent. With no new artistic impetus of its own, the mid nineteenth century forced its jewelers to turn to the past for inspiration. A spiritual longing for the Middle Ages, an idealized 'age of chivalry', ushered in a revamped Gothic style (in France, the *Style Cathédrale*), while the neo-Renaissance look occupied the last part of the nineteenth century.

The industrial revolution and mass mechanization seemed to have drained the age of creative energy. In a materialistic society, jewels inevitably became mere status symbols. The fact that they were intrinsically valuable turned them into barometers of financial success. Expensive jewelry was more or less limited to stiff arrangements of diamonds, which were, admittedly, immaculately and skilfully set. However, the pursuit of technical perfection seemed to have driven out creative design. Secondary jewels, the less expensive daytime accessories which changed with fashion, also demonstrated the stale, derivative parade of patterns borrowed from history.

The most extensive influence on nineteenth-century jewel design came from ancient jewelry. By the 1860s, revivalist jewels, especially in the Italian manner, had taken a firm hold on fashion. The Castellani family of Rome had begun to make very fine and faithful reproductions of the Etruscan jewels that had recently been unearthed. No lady of fashion could visit Rome without calling into the Castellani shop to acquire one of their famous archaeological-style jewels. The fashion spread through France and England, and in 1863 the architect and designer William Burges observed that every goldsmith's shop window in London was full of these revivalist gold jewels.[1] Before long, the high ideals and faithful authenticity of the Castellani and their colleagues were diluted to suit popular tastes and pockets and to fit commercial considerations. Motifs were taken indiscriminately from an eclectic range of source material and overworked into endless similar permutations.

The appearance of individual jewelry designers like Carlo Giuliano (a Castellani protégé transplanted to London) brightened this Victorian outlook briefly in the 1870s and 1880s. Giuliano produced 'art' jewels for an élite clientèle. He concentrated on artistic interpretation in design rather than intrinsic value, but still looked to the past. In particular, he reinterpreted Renaissance styles, often working from specific prototypes. The Renaissance revival, with its echoes of the jewel as a work of art, its figurative compositions, and the use of enamel, paved the way for Art Nouveau. In 1898, Henri Vever, jeweler and jewel historian, wrote aptly that the public had been 'saturated with *déjà vu*'.[2] He and other critics looked back in deeply analytical mood on the impoverished jewel, as they explained the circumstances of its rejuvenation.

The roots of Art Nouveau are as convoluted as the meandering line it worshipped. It was short lived, in jewelry lasting only from about 1895 to 1910. In the last years of the nineteenth century critics were unanimous in attributing the start of the jewel revolution to the renewed study of plants and their application to decorative design from the middle of the century. Nature, and its associations of femininity and fertility, is the dominant theme of Art Nouveau jewelry, but it took on a very different image from its nineteenth-century garb of minute realism, changing from stiff imitation to vivid interpretation.

One of the chief principles of Art Nouveau proposed that the aim of art was to *suggest* reality – in Mallarmé's words, 'to suggest it, that's the dream.'[3] It had to provide a 'veiled essence of reality'[4] which, like Impressionism, became true to nature, more lifelike – or rather full of life – than any exact copy.

The art critic W. Fred, writing of Austrian jewelry in 1902, said: 'Of course, bouquets of brilliants, and leaves consisting entirely of diamonds, have always been easily made at any period, but what is now aimed at, for that very reason, is the evolution of designs which shall be essentially true to nature, but at the same time really artistic. Crude masses of naturalistic flowers are really of no account whatever, for a bouquet of diamonds can never have the exquisite charm of a fresh sweet-smelling bunch of real blossoms.'[5] Impressionism was preoccupied with a dreamy haze of light that epitomized this 'veiled reality', and aimed, like Art Nouveau jewels, at a deeper relationship to nature, a portrayal of its very force and sensuality.

If Art Nouveau jewels were a reaction against imitative naturalism, they had their roots there, firmly implanted 'in our old French soil, nourished by its rich and fertile sap.'[6] A horticultural zest had manifested itself in the early years of the nineteenth century. Plant collecting had turned into a mania, and in England and Europe there was a passionate interest in botany, particularly in flowering plants and their hybridization. Expeditions were led to the Far East and to North and South America, to bring back exotic species, often to serve as models for Victorian artists and designers. It was in this period that so many favourite Art Nouveau floral motifs were born. Many flowers were first introduced to Europe early in the century, such as the tiger lily, wisteria, chrysanthemum, certain types of rose, the bleeding heart. This deep pink, plump and sensuous plant used by Lucien Gaillard, for example (pl. 83), was brought back to England from China in 1846 and became the popular decorative motif of the 1860s. The large iris, beloved of Art Nouveau jewelers, was developed in the mid century. The fuchsia, with its spectacular effusion of hanging colour, was a Victorian motif adopted by Art Nouveau jewelers. Although this plant had been known as early as the beginning of the eighteenth century, it had then been neglected; it was rediscovered at the end of the same century with the interest in flowering plants, and became fashionable after 1830.

In France, in the early nineteenth century, Empress Josephine kept a much envied garden. If she was passionate about her plants, she was uncontrollable over her jewels. It was a natural step for flowers to be turned into jewels, for diamonds to be transformed into flowers. By the mid century, in the fertile atmosphere of love for luxury, and of botanical fervour, the taste for naturalistic jewels flourished.

By the 1860s, and the pleasure-loving era of the French Second Empire, diamonds and flowers went hand in hand, and the fashion was truly mastered

by Oscar Massin. He was a dedicated French jeweler who became the undisputed genius of the flower jewel and an important influence on Art Nouveau jewelers. Massin dedicated his life to refining and perfecting diamond-set jewelry, particularly botanical jewels. He is now generally little known, but he is a crucial figure and was much admired 'in the trade' at the time. He had a particular talent for flowers and diamonds and created magical, trickling sprays that made his reputation. He was undoubtedly far-sighted, if entrenched in the rigid mid-century traditions. His blossoms and branches were lighter and livelier, more fluid than those of any other jewelers, hinting at the preoccupation with movement and life that was to come. More than any of his contemporaries, he anticipated the Art Nouveau concern with the realities of nature, in his keen observation of the structure and composition of plants. In sympathy with the Art Nouveau attitude, he acknowledged that the sparkle of a diamond alone was never sufficient to make a work of art; good design and setting were needed too. In 1863 he created a wild rose brooch with heart-shaped petals, so popular that it was repeated for well over twenty years. Massin achieved a great deal within the framework of his era (1860–80) and, like Lucien Falize, the famous Paris jeweler, he contributed in a highly individual way to the success of Art Nouveau. Later he became a keen observer and commentator on the new jewels. Apart from his lively flowers and rivulets of dew-drops, he also perfected precise, light and 'invisible' settings and a new brilliance of finish. His refined feather jewels, luxuriant plumes rippling on flexible stems, were also curtain-raisers to another popular Art Nouveau motif. Massin clearly inspired his contemporaries: in the 1870s and 1880s, Loeuillard's designs for Boucheron explored unusual plant forms like withering ferns, further anticipating Art Nouveau.

Imitative jewels thrilled the public, but often horrified the growing band of critics who suggested that this striving after exact representation destroyed any artistic expression. When the Paris jeweler Léon Rouvenat made a diamond brooch faithfully imitating a lilac spray (a jewel that was later bought by the Empress Eugénie), he ordered a bunch of fresh lilac to be brought to the workman's bench every day for him to copy exactly. There was no question of personal interpretation. The piece was a fantastic feat of engineering, but was stiff and lifeless. For Art Nouveau artists, this contrived freshness hid the reality, and the beauty, of natural decay. For them, flowers never served as precise models. Lalique, for example, surrounded himself at work with flowers to serve as subtle inspiration for his art.

This change of attitude towards nature, so central to Art Nouveau, was urged by several important and influential mid-century illustrated books on the use of plants as ornaments. John Ruskin, Owen Jones and A.W.N. Pugin, among many others, emphasized the need for using nature as a basis for interpretation in decorative design. In 1856, Owen Jones published his famous work, *The Grammar of Ornament*, which suggested ways in which plant forms might serve merely as inspiration and be adapted to ornament. Dr Christopher Dresser, a leading exponent of Japanese and modern styles, and a Doctor of Botany, wrote along the same lines in his articles on the principles of design in the early 1870s, addressing himself particularly to silversmiths and jewelers. Ruskin's influential *Proserpina* (1874–86) described in detail plants and the way they grew.

In France, the new study of plant forms was stimulated by the work of the Swiss artist Eugène Grasset. He edited *La Plante et ses applications ornementales*

Illustrations from *The Grammar of Ornament* by Owen Jones, 1856

which appeared in monthly parts from 1896 to 1900. In 1902 the Czech artist Alphonse Mucha published his *Documents décoratifs*, a book which went further than its predecessors by providing complete designs for metalwork adapted from illustrations of plants. He also included jewelry designs which were quickly and widely copied. Emile Gallé, best known for his glasswork, who was at the centre of Art Nouveau and the revolution in decorative arts in France, was also inspired in creating new beauty by a study and love of plants, especially plant structure. Art Nouveau jewelers thus inherited the tradition of flower jewels and they combined it with the modern approach to natural design, interpreting and reworking themes according to their new ideology.

The nostalgic fin-de-siècle atmosphere was echoed in the interest of these artists in the decay and death of plants, in the reproductive cycle of birth, death and rebirth. Jewelers and designers turned to certain images from nature: the bud, alluding to the springtime of artistic fervour and to youth, was preferred to the blossom; the tendril of the vine appealed more than the vine leaf; the brittle, winged sycamore seed, the curious weathered hardness of the pine cone, the pistil and stem all became more intriguing than the flower itself, and were developed into organic and symbolic motifs. In 1897, a critic observed in *Art et décoration*: 'The artist sees nature in closer detail, and in his eyes the pistil is as beautiful as the entire flower'. Unusual flowers were chosen for their special characteristics: hothouse blooms were popular, especially the rare orchid, languid lilies, erect sunflowers, shaggy carnations; or simple, wild field flowers, the heavy umbellifers, the poppy with its scarlet limp petals, the mistletoe, or honesty with its flat, translucent seed-pods.

Plant motifs now had what was called 'le frisson de la vie' – the quiver of life.[7] Petals seemed just about to wrinkle with a breath of air, thistles and dandelions were on the point of disintegrating into the wind; the rose was withered, the lily curled in sensuous melancholy. Artists were particularly fascinated by the orchid, which they treated differently, giving it an almost surreal character and transforming it into an erotic form with its purplish veined leaves, thrusting stamens and curling tongue.

Almost all the plant forms shared the feeling of movement, which stood for life, and the use of the line suggesting surging growth is especially noticeable in motifs like the bulging pea or seed pod.

Other plants used in Art Nouveau jewelry were the blossoms of wisteria, mimosa, daisy, begonia, anemone, clematis, columbine. The contours of sea plants and sea creatures that lurked mysteriously at the bottom of the ocean appealed to the artists' feelings for movement, for the dynamic line that swayed continuously and rhythmically with the movements of the water. Waving, withered fronds of algae became popular: their soft, rubbery texture and their clear gelatinous substance could be conveyed in soft goldwork or rippling horn in changing, watery colours. The rhythmic energy and the dynamic forces of nature concentrated into decorative design made Art Nouveau jewels highly emotionally charged works of art.

Outside Influences

The Arts and Crafts Movement

The wind of change, carrying the first hints of dissatisfaction with stagnating design and the traditional role of art, had come from England. The influence of the Arts and Crafts Movement in the 1880s, which is discussed in more detail in Chapter 3, was revolutionary in the decorative arts and in design through the turn of the century, and in many cases up to the 1920s. The movement urged art for all; it stemmed from an early-nineteenth-century reaction against the demoralizing effects on art, and on everyday life, of factories and the machine. Exponents of the movement advocated introducing art to everyday objects, and thus to everyday life, making it available to ordinary people and a source of contentment to both the craftsmen and the user. William Morris was a leader of the movement, encouraged by the writings of John Ruskin, and deplored the display of shoddy, machine-made goods that he saw at the Great Exhibition in London in 1851. The Arts and Crafts Movement promoted self-expression in the individual craftsman, who was to design and make the object himself, by hand, from start to finish. Co-operatives or guilds, based on those of the Middle Ages, were formed to provide the right aesthetic and social environment.

In France, art journals of the turn of the century traced the first rumblings of artistic discontent to England and Arts and Crafts, for the movement had openly expressed the budding artistic consciousness in other European countries. If it did not quite succeed in effecting its wide-ranging programme, this must have been largely due to its unrealistic total rejection of the machine. It did provide the impetus and support, however, for a growing number of new ideas to do with the applied arts in France, and other parts of Europe, and in the United States. The fields of jewelry and metalwork benefited most from the crafts revival, for they had by the very nature of the work involved the greatest chance of achieving its ideals.

Japonisme

The pervading fashion for Japanese art and design that developed in the 1860s and that came to be called japonisme was the single most important contributing factor to Art Nouveau jewelry design and to Art Nouveau in general. French Art Nouveau jewelry showed the greatest influence of Japanese art, although of course the 'Europeanization' of Japanese design applied, to a greater or lesser extent, to all countries. Louis Gonse, a revered critic, writing in 1900 in *La Revue de la bijouterie, joaillerie, orfèvrerie*, compared Japanese art, in an appropriately naturalistic analogy, to a vine planted in another country which gives a very different wine to that produced in its country of origin. But most contemporary writers agreed that when French jewelers used Japanese ideas and motifs the result was in the end a totally French creation, as indeed it was.

The instigators of the plant-inspired decoration, Eugène Grasset, Christopher Dresser, William Morris, and their aesthetically inclined followers also welcomed the appearance of Japanese art and artefacts. In *The Grammar of*

Ornament, Owen Jones had suggested the use of Oriental elements as well as historical and naturalistic ones. In France, Grasset's illustrations to the tales *Les Quatre Fils d'Aymon* of 1883 had a strong Oriental and exotic flavour. Because of Japan's isolation policy, Japanese art had been something of a mystery in Europe until the mid nineteenth century. In the early 1850s, however, the American naval commander Commodore Matthew C. Perry negotiated to reopen trade routes with the East. The crucial trading agreement was signed in 1858, after five years of negotiations (although Japanese objects had made their way to Europe before the final signing of the treaty). The first European exhibition of Japanese art was staged at short notice, as early as 1854, at the Old Watercolour Society in London, and during the next few years Japanese objects filtered through to artists and collectors in England and in France, where they had a profound effect. The Japanese were then invited to exhibit at the International Exhibition in 1862 in London, which introduced their art and design to a much wider audience.

It was the simplicity of Japanese prints and woodcuts and the Japanese affinity to nature that most impressed the new collectors and admirers. The calm portrayal of nature in art provided the impetus for burgeoning Art Nouveau ideals. Some traditional French Second Empire jewelers had already been captivated by Japanese art and design. Lucien Falize, son of the prominent jeweler Alexis Falize, was a pioneer in this field, despite his grounding in the nineteenth-century tradition of technical brilliance. The influx of Japanese artefacts made a great impression on Falize. He loved the delicate, yet powerful designs, particularly the enamels, the chasing and the metal alloys. He was eager to go to Japan to study enamelling techniques and he wanted to bring Japanese craftsmen back with him. But family pressures prevented him from ever realizing his intention, and he had to be content with studying *cloisonné* enamels at home, working closely with the enamellist Antoine Tard.

Falize is famous for his distinctive jewels of gold and *cloisonné* enamels in clear, bright colours, with bold Oriental motifs of birds, flowers and leaves in simple outlines reminiscent of Japanese brushstrokes. He worked tirelessly on the pursuit of Oriental interpretation in jewels, and his efforts made a real contribution to the new style. Nevertheless, his work still belongs firmly to the Victorian aesthetic. For instance, he continued to use enamels and mixed metalwork techniques within a medieval-style framework. In his jewelry there is a significant overlap of Japanese influence and historicism, an indication of how the new style took time to evolve. It was none the less a step away from traditional materials and concepts.

Jewelers, led by Lucien Falize, seized on the simplicity of form, the intensity and clarity of colour of Japanese enamels, and the intriguing effect of mixed metalwork. As Falize was to write, 'It is impossible not to admire in Japanese jewelry, or rather in the products of the worker in metals, a taste in the arrangement, a science in colouring, a manual dexterity'.[8] These were the very attributes of Art Nouveau jewels. As has been rightly pointed out, 'the Japanese were able to deal intimately with nature without ever copying its surface movement.'[9] It was this way of dealing with nature that artists were seeking, to replace realism. The impressionistic style of much of Japanese art produced a striking, almost tense atmosphere through the simplest brushstrokes.

In England, the Japanese simplicity of design and asymmetry were welcome after the mid-century fussiness. Simplicity was the keynote to all Japanese

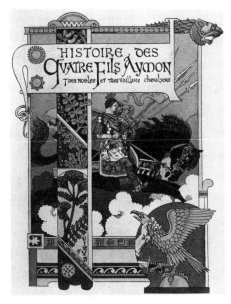

Title page by Eugène Grasset for *Les Quatre Fils d'Aymon*, 1883

design: an economy of line, perfectly spaced and proportioned asymmetrical compositions that did not overpower the main outlines, and just one carefully observed detail of a leaf, a flower, a bird; these were the elements needed to create the atmosphere and beauty that captivated the West. William Morris and his followers drew great encouragement and inspiration from the Japanese stand at the 1862 Exhibition and at the Paris International Exhibition in 1867. The objects they saw there, and the force of the artistic effect, propelled them towards their goals, and Japanese design became a key instrument for the new art.

In France, Henri Vever considered the impact of Japanese art on French Art Nouveau jewelry so important as to devote several pages of his *La Bijouterie française au XIXe siècle* (1908) to an explanation of its basic characteristics. An understanding of certain aspects of Japanese art is essential to a fuller appreciation of Art Nouveau jewelry. As we have seen, to the French the most important feature was the Japanese attitude to nature: it was their affinity with nature that provided the tranquil purity of form and the fresh simplicity so much admired by nineteenth-century artists. The relationship between nature and design had, claimed Vever, been lost to the West since the Middle Ages, and this he felt in some way accounted for the degeneration of decorative design.

While social and aesthetic movements across the world were preaching art for all, Japanese artefacts demonstrated that art was already a part of life and therefore meant not only for a social élite but for all classes of society. Vever pointed out that in Japan it was common for people to go to the country at certain times of the year to look at and admire the cherry blossoms, irises and chrysanthemums in bloom, the maple trees burnished by autumn, or a sunset observed from a particular viewpoint. Such images also occur frequently in French Art Nouveau jewelry design.

Apart from images and composition, ideas for techniques and materials were borrowed by Art Nouveau jewelers from Japanese art and objects. They drew inspiration from textiles, ceramics, lacquerwork. They studied Eastern use of vibrant colour, particularly in enamels, and the Japanese traditional techniques of mixed metalwork, inlays and lacquers found on *inro* (small boxes with compartments for carrying personal accessories) or *tsuba* (sword guards). Often Japanese workmen were imported to workshops in Paris and New York to share and implant their skills.

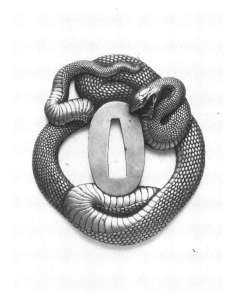

Nineteenth-century Japanese brass, gold and silver snake sword guard

The Art Nouveau Line

The new free-flowing 'whiplash' line expressed the struggles of art at the turn of the century. It suggested movement, as well as passion, vitality, the youthful vigour of the new ideas, and it was through line that, in the critic Robert Melville's phrase, the 'visible waves of erotic vertigo' were generated.[10]

Very often, this moving line was used on its own, rather than to join different elements in a jewelry design, and created an abstract linear look. In other pieces, it represented organic or sensuous symbols such as wriggling marine plants, rippling hair, billowing veils, or even the natural curves of the female form.

Belt buckle by Théodore Lambert showing the linear, abstract aspect of Art Nouveau design

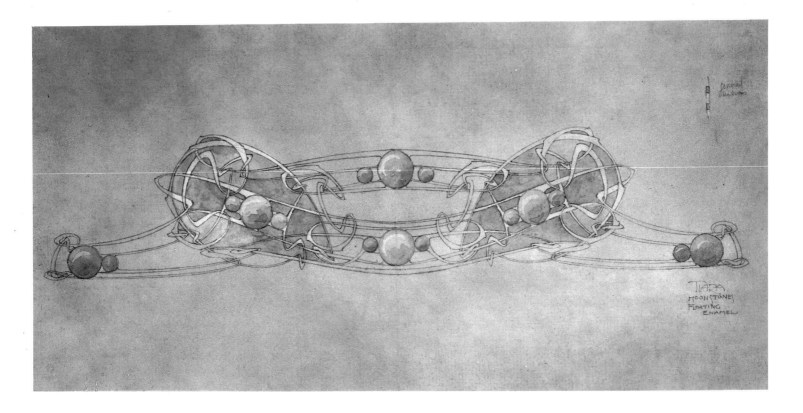

Design by Archibald Knox for a tiara set with moonstones and decorated with enamel, *c.* 1901–11

Its use was perhaps excessive and overpowering in many cases, and this led to various pejorative names for the style as a whole: Art Nouveau was nicknamed 'Paling Style' (eel style) in Belgium, 'Style Nouille' (noodle style) in France, and 'Bandwurmstil' (tapeworm style) in Germany. It was this kind of excess that Vever blamed for the decline of Art Nouveau: the line, he said, simply died of exhaustion. He pointed out that the commercial makers of Art Nouveau who did not really understand the theory or driving force behind the motifs produced bizarre curves that looked like macaroni.[11]

The use of line, and the linear aspect of design, are the common characteristics of Art Nouveau jewelry from different countries, and are also what distinguish the jewelry of one country from that of another. The French, for instance, use line in a figurative manner (as in the portrayal of flowing hair or seaweed), while other countries concentrate on the line itself, turning it into abstract designs. In England, the Celtic revival with its interlacing and whiplash, its groups of leaning squares and triangles and pools of mingled colours, was the basis of modern jewel design. In Scotland, Mackintosh used a highly individualistic, austere approach to the controlled but dynamic line, which was further explored in German and Austrian jewelry at the turn of the century and which was to be developed in modern styles.

The importance of the melodious line was expressed by Walter Crane: 'Line', he wrote, 'is all important. Let the designer, therefore, in the adaptation of his art, lean upon the staff of line – line determinative, line emphatic, line delicate, line expressive, line controlling and uniting.'[12]

Motifs and Themes

Insects

Insects, animals and birds were greatly loved motifs in the vocabulary of Art Nouveau jewelry. Although tigers, apes, elephants and leopards occur occasionally, insects – especially the dragonfly and butterfly – were the most characteristic subjects of the new decorative language. This marked another departure from Victorian design. Realistic but rather unimaginatively depicted insects had long been favourite motifs for young ladies' brooches, despite the revulsion they arouse when real. In the 1870s there had been a plague of beetles, ranging from rose beetles to huge stag beetles which settled on hats and veils; woodlice and earwigs clung to parasols, necklaces and earrings. Mrs Mary Haweis, severe fashion critic of the Victorian age, in her book *The Art of Beauty* of 1878, condemned the presence of slugs and snails in places where they would not be allowed to reside if alive.

In Art Nouveau jewelry, however, insects became fantasy creatures, sometimes shocking, often exceptionally and sensuously beautiful. The innocuous butterfly, freed from its glass case, was metamorphosed into a dragonfly with wings so real that the insect might at any moment flutter into life and fly away. The dragonfly's face often seemed to grin as if wearing a nightmarish mask, but on closer examination it was revealed to be that of a young girl. The images of fantasy and nightmare, and particularly metamorphosis (for example of chrysalis into butterfly), coincided with Freud's new theories of psychoanalysis which advocated probing into the subconscious to reveal rich or sinister imagery.

The butterfly and the dragonfly were the most common insect motifs and were used in endless variations. The slender serpentine body and the subtlety and variation of wing markings and veinings appealed greatly to the Art Nouveau jeweler. The insect hovering above water was a motif borrowed from the Japanese. In one magnificent dragonfly jewel by the Belgian Philippe Wolfers, the exquisite play of light through gossamer enamelled wings is captured in translucent *plique à jour* enamel (pl. 8). The wings are edged with rubies and, to recreate the light shining through them, the lower wings are tinged with a refracted pink glow. Very often the hovering movement was emphasized by the engineering of trembling wings. The motif of the winged insect encompasses all the characteristics of Art Nouveau jewelry: it is at once purely decorative, a feat of technical skill, a vehicle for *plique à jour* enamel, and is imbued with a certain symbolic allusiveness.

Other insects commonly used included the grasshopper, depicted with stylized angular antennae, very Japanese in character and used beautifully by Lalique and Gaillard; the scarab, the ancient Egyptian symbol of the cycle of life, which had been brought to artistic attention by the Egyptian craze of the 1870s, and was interpreted by the German designer Georg Kleemann; the cicada, another Oriental motif, often used in Art Nouveau jewels by craftsmen who enjoyed exploring the transparency of horn and the subtlety of enamel for its folded compact wings; finally, the spider, usually together with its web, which was used in later Art Nouveau jewels, by Charles Boutet de Monvel, for example, who produced an extraordinary spider necklace exhibited at the 1902 Salon.

Reptiles

The serpent, symbol of life, eternity and sexuality, had wound its way through the history of jewel design. In the mid nineteenth century it was tamed and turned into a meek design for coiled gold rings, brooches and necklaces. In the hands of Art Nouveau jewelers it was restored, glinting and scaly, to its primal glory, its slithering body a metaphor for sensual movement.

Lalique was supreme among Art Nouveau designers in creating jewels of entwined, writhing serpents. Among others who produced remarkable jewelry using this motif, Georges Fouquet created a magnificent serpent bracelet and hand ornament for Sarah Bernhardt (p. 21). Other reptilian creatures which became frequent motifs were the lizard and the frog which had also been tamed by Victorian priggishness and which were now restored to their glistening iridescence, while the chameleon with its ability to change colours also became a favourite and suitable motif for Art Nouveau jewel design.

Birds

The preening peacock and the silky peacock's feather became recurrent motifs of fin-de-siècle jewels in all countries. Like other motifs, the peacock had also been used by mid-century jewelers, but there is a vast difference between the stiff, jeweled bird of the mid century and the free, quasi-symbolist versions of the last years of the century. In England, the Arts and Crafts jeweler C.R. Ashbee used the peacock motif in silver jewels, decorating its tail with restrained and subtle use of mother-of-pearl. French designers, notably Gautrait, depicted the voluptuous plumage in densely coloured, glinting enamels; and, among cheaper Art Nouveau jewels, the gilt and enamelled buckle by Piel Frères was a stunning, high-fashion ornament. Outside jewelry design, artists such as Beardsley and Whistler (in his Peacock Room) immortalized the proud creature in their work. The peacock combined fantasy and beauty in nature while symbolizing the underlying narcissism of Art Nouveau. Art Nouveau jewels were ideal in portraying the bird: its rich, glowing colours translated perfectly into shining or matt enamels with a gold shimmer, mingling colours which flowed into one another in stylized representation.

Alongside the flamboyant peacock, the stately white swan, symbol of pride and metamorphosis, drifted dreamily through designs of Art Nouveau jewels. Other bird motifs include swooping swallows, illustrating movement, and cockerels, brilliantly used by Lalique, for example, pecking at a pool of enamel, flounced feathers pointing upwards. Lalique used jewel-like enamels to depict the cockerel's head, a typically French image and also the symbol of the dawn, which in jewel design was often shocking and unexpected. As an antidote, he introduced pairs of plump cooing doves.

Eerie creatures of the night, the owl and the bat introduced a sinister element, especially the latter with its outstretched flaccid and wrinkled wings hung on bony frames. Finally, vultures or eagles, sometimes with *plique à jour* enamel wings, were openly menacing.

Grotesques and Mermaids

In France, in the 1870s and 1880s, a tradition of fine goldwork had been developed, and a whole species of mythological grotesque or winged creatures, dragons, chimeras and griffins became popular. Some of the main firms known to have made jewels in this style, and who later incorporated the theme into Art Nouveau jewelry, include Jules Wièse, Maison Robin, Plisson et Hartz, Lefebvre and Falguières. It is possible that these jewels were inspired and possibly designed by some of the famous French *animalier* sculptors of the day, who produced small-scale representations of animals. A whole range of finely chased gold jewels grew out of this fashion in the 1880s, later incorporating Art Nouveau elements, especially flowers and maidens, but still in a very traditional manner. The mermaid, with her sparkling, swishing tail, long waving hair and air of sensuality also became a favourite subject.

Perhaps what is most important about the use of grotesques or hybrids in Art Nouveau is the fascination with the shocking and nightmarish, with things which are not what they appear to be.

Landscapes and Seasons

Art Nouveau jewels often brought together plants and birds in miniature landscapes. Very clearly showing the Japanese influence, water was usually a feature; it rippled in a lake, or occasionally took the form of fast-falling sheets. Sprawling roots and branches of trees often composed an outline to a pendant or brooch in which stood a human figure. Grass and sky would be added in subtly changing colours of enamels or an opal mosaic. The seasons and the cycle of the year were popular themes that went hand in hand with landscape motifs. A woodland, for example, would be sparkling in crisp winter white, with a bluish tinge of icy stillness. The mellow sadness of autumn was especially appropriate to the fading century, its russet, golden curling leaves so beautifully interpreted by Lalique. The depiction of different times of the day completed this section of themes directly inspired by the Japanese interpretation of nature and art: sunsets and sunrises spread a pale rosy glow of light and colour in some of the most stunning Art Nouveau jewels.

The Female

Industrial growth, science and technology, military might had all imposed a masculine character on the nineteenth century. As a reaction against such prevailing male emphasis, the vision of the female face and body dominated Art Nouveau jewelry. For Art Nouveau artists, woman represented all that was missing from such an imbalance, and the extensive use of the female motif in Art Nouveau jewelry became almost an invocation for the restoration of harmony in life and art. Woman and the female body corresponded to the recurrent theme of nature bursting with new life, while the images of struggling winged females reflected the hard-won emancipation of woman and her changing role in society. Sensitivity and passion, and awareness of the feminine, were blended in Art Nouveau jewels with the 'masculine' technical progress of the nineteenth century, and it was this combination that produced the brief and exciting creative moment in immaculately made and artistic jewelry.

While Art Nouveau was still struggling for acceptance and recognition, in the late 1880s and 1890s, the use of a woman's face or form in jewelry was considered distasteful. It was thought to be wrong for a woman to be ornamented with another woman's face or body.

François-Désiré Froment-Meurice, a leading exponent of the French *Style Cathédrale* (Gothic style) in jewelry had been one of the first nineteenth-century designers to make use of the naked female figure. In 1841, he had designed a bracelet (now in the Musée des Arts Décoratifs in Paris) made by Pradier, which shows two voluptuous, half-naked females in languorous poses. But this was an exceptional incident. It was not until the 1880s that the female head or form made more regular appearances as a decorative motif for jewels, and then it was the subject of much controversy. When a young designer called Marchand won the first prize in the second annual competition organized by the Chambre Syndicale de la Bijouterie in 1899, there was much discussion about the suitability of his use of a girl's head and shoulders. Vever, writing about the competition in *Art et décoration*, defended the use of the human figure in design on historical grounds, but agreed the motif had to be used sparingly, with discerning taste.

The Paris jeweler Alphonse Fouquet (whose son Georges was a leading Art Nouveau jeweler) began to use the human figure and female head in his neo-Renaissance jewels of the 1880s. In about 1883, in anticipation of fin-de-siècle fantasy, he produced a design that could be used for either a diadem or a bracelet, which had jeweled butterfly wings attached to the back of the figure. In 1899, he looked back on this innovation and the criticism it incurred: 'I made pieces of jewelry in which I combined the human figure in chased gold with the sparkle of gemstones. I have been told that my colleague, Massin, a man of great talent and fine character, whom I respect and admire greatly, under the same misconception as Charles Blanc, was of the opinion that I had committed some sort of heresy, that the aesthetic design rules do not allow a woman to wear on her head, around her neck or on her breast the image of a

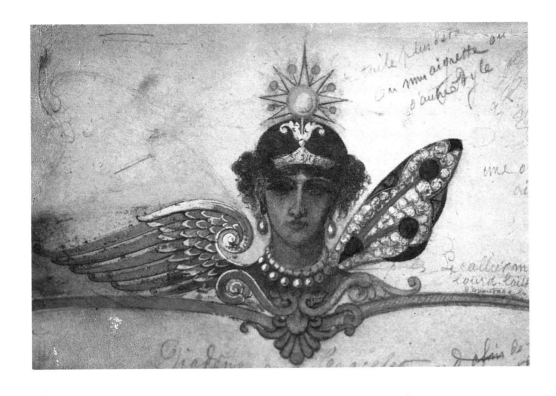

Design by Alphonse Fouquet for a diadem or bracelet, *c.* 1883. The left wing is in the neo-Renaissance style while the right is budding Art Nouveau

human figure. This was not the opinion of art critics who had the job of judging and appreciating these pieces.'[13]

By 1900, however, tastes had radically changed: the cult of the female figure reigned. The now recurrent image of passionate sensuality contrasted sharply with the prim, corseted and sheltered early nineteenth-century image of a lady of fashion. Women started to free themselves from earlier bonds: hints of emancipation and the need for greater independence were felt in society. In England, the Pre-Raphaelites had depicted a very different kind of female from earlier academic models. The Pre-Raphaelite woman is mysterious, dreamy, beautiful in an unconventional, strong and heroic way, no longer the coy, doll-like creature admired in Victorian novels. Pre-Raphaelite women have long, rippling hair and loose-fitting gowns based on classical or medieval models. Their distant, sometimes yearning expressions were evident in Art Nouveau jewels, often in contrast to other struggling passionate motifs and lines. The face of a woman, unashamedly sensual, framed by recklessly untamed hair, became a symbol of Art Nouveau jewelry, and is its most widely recognized motif. Furthermore, the whole female form, nude or provocatively draped in clinging or diaphanous fabrics, vividly expressed the freedom of the new movement.

Aspiring to even greater symbolic stature was the winged female: in the guise of a butterfly represented as a woman, she appeared to point towards the new art or the new century.

Two women in particular inspired this image of freedom. Loïe Fuller was an American dancer, born in 1862, who had caused a sensation at the Folies-Bergère where she made her début in 1892 and had taken Paris by storm with her dancing in swirling, diaphanous fabrics. In her performances, lighting was extremely important: she often began in pitch black and used incandescent electric lights. She put wands of aluminium or bamboo in her skirts to create waves of light and movement, which echoed the sensuality and energy of the Art Nouveau line.

She was neither young, nor by nineteenth-century standards pretty, but rounded and plump-faced. Her personality, however, exuded a sensuality that went with her individuality and independence; paradoxically, she also possessed an androgynous quality characteristic of so many Art Nouveau jewels portraying females – the curious and haunting image of the boyish girl who was yet to become a woman.

Loïe Fuller became the living emblem of the new style, immortalized in action, fusing the performing and the visual arts, in posters, bronzes, figurines and in jewels – as in the bracelet of linked dancers by Henri Téterger, made for the International Exhibition of 1900.

Like Lalique, Loïe Fuller triumphed at this exhibition. She had her own theatre there, one of the temporary buildings designed by the young architect Henri Sauvage. The daring façade of the building, an undulating veil of plaster, was designed by Pierre Roche. Her statue, with its floating draperies, stood above the alluring, cave-like entrance. Inside, huge butterflies fluttered around the audiences as they awaited her dances, which had names like 'The Fire', 'The Lily', 'The Butterfly' and 'The Orchid'. Outside, fans could buy figurines or statuettes by Pierre Roche, to be used as lamps or ornaments. Lalique paid tribute to the dancer at the exhibition by installing in his window-display a grille of linked butterfly women (p. 66).

Her energy seemed to correspond to the newly discovered electric light, which was a major feature of the exhibition. As one contemporary critic, Jean

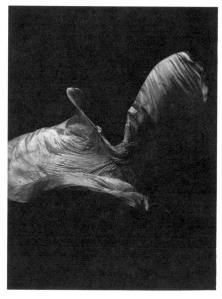

Loïe Fuller

Lorrain, commented: 'modelled in glowing embers, Loïe Fuller does not burn, she oozes brightness, she is flame itself.' Her smile under her red veil, he said, was like a grinning mask; an echo, too, of so many of Lalique's designs. Lorrain then went on to describe the 'morbid voluptuousness' of the Dance of the Lily: 'La Loïe, wrapped in wreaths of frost and opal shimmerings, herself becomes a huge flower, a sort of giant calyx with her bust as the pistil.'[14] This description is a good indication of the melodrama and concern with metamorphosis that were characteristic of Art Nouveau jewels. The critic Robert Schmutzler has pointed out that in her performances Fuller seemed to turn into something non-human, a jelly fish or a Tiffany vase: 'whirling on her own axis, like a corkscrew or a spinning top, with countless yards of veil-like materials shining in a coloured light like an iridescent Tiffany vase, [she] became in her increasingly audacious serpentines, a gigantic ornament; the metamorphosis it underwent, as it flared up or sank again, being swallowed up by darkness or by the fall of the curtain seems to us now, as we look back, to have been the very symbol of *Jugendstil*.'[15]

The Belle Epoque was the age of great actresses and opera singers, and the legendary tragedienne Sarah Bernhardt was the most famous of them all. Flamboyant, independent and dramatic, she was, as we have seen, at once inspiration for and patroness to the most adventurous Art Nouveau jewelers. She commissioned designs from several leading artists, notably Lalique and Georges Fouquet, and gave them the opportunity to create some of their most famous jewels. Like Loïe Fuller, she personified the new woman, unrestricted by the social etiquette of the day, a butterfly who had emerged from the confines of a stifling Victorian chrysalis. Her handsome features were often used and variously interpreted in the jewels of the period. One brooch, until recently attributed to Fouquet, shows Sarah Bernhardt as the Princesse Lointaine – an image taken from a poster by Alphonse Mucha for Edmond Rostand's play of the same name performed in 1896. Her career was enhanced when Mucha designed a series of very successful posters in an opulent, Oriental style, which projected her as a siren, a *femme fatale*.

Sarah Bernhardt, passionately fond of jewelry, asked Mucha to design a series of magnificent and flamboyant jewels for her. Her love of drama and exoticism gave him wide scope to indulge his imagination, in a short but fruitful collaboration with Fouquet. The first item to emerge from this association was a superb bracelet joined to a ring, together representing entwined serpents, which was made for the actress in 1899. It reflected Mucha's own love for the theatre and for drama. The articulated serpent's head sits on the top of the hand, and is linked by fine chains to the ring, made exquisitely of gold, opal mosaic, enamels, rubies and diamonds. Lalique had led the way for Mucha by designing stage jewels for Sarah Bernhardt from 1894, and she also patronized the leading designer Georges de Ribeaucourt whose work was characterized by a spiky and stylized interpretation of nature.

The soprano Lina Cavalieri and the actress Eleonora Duse, both from Italy, and the actress and courtesan Liane de Pougy, were among those who are known to have patronized Lalique and others.

The proliferation of posters, including those by Toulouse-Lautrec, and the ever-growing power of publicity, helped diffuse the image of splendour and womanhood, with Art Nouveau jewels playing a vital part in that image. Furthermore, important designers such as Henry van de Velde and Victor Prouvé also turned to designing clothes for women which confirmed the

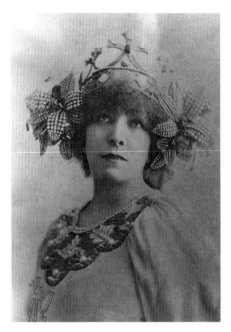

Sarah Bernhardt in *La Princesse lointaine*, 1896

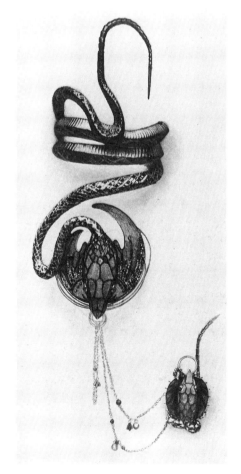

Drawing for a bracelet/hand ornament designed by Alphonse Mucha for Sarah Bernhardt and made by Georges Fouquet, 1899

attention drawn to the new woman and her femininity (see p. 197). As observer and critic, Gabriel Mourey, writing in 1902 of modern French jewelry, stated, 'since the full expansion of the modern movement, jewels have become a sort of passionate homage laid by the men of today at the feet of the Eternal Feminine.'[16]

Materials and Techniques

The change in the choice and use of materials for jewels was a distinctive aspect of the overthrow of old traditions. As Robert Melville has pointed out in his article 'The Soft Jewellery of Art Nouveau',[17] traditional 'hard' metals and gems were as if transformed into soft, liquid, organic substances. It was this move towards deliquescence that was 'a contributing factor to the unprecedented nature of Art Nouveau jewelry'. The idea and the visual impact of giving the unyielding, enduring materials of the jeweler the look of softness or of flowing, liquid substance, provided an imagery at its most beautiful and magical and added to the unrivalled emotional depth of Art Nouveau jewels.

Art Nouveau jewelers were so much masters of their skill that they aimed to subordinate materials as well as motifs to the rules of nature. The softness they extracted from the metals and gems was part of the 'symbolic-organic' structure of Art Nouveau jewels. The gems were to look as if they grew organically out of the metal. The metal itself was, according to Melville, given a life of its own: it was made to look soft, like a skin, as if it were somehow 'mysteriously perspiring'.

The opal was especially popular in Art Nouveau jewelry, for its organic look. It had delicate, shifting colours, alive, as if they were 'coming and going under a milky bloom'. Elsewhere opals could look like 'softly gleaming mucus slowly emerging from silver.' The idea of dissolving and evaporating coincides with the theme of transformation of substance. It also emphasized the transience of nature, of female beauty, and of the century itself as it slowly changed into a new era. Apart from this, materials and gems were generally selected for their artistic merit and not for their intrinsic value. The 'soft gleam' of stones was preferred to the cold glint of diamonds, and the texture of horn, ivory and non-precious materials was fully explored. In France, Art Nouveau goldwork was very much an extension of the heritage of superb chasing and sculpting.

The skilful use of horn is characteristic of Art Nouveau jewels. It is a good example of the artist's desire to turn the most humble and inexpensive materials into works of art. Lalique is credited with the innovation of using horn for jewels, but many of his colleagues, particularly Gaillard, Boutet de Monvel, the designers of pieces commissioned by the gallery La Maison Moderne, and Partridge in England, also explored the qualities of this unusual material. Horn could be given a skin-like bloom or sheen, a living organic coating, and its translucency, its lightness and moody shifts of colour appealed to the Art Nouveau jeweler. Horn was used by less well-known French workshops to produce inexpensive but effective and decorative pendants, brooches, hair ornaments and accessories such as letter openers. Even pieces produced in large quantities remained true to Art Nouveau themes: plants, flowers and, particularly, insects, bees, flies and dragonflies.

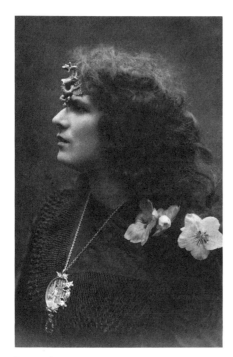

Liane de Pougy wearing a René Lalique Egyptian-style head ornament and pendant (pl. 57)

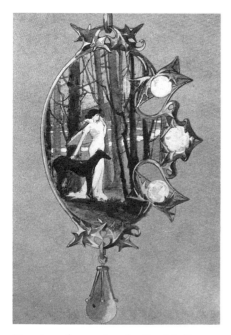

Drawing of a pendant by René Lalique worn by Liane de Pougy (see above), from *La Revue des arts décoratifs*, 1901

Many of these objects were signed, and the name of Bonté and GIP are among the best known.

Bonté was a French designer who had studied at the Ecole des Arts Décoratifs in Paris and worked, not very successfully, in a wide variety of unusual materials until she came across horn. She produced many sophisticated and pretty jewels made of horn, which being hard and brittle, is a difficult material to work. Many of the techniques that she and others evolved are virtually lost today.[18] Her main rival was Georges Pierre, known by his initials, GIP. He eventually merged his workshop with Bonté's, and they continued working together until 1936, still producing Art Nouveau-style pendants as late as the 1930s when plastics began to take over from natural materials.

The most important material used in Art Nouveau jewels was enamel, for which Art Nouveau craftsmen developed new techniques and applications. During the neo-Renaissance vogue, there was renewed interest in enamel decoration generally, and Eastern *cloisonné* enamel techniques were, as we have seen, an important influence. Enamel is coloured glass, usually lead-soda or lead-potash, in powder form, which is fused to a metal surface under heat. In *cloisonné*, the enamel fills little *cloisons* (cells) of metal which separate the various colours, so that the outlines of the metal show on the surface. The cells are made of narrow strips of metal wire which have been soldered to the base.

An extension of this technique is *plique à jour*, which was undoubtedly the most inventive and important technique in Art Nouveau jewelry, as well as being one of the most difficult of all enamelling processes. It produced an effect like that of stained-glass windows.

Plique à jour was not a new process. Mentioned by Cellini in 1568, it is said to have been used by Byzantine craftsmen but had passed into oblivion. Experiments went on in France in the second half of the nineteenth century to revive the technique and there are varying opinions as to who should receive the credit for its revival. Its rediscovery is often attributed to André Fernand Thesmar, who used the technique of copper plate backing and who made enamel Art Nouveau jewelry and objects of distinctive, richly coloured character.

Plique à jour is constructed with cells like *cloisonné*, but is left open at the back so that light can shine through the translucent enamel. There were originally at least two ways of achieving this effect. The metal *cloisons* could be laid onto a base to which the enamel would not adhere when it was fired, and the base removed after firing. Alternatively, a sheet of copper foil could be used as the backing and then dissolved after firing by soaking in acid. In all cases, the partitions are filled with enamel in the same way as with *cloisonné*. The disadvantages of *plique à jour* are its fragility and the high degree of skill it therefore demands. Lalique, who made *plique à jour* from 1898 to 1905, improved the method by using saw-pierced sheets of gold for the *cloisons*, usually with a copper backing, which made a much sturdier framework. This method produced an effect which suited the interpretation of the filmy veined membranes in nature, especially insect wings and the crisp, brittle translucency of leaves. It permitted a greater play of light, and for that reason was unsuitable for jewels that had to be pinned to fabric or worn against the skin.

An intriguing Art Nouveau technique is *cabochonné* enamelling, a variation of *plique à jour* imitating cabochon (unfaceted) stones. Layers of translucent

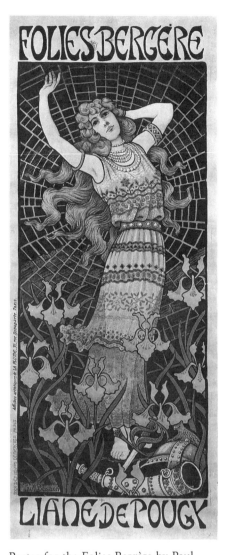

Poster for the Folies Bergère by Paul Berthon featuring Liane de Pougy, *c.* 1900

enamel are built up to give depth of colour and a rounded effect, just like polished stones. Comte du Suau de la Croix is best known for this work, which was also made by Mademoiselle Jeanne de Montigny. It was, however, a technique that had little following, partly because it was a specialized and tricky technique and also because its effect was more typical of the neo-Renaissance style than of Art Nouveau.

Champlevé enamel, on the other hand, was extensively used. In this technique the metal background is hollowed out to provide a 'field' (*champ*) filled with coloured enamel. This method was most effective on relatively large areas. Lalique achieved a special effect by laying two opaque colours one on top of another, adding depth and subtle changes of colour. He also added shimmering flecks or *paillons* of gold or silver foil to areas of translucent enamel, a technique also used by Fouquet's enamellists.

In England, Alexander Fisher (1864–1936) was the most important Arts and Crafts enamellist. His book, *The Art of Enamelling upon Metal* (1906), gives a history of techniques and encourages artists to take advantage of the decorative potential of enamel: 'All the bewildering surfaces, all the depths and lovelinesses that lie darkly in the waters of sea-caves, all the glistening lustre of gleaming gold or silver back and fin of fish, the velvet of the purple sea anemone, the jewelled brilliance of sunshine on snow, the hardness greater than that of marble, the flame of sunset, indeed, the very embodiments in colour of the intensity of beauty – these are at hand waiting for expression in enamel.'

Enamel, being powdered glass, was related to the great progress achieved in the same period in glassmaking by Emile Gallé and his colleagues. Glass itself was widely used in jewelry too, especially by Lalique who had a great interest in glasswork and who later devoted his talents to this medium. Its versatility allowed it to be moulded, coloured, frosted or made matt (as in *pâte de verre*) or shiny.

In *pâte de verre*, glass was ground down and refired in a mould; this gave it the appearance of opaque, precious or more often semi-precious stones. An ancient Egyptian technique, the process had been developed in France in the nineteenth century by the sculptor Henri Cros. *Pâte de verre* was frequently used by Art Nouveau glassmakers and occasionally by jewelers, being particularly suitable for flesh-coloured faces and figures.

Gems used by Art Nouveau jewelers were usually semi-precious. Diamonds were often used for border decoration, or to emphasize lines. To a great extent, coloured precious stones were replaced by enamels, and stones generally were chosen to complement enamel and glass, to suit decorative or figurative purposes. Opals, as we have seen, were the favourite Art Nouveau stones. The cloudy blue-tinged moonstone was perfect for shiny dew-drops and other organic effects. Chalcedony was used for faces, with dark green chrysoprase or any agate that fitted the composition. Pearls were popular in all countries, but mother-of-pearl and turquoise, widely used in England and Germany, were used for abstract designs. The Art Nouveau jeweler used his range of stones as an artist used his palette.

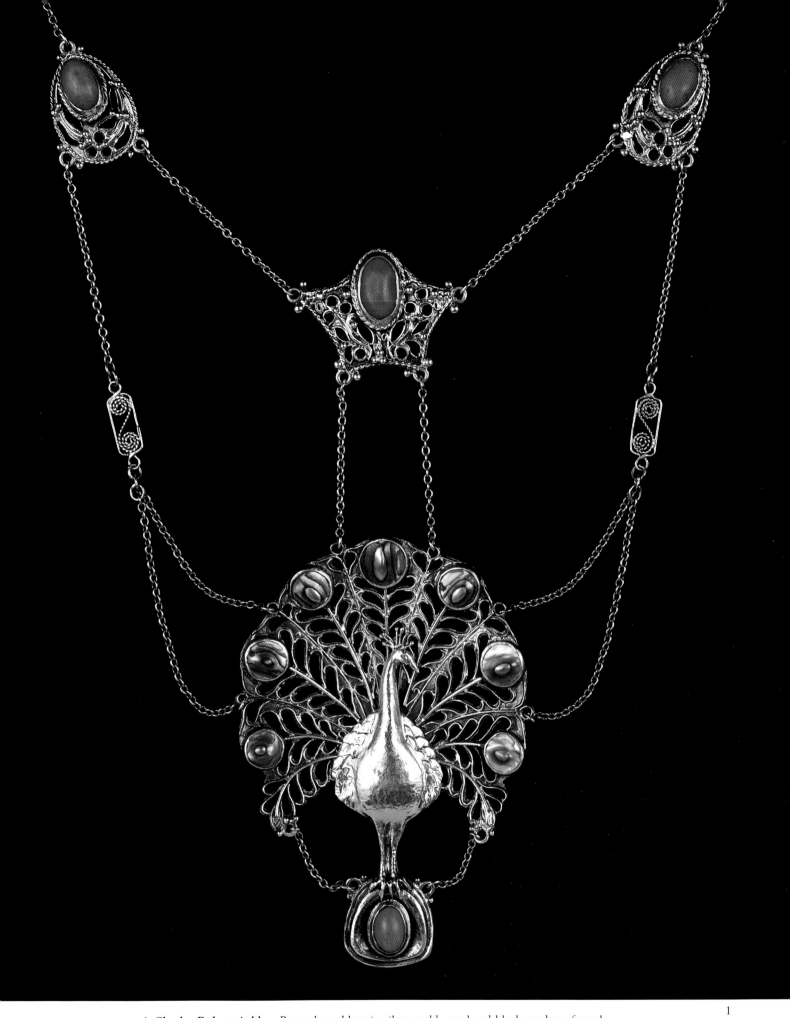

1 **Charles Robert Ashbee** Peacock necklace in silver, gold, coral and black mother-of-pearl (abalone shell). The peacock was probably made by the Guild of Handicraft; the chain is contemporary, probably made by another Arts and Crafts Guild workshop. Great Britain, c. 1900.

2

2 **Alfred Gilbert** Pendants of silver wire and paste. Great Britain, c. 1900.

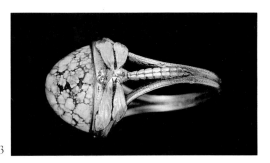

3

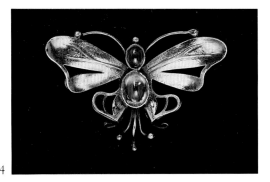

4

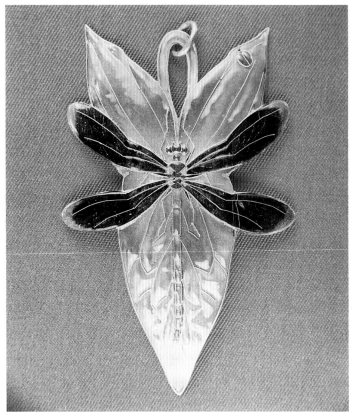

5

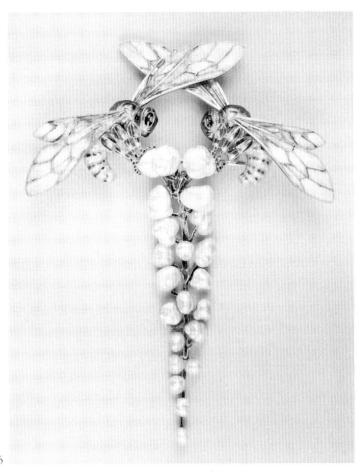

6

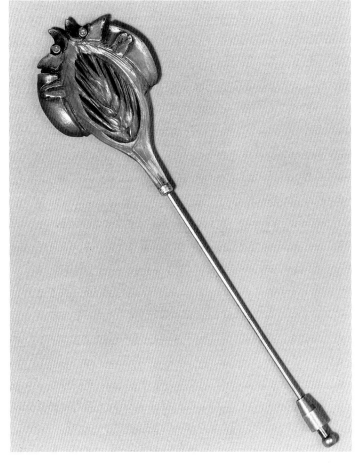

7

3 Gold and turquoise matrix ring with dragonfly motif. France, c. 1900.

4 **Charles Robert Ashbee** Silver butterfly brooch set with cabochon peridots, showing Ashbee's characteristic wing motif. Great Britain, c. 1900.

5 **André Fernand Thesmar** Silver and enamel pendant in deep opaque colours, showing a purple dragonfly and a ladybird resting on a bright green leaf. The simplicity of the composition shows strong Japanese influence. France, c. 1900.

6 **Paul Liénard** Gold brooch with two enamelled wasps hovering over a spray of Baroque pearls. France, c. 1902.

7 **Lucien Gaillard** Horn hatpin carved with insect and wheatsheaf motif. France, c. 1903.

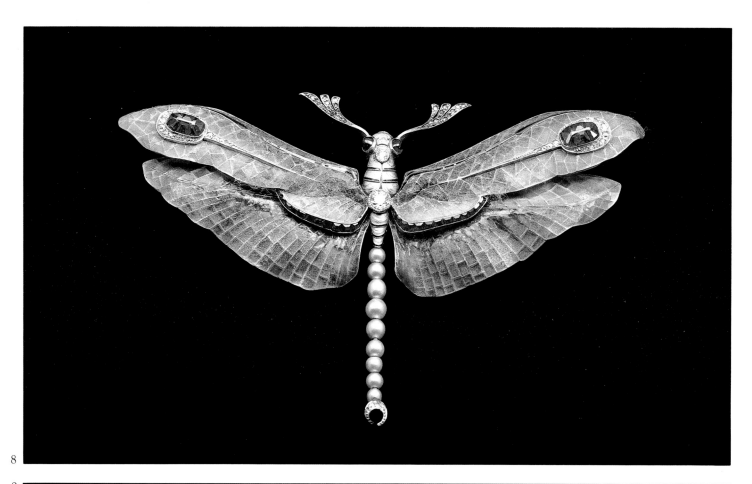

8

9

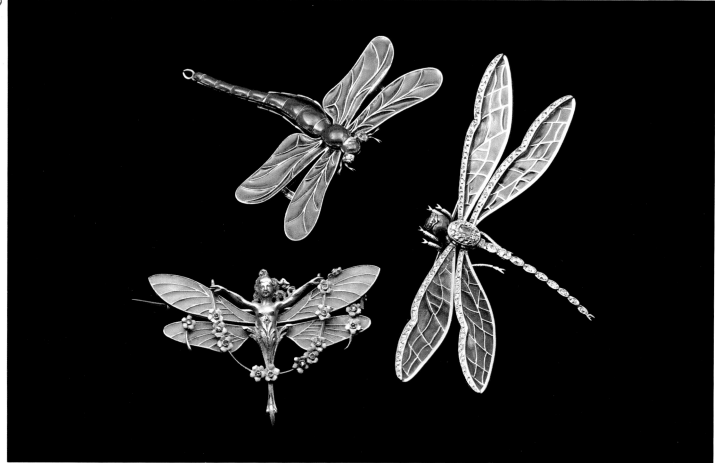

8 **Philippe Wolfers** Large dragonfly brooch with brilliantly shaded *plique à jour* wings, with *paillons* added to the pink, and set with rubies and diamonds. The body is of gold, pearls and black enamel. Belgium, *c.* 1902.

9 (Above left) **Child and Child** Enamelled dragonfly brooch, the opaque enamelled body contrasting with delicate *plique à jour* wings, Great Britain, *c.* 1902; (right) **Alphonse Auger** gold, diamond and gem-set dragonfly brooch with *plique à jour* wings designed to tremble when worn, France, *c.* 1900; (below left) **C. Duguine** gold and enamel brooch, France, *c.* 1900.

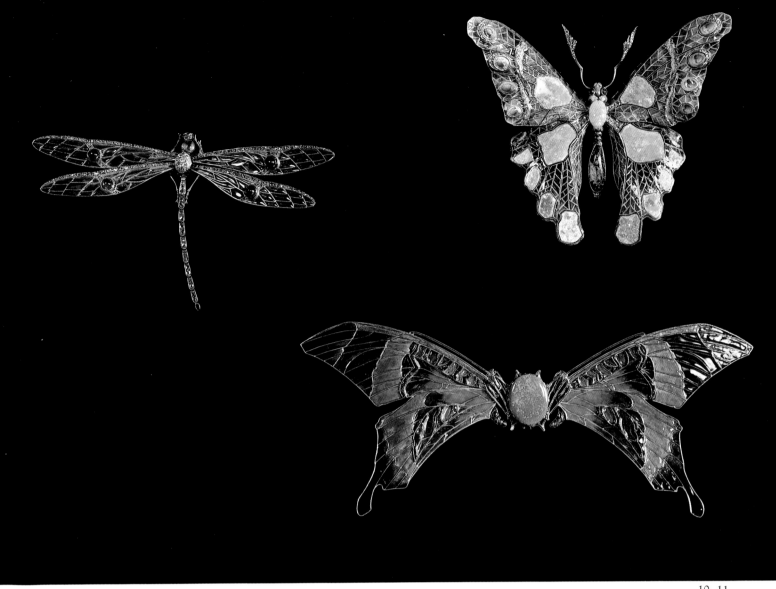

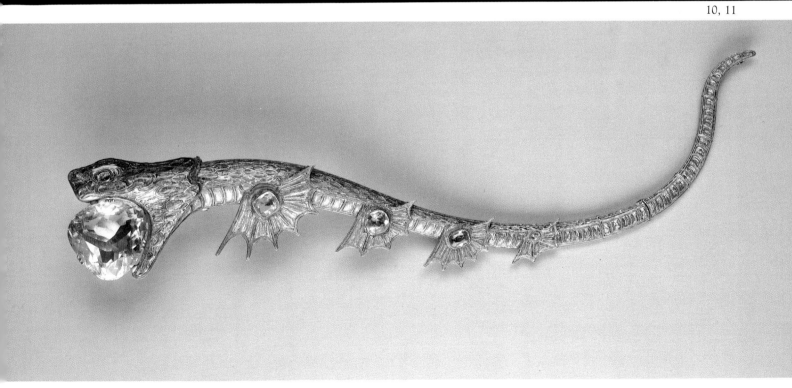

10 (Left) Dragonfly brooch with *plique à jour* wings mounted on springs to tremble when worn, set with sapphires and diamonds, France, *c.* 1900; (right) butterfly brooch in *plique à jour* enamel, set with opals and diamonds, France, *c.* 1900; (below) **René Lalique** Gold and *plique à jour* enamel belt buckle with stylized butterflies flanking an opal, set with sapphires, France, *c.* 1903–04.

11 Articulated dragon brooch in iridescent enamel on gold, set with aquamarines. The quality of the enamel and its foil inclusions suggest the work of Etienne Tourette. France, *c.* 1903.

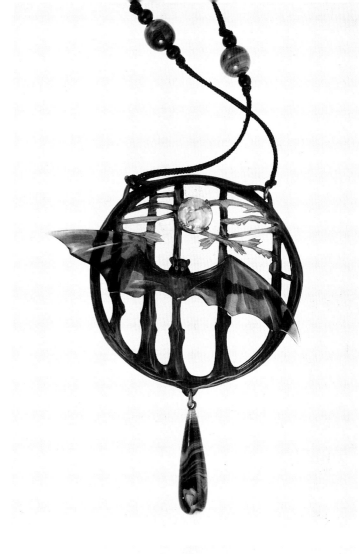

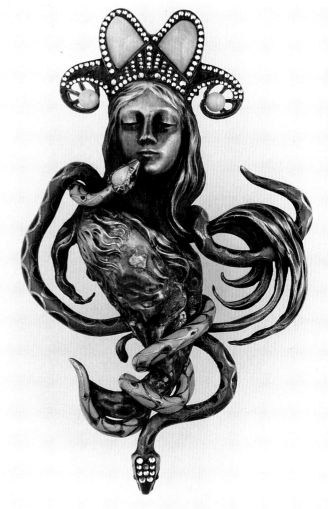

12 **Bonté** (attrib.) Horn pendant carved with bat and tree motif, set with agates and hung on a silk cord. France, c. 1900–05.

13 **E. Dabault** Silver gilt pendant with multicoloured enamels, the headdress set with coral and opals, and the whole piece ornamented with clusters of small emeralds and rose-cut diamonds. France, 1901.

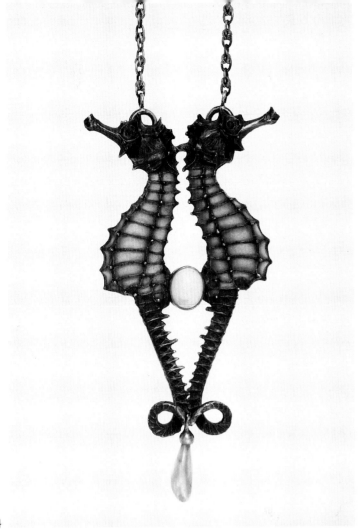

14

15

16

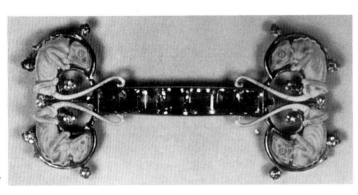

17

14 Silver seahorse pendant with *plique à jour* enamel. Bought by La Maison Moderne at the Turin International Exhibition, 1902. France, *c.* 1902.

15 **Almeric-V. Walter** *Pâte de verre* pendant representing a blue-green chameleon against a graduated multicoloured background. France, *c.* 1900.

16 **René Lalique** Belt buckle in the form of two cockerels' heads enamelled on gold. France, *c.* 1900.

17 **René Lalique** Chameleon brooch of gold, emeralds, green enamel and glass. France, *c.* 1906–08.

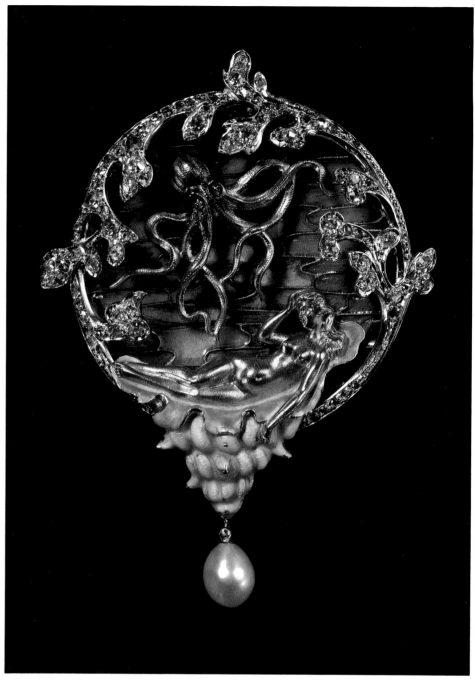

18

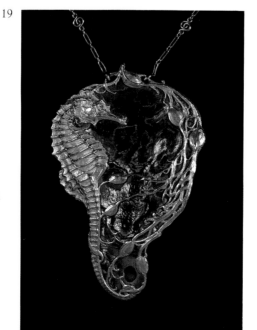

19

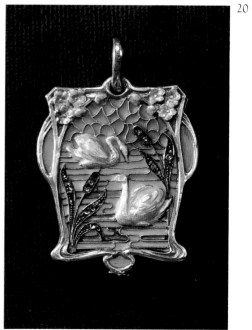

20

18 **Louis Aucoc** Gold and diamond brooch showing an underwater scene with *plique à jour* enamel water and a Baroque pearl. France, *c.* 1900.

19 Gold pendant with black mother-of-pearl (abalone shell) representing the sea. France, *c.* 1900.

20 Gold, *plique à jour* enamel and gem-set pendant locket. France, *c.* 1900.

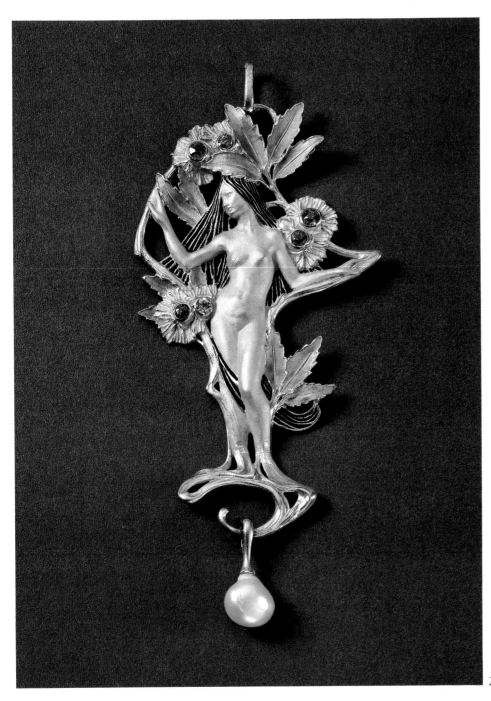

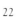

21

22

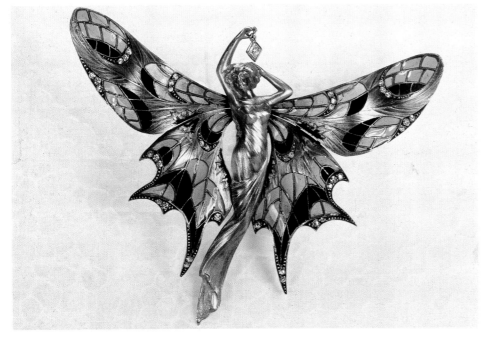

21 **Vever** Pendant incorporating a nude
female form among flowers in gold, enamel
and precious stones. France, c. 1900.

22 **Gaston Lafitte** Gold brooch designed as
a winged female with deeply coloured *plique
à jour* wings edged with diamonds. France,
1904.

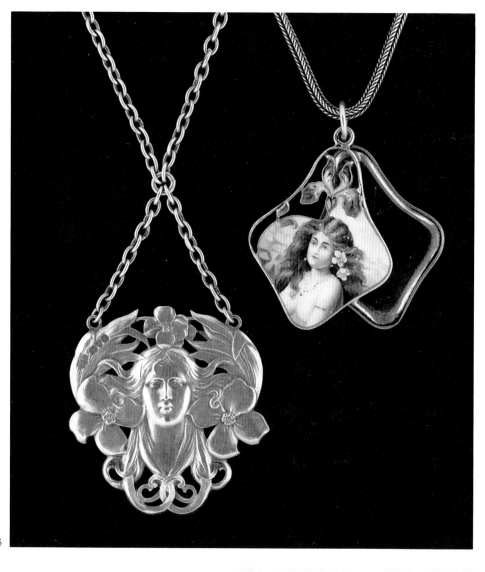

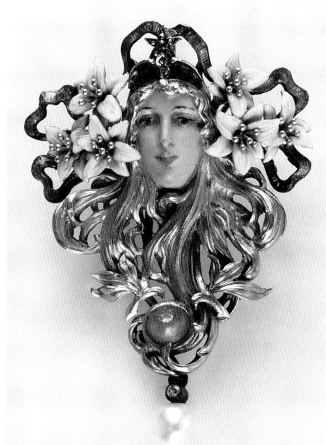

23 Two silver pendants, the one on the right decorated with enamel. Both are popular variations on the 'Princesse Lointaine' theme (the female with flowers). Left, Great Britain; right, France; both c. 1900.

24 'Princesse Lointaine' brooch, after the portrait of Sarah Bernhardt by Alphonse Mucha, in gold, enamel, rubies and sapphires. France, c. 1898.

25 **Hector Guimard** Model for a hatpin ornament in gilded bronze and paste, designed for his wife, c. 1909–10.

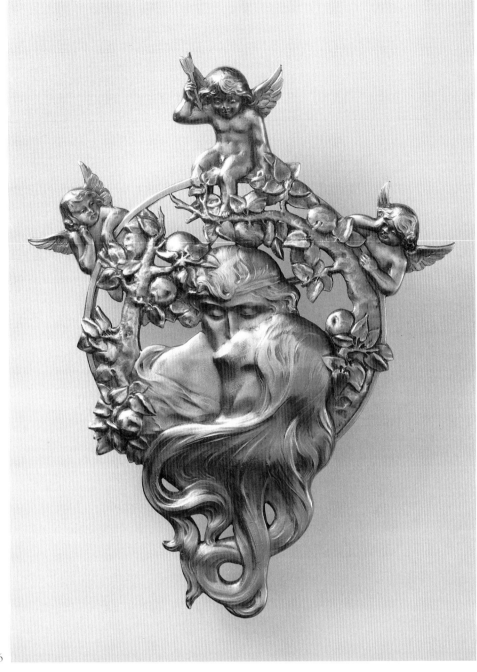

26

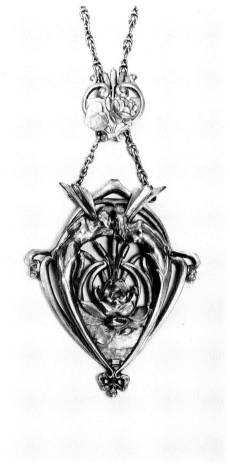

27

28

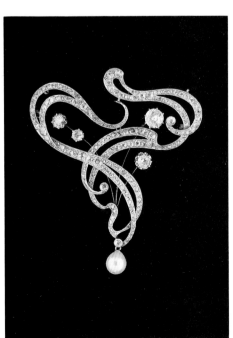

29

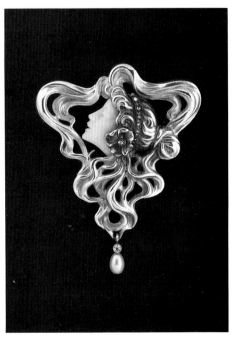

26 H. Perrault Gold brooch in the form of two lovers kissing watched by winged cupids amidst a wreath of apple boughs. France, c. 1900–10.

27 C. Duguine Gold and diamond-set pendant showing two water sprites in a setting of waterlilies and reeds. France, c. 1900.

28 Platinum and diamond pendant/brooch, illustrating how *joaillerie* adapted to Art Nouveau lines. France, c. 1900–05.

29 Gold brooch with female face of carved coral, the hair forming a deliquescent outline. Germany, c. 1900.

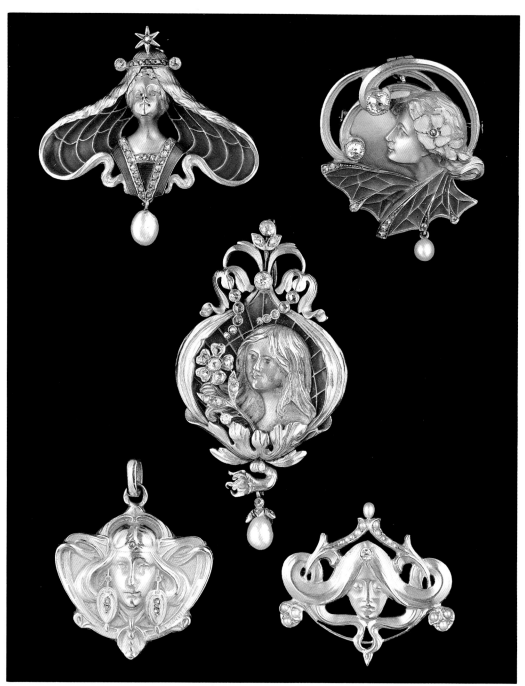

30

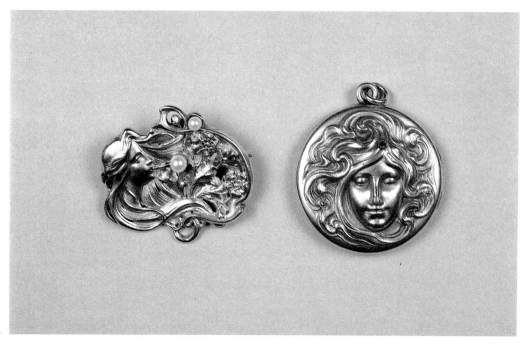

31

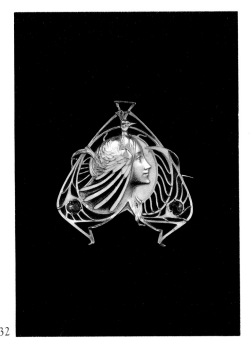

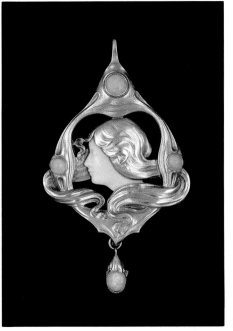

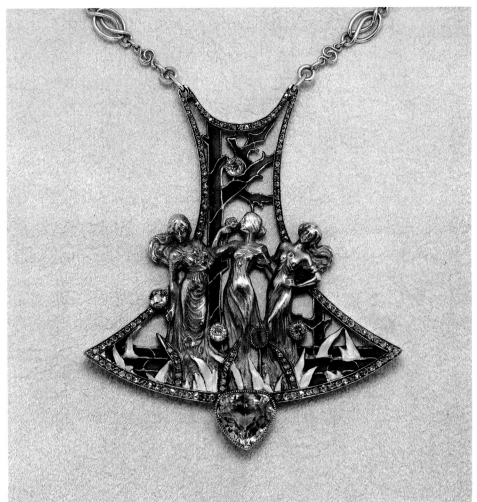

30 Five gold and enamel brooches, the one bottom left by **Lucien Janvier**. France, *c*. 1900.

31 Two jewels showing fluid goldwork: (right) pendant locket; (left) brooch with girl blowing pearl bubbles. France, *c*. 1900.

32 **Lucien Gautrait** Gold and *plique à jour* enamel brooch, the girl's head combined with a peacock motif. France, *c*. 1900.

33 Pendant set with opals, the girl's hair in fluid goldwork and her face in ivory. France, *c*. 1900.

34 **Lucien Gaillard** Pendant with chased gold female figures among *plique à jour* enamel trees, set with diamonds, a ruby, citrines and a peridot. France, *c*. 1902.

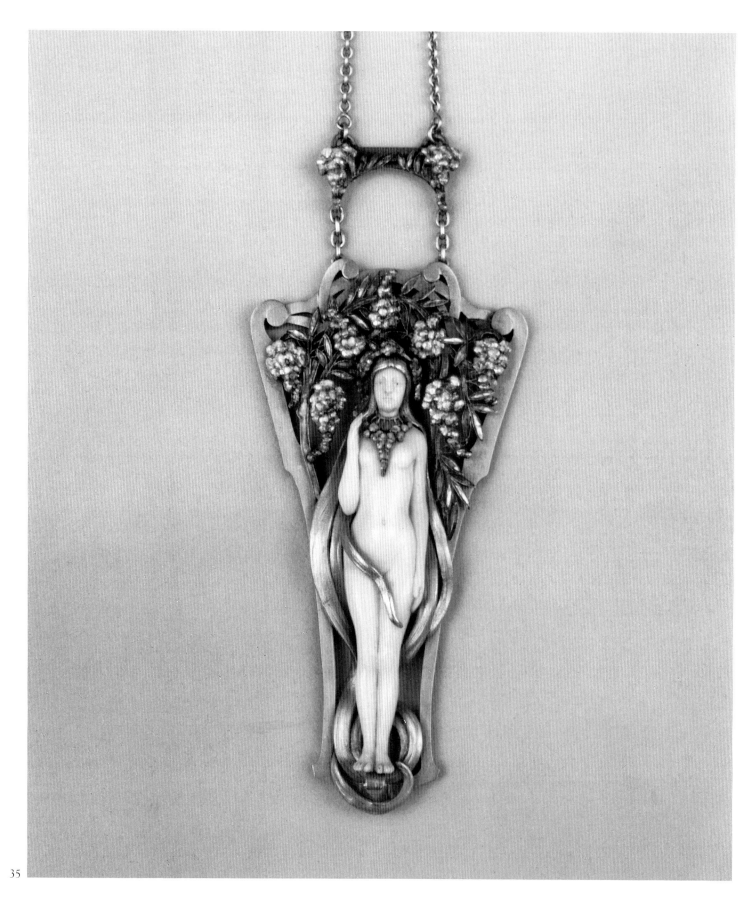

35 Pendant in ivory, gold and green and purple enamel. Its original box bears the title 'La Fée aux Glycines' ('The Wisteria Nymph'). France, c. 1900.

36 **René Lalique** Pendant of gold, enamel and sapphires, showing a blue-white winter landscape. Exhibited at the Paris International Exhibition, 1900. France, c. 1898–1900.

37 **René Lalique** Gold and enamel pendant with an enamelled grey-green female profile veiled in gold plane leaves. The branches are in brown, and the fruit in fiery orange enamel. France, c. 1898–1900.

38 **René Lalique** Gold *plaque de cou* with green *plique à jour* leaves, enamel pea pods and glass flowers. Exhibited at the Paris International Exhibition, 1900. France, 1899–1900.

39 **Piel Frères** Silver, partly gilt belt buckle portraying a medieval female figure with elaborately 'jewelled' cape. France, 1900.

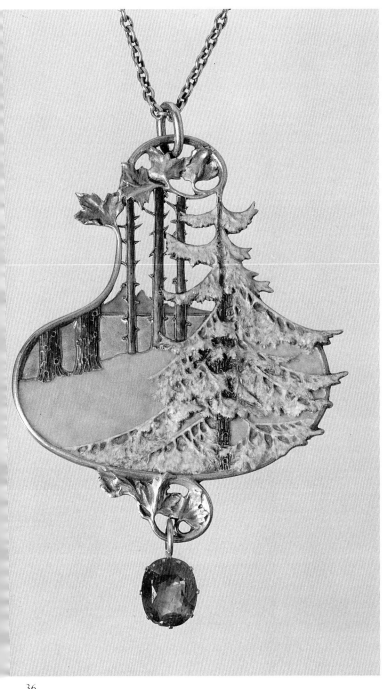

36

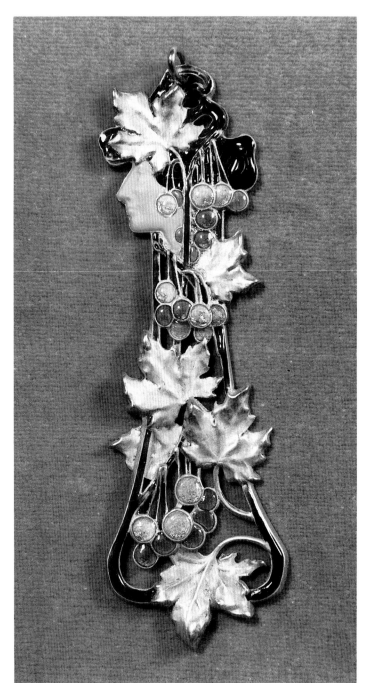

37

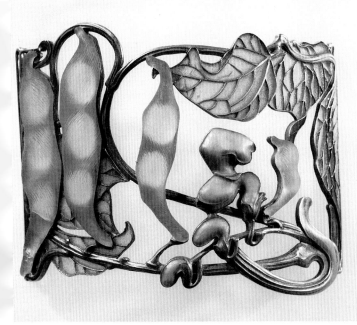

38

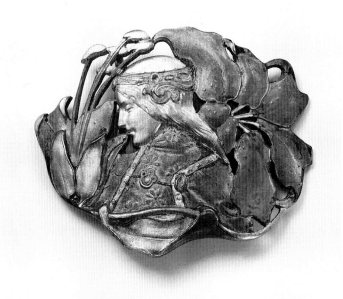

39

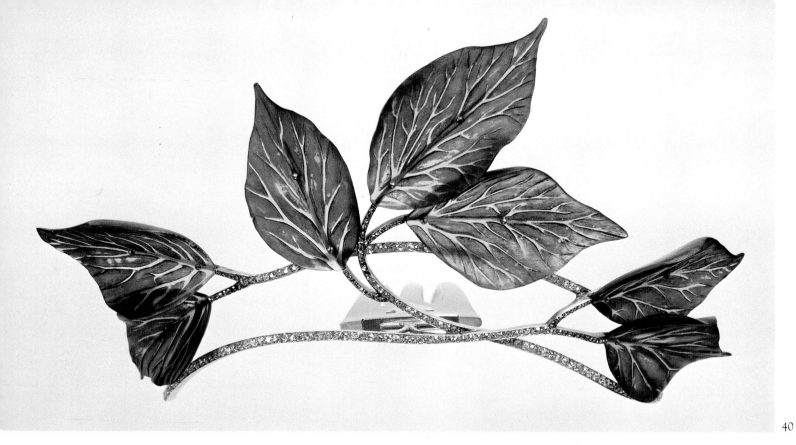

40

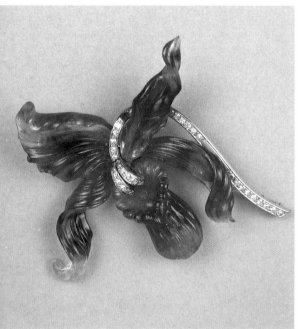

41

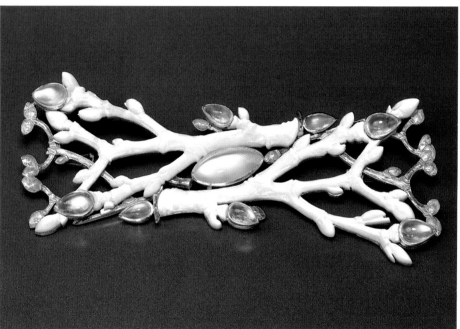

42

40 **René Lalique** Horn and diamond tiara. France, c. 1900.

41 Orchid brooch of carved amethyst and gold, set with diamonds. Austria, c. 1900.

42 **René Lalique** Gold, glass, moonstone and enamel brooch, with willow twigs of moulded glass. France, c. 1902–04.

43 **René Lalique** Gold, enamel, glass and diamond-set brooch, depicting dying anemones. France, c. 1901.

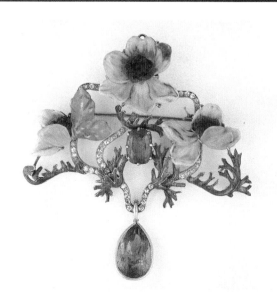

43

1 France

When, in 1895, Samuel Bing transformed his Paris shop of Oriental art into a gallery for the modern decorative arts, the name he chose was simply 'L'Art Nouveau'. The name was to reverberate around the world as that of an exotic, ornamental art form which was both shocking and intriguing.

Samuel Bing's ventures offer a good starting point for the examination of French Art Nouveau jewelry, as he was to become a central figure in the movement.

Bing was born in Hamburg in 1838. He stayed in Germany until the Franco-Prussian war, working in the ceramics industry. He moved to Paris in 1871, became a naturalized citizen and, in the same year, when the craze for Japanese art was getting under way, he opened a shop at 22 Rue de Provence selling objects imported from the Far East. Obviously successful in this venture, he travelled to China and Japan in 1875 and then, to expand his business, took a second shop. He was, according to the jeweler/historian Henri Vever, a man of great taste, and had remarkable artistic courage and foresight. At the height of the fashion for Oriental art, he attracted attention as a dealer at the Paris International Exhibition of 1878, where he was much praised for his Japanese ceramic wares. It was at this exhibition that Bing met Edward C. Moore, an American silversmith and a collector and lover of Oriental art. This was to prove a long-lasting and important relationship for Bing. Moore was a partner of, and chief silversmith for, Charles L. Tiffany (the father of Louis) in New York. He won a gold medal in Paris in 1878 for his silver designs which were influenced by Japanese art. What most impressed Bing in Moore's work was the way the various elements of the design were so ingeniously interpreted as to resolve into a new, exciting and original design.

At this time, the Japanese influence had entirely taken hold of Paris and Europe, and Bing was one of the most important dealers and connoisseurs in Japanese art in Paris. He had eminent customers, including the Goncourt brothers, critics and writers, Louis Gonse, editor of the *Gazette des beaux arts*, and the artist Vincent van Gogh who was a frequent and honoured visitor to Bing's gallery and who thereby introduced several of his friends to Japanese art.

In the 1880s, Bing opened a branch in New York, represented by John Getz who had worked in the field of interior design. Moore, Tiffany and other designers were among Bing's best customers, and business thrived as the Oriental fashion hit New York as it had Paris. Bing was at the centre of the art world, and was revered as an organizer, critic and instigator of ideas. Responding to the vogue for art magazines and industrial design criticism, Bing launched, in 1888, a monthly illustrated journal called *Le Japon artistique* (*Artistic Japan*). It was a handsome journal of the arts and industrial design, and was published in three languages (French, German and English), with special editions for London and New York. In his introductory article, Bing summed up one of the most important aspects of Japanese art: 'The Japanese artist . . . is convinced that nature contains the primordial elements of all things, and according to him, nothing exists in creation, be it only a blade of grass, that is not worthy of a place in the loftiest conceptions of Art. This, if I do not err, is the great and salutary lesson that we may derive from the examples which he sets before us.' Bing believed that the influence of the Japanese artist, in touch with nature, would gradually relax the 'lifeless stiffness' of technical design so that the resulting works would become 'animated by the breath of real life that constitutes the secret charm of every achievement of Japanese art'.[1]

Decorations for this chapter: after a design by Eugène Grasset, from his Méthode de composition ornementale, *Paris, 1905 (chapter title page); design by Paul Liénard from* La Revue de la bijouterie, joaillerie, orfèvrerie, *Paris, 1900–05.*

Le Japon artistique continued publication until 1891 with contributions from critics and artists, including Lucien Falize. Falize wrote for the journal about the importance of Japanese metalwork to contemporary jewelry.

Bing's visit to America in 1893 helped him make the next move towards Art Nouveau. He was sent on an assignment by the French Government to investigate the state of decorative and industrial art in the United States. In his report, published as *La Culture artistique en Amérique* in 1896, he discussed architecture, painting and sculpture and the individual artists. The report also contained ideas about modern art and design, and comments on the importance and relevance of the machine, in what he called 'le relèvement du goût publique' ('the raising of public taste'), a notion that was, surprisingly, opposed to English Arts and Crafts doctrine. It was when he returned to Paris that Bing began to change his Oriental gallery at 22 Rue de Provence into a gallery for Art Nouveau.

On 26 December 1895 Bing opened his new gallery to the public, with a varied international exhibition of Art Nouveau, covering all forms of art, fine and applied. In retrospect, the opening of Bing's gallery was well timed in terms of gathering together many of the artists who were to become central to the movement, but the general public was not yet ready to appreciate the strange new art he presented. The exhibition emphasized not only the freshness of the new design but the importance of the decorative arts: its main theme was that of art in everyday objects. Art Nouveau had not yet developed into the unified style that we can recognize today, and this first gathering of objects were in a tremendous variety of styles. In addition to paintings and sculpture, there were some twenty pieces of Tiffany *favrile* glass, glass by Gallé, furniture, metalwork, textiles, posters, and jewelry by Lalique.

Although 1895 was a significant year, it is useful to look back just a few years earlier. From 1891 the Société Nationale des Beaux Arts had admitted applied arts to its annual shows at the Champ de Mars, without meeting much resistance. This was the first gesture towards acknowledging the principle of the unity of the arts. Seven years earlier, in May 1884, L'Union Centrale des Arts Décoratifs had organized a congress to establish a new plan of action for the revival of the decorative arts, including the distribution of high-quality objects to provincial museums. The first exhibition, of purely contemporary material, was held at the Galerie Georges Petit in December 1894. Most of the artists had exhibited work at the Salons of the previous few years and there were even a few English artists represented. In 1895 the Société des Artistes Français, who had organized the Salons since 1881, gave in reluctantly to public pressure and created a special section for decorative objects at a new Salon in the Champs-Elysées. Although a few objects had crept into these shows, year by year, including jewels, very few were sold – partly because prices were very high and also because they were not given much prominence. Conventional critics usually gave them a passing mention, tagging on a paragraph at the end of their essays. Lalique exhibited here for the first time and was an immediate success. Bing's 1895 exhibition, the Salon de l'Art Nouveau, was greeted with great interest but also with hostility. The objects he chose to show were those which succeeded in manifesting a 'personal conception in accordance with the modern spirit'. Later he explained that he intended his gallery to be a 'meeting ground for all ardent young spirits anxious to manifest the modernity of their tendencies'.[2]

To begin with, however, Bing could see that the objects he had gathered together in his gallery lacked unity of style. Striving too hard to be innovative,

most of them were over-complicated in conception. As he was to say, the objects had a 'chaotic appearance'.[3] The opening of his gallery was, however, a brave move, and many of the conventional Paris critics opposed him violently. For one thing, they resented his encouragement of foreign artists; there was even a hint of anti-Semitism because of Bing's German-Jewish origins. Soon after the opening of L'Art Nouveau, Bing decided that he would personally supervise the manufacture of all objects and would carefully choose the artists who he felt were in tune with his own ideas. This plan was a lengthy and ambitious one and was not fully worked out until 1900, when Bing was to display the results in his own pavilion, 'Art Nouveau Bing', at the International Exhibition in Paris.

Among the contributors to the design of the pavilion interior was the young artist Edward Colonna (1862–1948). Colonna's jewels are particularly associated with Samuel Bing and L'Art Nouveau. Colonna worked in a very distinctive, modern, linear manner, characteristic of Belgian work and more abstract than French Art Nouveau. Colonna (his family name was Klönne) was in fact German, but through his association with Samuel Bing he is considered a French Art Nouveau jewel designer. After studying architecture in Brussels,[4] Colonna left Europe to settle in New York and found a position with Tiffany, working from 1883 to 1884 on luxurious interior design projects, and then with the New York architect Bruce Price. From there he moved to Dayton, Ohio, where he designed railroad cars. At the age of twenty-five, Colonna wrote a small book, *Essay on Broom Corn* (1887), which was inspired by the lines and movement of the broom corn, the branches of which were used to make the rustic or besom broom. It was a series of architectural designs which were all based on rhythmic, linear and interwoven motifs and were very much in tune with the new interests of designers throughout the world.[5] The book was well received but did not bring lasting fame (which was to elude Colonna throughout his life). Another move took Colonna to Montreal where his jewel designs were exhibited in 1890. This is the first time we hear of Colonna's interest in jewelry.

He eventually found his way to Paris. The years 1898 to 1903 were the most important and creative in his career, for it was during this time that he worked for Samuel Bing and made his contribution to Art Nouveau jewel design. Colonna would no doubt have heard of Bing through Tiffany and his Associated Artists. When Colonna arrived in Paris, Bing was formulating his plans for a unified modern style, jewelry being an important aspect of his scheme. Until then he had concentrated on jewels by Lalique. Bing was concerned that jewelry should maintain a feminine grace, but also have the dynamic, flowing lines that were becoming characteristic of architecture, interiors and utilitarian objects. Colonna was unknown in Paris when he turned up at L'Art Nouveau sometime in 1898, but his portfolio was full of just the kind of designs that Samuel Bing was concerned to find.[6] Colonna's work at this time was largely on the theme of orchids, and his portfolio was entitled 'Lignes décoratives tirées de l'orchidée'. Colonna fulfilled the current preoccupation with plant forms and had interpreted them in an economical, Japanese-like fashion. In this, his work was the quintessence of Art Nouveau, and was even more forward-looking in its perfect proportion of form and purity of line. Critics of his jewels shown at Bing's Pavilion at the International Exhibition in 1900 said that Colonna's work showed a discreet charm[7] – rather a tame description for such modernist, unique designs. His work marked a drastic break with the past sumptuous suites of jewels, and it

is likely that the critics did not fully understand the meaning of the new designs. Small brooches and pendants, of softly undulating and interlacing gold, curves and ribbons, represented a very abstract, sensuous interpretation of Nature and her movement. Colonna used softly coloured opaque or *plique à jour* enamels, highly suited to the modern woman, with her delicate but streamlined silhouette: 'la sveltesse de sa taille, la ligne onduleuse de ses toilettes' ('the slenderness of her figure, the softly curving outline of her costume').[8] Sarah Bernhardt was soon to own a Colonna pendant.

Colonna was one of the three main artists, along with Georges de Feure and Eugène Gaillard, employed by Bing to produce his own co-ordinated range of modern objects. Initially Colonna designed just jewelry and objets d'art – including fans and silver mounts for Tiffany glass and for trinkets such as snuff bottles or card cases. His work was first displayed at Bing's gallery in the summer of 1898. In 1899 Colonna won an honourable mention at the Salon des Artistes Français and his work was shown at the annual Brussels exhibition of La Libre Esthétique, at the Munich Secession, and in London at Bing's exhibition at the Grafton Galleries. Colonna's orchid designs were made into jewels and were exhibited in 1900. They included collars with long pearls, the rhythmical swirls of the designs being accompanied by enamel or enhanced by the lustre of Baroque (misshapen) pearls, mother-of-pearl or a cabochon emerald.

Colonna also designed furniture, porcelain, textiles, silver and other objects for Bing, which were shown in 1900. He thus achieved brief international success with Bing, although in America there was little sign of recognition.[9]

When Samuel Bing's gallery was turned over to Oriental art, Colonna had to find employment elsewhere and in 1903 he returned to Canada. He travelled extensively and restlessly, attempting again to be a professional artist, and finally returned to New York in 1913. In 1923 he retired to the South of France and took up his former hobby of antique dealing. He died penniless, and his work forgotten, in 1948.

Another designer of jewelry associated closely with L'Art Nouveau was Samuel Bing's son Marcel. His work is rare, and examples illustrated in contemporary magazines are scarce although his name is frequently mentioned. His designs, along with those of Colonna, were featured in his father's Art Nouveau pavilion in 1900. While Colonna was inspired by plant forms, Marcel Bing interpreted the other main Art Nouveau theme: woman. His

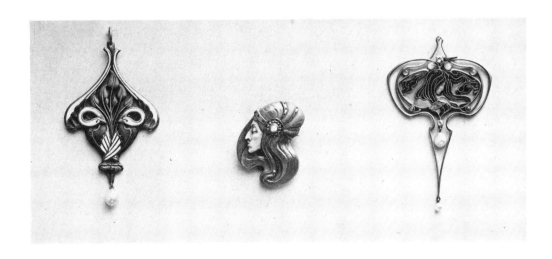

Jewelry designs by Marcel Bing

45

version of the female form had a distinctive look: the slim yet shapely silhouette, the unconventional features of a long, narrow and rather pointed face, inspired perhaps by the classical ballet dancer, Cléo de Mérode, with her perfect oval face, hair bound in ribbons. As a contemporary reviewer suggested,[10] even this effigy was subservient to the demands of the overall style, to the harmony of flowing and well-ordered lines.

At the International Exhibition in 1900, critics praised the essentially French character of the display. One of the objectives of Bing's new plan was that the objects should appeal to a Parisian clientele, and apart from Tiffany glass, he dispensed with many of his foreign contributors. Before this, in 1895 at the opening of L'Art Nouveau and in 1899 at Bing's exhibition in London at the Grafton Galleries, he had included jewels by other foreign designers. He had selected gold brooches made by a metalworker, George Morren of Antwerp, made in collaboration with H. Hooseman of Brussels, and had also shown medals by Victor Prouvé, and some jewels by the Dutch-born sculptress Eliza Beetz.

Although Bing's Art Nouveau pavilion at the International Exhibition in 1900 attracted much attention, he had perhaps been over-ambitious in his plans for L'Art Nouveau. It seems that he had become so involved with creating a new style – one which was not commercial – that he had lost sight of the necessity of running a profitable business. After 1900 he encountered grave financial problems and, still working with his son Marcel, he was forced to return to dealing in Oriental art.

Advertisements for the gallery continued through 1904, but sometime before that L'Art Nouveau itself had virtually disappeared. By 1905, it had been renamed Galeries Bing, and had moved to 10 Rue St Georges.[11] Samuel Bing died, sadly disillusioned, in 1905.

The dreamy image of the new woman was part of the design for living promoted by another major innovative Paris gallery, La Maison Moderne. This was a similar set-up to L'Art Nouveau, but put more emphasis on jewels, and especially on the diffusion of the modern style through jewels for more general tastes and budgets. Pieces are rare, but of exceptional creative design.

La Maison Moderne was established in 1898 by Julius Meier-Graefe, a leading German writer and art critic, who also founded the magazine *Pan*, a Munich-based journal of decorative arts. It was situated near Place Vendôme, at 2 Rue de la Paix and 82 Rue des Petits Champs. Their evocative poster makes use of a severe silhouette of a woman set against a background of objects in modern design, and adorned with jewels in a very avant-garde style. The poster, by Manuel Orazzi, has the haunting quality of a Klimt. The other principal artists who worked for La Maison Moderne were Maurice Dufrène, Clément Mère, Paul Follot, Henry van de Velde and Lucien Gaillard. When Samuel Bing began to work on co-ordinating his designs to suit French tastes, giving all the objects a uniform look, he recommended many of the foreign artists he had commissioned earlier to La Maison Moderne. Sadly, La Maison Moderne suffered the same fate as L'Art Nouveau. Financial disaster forced Meier-Graefe to close his doors in 1903.

Orazzi, Dufrène and Follot were noted for their exclusive jewel designs made for La Maison Moderne. Orazzi, creator of the poster, designed jewels that had an organic strangeness which was criticized by some as an extravagance,[12] using sea anemones with wriggling fronds, or slippery sea creatures, open-mouthed, clenching a pearl or stone, or with turtle-shell backs. Dufrène had a somewhat softer style and was the leading light of the

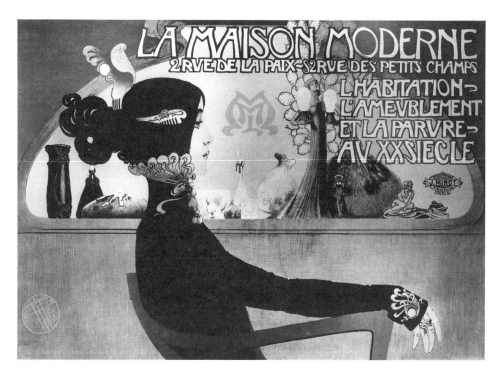

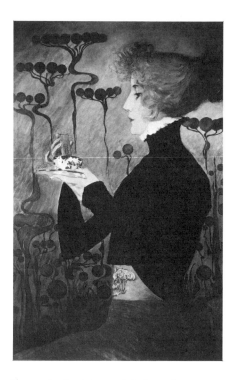

Poster for La Maison Moderne by Manuel Orazzi, c. 1905

Sarah Bernhardt, poster c. 1900–03 by Manuel Orazzi

Maison Moderne designers. He was fond of the fluted lily shape, which he pared down into a stylized, soaring outline. Paul Follot's work was emphatically modern and linear, taking La Maison Moderne firmly into the twentieth century. Like Colonna, Follot concentrated on abstract jewels, but worked with angular and forceful lines. He too was fond of using stylized withered sea algae as a motif.

René Lalique (1860–1945) was the undisputed genius of Art Nouveau jewelry. He was the leader of a group of brilliant French artist-craftsmen who created the Art Nouveau style of jewelry.[13] The French critic Léonce Bénédite described him in 1900 as 'the true innovator. He was the one who tore down old barriers, overturned entrenched traditions, and created a new language'.[14]

The first hint of Lalique's unusual combination of artistic talent with an alert business sense came when he was just fifteen. Having shown a promising talent for drawing as a child at school, he decided to try to put his talent to practical use. During a school holiday he began by painting gouache miniatures of flowers on thin ivory plaques, and selling them. His morning's work earned him 700 sous.

For two years Lalique was apprenticed to the well-known jeweler Louis Aucoc, where he learnt the techniques of jewelry manufacture and also began to do some jewel designs which were then carried out by Aucoc.

Having worked in various jewelry workshops, he finally decided to become an independent freelance designer, so that he could follow his own imagination. Lalique's early work, of the early 1880s, is traditional, diamond-set jewelry: elegant diamond flower sprays, a branch of sweet briar, a geranium branch. Occasionally, there is a hint of lilting movement, but the work is generally conventional.

Lalique continued to sell jewelry designs to his former employers, and his customers included Jacta, Aucoc, Cartier, Renn, Gariod, Hamelin and Destape. He also designed fans, fabrics and wallpapers. He took a sculpture course and experimented with etching. At some time during the early 1880s,

An early brooch of conventional design by René Lalique

Diamond ear-of-corn brooch by René Lalique

Lalique went into business with a family friend, M. Varenne, at 84 Rue de Vaugirard. Lalique made the designs and Varenne sold them to jewelers. They were painted in bright yellow, to look like goldwork, on a black background. The jewels were fairly conventional, showing occasional glints of originality. This association lasted for two years. In 1884 Lalique exhibited his own jewels for the first time at an exhibition of the Crown Jewels in the Louvre. To extend the show, a display of industrial arts was added, in which Lalique was invited to take part. His display was modest and attracted little attention but it did bring the farsighted praise of Alphonse Fouquet. Jules Destape, a manufacturing jeweler who regularly bought designs from Lalique, decided in 1885 to retire, and offered his workshop to Lalique. Lalique accepted the offer, and found himself truly independent for the first time, and so able at last to begin to develop his own style. He first kept to diamond jewelry, selling to Boucheron, Cartier and Vever among others, but gradually introduced some fantasy and originality into his work. As early as 1887, he had an idea for a set of jewels representing a flight of swallows arranged in perspective to add to the effect of swooping movement. He presented a model to Boucheron, but the firm thought the idea too far-fetched and did not place an order. Lalique had faith in his plan and made up the jewel. Boucheron bought the finished item, which proved a success in the shop and led to other variations on the swallow theme.

Lalique's business thrived, and in 1887 he moved to larger premises at 24 Rue du Quatre Septembre. Here he made many of the pieces which were shown at the 1889 Exhibition but under the names of other famous Parisian jewelers. It was around this time that he was drawn to enamelling techniques, and he made some charming jewels in the form of butterflies, flowers, ribbon bows and knots enamelled in light and fresh colours. In 1890, now married to the daughter of the sculptor Auguste Ledru, he moved to even bigger workshops, with his thirty craftsmen, at 20 Rue Thérèse, at the corner of the Avenue de l'Opéra. He designed the furniture and decor of his new workshop and surrounded himself with flowers for detailed study. It was in this secure artistic environment that he began to produce the first of his distinctive 'art' jewels. What Lalique was searching for was something completely different from the past: it had taken him two years of determined effort, from 1887 to 1889, to achieve the combination of artistic design and technique that he was seeking.

Again, in 1892, still not satisfied, he made a renewed effort to break away totally from all that had been done before. He designed, modelled, made studies and technical experiments without ceasing. His efforts culminated in the jewels he showed at the annual Salon from 1895 onwards. All the time he was gradually substituting sculptural, figurative goldwork for traditional diamond settings, adding subtle colours in enamel and introducing motifs from nature. By 1893 he had felt ready to take part in a competition organized by the Union Centrale des Arts Décoratifs, where he won second prize with a drinking vessel. During his experiments with enamel he had become very interested in glass, to which he later turned his entire attention. There was a local glassworks in the Rue Thérèse, where he spent three years studying and experimenting. It was his utter dedication that led to his success with enamel and glass, both of which he incorporated into his jewels. At the Salon of 1895 Lalique showed an oval glass cameo, using a nude female (an early appearance of this motif), and the following year he made a large corsage ornament in glass representing Winter.

Continued on p. 65

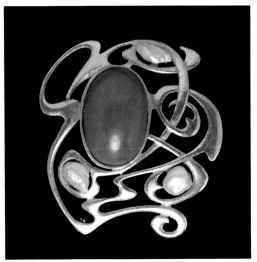

44

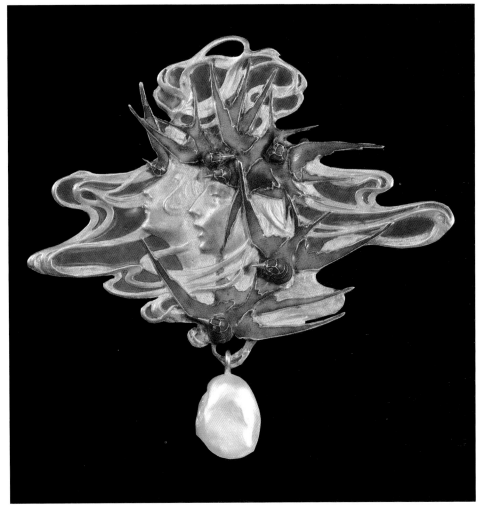

45

44 **Edward Colonna** (attrib.) Gold, pearl and coral brooch, c. 1900.

45 **René Lalique** Gold and enamel pendant with Baroque pearl drop, showing two female faces, their hair forming the outline of the piece, c. 1898–1900.

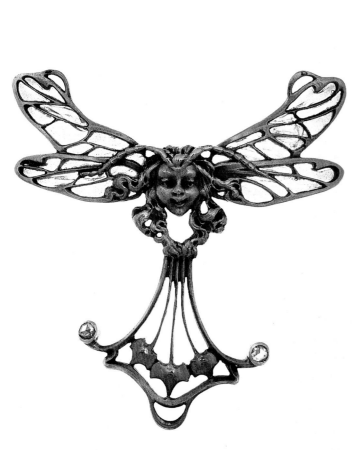

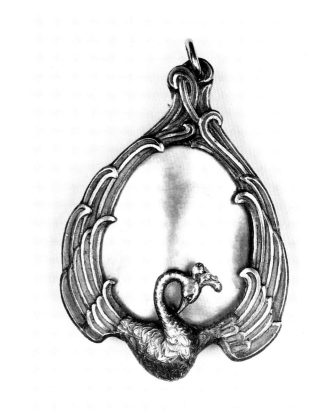

47

46

46 **Saint-Yves** Gold, *plique à jour* enamel and diamond pendant, designed for La Maison Moderne, *c.* 1900.

47 **Marcel Bing** Gold and mother-of-pearl pendant with swan motif, *c.* 1900.

48 **Marcel Bing** Gold, enamel and copper brooch, 1900.

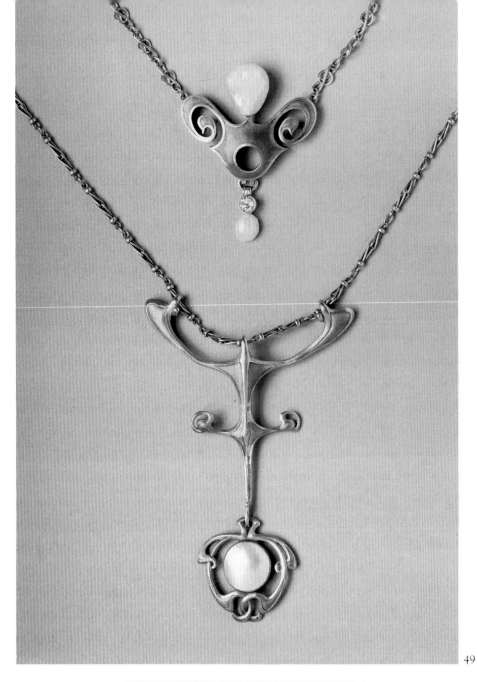

49

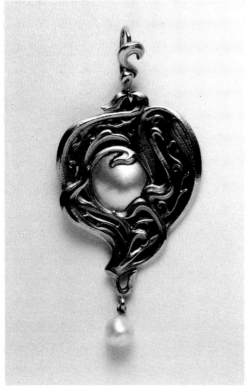

50

49 **Edward Colonna** Two gold pendants with light green enamel, pearls and mother-of-pearl, c. 1898–99.

50 **Edward Colonna** Gold and green enamel pendant with pearl drop, c. 1898–99.

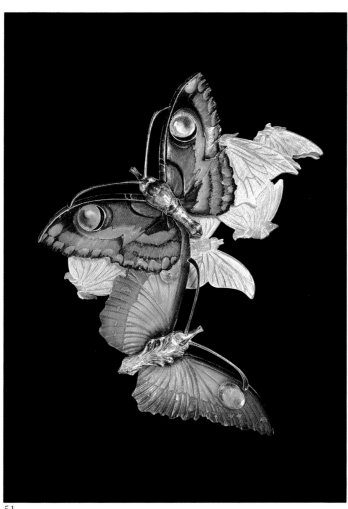

51

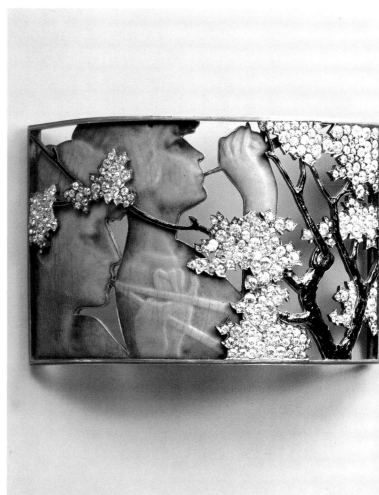

52

51 **René Lalique** Butterfly brooch in carved horn with wing markings in enamel, and bodies and antennae in gold and enamel, *c.* 1906–07.

52 **René Lalique** Fairyland *plaque de cou*, with glass nymphs and enamel trees set with diamonds, *c.* 1900.

53 **René Lalique** Brooch of silver, ivory and enamel, the androgynous face surrounded by pine cone motifs, *c.* 1900–02.

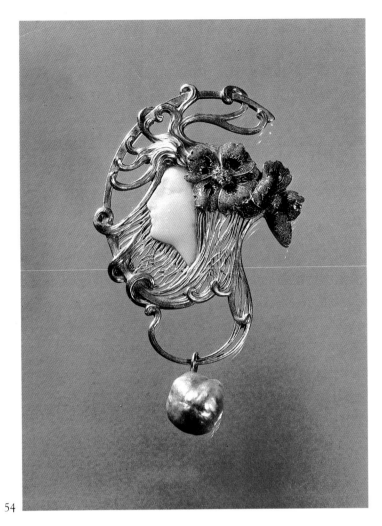

54

55

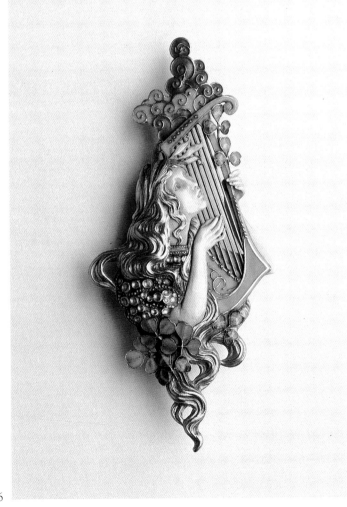

54 **René Lalique** Gold pendant, the face of carved chalcedony, with enamelled poppies and Baroque pearl drop, c. 1898–99.

55 **René Lalique** Gold and opalescent enamel pendant showing a procession of nuns, c. 1900–02.

56 **Eugène Grasset** (designer) and **Vever** (maker) 'Poésie'. Gold, enamel and ivory brooch, 1900.

56

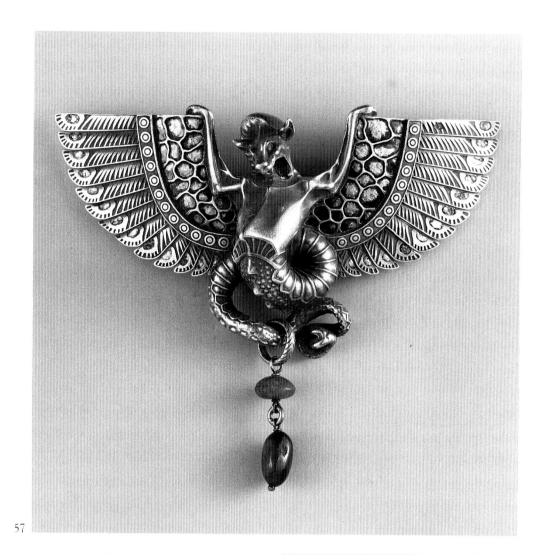

57

58

59

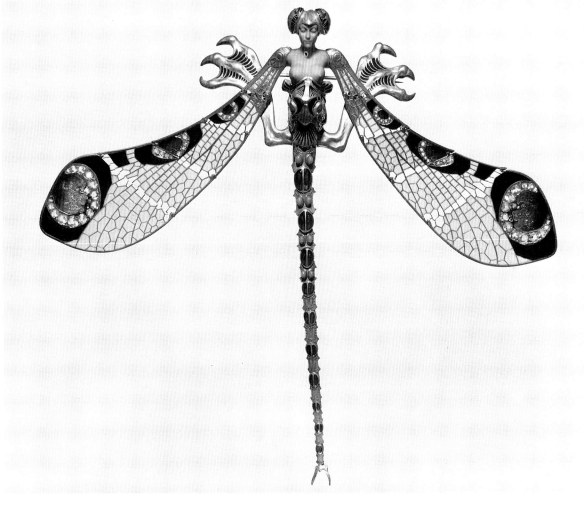

57 René Lalique Egyptian-style head ornament of the type made for Sarah Bernhardt. This example, of oxidized silver and turquoise enamel set with turquoises, was worn by Liane de Pougy (see p. 22), c. 1885–90.

58 René Lalique Diamond-set pendant formed as two cockerels' heads with long curving feathers, in blue enamel, around a star sapphire, c. 1901–02.

59 René Lalique Gold corsage ornament richly enamelled in black, light and dark blue and green. In another version, long chains of pearls hung from the serpents' mouths, c. 1898–99.

60 René Lalique Corsage ornament of gold, *plique à jour* enamel, chrysoprase and moonstones. The dragonfly holds a half-eaten female of carved chrysoprase in its open mouth; the wings are of pale greens and pinks, with dark blue-green and blue-black markings. One of the series of jewels made for Calouste Gulbenkian, c. 1897–98.

61 René Lalique Gold, ivory, enamel and nephrite brooch, the sculpted writhing figures entwined with serpents around two nephrite cabochons, c. 1899–1901.

62

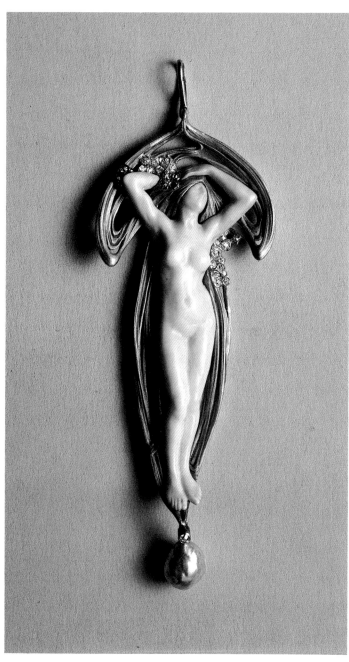

63

62 **Eugène Grasset** (designer) and **Vever** (maker) 'Apparitions'.
Gold, ivory and enamel brooch, 1900.

63 **Vever** Gold and enamel pendant with carved ivory nude female,
set with diamonds, 1900.

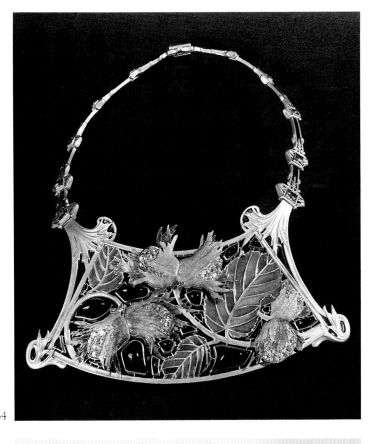

64

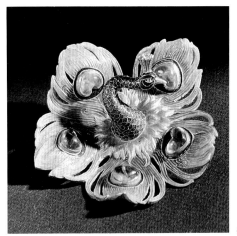

66

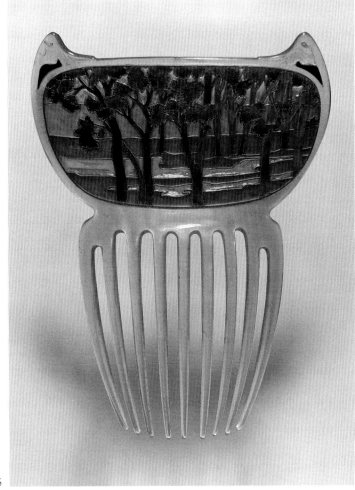

65

64 **René Lalique** Gold necklace with diamond-set hazelnut motifs,
light green enamel, *plique à jour* enamel in light blue tones and dark
blue glass cabochons, set with peridots, c. 1899–1900.

65 **René Lalique** Haircomb with lake and woodland scene of gold,
enamel and agate, the colours ranging from dusky violet in the trees
to shimmering foiled blue enamel and dark blue agate in the lake,
c. 1899–1900.

66 **René Lalique** Peacock brooch of gold, the blue enamelled head
emerging from the cluster of feathers in blue and white enamel,
each set with a moonstone, c. 1898–99.

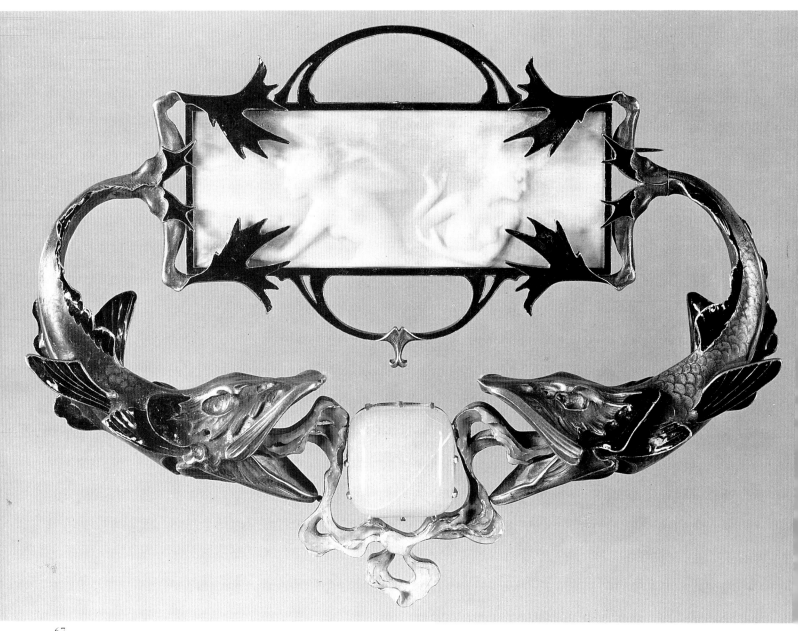

67

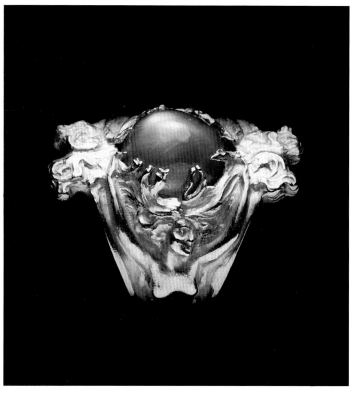

67 **René Lalique** Corsage ornament of gold, enamel, ivory and opals, the fish and sea plants enamelled in shades of dark blue and green, the ivory plaque carved with two females struggling against the water, c. 1898–1900.

68 **René Lalique** Gold ring showing two nude females, their hair flowing onto the central star sapphire, c. 1900.

69 **René Lalique** Brooch/pendant of black patinated silver, the glass face covered with a layer of opalescent enamel and surrounded by poppies, c. 1898–1900.

70 **René Lalique** Gold *plaque de cou* depicting a female profile in carved chrysoprase, her hair tied with a blue enamelled ribbon and the surrounding poppies in dark blue-black enamel, c. 1898–1900.

71 **René Lalique** Jester's head brooch of carved ivory, gold and dark green enamel, c. 1900.

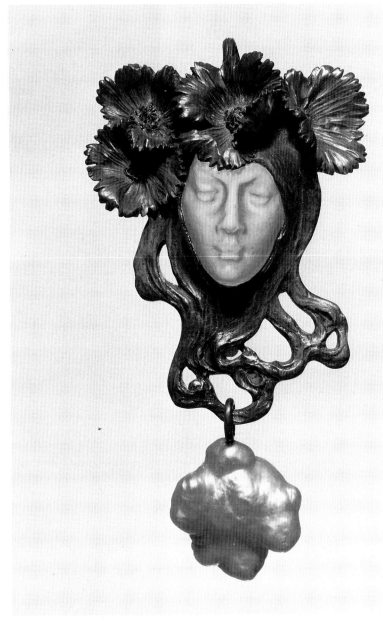

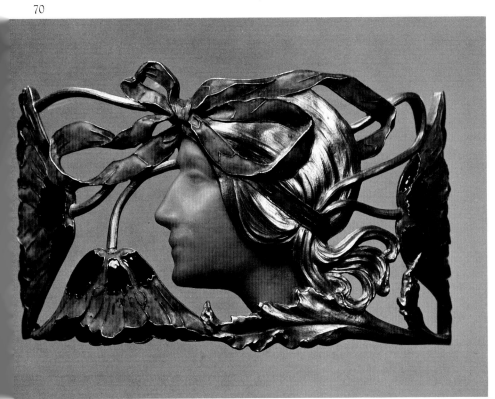

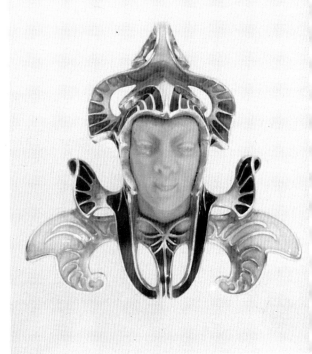

70

69

71

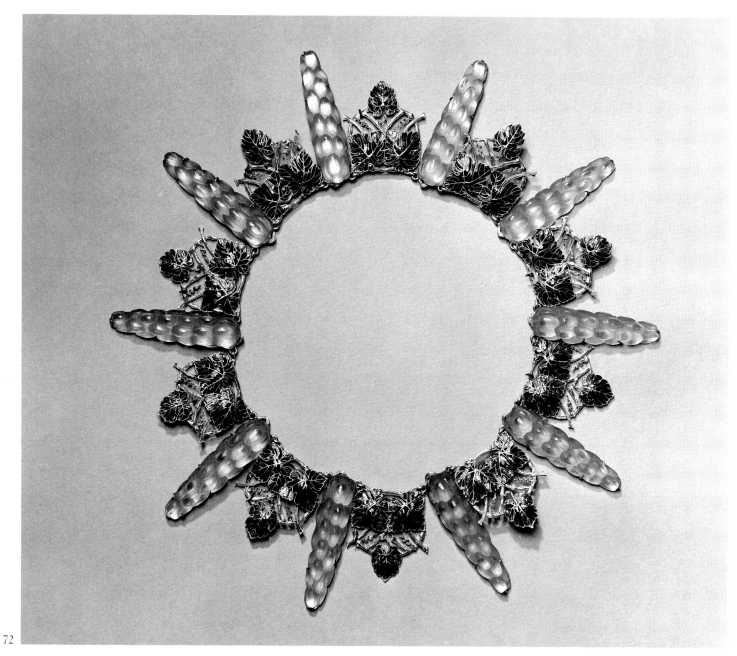

72

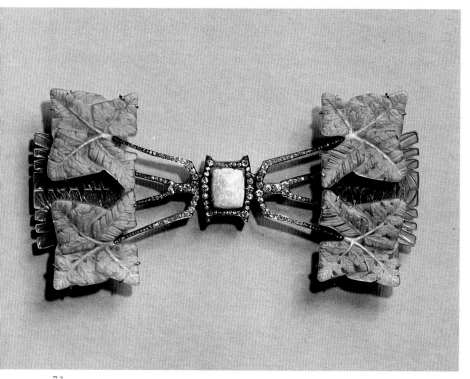

73

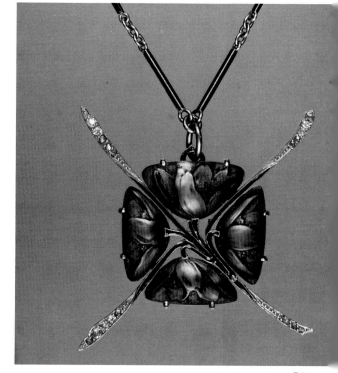

74

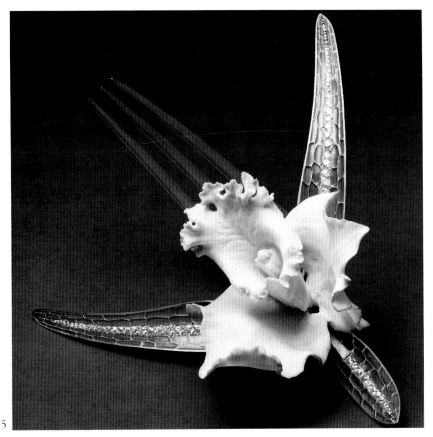

75

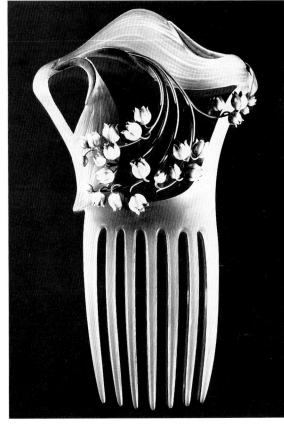

76

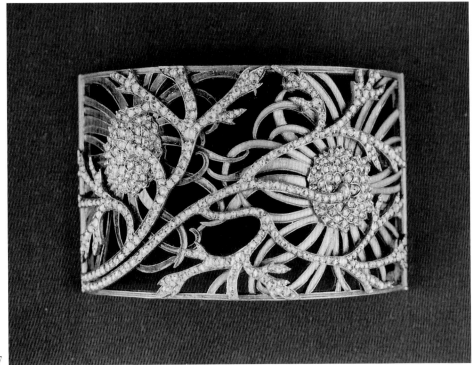

77

72 **René Lalique** Gold necklace with clusters of grapes in translucent glass alternating with green enamelled vine leaves, c. 1903–04.

73 **René Lalique** Gold corsage ornament, the central opal framed with diamonds spreading outwards to sprays of fern leaves in opalescent glass and green *plique à jour* enamel, c. 1903–04.

74 **René Lalique** Amber-coloured glass and diamond pendant, on a gold and enamel chain, c. 1900.

75 **René Lalique** Orchid hair ornament of carved ivory set on a gold stem, with brown *plique à jour* leaves set with diamonds, c.1903–04.

76 **René Lalique** Horn haircomb with gold lily-of-the-valley decoration, the flowers in white enamel and the curling leaves in grey-green enamel, 1900.

77 **René Lalique** Gold, green enamel and diamond *plaque de cou*, with wispy chrysanthemum motifs, c. 1900.

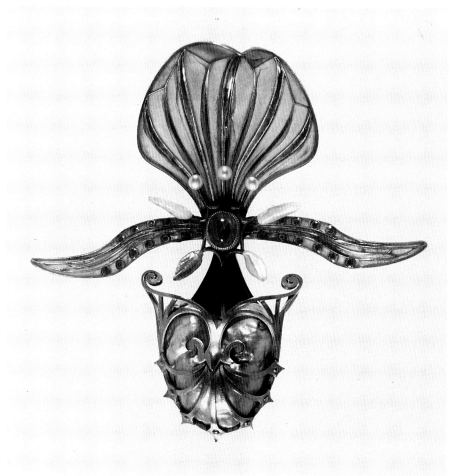

78

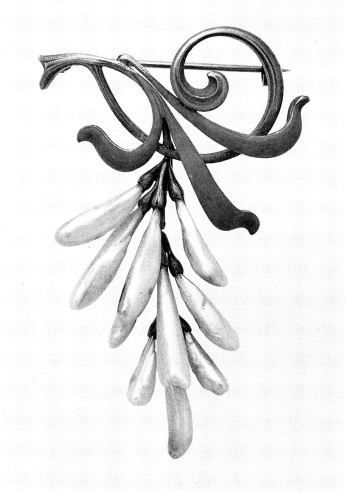

79

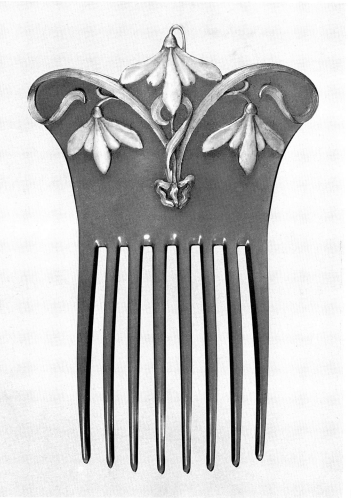

80

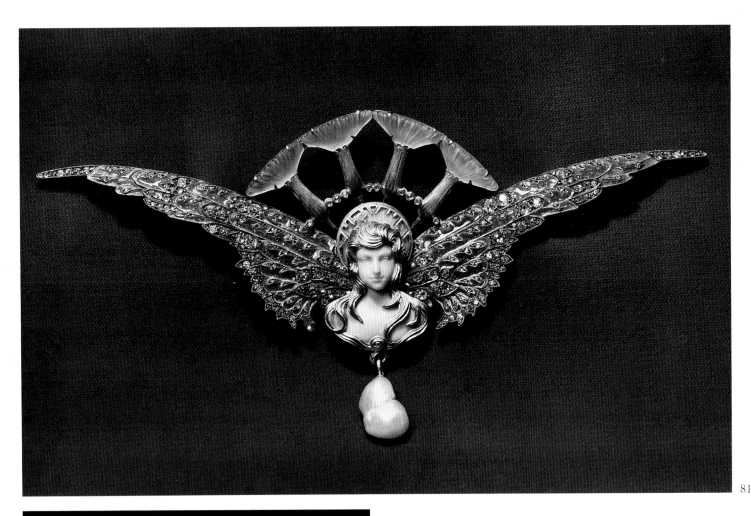

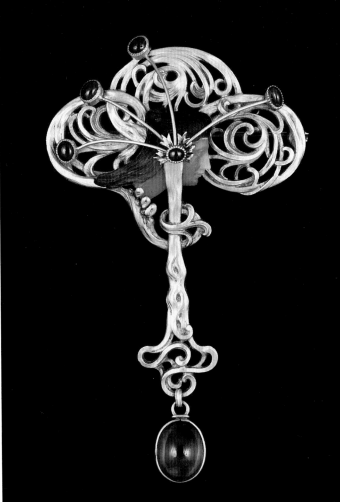

78 **Georges Fouquet** Orchid pendant, of gold, *plique à jour* enamel, rubies, pearls, and large encased Baroque pearl, 1898.

79 **Vever** Gold brooch set with pearls, *c*. 1900.

80 **Vever** Tortoiseshell haircomb with silver gilt and white enamel floral decoration, *c*. 1900.

81 **Georges Fouquet** Corsage ornament, set in gold. The bust is of carved ivory-coloured hardstone, the halo of opals, the wings of *plique à jour* enamel set with diamonds, and the flowers of enamel and glass, 1904.

82 **Georges Fouquet** Gold pendant, the central face and hair motifs of glass set against a sinuous tree design, with cabochon rubies and a pendant cabochon sapphire, 1899.

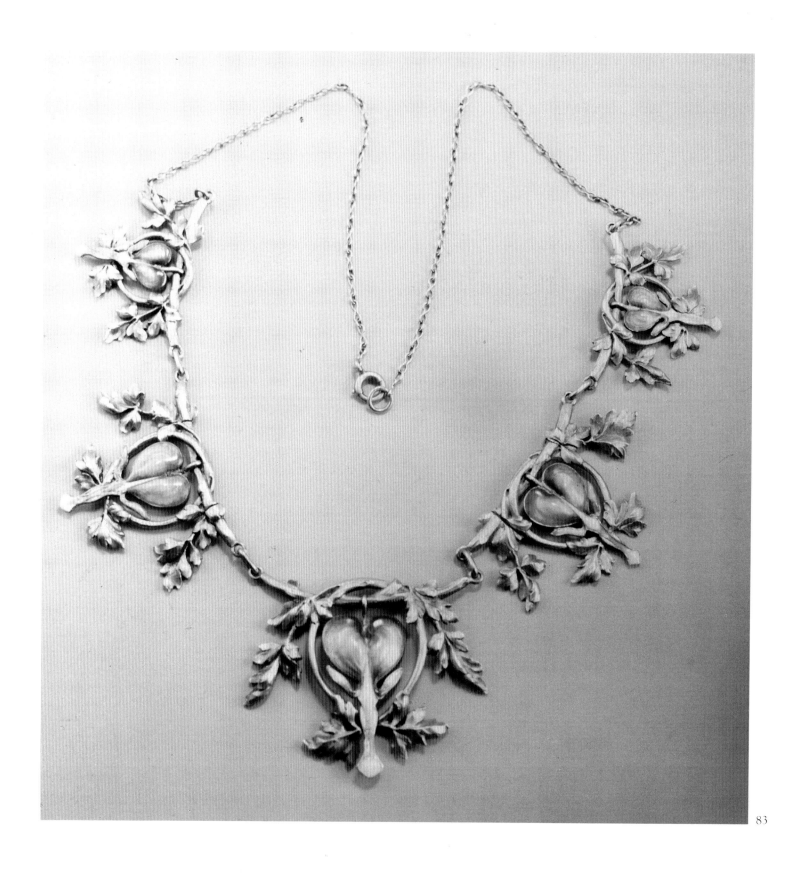

83 **Lucien Gaillard** Gold necklace with bleeding-heart flower motifs in shades of pink and white enamel, c. 1900–02.

During the 1890s Lalique began working with Sarah Bernhardt, an association which proved to be an important catalyst to his career. In 1890 Lalique had modelled a portrait of Sarah Bernhardt which in 1894 was used for jewels made for the celebration organized for the actress by her friends. Lalique subsequently worked on a number of personal jewels for her, and her flamboyant personality touched a chord of his imagination. From 1891 to 1894 Lalique designed and made a series of jewels for the actress in her roles as Iseyl and Gismonda. Opinion varies as to how much Lalique's work was influenced by these stage jewels. In Vever's view, Lalique was only partially seduced by theatrical jewelry. Some productions gave him an opportunity to unleash great melodrama and passion in design, and perhaps this helped unblock another creative channel. Lalique's association with Sarah Bernhardt attracted wide publicity in the decorative art magazines. The jewels were much admired and brought Lalique's name to the attention of the public.

In 1894, Lalique exhibited for the first time under his own name at the Salon of the Société des Artistes Français, at the Palais de l'Industrie. He showed two objects, an ivory music-book cover and a metal vase. The book cover had been made in his workshop by the special method he had developed of 'reducing' (*tour à réduire*). This was a technique used mainly by engravers and medallists. The details of the mechanism are not known today, but basically it involved reproducing from a large prototype so that the details looked delicately hand-chased. A large master model, of plaster or wax, was first made to incorporate all the details, and the lines were then transferred onto the metal, using a special contraption for scaling them down. The pieces were extremely effective, and the method was immediately and widely copied. Lalique first made gold brooches in this way in 1893, and then a variety of other objects, rings, combs and bracelets, sometimes obtaining very high relief.

Lalique was anxious to send a large collection to the decorative arts section of the 1895 Salon of the Société des Artistes Français because there was still commercial resistance to his work, mainly from retailers who felt that his jewels might be attractive but that their customers would not buy them. Lalique knew they were wrong, and he wanted the opportunity to be judged directly by the public. Among the pieces he displayed (for which he won third prize) was one particularly charming dragonfly jewel with wings of amethysts and yellow sapphires, and an extraordinary cloak clasp or brooch which had a strong Renaissance flavour but whose historicism was contradicted by the inclusion of a totally nude female figure. From now on, his use of the supple, soft lines of the female body as a central motif was to become his trademark. This jeweled clasp had been made in 1893 or 1894, arguably the first Art Nouveau jewel to use a naked female. Naturally, it caused a great deal of comment: some thought it a stroke of genius, others found it distasteful and improper. Contemporary debates about the motifs which should or should not be used in jewelry went so far as to suggest banning representations of human figures and animals, and only allowing subjects such as butterflies, dragonflies and swallows. Other jewelers all over Europe, however (even in countries, says Vever, known for their rigid principles), lost no time in following Lalique's example in reviving the medieval tradition of using the human figure as a decorative feature.

At the Salon of 1896, Lalique's display was even more exciting and won him a second prize. Several pieces of goldwork were shown, but the

exhibition was notable for a horn bracelet: his first piece in this medium. Horn was then not a material much used in jewelry and was therefore not readily available. Lalique had been fascinated for some time by its misty translucency, its floating clouds of milky colour, its texture and lightness. He had bought horn at the local abattoirs, thinking he would make use of it one day and, like the flowers he kept in his atelier, a large white horn was put next to his work table.

Contrary to general opinion, horn is in fact extremely difficult to work and Lalique must have been wondering how to tackle the brittle substance. There is no detailed record of how he generally managed to fashion it, but for the 1896 bracelet he simply cut the centre piece from a slice of horn to leave a bracelet shape, to which he applied silver decoration. By the following year he had made enough progress to send to the Salon a whole showcase full of ivory and horn haircombs which proved extremely successful. The combs incorporated his lyrical flower motifs, fluid and full of movement. With horn, he had introduced another magical transformation to Art Nouveau jewelry. This time he achieved a first prize medal, and in the same year was awarded a Grand Prix for the jewelry he sent to the International Exhibition in Brussels.

Lalique's success was now certain and swift. He very quickly outgrew his workshops as demand for his jewelry increased. Each new collection was awaited with anticipation. Each showing became an artistic treat, an event – and this after so many years of public resistance. He now had hordes of admirers, followers and imitators. His creative energy was swelled by praise and success; he was in full flight and created fantasy upon fantasy in jewels. The flowery pens of the critics flowed just as quickly, praising his talent and genius; he was compared to the greatest artists of all times, hailed as the 'rénovateur' who had completely overturned the old, stale styles and who, single-handed, had breathed life into the dying jeweler's art, rejuvenating old traditions. Most of all, he was hailed as the home-grown French creator of Art Nouveau jewelry. Chauvinistic critics could now pay tribute to foreign influences but comfortably claim Art Nouveau jewelry as their own. Lalique became a national hero.

In *Art et décoration* in 1899,[15] the French critic Roger Marx enthused over Lalique's work and challenged the generally held view that the renaissance of the French decorative arts was due to influences from abroad, principally from England. The French masters, he proclaimed, had escaped contagion from foreign styles, and it was only from Frenchmen that such works of new art could come, works whose essence was the glorification of womanhood. Furthermore, he wrote, this was 'the radiant work of René Lalique'. He stressed the difference between the roles of French and English women; the latter were not, in his view, so concerned with their appearance, not able, he said, to be naturally coquettish and aware of their femininity. Roger Marx and his colleagues emphasized the sudden and enormous impact of Lalique's work on the public and on his fellow artisans. He also recognized the effort it took for Lalique to achieve the title of 'the emancipator and master of modern French jewelry'. Lalique's fame and success reached their peak at the International Exhibition in Paris in 1900. As he was always concerned with every aspect of design, furniture, objects, interior decoration, his showcases at the Exhibition were a sensation. The central piece was a wrought-iron grille, formed by a series of luscious butterfly women in patinated bronze,[16] naked and in various languorous poses linked by their spreading wings.

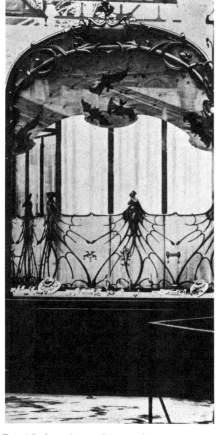

René Lalique's pavilion at the International Exhibition, Paris, in 1900

Many of the jewels on exhibition were enamelled. They were apparently presented in the showcases on ground glass, resting on white watered silk. At the back of the display was the wrought-iron grille, and behind it a curtain of pleated black gauze. Above the grille and the showcases in the window, black velvet bats hung against a grey pelmet which echoed the grey carpets and curtains. On one wall there was a large panel painted by Georges Picard, depicting young sylphs frolicking in the moonlight among the trees, on the edge of a lake encircled with reeds. A cheval glass framed by two enormous bronze serpents – each 'as thick as one's wrist' – completed the effect. Vever provides a detailed description of Lalique's display, taken from hasty notes written at the opening of the display. He found the jewels breathtaking, and lists some twenty horn haircombs, with enamels, chrysoprases, amethysts and opals, necklaces, diadems, entwined serpents of shimmering enamels, disgorging cascades of Baroque pearls. 'I felt a shudder . . . everywhere a profusion of gems, harmoniously arranged and cut, in perfect taste; "plaques de cou" [neck plaques], bracelets, a thousand other different objects. You thought you were dreaming when you saw these beautiful things . . . a cockerel holding an enormous yellow diamond in its beak; a huge dragonfly with a woman's body and diaphanous wings; enamelled country scenes sparkling with diamond dew-drops; ornaments like pine cones.'[17]

Crowds flocked to Lalique's showcases, to press their noses to the windows and marvel at the works of art. He had won the public over to his conviction that jewels could and should be works of art, that fine workmanship and artistic composition could be more valuable and breathtaking than precious stones. Lalique was rewarded with a Grand Prix and the rosette of the Légion d'Honneur. In the aftermath of the Exhibition, he could hardly cope with the flood of orders that came as a result.

Lalique now had two main collaborators, N. Hoffmann, a sculptor, and a designer called Chardon. They all moved in 1902, together with the workshops and offices, to a five-storey building at 40 Cours la Reine, which was designed by Lalique. The outside of the new shop was decorated with pine motifs, and moulded glass adorned the carriage gates. In 1905 he was to open another shop at 24 Place Vendôme.

After the 1900 Exhibition, Lalique became sought after internationally. He took part in the Turin International Exhibition of 1902, and those of Berlin in 1903, St Louis in 1904 and Liège in 1905. In London he was invited to exhibit at the Grafton Galleries in 1903. The walls of the Galleries were decorated with his designs, and his objects were displayed in his own showcases of glass panels moulded into flower designs. The exhibition was a great success and he was invited to have another at Agnew's in 1905. Orders came from around the world, including one from Alexandra, the Queen of England, as well as from museums. The most spectacular order came from Calouste Gulbenkian, the Armenian banker magnate who at that time lived in England: he commissioned a series of 145 pieces which were to be the most fantastic and original objects of Lalique's repertoire (now in the Gulbenkian Foundation in Lisbon; pls 59–61, 65, 69, 70), and occupied Lalique from 1895 to 1912. At the same time, he continued to make a variety of objects other than jewels: gold accessories, dressing-table trinkets, boxes, bottles, brushes. In 1908 or 1909, when he took over a glass factory near Paris, he returned to glassmaking. Eventually, he was to turn his entire attention to glass, and many later jewels are simple glass plaques, produced as pendants or brooches. However, the price he paid for his success was that a whole

Cover of L'Album d'art, 1904, showing a René Lalique pendant owned by Queen Alexandra

industry of copies and unworthy imitations developed, and he was greatly disillusioned by the cheap commercialization of his art.

Lalique was without doubt the instigator and leader of the French Art Nouveau jewel. Although perhaps a handful of great designers followed him, there were a multitude of imitators of the Art Nouveau style. Hundreds of artists and designers, many from other, industrially based fields as well as jewelers, turned their talents (or lack of talent) in this direction; contemporary journals give this as the reason for the rapid decline of Art Nouveau jewelry. Inevitably, much of the work was derivative, and everyone seemed to be copying everyone else. By 1912 observers were bored with seeing, for example, four haircombs by different people, all in the same design.

Many well-established jewelry firms turned to Art Nouveau jewel design towards the turn of the century, principally Vever and Fouquet, while other masterpieces in Art Nouveau jewels were the work of more individual designers, or craftsmen who presided over smaller workshops. These included Gaillard, Gautrait and Liénard, who sold through retailers. The system within the Paris jewelry trade around 1900 can be confusing, as it has not been verified whether certain names are those of craftsmen or designers or both; whether they were manufacturers or retailers or both; whether they were individual craftsmen or part of a large team. There was no standard practice: designs were bought and sold, or borrowed. Many designers were freelance and worked for large firms, or at other times created designs on their own account, while others, such as Desrosiers, were employed full time by one firm.

The firm of Vever became outstanding for its Art Nouveau jewelry. It had been founded in 1821 by Pierre Vever (1795–1853) in Metz, where he had a shop and jewelry workshop that quickly attracted a large clientele and a group of skilled craftsmen. His elder son, Ernest (1823–84), joined him in the business in 1848, having perfected his skills and broadened his manufacturing experience in Germany and Austria. During his time abroad, he had realized the value of provincial workshops, which had to be self-sufficient and become involved in every aspect of jewel manufacture. When Alsace-Lorraine was annexed by the Germans in 1871, Ernest Vever left Metz and went to Paris where he bought the prominent jewelry firm of Baugrand at 19 Rue de la Paix (Baugrand having died during the siege of Paris in 1870). Thus Vever was able to combine the expertise gained in his provincial factory with the prestige of a famous Parisian jewelry house.

Ernest Vever became a highly successful and respected member of the trade, and his reputation continued to grow. When he retired in 1881, the firm was taken over by his two sons, Paul (1851–1915) and Henri (1854–1942), who had been working with him since 1874. Both were thoroughly trained in manufacturing techniques. Together, the two brothers achieved international acclaim through exhibitions in Paris, Moscow, Chicago and Brussels in the late 1880s and 1890s, and triumphed with their harmonious gem-set jewels. In 1900 they won a Grand Prix at the International Exhibition for their Art Nouveau enamelled works of art.

Henri Vever was also a prolific writer and critic of jewelry design and is an invaluable source of information about French jewelry in the nineteenth century, especially Art Nouveau jewelry. He was a principal figure in the development of jewel design and production around the turn of the century. He also wrote the standard three-volume work, *La Bijouterie française au XIXe siècle*. Writing of Henri Vever as a designer, the art critic Léonce

Bénédite pointed out that he was unusual in that he continued to use only precious stones, and added: 'Lalique on the one hand, and Vever on the other, are two names sufficient to represent the entire display of the jeweler's art at the International Exhibition.'[18]

Henri Vever's reputation was similar to that of Fouquet and Lalique. Like Fouquet, he drew on the talents of another inspired designer to produce the firm's most remarkable jewels: those of Eugène Grasset (1841–1917). Grasset's jewels were original and spectacular, full of the verve, imagination and dreamy quality of the best Art Nouveau work. Many of these are now in the Musée des Arts Décoratifs in Paris; his most famous piece is the 'Sylvia' pendant (pl. 84). His designs were not executed in precious stones but in gold and enamels, falling into the category of *bijouterie*, as opposed to *joaillerie*, or gem-set jewels. Several of Grasset's jewels feature a young girl's profile or full face, with a longing, dreamy expression. One, called 'Apparition', features a girl's and a boy's head emerging from rippling water (pl. 62). His designs sometimes incorporated medallions by Louis Bottée. Vever also used other designers, such as Henri Vollet and the sculptor René Rozet who designed jewels for the 1900 Exhibition. Etienne Tourette, the sought-after enamellist, and Gautrait, who worked for Léon Gariod, also worked for Vever at different times. Apart from the celebrated 'Sylvia' pendant made in 1900, the jewels designed by Grasset and gem-set pieces, Vever is famous for haircombs using organic motifs made in *plique à jour* enamel, and freshwater pearls tumbling in naturalistic interpretations.

There were three generations of the Paris jewelry firm Fouquet.[19] The firm was founded in 1860 by Alphonse Fouquet (1828–1911), who designed and produced jewels in the neo-Renaissance style of the 1870s and 1880s, made of heavily chiselled gold, with painted enamel. By the 1880s he had started introducing into his designs characteristic Art Nouveau motifs like the human figure and the dragonfly, but their use was stilted and lacked the freedom of movement of the more successful Art Nouveau designs. The first period of the firm's production runs from 1860 to 1895, the year Alphonse's eldest son, Georges (1862–1957), took over. He had joined his father in 1891, working on the second floor of the premises at 35 Avenue de l'Opéra, which remained the firm's base until 1900. Georges Fouquet exhibited new-style jewels for the first time in 1898 at the Salon of the Société des Artistes Français. Vever noticed them and criticized them for their heaviness: the chasing, he thought, seemed to be done by a bronze-worker rather than a jeweler. The first few years after Georges took over were a period of great transition as the firm adapted to the new style and broke completely with past traditions. Georges' first display in 1898 included a hairpin with a girl's head of ivory, a haircomb in the form of a butterfly in tortoiseshell encrusted with opals, and an orchid brooch with *plique à jour* enamel petals.

By 1900 the firm was installed in the famous shop at 6 Rue Royale: the workshop was on the upper floor, where all the specialist craftsmen worked with great dedication. The work was mostly in gold, with enamels and coloured stones. The opal was much used, sometimes as a mosaic, and the Baroque pearl was popular. The first jewel that Fouquet made in *plique à jour* enamel was an orchid brooch, in 1898. Transclucent enamels were later often made with little glinting inclusions of coloured foil or gold (*paillons*). On other pieces, translucent enamel was applied to a background of engraved gold. Fouquet used lines of diamonds in these compositions to emphasize form and shape. Perhaps the best pieces of this period are the result of his

collaboration with Charles Desrosiers, an independent designer and former pupil of Eugène Grasset. Fouquet's designs underwent a dramatic change around 1895, largely as a result of his association with Desrosiers. By 1899, just one year after Vever's criticism, jewels designed by Desrosiers for Fouquet were highly praised for their beauty, colour and use of materials. Desrosier's beautiful organic designs played a major part in establishing Fouquet as a top-rank Art Nouveau jeweler. One great feat of production is a coiled sea-serpent in breathtaking *plique à jour* enamel, with soaring, delicately shaded wings, set against fronds of gold seaweed and little misshapen pearls (pl. 94). The deep, shifting greens of the almost mythical creature are enhanced by the use of emeralds. A similar shape and design used a stylized dragonfly as its central theme, amongst *plique à jour* fronds. Wonderfully soft goldwork can be seen in the use of trees incorporated into organic designs that melt into a young girl's hair or are spread over an enamelled landscape; entwined peacocks' heads look down proudly over their own beautiful bodies enamelled and set with opals.

Desrosiers was a master of the Art Nouveau style, using its symbolism, motifs and themes to produce stunning designs. For horn haircombs, for example, he used natural motifs including maple, sycamore seeds, the orchid, the female form, simple wild flowers, chestnut leaves, mistletoe, peacocks and winged sea creatures. It must be added, however, that the fruits of Fouquet's collaboration with Desrosiers, beautiful and technically perfect as they are, do not have the originality of those by Lalique. Fouquet and Desrosiers worked together from 1898 to 1910, perhaps until 1914. Desrosiers' designs were done in pencil or watercolour, with some gouache for the stones, on yellow-beige paper, and are works of art in themselves.

Fouquet often employed the talents of Etienne Tourette, who is known to have been responsible for the wonderful enamels with gold inclusions which date from 1904, their iridescent shimmering effect created by acid etching the surface of the enamel. Tourette was a master at making enamels particularly bright and vivacious and full of reflected light.

When Fouquet moved to new premises at 6 Rue Royale in 1900, this initiated the production of fully fledged and important Art Nouveau jewelry second only to Lalique and Vever. Visitors to the shop were greeted by a monumental tribute to femininity: a bronze panel in relief of a woman, almost nine feet high, her ample naked form draped loosely in flimsy veils, her hair swirling around her, holding in her hand a dramatic piece of jewelry. This panel, in the centre of the façade, was part of the decoration plan for the shop designed by Alphonse Mucha. One important reason for Fouquet's fame was his collaboration with Mucha. It is not known how Fouquet and Mucha met, but Mucha was seduced by the drama and potential of jewel design, perhaps through his connection with Sarah Bernhardt, and Fouquet by Mucha's opulent Orientalist poster designs and his depictions of exotic females. Mucha, to whom fame and success had come almost too easily, needed a new challenge – one that Fouquet could offer.

Fouquet decided to employ Mucha, who was at that time the rage of Paris, to create jewels which would stun audiences at the International Exhibition, and also to design and decorate his new shop. Their partnership lasted only two years, from 1899 to 1901. The exotic interior of Fouquet's Rue Royale shop was a maze of evocative motifs, massive peacocks, statues, rounded crescent-shape motifs (Mucha's hallmark), serpents, females and lush swirls and curves from ceiling to floor.

The first result of the collaboration was the superb ring-bracelet of entwined serpents made for Sarah Bernhardt (see p. 21), also the subject of Mucha's posters. Most of the jewels Mucha designed for Fouquet were intended for the 1900 Exhibition. They were strange objects, theatrical and unwearable, shoulder and breast pieces, head ornaments draped with chains, with fabulously enamelled plaques, Byzantine in flavour and entirely different from the usual run of naturalistic Art Nouveau jewels. They were, needless to say, criticized for their irrelevance to current fashions. Inspired by Sarah Bernhardt's handsome features, Mucha designed a huge corsage ornament representing a female figure, executed in several versions: the face was made of sculpted ivory, totally surrounded by the most luxuriant gold chased hair from which was suspended a painted panel, also on ivory, of an Art Nouveau female.

A feature of Mucha's designs was the use of clusters of pendant motifs, little stones in gold cases, like charms. His colours are rich but soft, with the golden glint of sumptuous Eastern richness. Mucha's work with Fouquet must have involved Desrosiers; many designs by Desrosiers are so similar to Mucha's as to be almost indistinguishable. One such is a diamond winged corsage ornament made in 1904 with a sculpted face of ivory-coloured glass, a halo of gold hair, and surmounted with engraved glass panels.

Fouquet's jewels remained much the same until 1908. He stopped exhibiting at the Salons in 1904 and concentrated on large International Exhibitions, for example that of 1900 in Milan. Around 1910 Fouquet lapsed into a more subdued semi-abstract Edwardian style, leaving naturalistic excesses behind him.

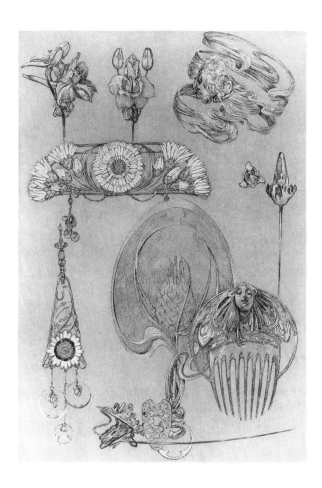

Jewelry designs by Alphonse Mucha from *Documents décoratifs*, 1902–03

71

After Lalique, Vever and Fouquet, Lucien Gaillard (b. 1861) made, in my opinion, the most innovative contribution to Art Nouveau jewel design. His work, with its strong emphasis on nature and Japanese designs, has a very distinctive beauty. Gaillard was apprenticed as a silversmith in his father's workshop in 1878, as well as working in a number of other specialist workshops. He was passionate about his work, studied and researched tirelessly and experimented with alloys, gilding and patinations. His work was much praised at the Exhibition of 1889, when he won a gold medal for his metalwork. In 1900 he moved his workshop to 107 Rue la Boétie, reorganized it for more efficient production and installed the latest equipment.

From the moment he went into the business in 1878, he had been totally captivated by Japanese art, design and technique, and had made up his mind to unravel the secrets of Japanese manufacturing processes and the composition of the metal alloys they used. From 1881 he embarked on serious research to this end. The objects made by the French craftsmen did not completely satisfy him and after 1900 he had craftsmen sent over from Tokyo: engravers, lacquerists, jewelers, were installed in his workshop. He was very much an innovator in this field, particularly in producing lacquered wares. His showcase at the 1900 Exhibition drew a great deal of attention for its new look, although, at this stage, he still showed little jewelry. Instead it contained little vases and silver trinkets that illustrated his work with patination.

It was around this time that he felt encouraged by the work of Lalique to turn to jewelry design, for which he had a brilliant and natural talent. By 1902 he was designing and exhibiting remarkable work: haircombs, pendants, *plaques de cou*, all of which were very successful. Gaillard's work was constantly praised at all the Salons in which he participated, and he won the first prize for jewelry at the Paris Salon in 1904. A Japanese flavour and simplicity continued to be his trademark. Probably under the influence of Lalique, he worked a great deal in horn, with considerable success, as well as with exquisite, shaded enamels set with semi-precious and precious stones. The patina he used, which became a speciality of the firm, was applied to horn, and as a result his combs and pins have a special milky, iridescent bloom. His graceful compositions, forceful in their clarity and simplicity, were highly praised even by the most severe critics. His work, they said, although so obviously influenced by the Japanese, was still totally Parisian – anxious as they were to claim this talented master for their own. Examples of his use of Japanese style and naturalistic themes are an ear of corn carved as a motif on a horn haircomb, its golden glints suggested in the addition, asymmetrically positioned on one side, of a sherry-coloured topaz, and also a gold necklace of enamelled bleeding-heart motifs with swirls of opaque deep pink that stress the organic sensuality of the flower, mixed with a gold framework of leaves and branches that recalls the inherited tradition of chased goldwork (pl. 83). Gaillard was praised in *L'Art décoratif* in 1903,[20] along with Lalique, for his experimental work in giving ivory and horn an acid-derived luminous skin, and producing tints of dark green, purple, orange, mauve or pearlized grey. The same article pointed out that Gaillard's jewels were modern, yet flattering to Parisian women and at the same time comfortable and practical to wear. Gaillard was fond of opals and the subtleties of *pâte de verre*. He often used flower motifs of chrysanthemums, fuchsias, or the water plants 'which seem to keep, in their gracefulness, the ripples of the water that gave them life'.[21]

Continued on p. 89

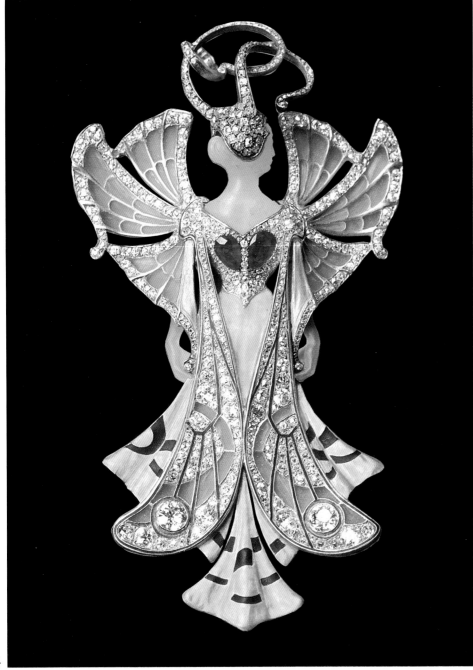

84

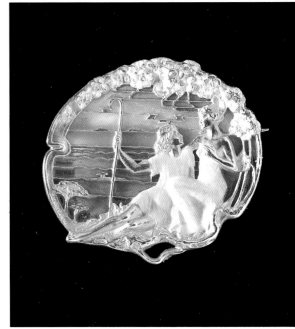

85

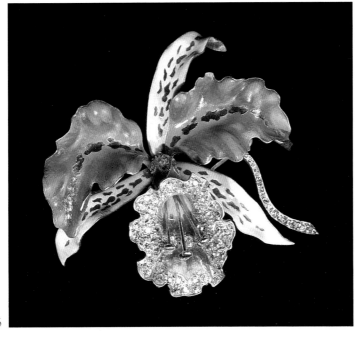

86

84 **Vever** 'Sylvia' pendant, in gold and enamel, set with diamonds, rubies and agates, 1900.

85 **Emanuel-Jules Joë Descomps** Gold, enamel and *plique à jour* brooch, c. 1900.

86 **Vever** (attrib.) Gold, diamond and enamel orchid brooch, c. 1900.

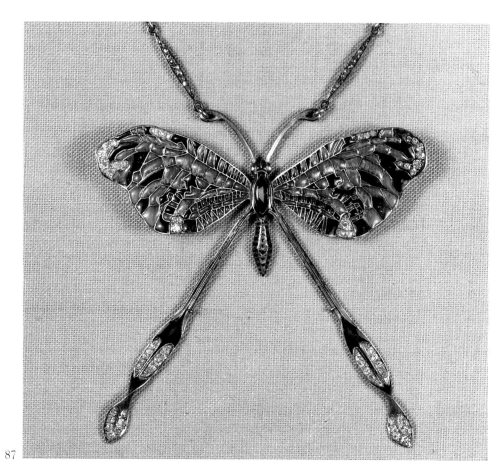

87

88

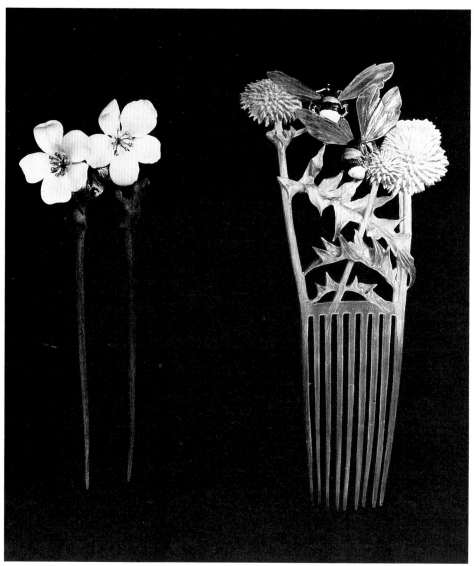

87 **Lucien Gaillard** Moth pendant in gold, enamel and *plique à jour* enamel, set with diamonds, c. 1900.

88 **Lucien Gaillard** Two horn haircombs: (left) with ivory and diamond apple blossom, 1902; (right) with enamelled flower and bee motifs, 1904.

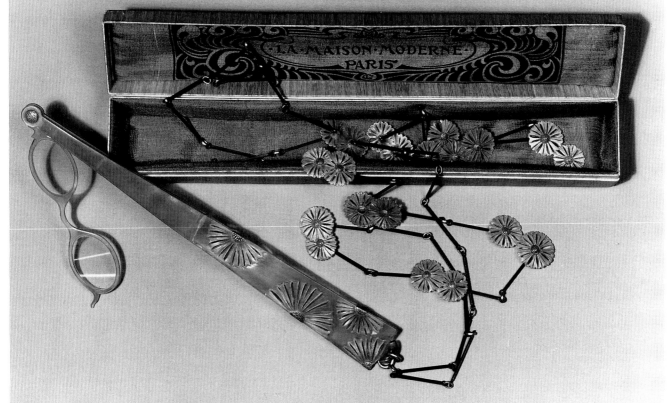

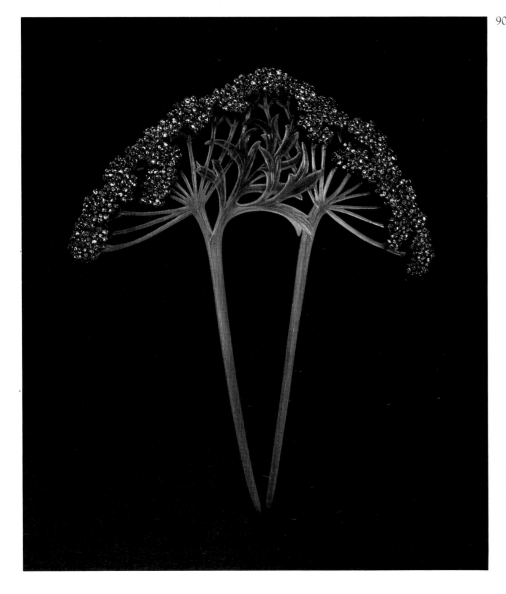

89 **Lucien Gaillard** Horn lorgnette and its original box. The openwork daisies have orange enamel centres, and the chain is of blackened steel, c. 1900–02.

90 **Lucien Gaillard** Horn haircomb with heavy clusters of gold and diamond petals, c. 1903.

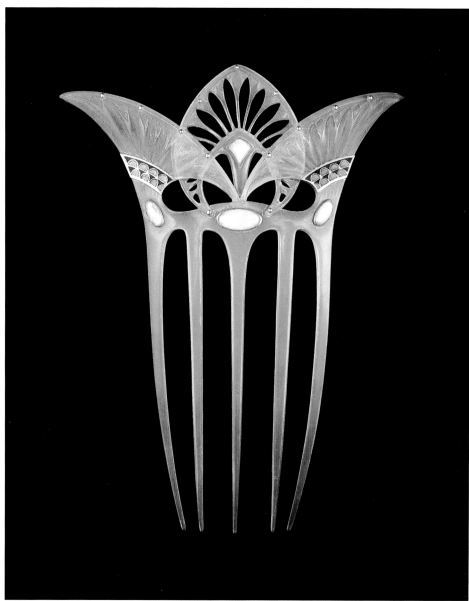

91

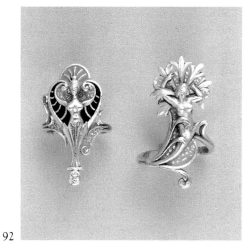

92

93

91 **Georges Fouquet** Horn haircomb with
Egyptian-style enamel decoration and opals,
c. 1905–08.

92 **Georges Fouquet** Two gold rings
decorated with foiled *plique à jour* enamel,
1900.

93 **Georges Fouquet** Gold ring of peacock-
plume design, set with an opal, a ruby and
diamonds, 1900–08.

94 **Georges Fouquet** Corsage ornament
with a winged sea-serpent and sea-weed
fronds. The serpent's body is of *cloisonné*
enamel, its tail and wings of *plique à jour*
enamel, and its head is of emeralds, all set
in gold, 1902.

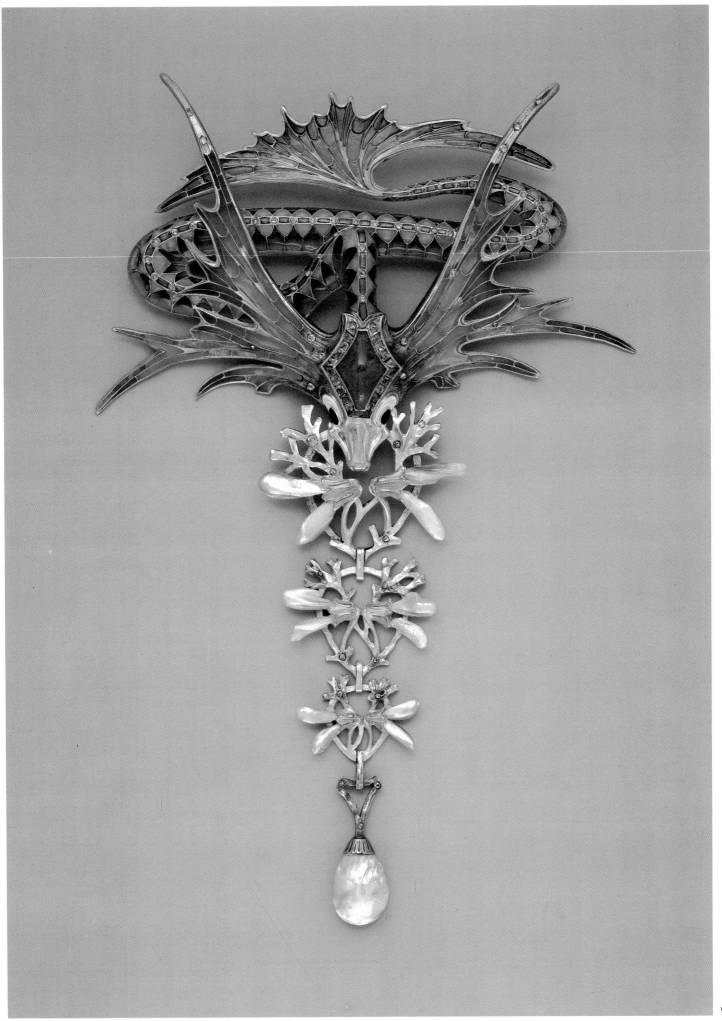

95

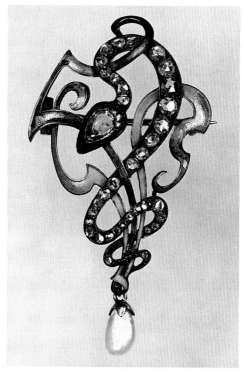

96

97

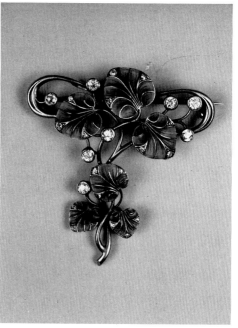

98

95 **Paul Liénard** Gold, pearl, sapphire and *plique à jour* enamel brooch. The cluster of small Baroque pearls is typical of Liénard, c. 1903–05.

96 **Gustave-Roger Sandoz** Gold serpent brooch set with diamonds, emeralds and pearls, c. 1900.

97 **Falize Frères** Gold and enamel lily brooch set with diamonds, c. 1897.

98 Gold, diamond and green *plique à jour* brooch, c. 1900.

99 **Henri Téterger** Pendant with stylized tree motif of textured gold and green matt enamel leaves, each with an emerald centre, hung with a Baroque pearl, 1900.

100 **G. Landois** (designer) and **Louis Aucoc** (maker) Gold, enamel and diamond belt buckle with fuchsia motif, c. 1899.

101 Gold and green enamel *plaque de cou* set with pearls depicting the popular motif of sycamore seeds, c. 1900.

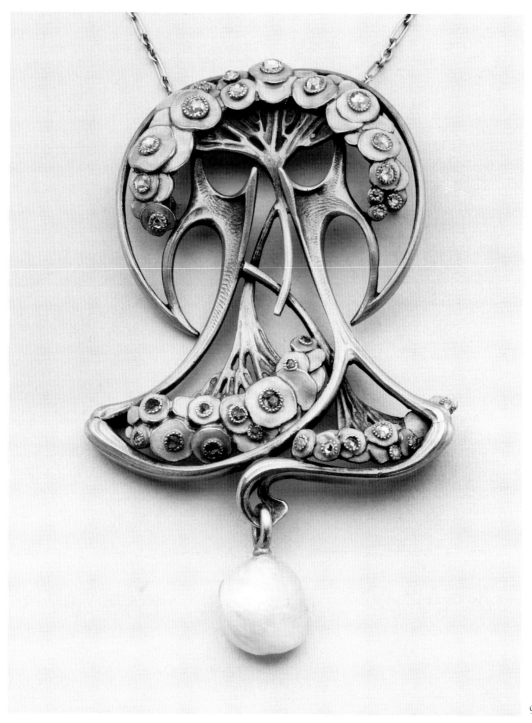

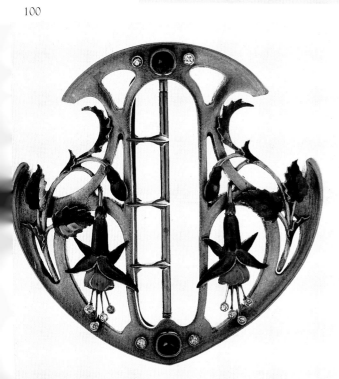

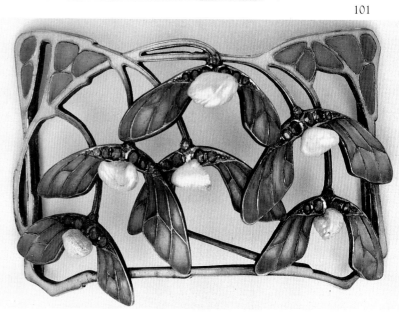

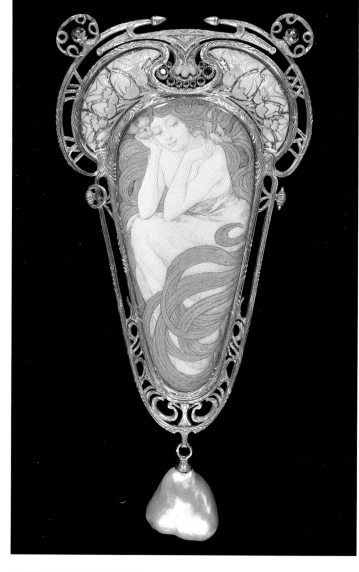

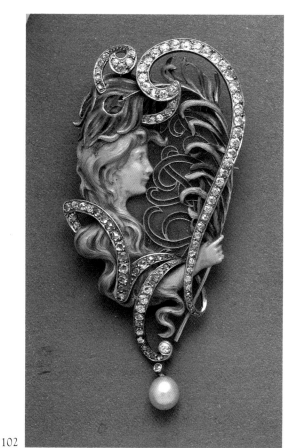

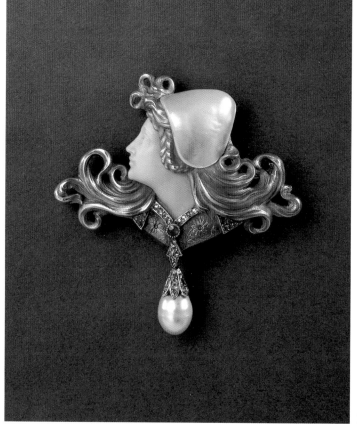

103

102

104

102 **Louis Aucoc** Gold, enamel and diamond brooch, the girl holding a peacock feather with a swirling line of diamonds, c. 1900.

103 **Alphonse Mucha** (designer) and **Alphonse Fouquet** (maker) Pendant made as a variation of the central plaque of a large corsage ornament. The miniature is painted in watercolour and metallic paint on mother-of-pearl, the gold border decorated with enamel and set with emeralds, 1900.

104 Gold brooch with carved coral face, mother-of-pearl cap, and jewelled collar, c. 1900.

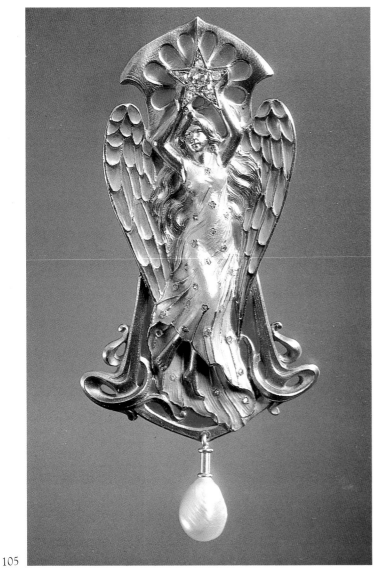

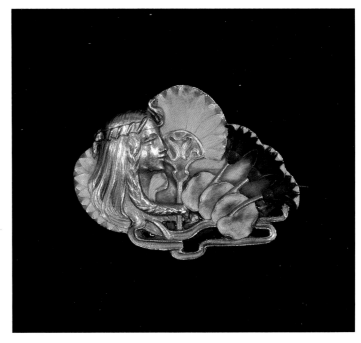

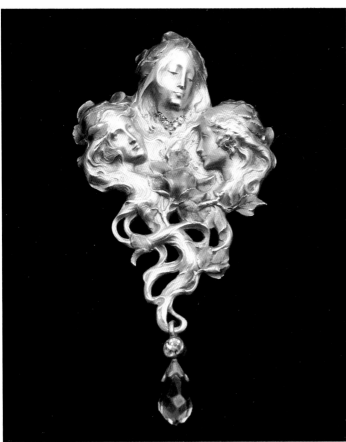

105 **Antoine Bricteux** Gold and enamel pendant, showing an angel with *plique à jour* wings holding a diamond-set star, *c.* 1900.

106 **Edmond-Henri Becker** (designer) and **Boucheron** (maker) 'Les Trois Filles d'Eve'. Gold, enamel and gem-set brooch after a woodcarving by Becker, 1897.

107 **Emanuel-Jules Joë Descomps** Gold and enamel brooch with lotus-flower motifs, *c.* 1900.

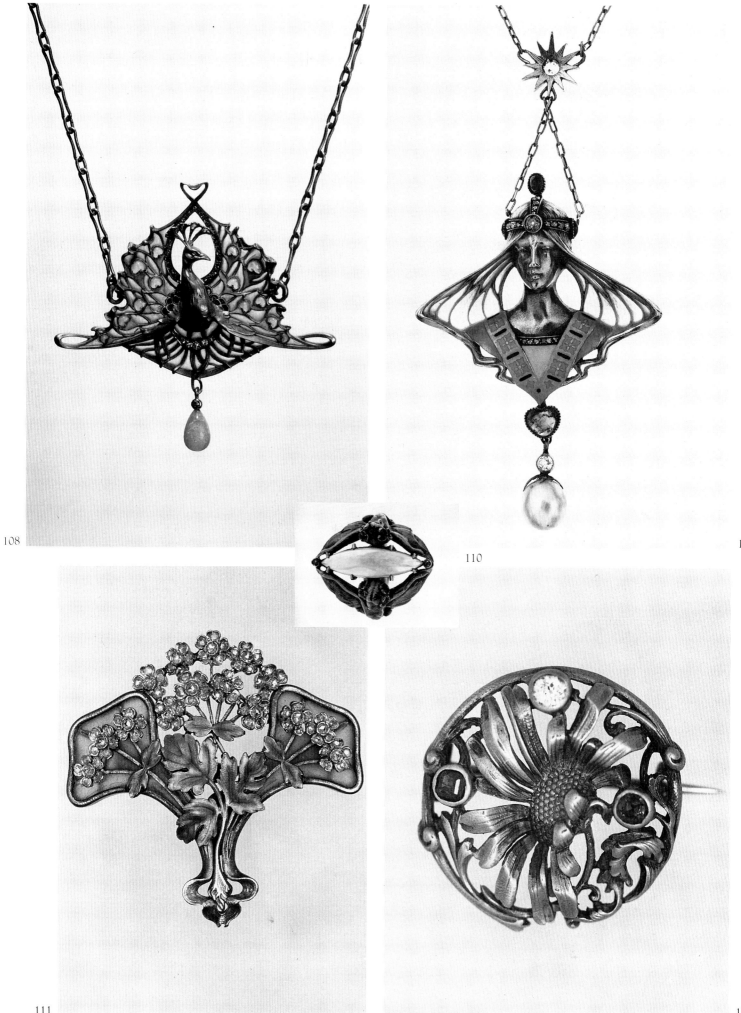

108

109

110

111

112

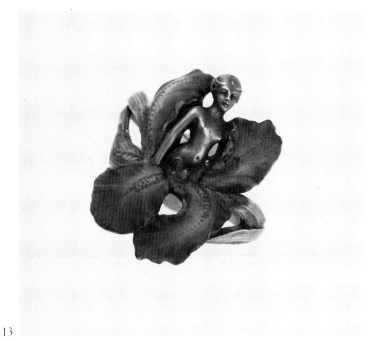

113

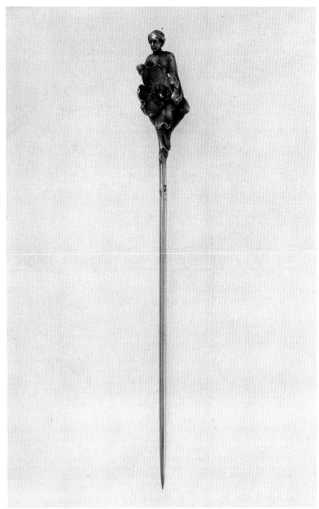

114

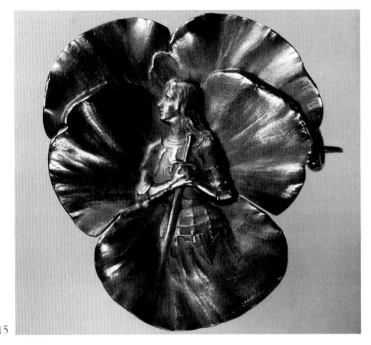

115

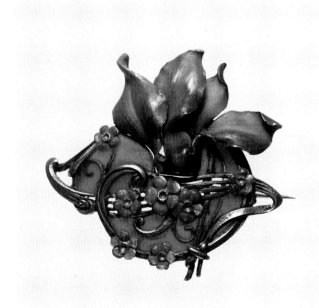

116

108 **Lucien Gautrait** Peacock pendant in gold, enamel, diamonds and emeralds, with carved opal 'eyes' in the tail and a pendant opal, c. 1900.

109 **Lucien Gautrait** (designer) and **Léon Gariod** (maker) Gold and enamel pendant representing a female bust with jewelled headdress and collar, set with diamonds, topazes and emeralds, c. 1900.

110 **Charles Boutet de Monvel** Gold, opal and ruby ring, c. 1900–03.

111 **Lucien Heurtebise** (designer) and **Massin** (maker) Gold, enamel, platinum and diamond-set brooch, c. 1904.

112 **Camille Gueyton** Gold and gem-set brooch with the daisy motif characteristic of Gueyton's designs, c. 1896.

113 **Henri Téterger** Gold ring representing a female figure emerging from an iris, decorated with violet opalescent enamel, c. 1910.

114 **Durand-Leriche** Gold tie-pin with female and poppy motif, c. 1900.

115 **Léon Gariod** (maker) and **Emanuel-Jules Joë Descomps** (designer) Gold brooch showing Joan of Arc emerging from a pansy, c. 1900.

116 **Henri Téterger** Gold, opalescent enamel and gem-set cyclamen brooch/pendant, c. 1900.

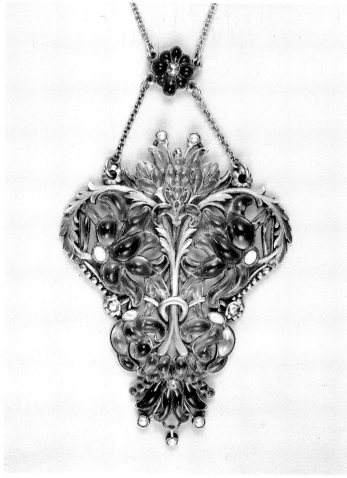

117

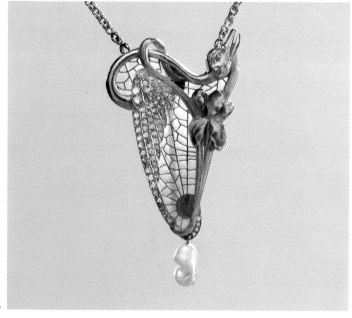

118

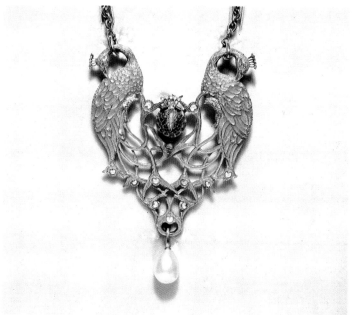

119

119 **René Foy** Gold and enamel peacock necklace, the feathers set with carved moonstones, c. 1900.

118 **E. Godet** Gold pendant with *plique à jour* enamel sunset motif, the asymmetrical outline formed by an enamelled iris, a diamond-set wing motif and a gold bird's neck and head, 1900.

117 **Comte du Suau de la Croix** Gold pendant with *cabochonné* enamelling, c. 1900.

120 (Above) **Louis Aucoc** Chased gold and enamel flower brooch, set with rubies, diamonds and pearls, c. 1900; (below) **Georges Le Turcq** Gold pendant and chain, with asymmetrical *plique à jour* flowers, an opal and diamonds, c. 1900.

121 Five gold, gem-set rings: top left by **Maurice Dufrène**; below right by **Albert Vigan**. All c. 1900.

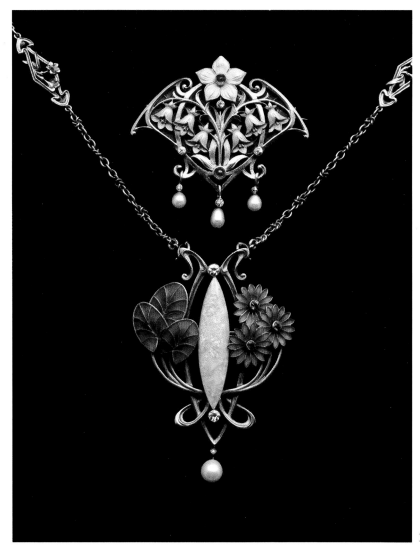

120

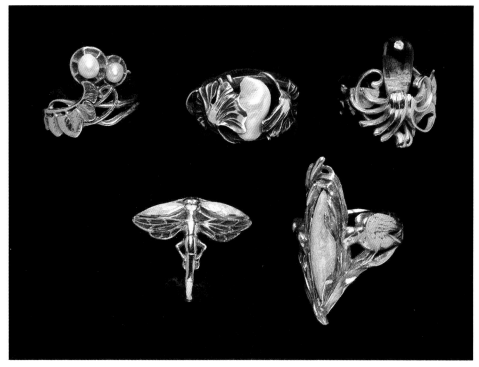

121

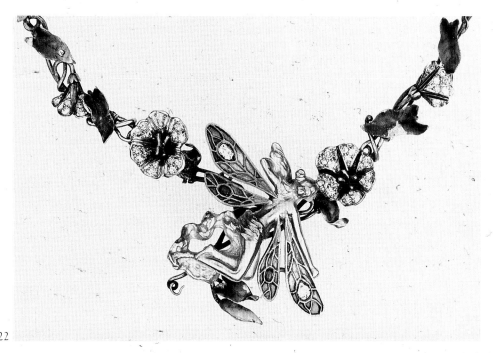

122

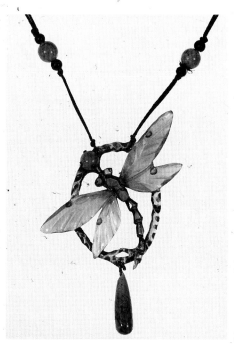

123

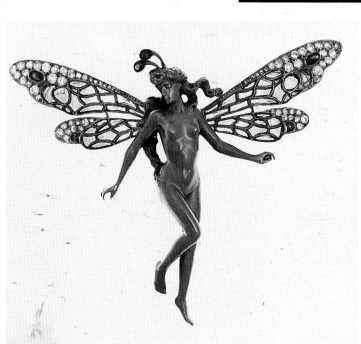

124

125

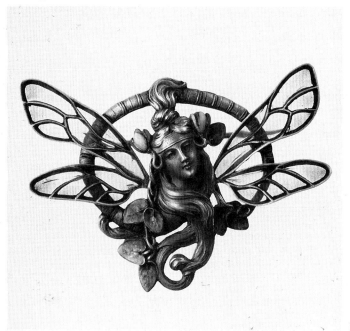

12

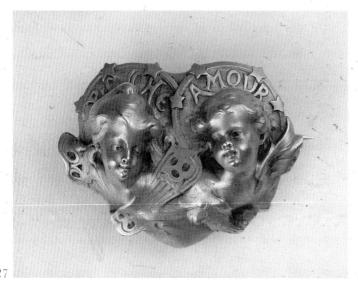

127

128

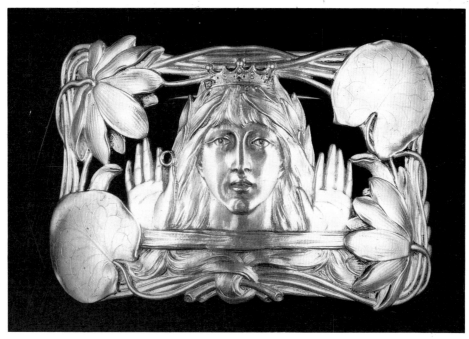

129

122 **Henri Dubret** Elaborate gold, enamel and gem-set necklace, c. 1900.

123 Carved horn dragonfly pendant, c. 1900–10.

124 **Gaston Lafitte** Gold and *plique à jour* brooch depicting a winged female, partially draped, set with diamonds and rubies. The wings are of deeply coloured green-blue *plique à jour* enamel, c. 1900–04.

125 **C. Duguine** Winged female brooch of gold and *plique à jour* enamel, set with rubies, emeralds and diamonds, c. 1904.

126 **Fleuret** Girl's head brooch in gold, with blue-green *plique à jour* wings, decorated with enamelled flowers and leaves. The delicate wings are typical of Fleuret's jewels, c. 1900.

127 **Edmond-Henri Becker** (designer) and **Paul Richard** (maker) 'Psyche and Amour'. Gold brooch, c. 1900.

128 **Louchet** Gold bangle with writhing female figures stretching out to each other against the current, c. 1900.

129 **Piel Frères** Silver gilt buckle depicting Mélisande with her wedding ring. (She was the heroine of Debussy's opera *Pelléas et Mélisande*, which took place in Paris in 1902.) c. 1902.

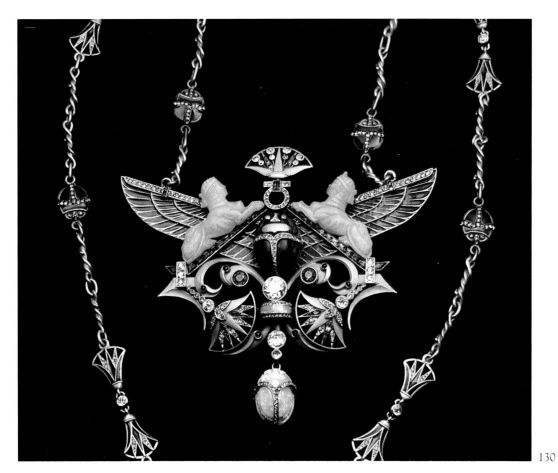

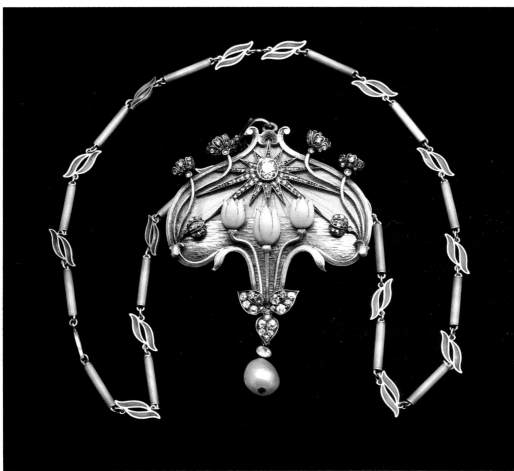

130 **Alphonse Auger** (attrib.) Egyptian-style necklace in gold and platinum, set with diamonds, emeralds and an opal, *c.* 1905–10.

131 **Plisson et Hartz** Gold, enamel and gem-set pendant, combining flower and sunrise motifs, *c.* 1900.

Some exceptionally fine and original Art Nouveau jewels bear the signature of Lucien Gautrait. Little is known of this craftsman and designer, and Vever only mentions his name in passing as a talented modeller and chaser who worked with Léon Gariod.[22] Gautrait's work is remarkable for its fine sculpted female faces and for exceptionally high quality enamelwork, such as a peacock pendant with shaded luminous enamels (pl. 108). Léon Gariod was also an excellent jeweler noted for his chased goldwork and enamelling, which was possibly due to Gautrait's skills.

The Major Jewel Houses

The well-established French jewelers, with major retail outlets – Boucheron, Chaumet and others – expanded their range after 1900 to include Art Nouveau design, some adapting gem-set jewels to the new free-flowing line, often with great success. Because they continued to use the expensive precious stones for which they were well known, most of these jewels were broken up and the stones sold or reset. There are, however, contemporary descriptions and commentaries, and Vever illustrates the kind of precious jewel that became a fashionable Art Nouveau accessory. Prices for these pieces were high, as they were made principally of diamonds and pearls, like the Edwardian style of jewels which was developing in both England and in France at the same time as Art Nouveau. The French jewel houses, aiming to please their regular customers, combined the most popular and attractive elements of both styles.

The firm of Boucheron was particularly noted for its display at the 1900 International Exhibition, and merited a special mention in *La Revue de la bijouterie's* survey of the jewelry on display. Boucheron was hailed as 'a valiant and glorious champion, always magnificent, always victorious, of whom the French jewelry trade has every right to be proud'.[23]

The firm was founded in 1858 by Frédéric Boucheron (1830–1902) and went from strength to strength, moving in the 1860s from Rue Royale to Place Vendôme. From this time it was noted for fine and lavish diamond jewels and for specializing in beautiful, delicate flower sprays that foreshadowed Art Nouveau interpretations. Throughout the nineteenth century, Boucheron had employed highly skilled craftsmen. Among those who contributed to the firm's success in 1900 was Louis Rault (1847–1903), who worked with Boucheron from 1868 to 1875; Jules Brateau (b. 1844); Lucien Hirtz, who was noted for highly chased gold jewelry; and particularly Jules Debût (1838–1900), who designed some of the jewels made by the firm for Sarah Bernhardt. Boucheron worked in both *bijouterie* and *joaillerie*. For the International Exhibition of 1900, Boucheron commissioned many artists and designers, including Michel Menu and Edmond-Henri Becker (b. 1871), who worked together – Menu mounting Becker's sculptures in wood which harmonized well with gold, enamel and stones. Becker designed other jewels for Boucheron: one charming gold pendant, made in 1900, is a group of three girls' heads called 'Les Filles d'Eve' (pl. 106). This came from one of Becker's sculptures. Boucheron was praised for maintaining a strong tradition and at the same time achieving a modern look. In an innovative mood, Boucheron introduced ivory to his figurative jewelry: one piece showed a young and graceful Oriental girl emerging from the sea, a negress holding her gown ready for her. Other themes included Eros and a druidess. In his 1900 display

Boucheron also exhibited a variety of precious objects, mirrors, scent bottles, lorgnettes and belt buckles.

Boucheron's reputation for expensive, gem-set jewelry was upheld by their display in 1900. Their exhibits were magnificent and technically superb, with diamonds flowing everywhere. Boucheron continued to use very large, fine-quality stones – which accounted for the high prices. They also continued using their standard themes of flower sprays of unusual species of plants: one example depicted a bunch of berries made of rubies; another was an almond branch.

Chaumet, like Boucheron, also adapted Art Nouveau ideas to new designs in gem-set jewelry, their speciality, and these new lavish jewels were exhibited for the first time in 1900. Very little is said of the Chaumet display at the Exhibition. Their chief interest was in large precious stones, and although they introduced some mild Art Nouveau lines, the jewelry remained classic.

In the realm of *joaillerie*, perhaps the greatest impact was made by the firm of Coulon, who achieved the most successful blend of gems and Art Nouveau design. One of their most spectacular pieces was a flexible dog-collar, in the form of linked peacock's feathers, whose 'eyes' were made of topazes, aquamarines and peridots and whose curling plumes were studded with diamonds.

Léon Coulon had been an employee of Boucheron and had set up on his own at 12 Rue de la Paix with Jules Debût, who also came from Boucheron, in 1879. Coulon and Debût made exceptional diamond jewelry until Debût left the partnership in 1890. In 1895 Coulon found a new partner in Deverdun and the company was re-named L. Coulon et Cie. The work they produced was characterized by impeccable production, using fine stones and high-quality engraving, which continued to delight their elegant and discerning customers. In *La Revue de la bijouterie* in 1900 the jewels were praised for their perfect execution, particularly a diamond and aluminium feather, light and flexible, to be worn in the hair. They also exhibited *bijoux* in chased gold with a delicate bloom (produced by means of an acid bath which left a film of pure gold on the surface), beautifully worked and in elegant but modern designs.

The house of Cartier continued to enjoy great success at the turn of the century with conventional Edwardian-style gem-set jewels. They made relatively little concession to Art Nouveau design, although Cartier did commission some well-known Art Nouveau jewel designers and workshops to produce a range of less expensive but fashionable and pretty jewels. Philippe Wolfers, the Belgian master of Art Nouveau jewelry, supplied Cartier with small serpent jewels, while Georges Le Turcq (b. 1859), a Parisian jeweler, made enamelled flower brooches for Cartier, and the Charpentier workshop also supplied enamelled Art Nouveau jewels with organic or naturalistic motifs to cater for current fashions. In 1900 Louis Zorra, another Parisian jeweler, made a gold brooch with his typical motif of a dreamy girl's head, and Louis Aucoc was commissioned to produce a one-off, spectacular necklace with a peacock motif. Finally, Cartier stocked a selection of the popular little gold medal-jewels (see below) bought from Julien Duval and designed by Frédéric de Vernon, and a range of small religious pendants in the same vein.

Louis Aucoc, head of La Maison Aucoc, is best known to us as the teacher and employer of Lalique, who made pieces for his firm. Born in 1850, Aucoc was the son of a well-known goldsmith. His brother André was also a well-known jeweler. In 1877 Louis took over the firm of Lobjois, which had been

founded in the year of his birth. He produced modern and highly original jewels in both gold and precious stones, which were well received at various exhibitions. He was extremely active in the societies, committees and juries of the jewelry trade and organized French jewelry displays at various International Exhibitions. Louis Aucoc made fine Art Nouveau jewels around 1899 and 1900, many with graceful floral designs. He drew on the work of designers such as Edmond-Henri Becker and G. Landois. Jewels from La Maison Aucoc are often made of chased gold or gold and enamels with trails of diamonds. Some pieces that have come to light show a strong link with Lalique and may have been made by Lalique for Aucoc. Most important are two dragonfly brooches of great beauty, made of carved horn decorated with enamels and set with precious stones. The horn is immaculately carved and has been given the pearly bloom or 'skin' for which Lalique was famous.

The Enamellists

Specialization was the key to the supreme technical achievements in French Art Nouveau jewelry. Among other specialists were brilliant enamellists, working in the medium which was most characteristic of the style and most cherished by its designers. They were employed as freelances for various manufacturers, but little is known about most of them individually.

Etienne Tourette is well known for his enamels with spangles of gold flecks, or *paillons*, which gave a particularly bright and iridescent effect. He had trained with another famous enamellist, Louis Houillon.

André Fernand Thesmar (1843–1912) has been credited with the rediscovery of *plique à jour* enamel, at which he was undoubtedly a master. At the 1873 Vienna International Exhibition, he showed a gold pheasant made of *cloisonné* enamel. This received great acclaim the following year at the Exposition de l'Union Centrale des Arts Appliqués à l'Industrie, where he also exhibited three trays with flower motifs. He continued to exhibit his enamels in the early Salons from 1875 and the two exhibits he sent to the International Exhibition in Paris in 1878, two unknown objects called 'Spring' and 'Autumn', were purchased by the Japanese Government for the Imperial Museum of Tokyo. When a special section devoted to *objets d'art* was added in 1891 to the Salon of the Société Nationale des Beaux-Arts, Thesmar displayed all kinds of gold *cloisonné* enamelled works, including vases, dishes, bowls and brooches. All the time he was carrying out extensive research into enamelling techniques, especially those using a mixed opaque glass powder and *plique à jour*.

One of the best known and most versatile enamellists, as well as an accomplished goldsmith and silversmith, was Eugène Feuillâtre (1870–1916). He began his career in Lalique's workshops, but later set up on his own. The extent of his involvement with, and influence on, Lalique is not certain, but it is thought that he experimented in methods of enamelling on silver. This is more difficult than gold because it has a lower melting point, and also because its colder colour makes a rich and warm effect harder to achieve. He also pioneered the use of platinum, which had until then been ignored as an enamelling medium.

It may have been Feuillâtre who was responsible for Lalique's main experiments in the art of *plique à jour* enamelling, before he began to work on his own in 1889. Feuillâtre exhibited at several of the Libre Esthétique shows,

the first of which was held in Brussels in 1894, and with Lalique and Fouquet in London in 1898. He also displayed work at the International Exhibition in Paris in 1900 and at Turin in 1902. In 1899 he became a member of the Société des Artistes Français, where he exhibited until 1910. He drew greatly on Japanese forms and colour, and is well known for his frequent portrayal of a young girl's profile enveloped in delicately curling *plique à jour* flower petals and for his triangular-shaped enamel winged females.

Other important French enamellists included Paul Grandhomme and Alfred Garnier, De Courcy, Charles Jean, Charlot, Soyer, Riquet, and Antoine Tard who worked with Falize.

The Medallists

In France, the origins of Art Nouveau design coincided with a new wave of interest in the art of medal engraving, and a 'modern' school of engraving developed and overlapped with the jeweler's art. Collectors often come across small pieces of jewelry in gold and silver with typical Art Nouveau motifs struck, stamped or engraved, looking very much like medals. The large numbers of such pieces, their Art Nouveau themes and the mass-produced, inexpensive copies they inspired in other countries and particularly in the United States, make them worthy of consideration in any study of jewelry in this period.

Several French jewelry manufacturers drew on the skills of master engravers, and these pieces are interesting because many bear the signatures of the engravers.

In his *Bijouterie française au XIXe siècle*,[24] Henri Vever also wrote on the rise in the popularity of these medal-jewels. The cameo had been among the most popular fashions in decorative jewelry throughout the nineteenth century, but the fashion was fast fading by the 1880s. Manufacturers, as ever, suffered from the whims of fashion and they sought a renewal or replacement for the cameo and intaglio. This, to begin with, resulted in copying ancient medallions and also ancient Greek and Roman gold coins. The warmth of gold provided the right contrast with the rather cold hardstone cameo carvings. Soon jewelers were using old French coins, and exploiting the talents of the medal engravers who worked for the Paris Mint. The medallist's art was thus revived, the gold (and later silver) medal-jewels adopting up-to-date Art Nouveau motifs to create fashion accessories that were pretty, popular and inexpensive. They were also a good way of making available 'art' jewels at a low price. The mechanical method of reducing to jewel size a detailed hand engraving (*tour à réduire*), a method explored by Lalique, was widely used (see p. 65). By this means, any craftsman accomplished at modelling could produce effective miniature medals with clear details, without learning special skills and without passing the engraving through the hands of different workers who might alter the desired effect. In 1886, the firm of Fonsèque et Olive, Paris manufacturing jewelers, asked Séraphin Emile Vernier (1852–1927), one of the most famous engravers of the time, for a model of Diana to use as a jewel. A gold medal-jewel was produced, and although there was little response at first, the fashion soon took off.

Jules Chéret, a popular poster artist famous for his exuberant portrayals of café society, was commissioned to translate his most flamboyant and Parisian

designs into gold medal-jewels. The accent in jewelry at this time was always on a 'Parisian' taste: chic, sophisticated and coquettish. Louis Desbazeille was one of the first jewelers to explore the idea of medal-jewels fully and in 1889 he commissioned Vernier to design a medal depicting Cleopatra (after Sarah Bernhardt's performance of the role). This was followed by traditional and classical themes such as the Four Seasons, the Arts, the 'Femme-Fleurs' (a woman's head set against a background of flowers), St George and so on. From 1895 onwards, Desbazeille turned to Oscar Roty (b. 1846), who was also experienced in the reducing method, and was perhaps the most famous French medallist of the time. He designed various little gold plaques, depicting religious subjects, another theme which became common. For the Paris International Exhibition of 1889, celebrating the centenary of the French Revolution, Roty designed a bracelet, the 'Centenaire', which was produced by Charles Rivaud, a successful jeweler and *éditeur* (manufacturer of medal-jewels). Rivaud was particularly good at enhancing the miniature sculptures by using pretty and feminine settings. Rivaud commissioned work from other leading engravers including Paul Richard, Jean Dampt, and Victor Prouvé. Vever informs us that Julien Duval and Georges Le Turcq became known for producing higher quality medal-jewels. Their pieces were made of thicker gold than those of other manufacturers and so were heavier and more substantial. Duval and Le Turcq set up together as jewelers in 1885, and their gold jewels met with much success, selling in great numbers in France and abroad.

Duval and Le Turcq went their separate ways after 1894, both still making medal-jewels. Le Turcq worked with Vernier, and Duval with Frédéric de Vernon on a series of highly successful models. Themes frequently used include the 'Femme-Fleurs', women representing night, day or dawn, or scenes commemorating certain events. Traditional French motifs, including Joan of Arc (sometimes emerging from a pansy, the symbol of remembrance), were popular too (pl. 115).

These gold pendants and brooches were, on the whole, transitional pieces, being neither typical nineteenth-century jewels nor fully fledged Art Nouveau. Drawing their inspiration from ancient coins and medallions, they are related to the archaeological revival of the mid century. As the art critic Roger Marx wrote in his treatise on the French medal, 'everyone knows how important a position has now been reached by the medal in the realm of jewelry. For a long time it was the fashion to have a piece of antique money mounted as a brooch or pin; then came the idea of substituting more modern images . . . these little discs of metal, with their time-worn, half-effaced relief, strove to be up to date. M. Roty was the first to understand their real value to jewelry, the first to appreciate them fully, and today, even in small towns in France, one may see in jewelers' windows these medal brooches, some the work of M. Roty himself, others by M. Vernon, M. Prouvé, or M. Yencesse, all most attractive, appropriate articles of ornament and at the same time genuine works of art.'[25]

In 1899, an engraver called Foisil made a medal-jewel called 'Parisienne', showing a pert feminine head in profile, with a necklace of rose-cut diamonds, and diamonds in her hair. This marked a change in the fashion, adding a more decorative and feminine element to the previously somewhat bland or severe medallions. Such gold medal-jewels set with diamonds (called *habillés*) proved very popular. Often the rose-cut diamonds occurred as if sprinkled on a background of mistletoe (a favourite Art Nouveau motif as

well as a Roman emblem) in the hair, and, most often, as a necklace – even, rather inappropriately, on a Joan of Arc piece.

Major jewelers – notably Boucheron, Vever and Ferdinand Verger – added medal-jewels to their current ranges. Comte d'Epinay de Briort (b. 1836) was a fine engraver who received frequent commissions from Boucheron, as did Edmond-Henri Becker. For medal-jewels, the firm of Vever turned to the talented Louis Bottée (1852–1941), who is best known for the medallions 'Bellone' and 'Cybèle', which he designed for Vever in early 1891.

Silver was widely used for medals, and French work was often imported into England where silver Art Nouveau brooches and buttons were extremely popular. Sets of buttons and single silver medallion brooches often bear an engraver's signature. Cheaper metals and gilt were also used, often in attractive stickpins bearing the trademark 'FIX' or 'FIXE'. Medal-jewels in the Art Nouveau style continued to be made for many years, and were worn well into the mid 1920s. Today they still provide a cheap and decorative way of wearing French Art Nouveau designs.

Magazines and Critics

By 1900 the jewel had become an *objet d'art* and had lured many artists from other fields; it had won over, for the most part, a distrusting public, and had aroused the sharp interest of art critics.

Art magazines were an important feature of the Art Nouveau period, and French magazines in particular form a revealing part of the study of the Art Nouveau jewel. Many journals devoted to an examination of art and design were founded around this time, and their commitment reflects the enthusiasm and introspection of the new movement. This became a time of emphasis on criticism and analysis, and as one writer in *Art et décoration* observed in 1897, 'our era is characterized by analysis in jewelry as well as in psychology.'[26] A monthly illustrated journal was now devoted for the first time entirely to jewelry design: *La Revue de la bijouterie, joaillerie, orfèvrerie* was founded in 1900 and continued until 1905. Other magazines which appeared at the time were *Revue des arts décoratifs* (1897–1902), *Art et décoration* (founded in 1896) and *L'Art décoratif* (1898–1914).

French magazines give an intriguing insight into the contemporary attitude towards the Art Nouveau jewel. The opening preambles of many essays deal with the history of the jewel as a work of art, looking back as far as the eclipse of original design by historical revivalism in the mid nineteenth century. They continue with lively and highly descriptive accounts of the magical reawakening by the genius of Lalique. Many of the melodramatic qualities of Art Nouveau jewelry are reflected in the flowery and philosophical essays on jewelry. Naturalistic analogies echo Art Nouveau themes. For example, in a review of jewels shown at the 1902 Salon, the writer appears to be quite overcome by the effects of the Art Nouveau jewel. He compares walking through the display to 'living in nature, walking through a wood in the last rays of sunlight. At a bend in the path you notice a change that, like a new perfume, eradicates all previous scents from your mind'.[27] This exciting change in artistic ambiance was so heady that he could 'breathe less easily'. He felt the conquering breath of the true artist and talked of the 'stammering' and 'stuttering' of the newness in jewel design. Writers often pointed out that jewels, perhaps more than any other of the decorative arts, expressed the new

emancipation of design. This emancipation was attributed to French ingenuity. French jewelry criticism at this time was characterized by an intensely patriotic tone, a pride in French workmanship. The intrusion of foreign influences, such as Japanese art or the English Arts and Crafts Movement, was frequently disclaimed, or occasionally grudgingly and defensively accepted.

In his essay on jewelry in 1900, the critic and expert in *objets d'art* Georges Meusnier goes as far as to say that foreign influences threatened the entire national artistic identity, but in the realm of jewelry could and ought to be avoided. As jewelers were totally immersed in the French traditions even when they used new forms or influences, the results still tended to be emphatically French.

The International Exhibition of 1900 and the jewelry pavilion (in the Esplanade des Invalides) gave jewelry critics ample opportunity to pride themselves on the superiority of French jewels. The modern style, it was said, was full of youth and vigour which 'our old French soil had nourished and revived with its rich sap.'[28]

As for foreign jewels at the Exhibition, a typical comment was that 'it is often difficult to judge with impartiality foreign goods and the effort that went into producing them.' Writing about the German representation, it was said that the Germans, 'industrious and persevering, . . . sometimes take advantage of our creations before we do ourselves'.[29] This referred to the copying of French designs, especially by factories in Pforzheim, the centre of the German jewelry industry. England, it was said, 'with its cold and unenthusiastic temperament', showed for the most part, nothing new.[30]

So great was national pride that in 1900 the Chambre Syndicale set up a special commission to keep a jealous look-out for new techniques and processes being used abroad. The committee had to keep French manufacturers informed of any ancient techniques that might be revived, and of any new patents or manufacturing methods.

Publicity and the spread of critical outlets about the arts helped the public become accustomed to the new look. Vever says that by 1900 most people of fashion had 'taught themselves' to like Art Nouveau.[31] The minority who still resisted were thought to have no taste, and by 1900 infatuation with the new style was complete. Everyone wanted to own some example of Art Nouveau, and jewelry was one of the easiest and most portable ways of adopting the style. In 1900 critics and the public were wondering in which direction the new art would progress. One thing was certain: it would not slip back into the impoverished conventions of the past century. The problem was how to keep the designs fresh and alive.

The great promise offered by the International Exhibition, however, was unfortunately not to be fulfilled. As soon as the style was embraced, it began to decline. Popularity bred great demand, and demand bred swarms of unknown artists (Vever calls them pretentious craftsmen)[32] trying their hand at Art Nouveau, picking up and using the external elements with no deep-rooted understanding of the style, its meaning and growth. After the initial dazzling originality, jewels became derivative of their own style. Vever condemned the limitless, tasteless imitations that the new popularity inspired. Motifs were for the most part all that the general public wanted, or needed, to identify with the modern look. Some artists jumped on the bandwagon and threw themselves into untidy and meaningless compositions; others were content to copy. In doing so, they degraded the creative

novelty of the original jewels. To ensure commercial success and a modern accent, the commercial imitations exaggerated the basic and obvious elements of design, upsetting the artistic balance. Basic ingredients were mixed indiscriminately until they became, in Vever's view, clumsy and pretentious caricatures of real works of art. Copyists, the second-wave artists, although technically able, took Art Nouveau to saturation point, and this inevitably led to decline. The emotional overtones became insincere, empty and devoid of meaning. Art Nouveau strangled in the neurosis of curves, tangles, leaves, stems, waves, simply because it had parted from its original creative and truthful insight.

Peter Selz has made the interesting comment that the whole Art Nouveau movement consisted only of beginnings. Artists died young, the style itself died in its youth: 'Everything remains in a state of unfulfilment. There is perhaps eager expectation but it never seems to go beyond the threshold.'[33] This certainly applied to jewelry design, where so many of the critical responses to each salon or exhibition were characteristic in expressing hope for the future of jewelry, implying that this was still a formative era.

The student of the Art Nouveau jewel can learn to distinguish easily between the handful of master craftsmen and their imitators. Differences may at first seem slight or over-subtle, but a breathtakingly beautiful motif in one piece can become florid excess in another. From today's standpoint, however, French Art Nouveau jewels, even those made by copyists, are impeccably made, and always evocative of their time.

Vever continued his criticism well up to the end of the first decade of the twentieth century. Highly disapproving of second-rate imitations, he deplored the workshops or 'factories' that turned out inferior examples in Pforzheim, Munich, Brussels, Geneva, implying that it was foreign abuses that had killed the new art.[34] What he most disapproved of was that such pieces were conceived primarily to be sold, and that artistic form was subjected to commercial considerations. Imitations, Vever felt, could only flaunt the faults of Art Nouveau design, producing bizarre and vulgar shapes – like macaroni, that gave the style its later pejorative nickname, 'Style Nouille'. By 1909 Vever sounded quite desperate, describing commercial Art Nouveau jewels as nightmarish instruments of torture. It was perhaps this point of view, together with a change of fashion, that was responsible for banishing Art Nouveau to the attic, to gather dust, until it was perceived with new eyes only about fifty years later.

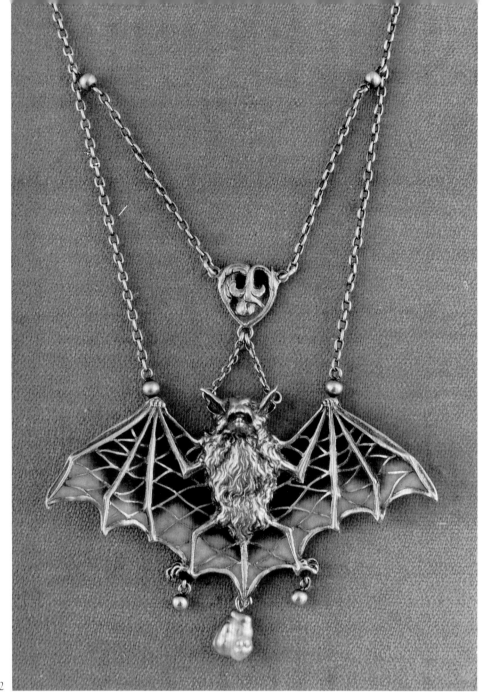

132

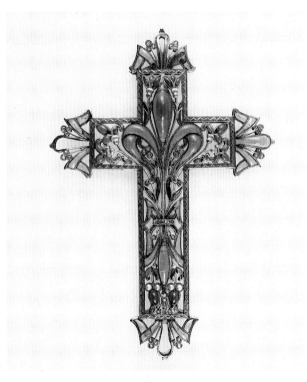

133

132 **Lucien Janvier** Bat necklace of silver, silver gilt and light and dark blue *plique à jour* enamel, c. 1900.

133 **Comte du Suau de la Croix** Silver gilt and *cabochonné* enamel pendant, c. 1905.

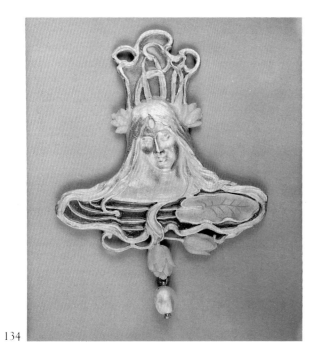

134

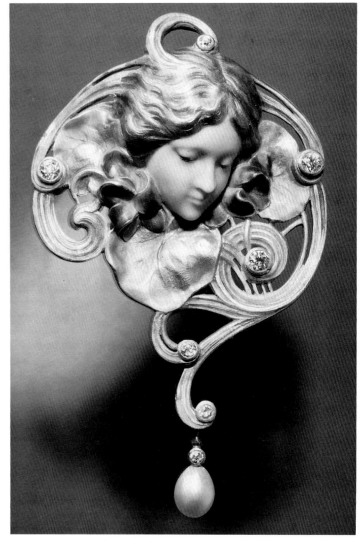

13

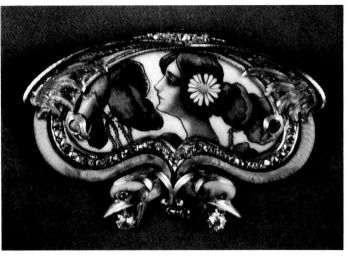

136

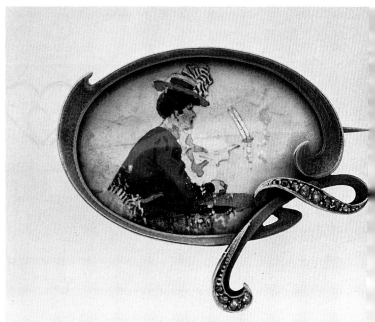

137

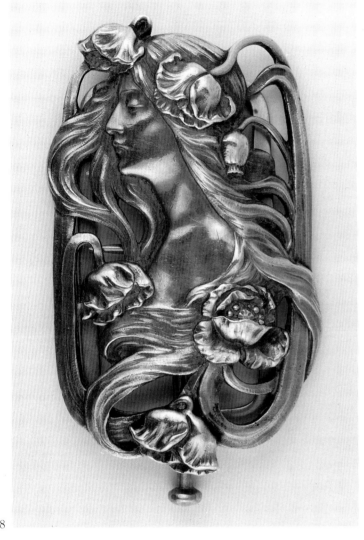

38

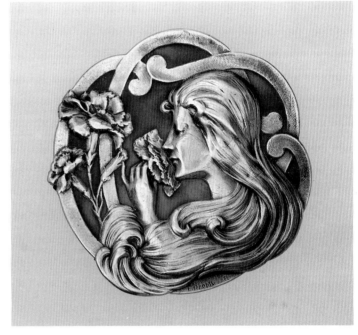

139

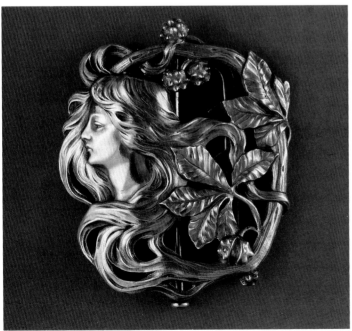

40

134 **Louis Zorra** Gold, pearl and enamel pendant, representing a water nymph rising out of an enamelled pond with a floating lily pad, 1900.

135 **Beaudouin** 'Modestie'. Brooch in gold, enamel and diamonds, with shaded green enamel leaves and purple flowers, c. 1900.

136 Gold, enamel and diamond-set brooch in the style of Alphonse Mucha. The central enamel plaque is painted in deep colours, with purple irises and a yellow and white daisy, c. 1900.

137 **René Péan** (designer) and **Fonsèque et Olive** (maker) Gold and diamond brooch with watercolour plaque, c. 1900.

138 **Gustave Obiols** (designer) and **Benjamin Wollès** (maker) Belt buckle of silver, partly gilt, c. 1900.

139 **Jean-Baptiste-Emile Dropsy** (designer) and **A. Savard** (maker) Silver brooch showing a girl smelling a carnation, c. 1900.

140 **Gustave Obiols** Belt buckle of silver, partly gilt, with the motif of a girl's head among chestnut leaves, c. 1900.

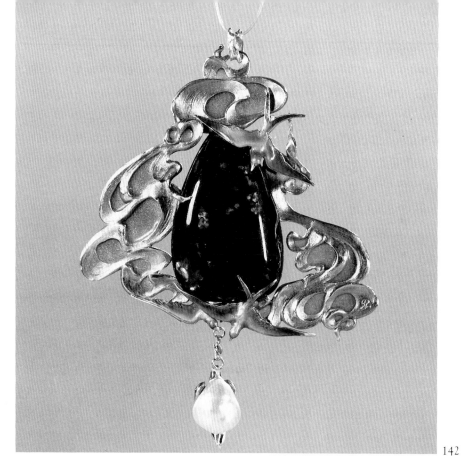

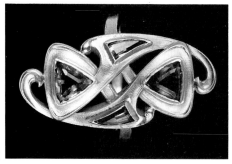

141

143

141 **Antoine Bricteux** Gold and amethyst ring, *c.* 1900.

142 'The Black Peacock'. Pendant with a large black opal set in gold and turquoise *plique à jour* enamel, *c.* 1900.

143 Gold lioness-head ring, *c.* 1900.

144 **Boucheron** Gold belt buckle with leopards biting a cornelian and standing on a lion mask in green cast glass, probably by Lalique. At the International Exhibition in Paris in 1900, Boucheron showed another version of this buckle with a carved emerald lion mask, by the gem engraver H.A. Burdy. *c.* 1900.

142

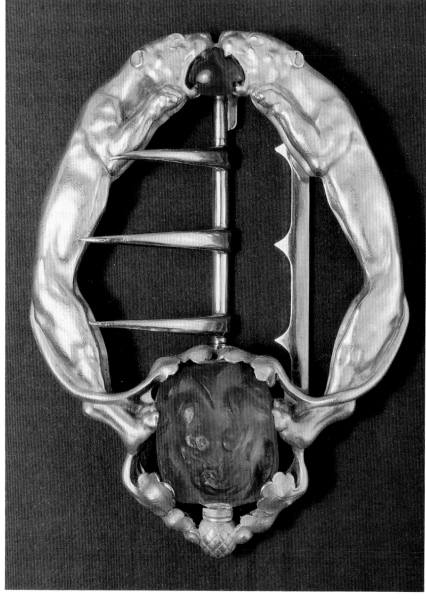

144

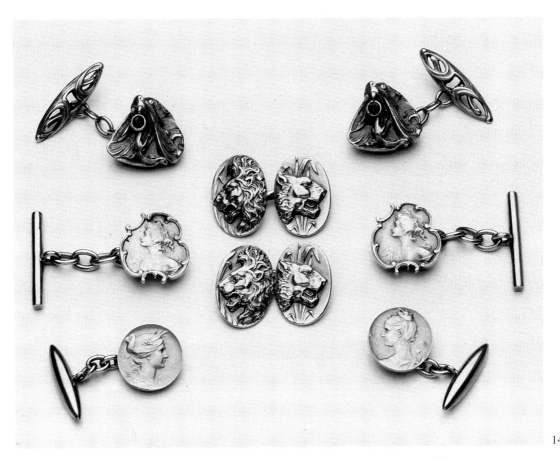

145

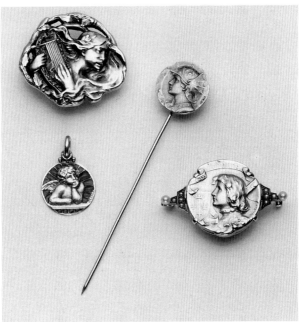

146

145 Engraved gold cuff-links in the form of
medal-jewels, with female, linear and animal
motifs. The bottom pair are by **Comte
d'Epinay de Briort.** All *c.* 1900.

146 Group of gold medal-jewels. The
brooch above left is signed **Kohler,** and the
other three are by **Edmond-Henri Becker.**
The small pendant, below left, is decorated
with *plique à jour* enamel. All *c.* 1900.

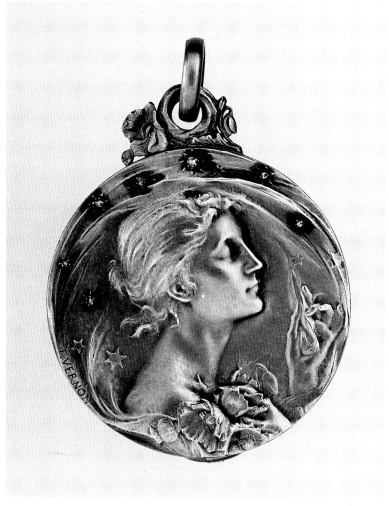

147

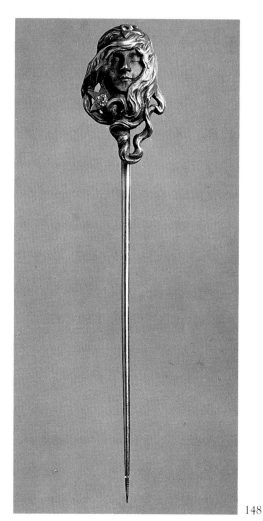

148

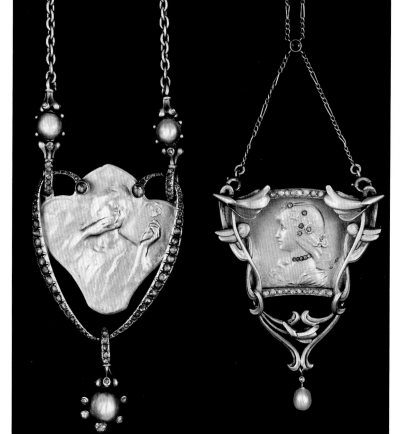

149

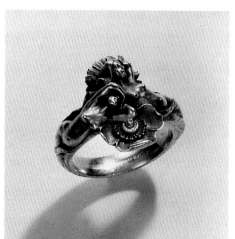

150

147 **Frédéric Charles Victor de Vernon** (designer) and **Julien Duval** (maker) 'La Nuit'. Gold pendant, engraved on both sides, set with diamond stars, c. 1899.

148 **Louis Zorra** Gold tie-pin with a girl's head motif, set with diamonds, 1900.

149 (Left) **Victor Prouvé** Gold and pearl pendant; (right) **Comte d'Epinay de Briort** gold, diamond and pearl pendant, c. 1900.

150 **Georges Le Turcq** Gold ring with flower and nude female motif, c. 1900.

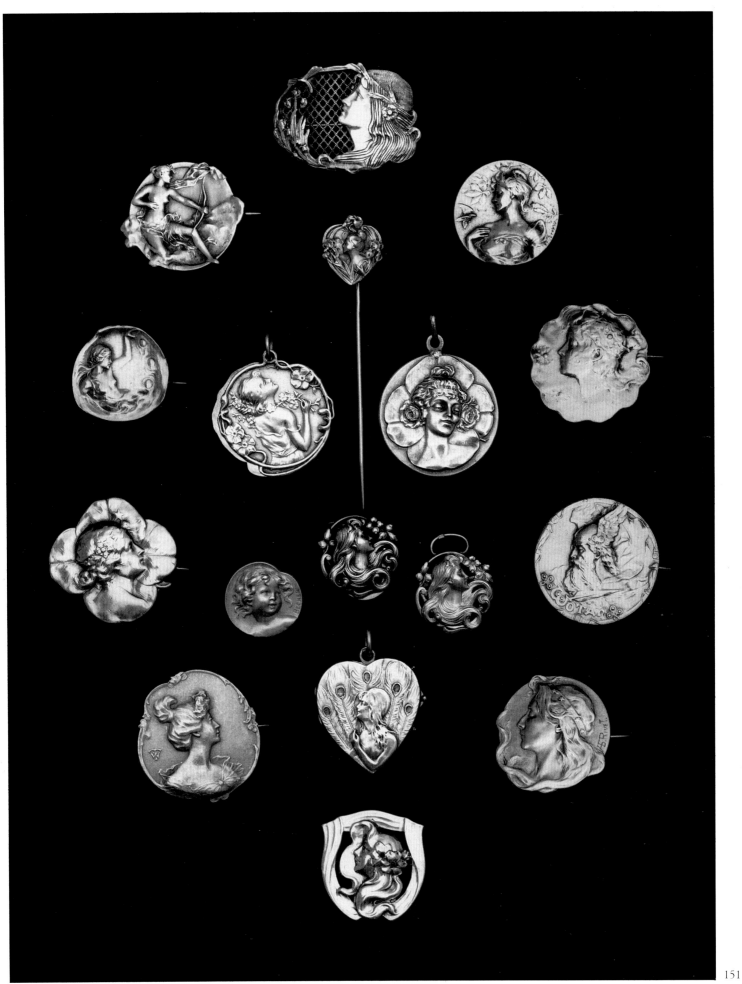

151 French and German silver medal-jewels, some bearing designers' signatures, including those of **Dropsy**, **Becker** and **Rivet**. All *c*. 1900.

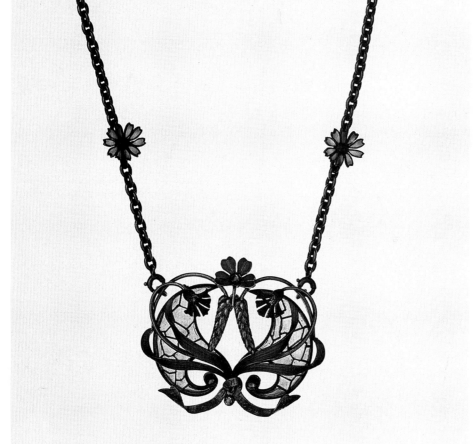

152

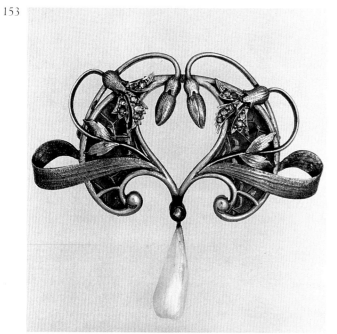

153

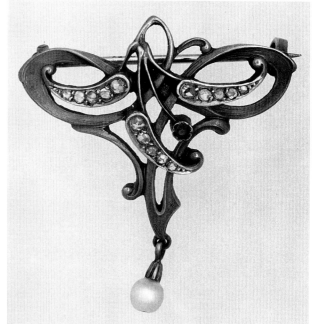

154

152 **Louis Aucoc** Gold necklace with
opaque and *plique à jour* enamel and
cornflower motif, c. 1899.

153 **Louis Aucoc** Gold and *plique à jour*
enamel brooch set with diamonds and a
drop pearl, on the theme of cornflowers,
c. 1900.

154 **Louis Aucoc** Gold brooch in simple
stylized leaf pattern, set with diamonds and
a ruby, c. 1900.

155 **Georges Le Turcq** Gold, pearl,
diamond and enamel ring, c. 1900.

156 **Georges Le Turcq** Gold and diamond
ring, c. 1900.

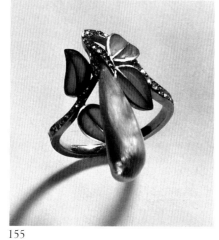

155

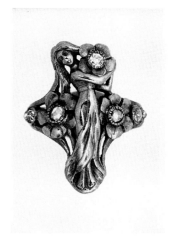

156

2 Germany and Austria

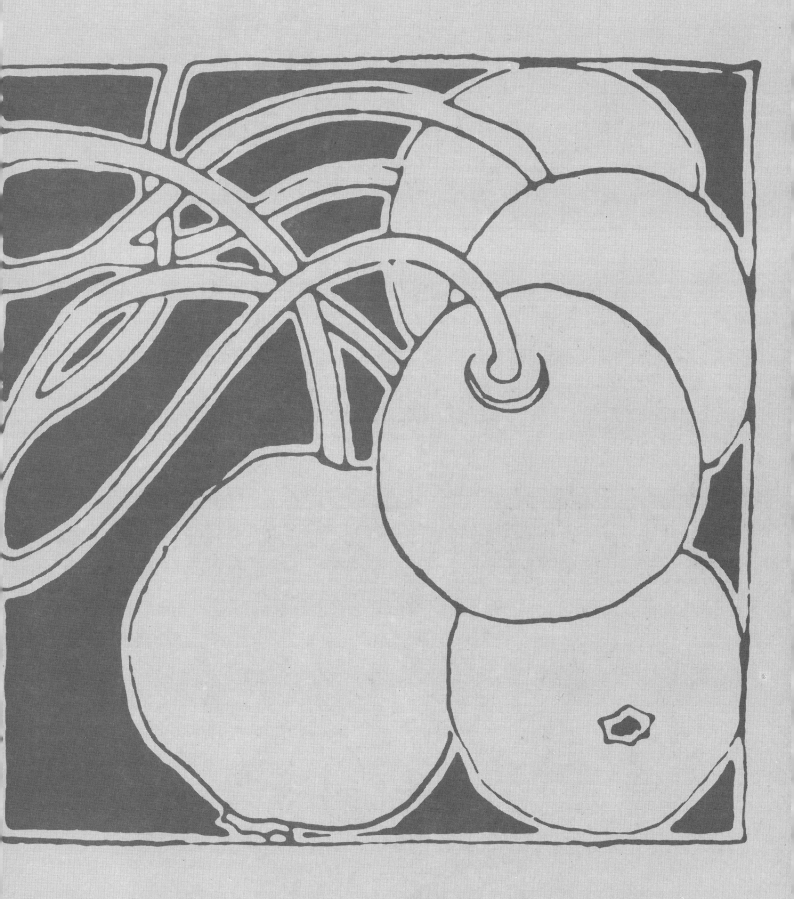

Germany

German Art Nouveau came to be known as *Jugendstil*, a name taken from the Munich-based arts magazine called *Jugend* ('Youth'). The magazine was launched in 1896, but the style had already appeared in Munich two years before. It was linked to current stylistic trends, such as naturalism, and more particularly the English floral style, and japonisme.

Jugendstil designs first appeared in Munich in the floral embroideries of Hermann Obrist (1863–1927), a sculptor and naturalist. In 1894 he exhibited embroideries that were ornamental, free-flowing interpretations of organic themes. It was his *Whiplash* embroidery of 1895 which became well-known as the epitome of the Art Nouveau line. The golden threads on turquoise fabric transformed a cyclamen into surging, dynamic lines, sensuous yet organic, and very much alive from its tight buds to its wriggling roots. The design was based on elongated loops and lashes recalling the elements of Celtic design, as well as showing traces of Japanese influence. The strong biomorphic theme that runs through *Jugendstil* stems from Obrist's work and his keen observation of nature. This was perpetuated by the architect and designer August Endell (1871–1925), one of Obrist's protégés who exerted a formative influence on *Jugendstil*.

Endell was associated with the Munich Vereinigte Werkstätten (United Workshops) which were set up in 1898 to extend the minor section of applied arts shown at the 1897 Munich International Exhibition. The workshops produced relatively few pieces of jewelry, but they did help establish Munich as a centre for progressive ideas and design in the arts and crafts.

A third major influence on German *Jugendstil* came from the graphic designer Otto Eckmann (1865–1902). He explored naturalism in design and also introduced a dimension of plant symbolism, particularly in his depictions of melancholy dying flowers. His illustrations and border designs for the new periodicals and art journals such as *Jugend* and *Pan* exerted a great influence on designers and reached a wide audience. In Germany, as in France and England, these journals were important to the development of the new style. *Pan*, first published in Berlin in 1895, was founded by the art critic Julius Meier-Graefe. This was followed in 1896 by *Jugend*, a light-hearted, more popular journal. In 1897 came *Deutsche Kunst und Dekoration* and *Dekorative Kunst*, both published in Darmstadt, and *Die Kunst* in Munich in 1899.

The decorative arts were gradually affected by the work of these major designers, jewelry from about 1898. There were two distinct strains represented: early *Jugendstil* was purely ornamental, a floral, stylized interpretation of natural forms, which flourished before 1900. The other, later strain was abstract and linear, flourishing from 1900 until around 1905, and developing towards the geometrical style of the 1920s and 1930s. This drew particularly on Belgian influence and the work of Henry van de Velde. The two trends overlapped for a while around 1900, and in the later jewels the biomorphic undercurrent is translated into abstract form. As the critic Robert Schmutzler has written, 'German *Jugendstil* aims at increasing abstraction and deformation of patterns derived from nature, seeking to achieve a metamorphosis which would result in the creation of an indefinable, organic and elementary mixture of forms.'[1]

In the 1890s mainstream German jewelry manufacturers were for the most part unmoved by the spread of the new style. Art magazines and jewelry trade

The Whiplash, 1892–94, design by Hermann Obrist

Decorations for this chapter: after a border design by Koloman Moser, from *Ver Sacrum*, vol. I, 1898, no. 9 (chapter title page); vignette by Otto Eckmann, from *Pan*, 1896, no. 1; book decoration by Josef Hoffmann, from *Ver Sacrum*, vol. I, 1898, no. 9.

journals throughout the 1890s promoted historicism and were extremely wary of the new styles that were reaching other areas of applied arts. On the other hand, there was a small group of architects and designers such as Peter Behrens and August Endell in Munich who made jewelry design one aspect of their proposed synthesis of the arts; such work is rare and it never became part of the main jewelry industry. By the end of the 1890s, however, some manufacturers started introducing new elements into their designs. Many of these were made in the French manner, often for the French market, and they are almost indistinguishable from French Art Nouveau.

The French Art Nouveau style was closely followed by a leading German jeweler, Robert Koch (1852–1902) who worked in Baden-Baden and Frankfurt. He made up jewels designed by the famous Viennese architect and designer J.M. Olbrich (although it appears that none of these now exist), but he is most famous for two exceptionally beautiful dog-collar plaques made in elaborate French Art Nouveau style. One is made of gold with dense clusters of winged sycamore seeds set with diamonds and decorated with delicate green *plique à jour* enamel; the other depicts an extraordinarily beautiful lakeside scene, in gold, onyx, diamonds and enamel, the water and mountains beyond viewed through slender trees. These pieces were illustrated in the special supplement to *The Studio*, on 'Modern Design in Jewellery and Fans' (1901–02).

Cover for *Jugend* no. 40, designed by Ludwig von Zumbusch, 1897

Apart from imitation French jewels, there was a distinct type of early *Jugendstil* floral jewel, produced mainly in Munich, the centre of this style. These German flowers are more fresh and springlike than their world-weary French counterparts, and do not have the underlying symbolism of death and decay. Jewelry produced in Munich was opulent, based on natural forms, flowers and birds, and often symbolic in imagery. The group of jewelers working in this style was headed by Karl Rothmüller (1860–1930) and included Nikolaus Thallmayr, active around 1900, and Erich Erler (known as Erler-Samaden) (b. 1870). Rothmüller exhibited at the International Exhibition in Paris in 1900 and made frequent use of Baroque pearls, also introducing an enamelled peacock motif. He had previously worked in the neo-Renaissance style, an element of which lingered in his modern jewels. Thallmayr adapted his style quickly to the new flower and plant themes, and in particular was noted for his use of chestnut and mistletoe. He worked in silver, giving it a special effect by gilding it in yellow or greenish golds.

New ideas for jewel design gradually spread to other centres in Germany. Berlin developed a distinctive, classical style inspired by plant motifs, characterized by fluid goldwork that resembled loosely tied gold ribbons. In general, Berlin adopted a rather conservative approach to new jewel design, but also produced some highly individual designers. Hugo Schaper (d. 1915), Court Goldsmith in Berlin, never fully abandoned historicism. His work shows Baroque, Renaissance and Gothic traces, even after 1898 when he took up the new style. His new work began with interpretations of plant motifs, much influenced by the graphic designs of Eckmann, but from this he developed his own style that became typical of Berlin *Jugendstil* jewels. He used simple leaves, flowers and sometimes butterflies. One of his best pieces was a French-style pendant called 'Frühlingserwachen' ('The Awakening of Spring') in which a naked ivory maiden, stretching sleepily, arises from the petals of a *plique à jour* crocus (pl. 168). He produced his best pieces for the Paris International Exhibition in 1900. Although not an innovator, he was successful in interpreting the motifs of flowers and females.

Poster for *Pan* designed by Joseph Sattler, 1895

Two major manufacturing jewelers in Berlin – they had the same surname – were Louis Werner and J.H. Werner (d. 1912). Nothing is known of these firms outside the *Jugendstil* period, when they produced some of the best jewels to come from the city. J.H. Werner executed designs by the architect Bruno Möhring (1863–1929), who adopted the Berlin style of soft goldwork using motifs of swaying flowers and leaves. O. Max Werner, the son of J.H. Werner, produced designs in the Berlin gold-ribbon style. Louis Werner, on the other hand, executed some jewels by more adventurous artists, principally Hermann Hirzel (b. 1864) and Lucas von Cranach.

Hirzel's style was modernist and abstract compared to most Berlin designers, showing Van de Velde's influence (see below). His jewels were based on simple plant forms, but highly stylized into linear motifs. Hirzel, who had spent some time in Italy, was inspired to make jewels decorated with mosaics depicting butterflies, insects or plants, set in gold, with a dull finish. In a review which appeared in *The Studio* in 1898, it was said that his work 'combined the vision of the artist with the minute observation of the botanical student.'

Wilhelm Lucas von Cranach (1861–1918) was probably the most original German artist-jeweler of the period. A former forester, he claimed descendancy from the sixteenth-century artist Lucas Cranach. In 1893 he came to Berlin to work as a landscape and portrait painter and during the 1890s broadened his scope to include jewel designs, which were executed in Berlin by Louis Werner and shown at the Paris International Exhibition in 1900. His work incorporated curious creatures and plants, often fierce and frightening, and was more closely related to Belgian or French Art Nouveau than German *Jugendstil*. His earlier work as a forester had helped him to understand plant life and he observed it in detail with the same unsentimental realism that shaped Obrist's work as a designer. He focussed on creatures like fish, owls, swans, bats and snakes. His most famous designs centre around the form of a medusa head, snake or cuttlefish, all with fluted, bat-like wings and a background of tangled worm-like roots. The most famous fish and butterfly jewel, now in the Schmuckmuseum, Pforzheim, has at its centre Baroque pearls flanked with wavering, deeply coloured enamel wings (pl. 157). This was made by Louis Werner and exhibited at the Paris Exhibition in 1900.

Outside Berlin and Munich, and the floral and gold-ribbon styles, it is the more abstract jewelry that is most characteristically German. Designers such as Patriz Huber and Moritz Gradl were chief exponents of this style, which was compounded of elements that came from outside Germany: from Belgium and Van de Velde (see p. 196) and from Austria and Olbrich (see p. 112).

The abstract style grew from a reaction to the floral and figurative styles of French Art Nouveau and early *Jugendstil*. This counter-movement represented a radical change in jewelry design and marked the turning point in the development of Art Nouveau, when it moved from a retrospective to a progressive attitude. The new German abstract jewels rejected ornamental and symbolic imagery and concentrated on line and form and increasing abstraction of shapes, particularly those based on biomorphic themes. The curving line was forcefully controlled into arched shapes, pointed ovals, softened triangles or tidy spirals. These elements were combined with straight lines and geometric openwork shapes. Design became more closely linked to materials: shapes and lines were made to look as if they were a natural formation in the metal, as if the gold or silver were actually folded or

pleated, and gemstones (non-precious and of subdued colours) appeared as if they too grew out of the metal. Van de Velde's influence was evident both in the control of line and in its suitability to material and object. The best abstract designs came from the artists in the Darmstadt colony (see below), led by Olbrich, many of whom were architects working towards a new linear, functional style.

The more progressive German jewelry of the years 1900 to 1905 was primarily manufactured in what was the country's most thriving jewelry centre, the town of Pforzheim, on the edge of the Black Forest. The Pforzheim jewelry industry dates back to 1767 when a small clock factory was started, followed by a jewelry workshop. This grew dramatically after improved mechanization was introduced to industry in the nineteenth century. Pforzheim is still famous for its jewelry and for its jewelry museum (the Schmuckmuseum). The display ranges from ancient to modern and contains a comprehensive selection of Art Nouveau and *Jugendstil* jewelry.

The Schmuckmuseum had come into being with the historicist and archaeological predilection of the mid nineteenth century. The designers and craftsmen of the industrious and technically proficient workshops of Pforzheim were anxious to see and examine the ancient artefacts that had become so fashionable and were in great demand and imitated in Italy, France and England. Jewels from ancient, Renaissance and medieval periods were collected and brought back to Pforzheim to serve as models in their workshops. These were bought by the Pforzheim Kunstverein (Arts Club) and Kunstgewerbeschule (Arts and Crafts School) which had been founded in 1877 for the promotion of the jewel industry and formed the basis for the Schmuckmuseum's collection. The jewelry industry in Pforzheim by the 1890s was dynamic, in terms of production; it was constantly searching for improved techniques and machines and popular fashions. As it was highly commercial, however, the first signs of *Jugendstil* did not immediately appeal. But once the style had become better established in other countries, it was naturally in Pforzheim that the first jewel designs surfaced.

When Art Nouveau first emerged as a style in France, Pforzheim jewelers went to Paris, returning with jewels which proved an inspiration and resulted in the production of a new line of jewelry. Until recently Pforzheim has been associated only with mass-produced, stereotyped *Jugendstil* jewels, inexpensive and fashionable, made of low-grade silver, usually showing a female face with streaming trails of hair. But, in fact, it is now known that many jewels previously thought to be French may well have been made in Pforzheim workshops for the French market.

The first *Jugendstil* jewel designs from Pforzheim can be traced to Emil Riester (d. 1925/26), a teacher at the Kunstgewerbeschule. Some of his jewel sketches were exhibited in Pforzheim in 1880, and showed a break with the past: they had Japanese and Art Nouveau-type floral elements and were interpretations rather than direct copies. Like many of his colleagues, Riester was an innovative designer, and his work ranged from early, simple, floral designs to linear *Jugendstil* after 1900.

The main Pforzheim manufacturers continued to resist the new style, until its success was confirmed in Paris and elsewhere in the late 1890s. As they became more familiar with the new-style jewels, however, their resistance was gradually broken down. On their regular visits to Paris, Pforzheim manufacturers brought back ideas and designs, as well as actual models to copy and interpret. The high technical standard of Pforzheim manufacture

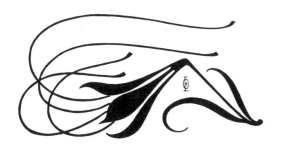

was well known in France, and some Parisian jewelers had jewels made to specific designs in Pforzheim. It is known, for example, that enamel plaques by the principal French enamellist Etienne Tourette were bought in Paris by a Pforzheim manufacturer, who then organized a competition among Pforzheim workshops for suitable frames or mounts. The Schmuckmuseum has one such brooch containing a Tourette enamel in a gold frame designed by the winner of the second prize, a man called Rühle (pl. 165).

Some Pforzheim manufacturers participated in the Paris International Exhibition in 1900, but the work shown was dismissed by the French critics who accused them of copying French designs with little creativity or sensitivity of their own. Later, the Germans were to be blamed by Vever for the decline of Art Nouveau by flooding the market with tasteless copies.[2] A good example of this eager borrowing of designs from the French is a stickpin with a motif of a girl dancing in the manner of Loïe Fuller, called 'Tänzerin' ('Dancer') by the Pforzheim designer and enamellist Georg Bastanier.[3] An almost identical motif appears in a bracelet of linked dancers by Henri Téterger, shown at the 1900 Exhibition.[4]

Although several Pforzheim firms specialized in copying French designs, there were others that encouraged native talent and produced original ideas. Wilhelm Stöffler (1842–1917) founded one of the first Pforzheim workshops to embrace the emerging style. Influenced by Riester's designs, he evolved his own style of plant motifs, concentrating on a Japanese-like economy of line. He also introduced enamelling as a central decorative feature. His jewels are characterized by a soft ripple of gold ribbons and enamel flowers. Georg Kolb was another designer who developed a distinctly German style based on early *Jugendstil* floral patterns and using soft gold outlines. He also made use of enamel, including *plique à jour*.

The firm of F. Zerrenner were among the leading Pforzheim manufacturers, and were also accused of imitating French ideas – which, much to the chagrin of the French, they accomplished with great skill and verve. The work of Zerrenner is little known, although the firm still thrives today in Pforzheim. They were large and successful, producing well-made and fashionable jewels. During the prosperous *Jugendstil* period they employed their own designers and toolmakers to help turn out the large quantities of Parisian-style, high-fashion accessories known as 'articles de Paris'. These were often passed off as French work and sold in Paris as such. At the time they were thought to look just like Bing's or even Lalique's creations. They were extremely well made and of good design. One important difference between these and French designs is that the forms and motifs of Zerrenner's pieces are often enclosed in a square; this contrasts with the open lines of the French. One beautiful piece in the Schmuckmuseum, which could be mistaken for French design and handiwork, is a pale tortoiseshell haircomb, heavy looking but with sensuous and delicately coloured decoration: a plump snake winding among water reeds and lily pads (pl. 197). The firm of Zerrenner are known also for a group of hatpins, brooches and pendants using colourful flowers and leaves, made in an almost American style, with the soft sheen of shaded translucent enamels. Around 1900 their designs reverted to a symmetry not in fashion in France. One range of brooches was based on Japanese sword guards, or *tsuba*, translating Far Eastern techniques of mixed metals: iron and brass with gold and silver overlay or inlay. At the same time, Zerrenner were able to cater for all tastes by supplementing their stock with elegant, Edwardian-style jewels.

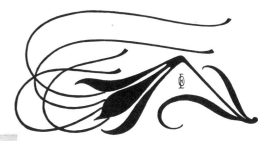

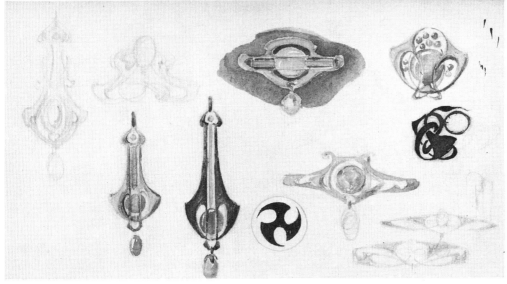

Jewelry designs by Richard Fühner, c. 1900

Another prominent Pforzheim company was that of Louis Fiessler, founded in 1857. Like Zerrenner, they made high quality a prime objective. Fiessler's jewels show the French influence in their use of plant forms.

The Gebrüder Falk (the Falk Brothers, Fritz and Heinrich) were well-established members of the Pforzheim jewelry community. Most of the designs were the work of Fritz, while the administration was looked after by Heinrich. Fritz Falk was a leading member of the Pforzheim Arts and Crafts Society. The firm was founded in 1897 and closed in 1926. They switched to *Jugendstil* design in the 1890s but continued to produce the good quality gold and silver gilt jewels for which they were known. Their first *Jugendstil* pieces were mirror pendants, with sliding covers, which were a vehicle for popular motifs such as the iris and the female figure and face. Medallions, charms and brooches came out of this workshop, which moved away from floral and stereotyped female motifs to explore the misty shapes of veiled dancers.

To collectors of German *Jugendstil* jewels today, the best-known name is that of Theodor Fahrner (1868–1929). He was certainly the most prolific and enterprising manufacturer in Pforzheim at the turn of the century. He achieved great success in producing inexpensive but very fashionable and stylish jewels, using a wide variety of designers. While other colleagues were away in Paris chasing fashionable ideas for jewels, Fahrner found inspiration nearer home for a new range, and he was quick to turn current idealism into commercial enterprise. He produced charming *Jugendstil* silver jewels, with young girls' profiles peeping from abundant tresses, but his best pieces resulted from his association with the artists' colony in Darmstadt.

The Darmstadt colony had been established under the patronage of Grand Duke Ernst Ludwig of Hesse (ruled 1892–1912), an art lover and a supporter of the progressive ideas emerging in artistic circles in Germany as elsewhere in Europe. Being a grandson of Queen Victoria, he made frequent visits to England and was familiar with the work of the Arts and Crafts movement and William Morris. In 1897 he had invited M.H. Baillie Scott and C.R. Ashbee to decorate rooms in his palace in Darmstadt for his first wife. He would also no doubt have been well acquainted with the Vienna Secessionists. At the same time he wanted to improve the arts and crafts in his duchy and so increase demand and business. To do this, he realized he also had to make the general public more receptive to the new art.

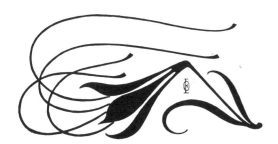

In 1897 Ernst Ludwig had the idea of establishing an artists' colony in his capital, Darmstadt, about a hundred miles away from Pforzheim. He chose the site of a small hill, the Mathildenhöhe, just outside the city. Apart from a reservoir and a Greek Orthodox Church, he managed to preserve the hill exclusively for his colony.

Joseph Maria Olbrich (1867–1908), a leading figure in the Vienna Secession and a brilliant architect, was commissioned by Ernst Ludwig to set up the colony and to design its buildings. While designing the Secession building in Vienna in 1897, Olbrich and his Secessionist colleagues had expressed a wish to build a whole town from scratch, so that everything in it, down to the contents of the houses, could be perfectly co-ordinated: 'What's the use of a beautiful street with beautiful houses if the chairs inside them aren't beautiful or if the plates aren't beautiful? No – a field; otherwise nothing can be done. An empty wide field; and there we will then demonstrate what we are capable of . . . everything controlled by the same spirit, the streets and the gardens and the palaces and the huts and the tables and the chairs and the lamps and the spoons.'

At the centre of this total design concept would be a 'house of work' where the artists could develop and thrive together, nurturing their special talents and noble intentions. It would be a place where the craftsmen 'would always have the liberated and purging art close at hand, until both would, so to speak, grow together as a single person'.[5]

Their dream came true. The Darmstadt colony was formally established in July 1899, and designers arrived from all over Europe to join it, including Hans Christiansen, Paul Bürck, Rudolph Bosselt, and Patriz Huber from Munich. Olbrich himself arrived ten days later, followed by Ludwig Habich and Peter Behrens. All the artists were young, in their twenties or early thirties, eager and exuberant, and Olbrich became the natural leader of the colony. He spent the rest of his life there.

The Darmstadt-based art publications, *Deutsche Kunst und Dekoration* and *Innen-Dekoration*, helped publicize the work of the colony.[6] In 1901 a large exhibition of art and design was held at the colony and called 'Ein Dokument Deutscher Kunst'. The buildings of the colony itself formed the basis of the display. The exhibition was an important milestone in the development of German design, but it was not a financial success and met with a mixed reception by critics. The colony was represented at the Paris Exhibition in 1900, at Turin in 1902 and at St Louis in 1904.

Just as the entrepreneurial instinct of Arthur Lasenby Liberty disseminated the work of the Arts and Crafts designers, Theodor Fahrner's business sense and keen eye used the eager fresh talent accumulated in Darmstadt. The Darmstadt designers did not at first design jewelry, but when they turned their attention to it as part of their plan for a complete design reformation, it was Fahrner who executed most of their work. In this way he brought their avant-garde style to the lives of the fashion-conscious public in the form of inexpensive, modern jewels. Almost all the leaders of the colony produced designs for Fahrner, which makes Fahrner's jewels important in terms of modernist design although of low intrinsic value.

When Joseph Olbrich himself designed jewels, he applied the same precise architectural lines that he had pioneered in his work with the Vienna Secession. Olbrich jewels are very rare and, because of his stature in twentieth-century design, are items of major historical importance. His designs are known to have been among those used by Theodor Fahrner.

Continued on p. 129

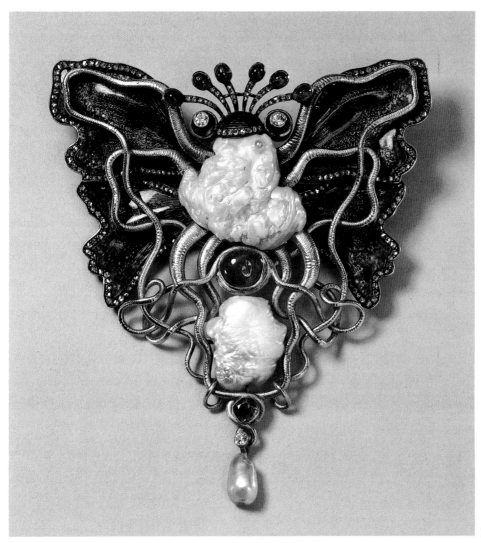

157

157 **Wilhelm Lucas von Cranach** 'Tintenfisch und Schmetterling' ('Cuttlefish and Butterfly').
Brooch in gold and enamel with a Baroque pearl, diamonds, rubies, amethysts and a topaz,
1900.

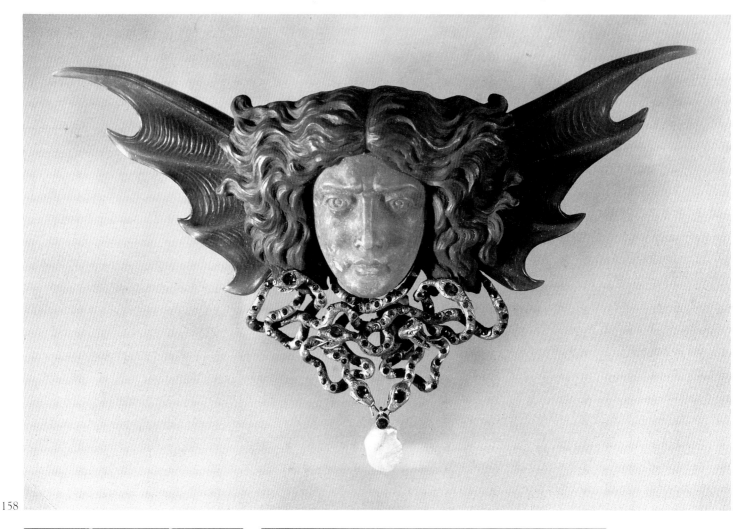

158

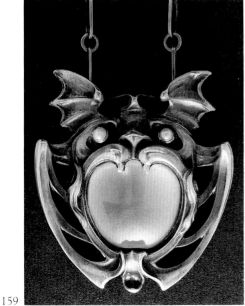

159

158 **Wilhelm Lucas von Cranach** Gold medusa-head brooch with carved opal face, wings of nephrite, hair of red jasper, and gold entwined serpents set with diamonds, 1902.

159 Silver, pearl and chrysoprase pendant. The webbed wing motif was a favourite German theme, c. 1902.

160 Two silver, enamel and pearl animal brooches.

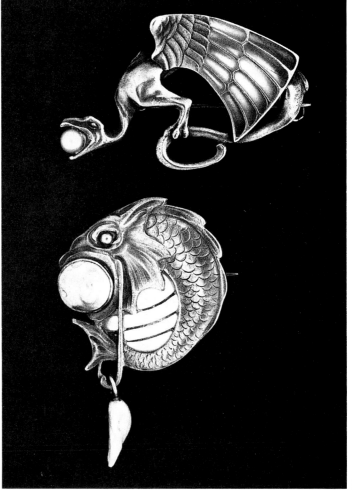

160

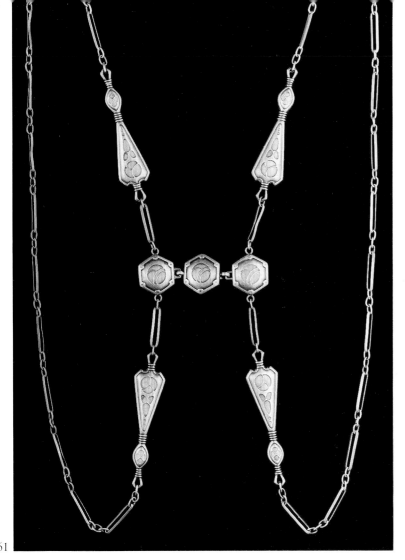

161

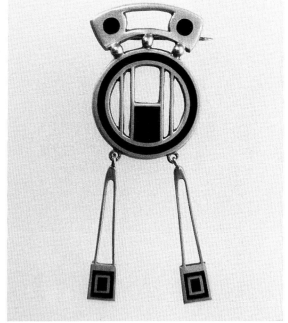

162

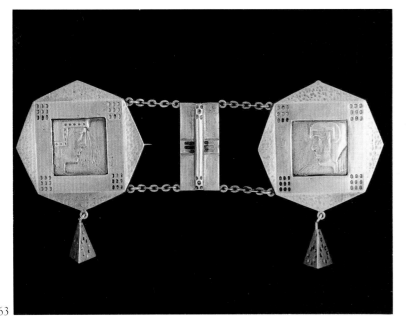

163

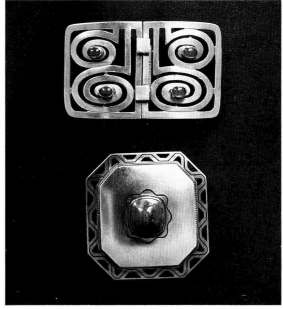

164

161 Silver and grey enamel chain, in the style of Theodor Fahrner, c. 1900.

162 **Albrecht Holbein** Silver brooch with green enamel, c. 1900.

163 Silver cloak clasp, c. 1900–02.

164 (Above) Silver belt buckle with chrysoprases; (below) silver brooch, partly gilt, with lapis lazuli and black enamel decoration, c. 1908.

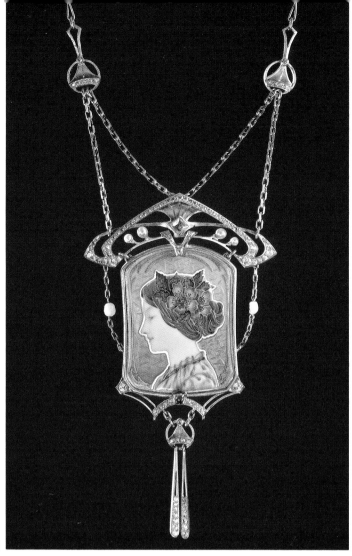

165

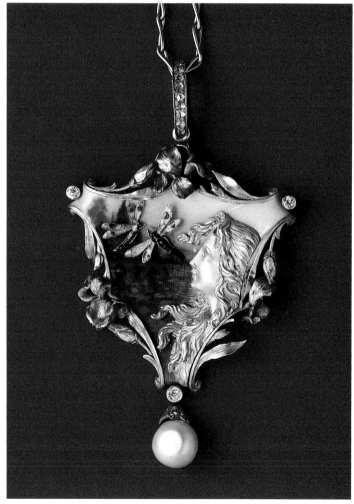

165 Gold pendant by **Rühle** of Pforzheim, 1905, with enamel plaque by **Etienne Tourette**, purchased in Paris, *c.* 1904. The frame is set with pearls and white zircons.

166 **Max Friedrich Koch** Gold pendant with enamelled lake scene and dragonflies and lilies, set with diamonds, *c.* 1903.

16

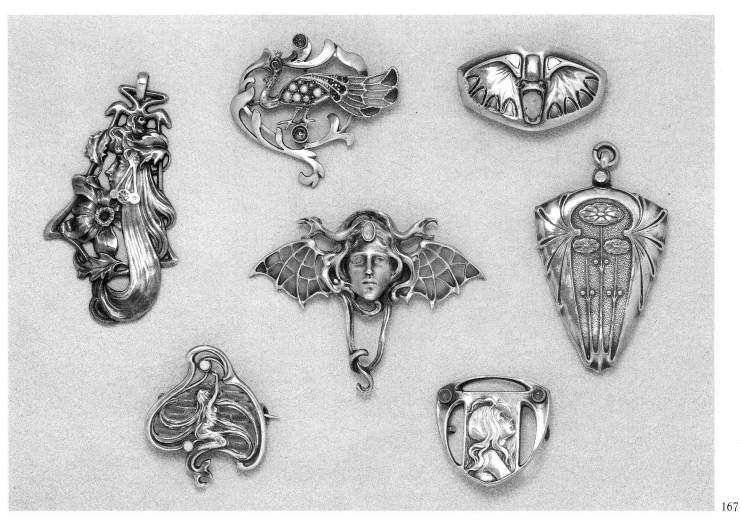

167

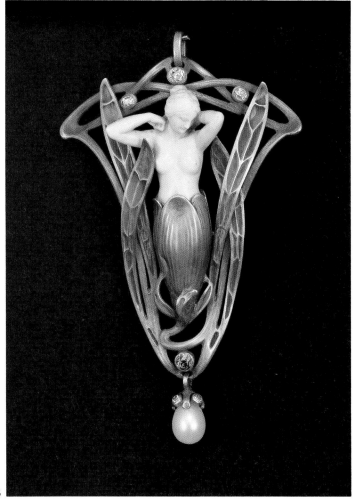

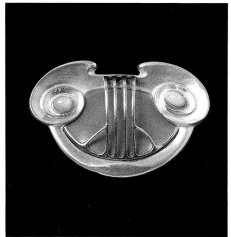

169

167 (Centre) **Albert Holbein** (designer) and **George Binhardt** (maker) Medusa-head pendant in silver, opals and *plique à jour* enamel, 1898–1900; (top right) **Julius Müller-Salem** (designer) and **Theodor Fahrner** (maker) silver belt buckle set with lapis lazuli, turquoise and mother-of-pearl, *c.* 1900–02; others unidentified, probably of Pforzheim manufacture.

168 **Hugo Schaper** 'Frühlingserwachen.' Pendant in gold and ivory with diamonds and *plique à jour* enamel, *c.* 1900.

169 **Theodor Fahrner** Silver, matt enamel and opal brooch, *c.* 1900–02.

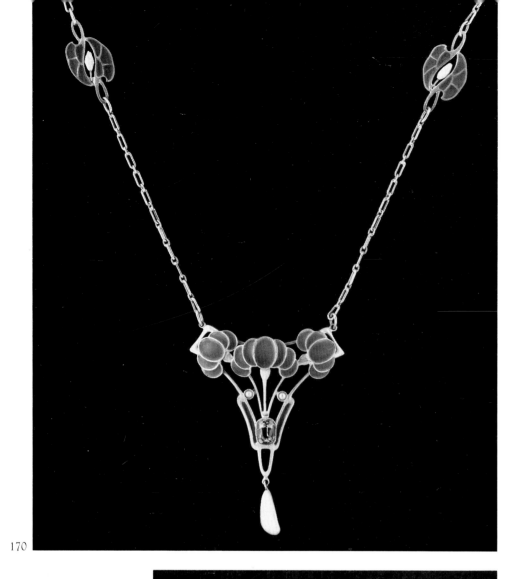

170

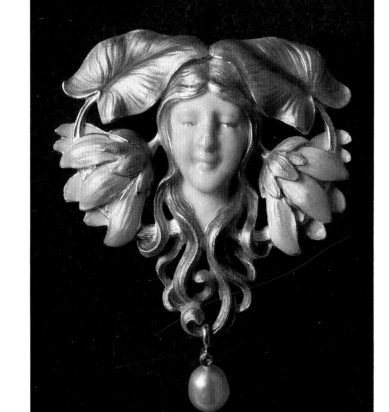

171

170 Silver and gem-set pendant with light blue *plique à jour* enamel, probably made in Pforzheim, c. 1900.

171 Girl's head and flower brooch in gold, with light green leaves and yellow flowers in iridescent enamel. Probably made in Pforzheim, c. 1900.

172 **Nikolaus Thallmayr** Silver oakleaf brooch, partly gilt, with opal acorns, c. 1898.

173 **Louis Fiessler** Girl's head pendant in gold, set with diamonds, the design very similar to that of Beaudouin's 'Modestie' brooch (135), c. 1898–1900.

174 Yellow and green gold brooch, set with diamonds framing a hardstone cameo in the classical style, c. 1900.

175 **Gebrüder Falk** Mirror locket, with sliding cover, in gold and coloured gold, c. 1900.

176 **F. Zerrenner** Gold hatpin, with green gold leaf and red enamelled flower, set with a pearl, c. 1898–1900.

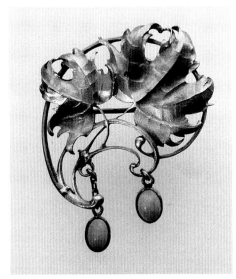

172

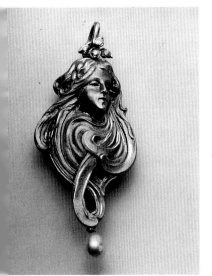

173

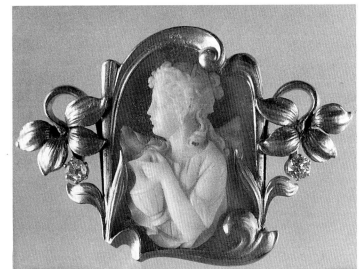

174

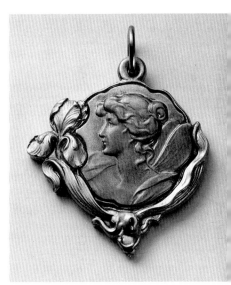

175

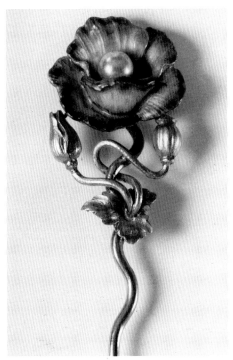

176

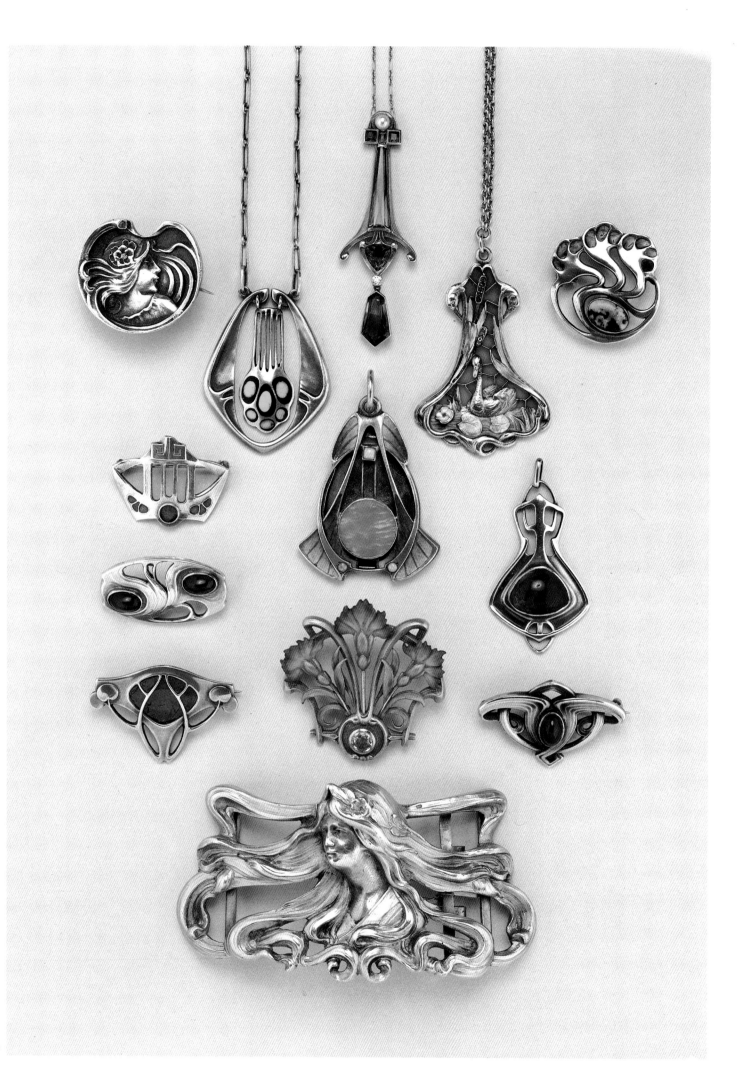

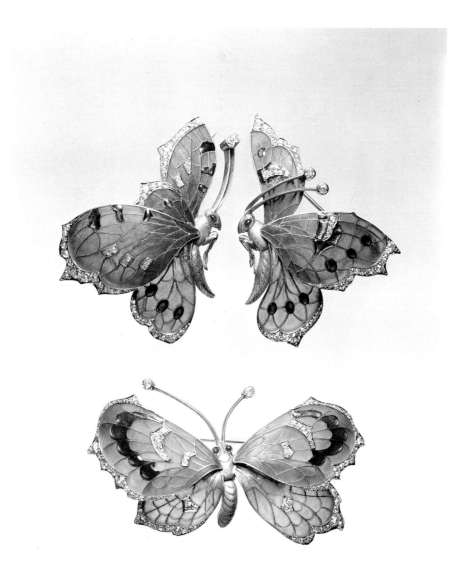

177 Jewelry showing the two distinct styles of *Jugendstil*: figurative and abstract. The brooch and the pendant in the top left-hand corner, the brooch top right, the third and fourth brooches down on the left, and the large belt buckle at the bottom, are all by the Pforzheim firm of **Fahrner.** The left-hand pendant shows the 'cell' motif typical of abstract *Jugendstil*. All *c.* 1900–05.

178 **Roset und Fischmeister** Butterfly brooches, designed by **Fischmeister**, in gold set with diamonds, rubies and *plique à jour* enamel, 1901.

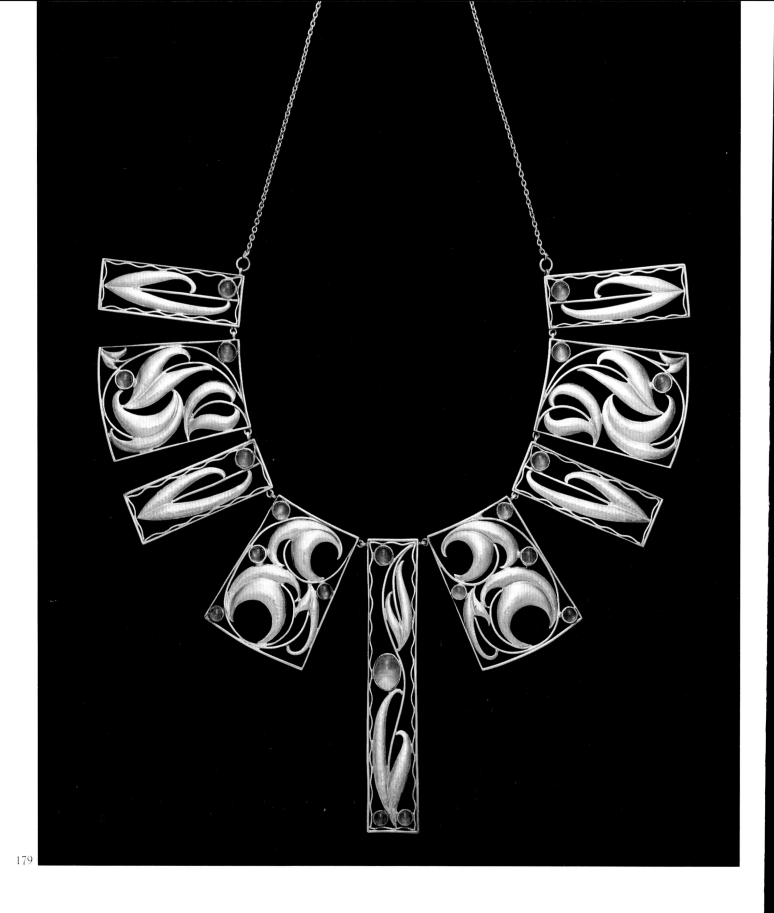

179

179 **Josef Hoffmann** Silver gilt necklace set with citrines, made by the Wiener Werkstätte, c. 1904.

180 **Josef Hoffmann** (Above) silver, malachite and moss agate brooch made by the Wiener Werkstätte, c. 1911–12; (below) silver brooch, partly gilt, set with coloured precious stones including malachite, coral and cornelian, made by the Wiener Werkstätte, c. 1910–11.

181 **Josef Hoffmann** Gold bracelet with a central carved ivory figure set with a diamond. Made by the Wiener Werkstätte, c. 1913–14.

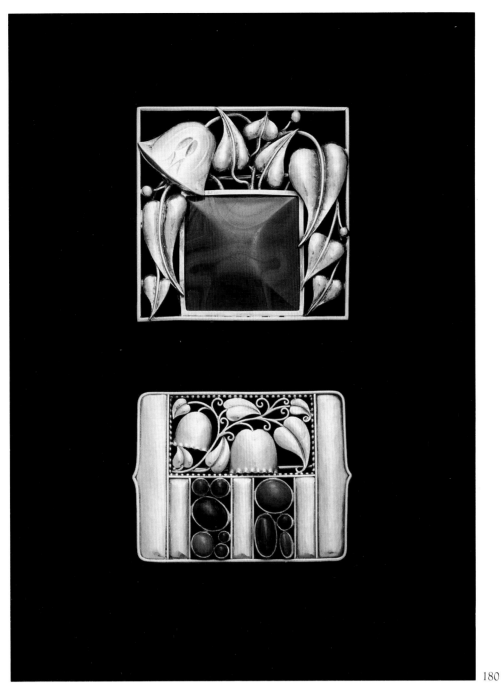

180

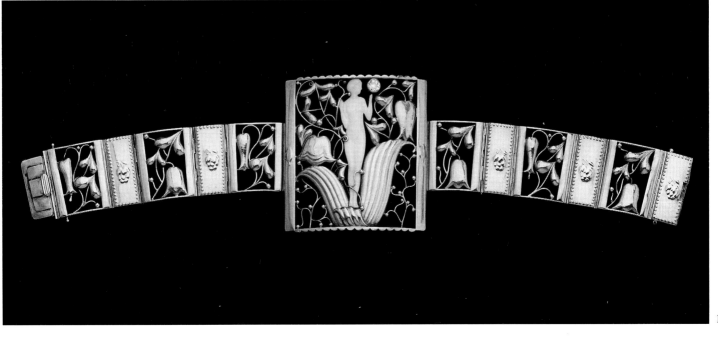

181

182

183

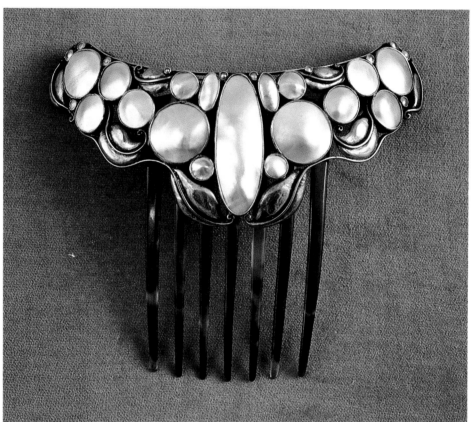

184

182 **Josef Hoffmann** Silver brooch. Made by the Wiener Werkstätte, c. 1908.

183 **Josef Hoffmann** Silver gilt and mother-of-pearl brooch. Made by the Wiener Werkstätte, c. 1910.

184 **Josef Hoffmann** Silver and mother-of-pearl haircomb that converts to a *plaque de cou*. Made by the Wiener Werkstätte, c. 1905.

185 **Koloman Moser** Silver pendant with a lizard motif set with an opal. Made by the Wiener Werkstätte, c. 1904.

186 **Koloman Moser** Silver gilt belt buckle decorated with blue and green enamel and lapis lazuli. Made by the Wiener Werkstätte, c. 1904.

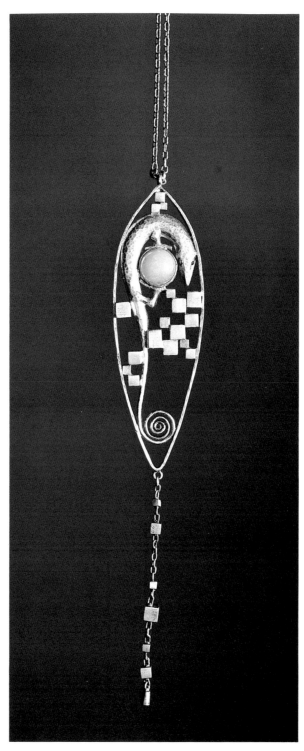

185

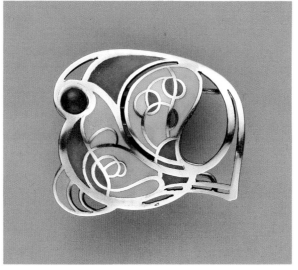

186

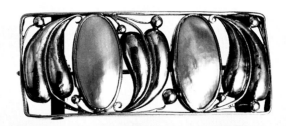

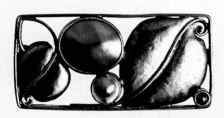

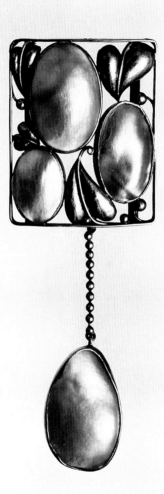

187 **Josef Hoffmann** *Plaques de cou* in silver gilt and mother-of-pearl. Made by the Wiener Werkstätte, c. 1913–14.

188 Two silver and mother-of-pearl brooches in the style of Josef Hoffmann, c. 1910.

189 **Eduard Wimmer** Gold ring set with a black opal. Made by the Wiener Werkstätte, 1911–13.

190 **Josef Hoffmann** Gold ring set with clusters of mother-of-pearl. Made by the Wiener Werkstätte, 1912.

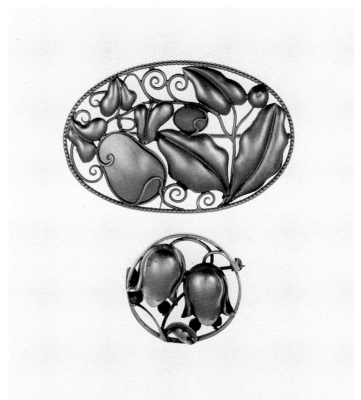

188

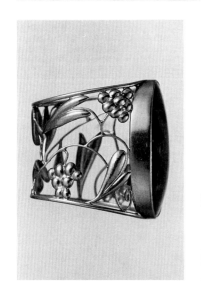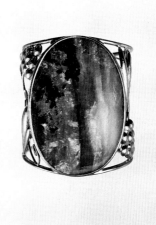

189

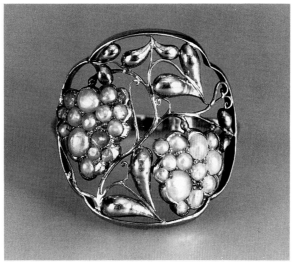

190

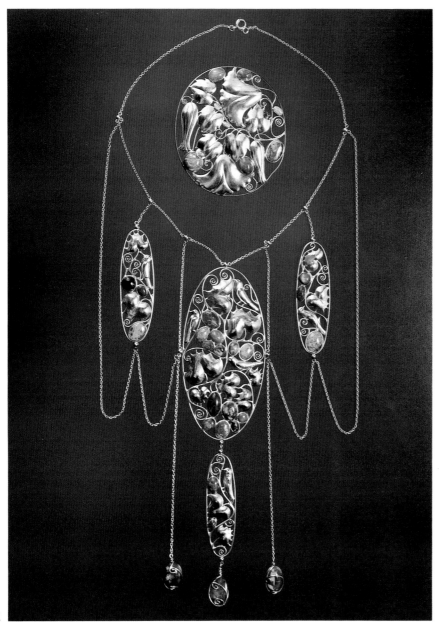

191

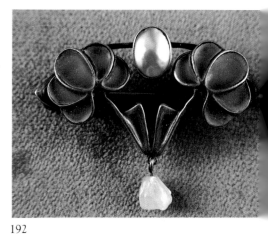

192

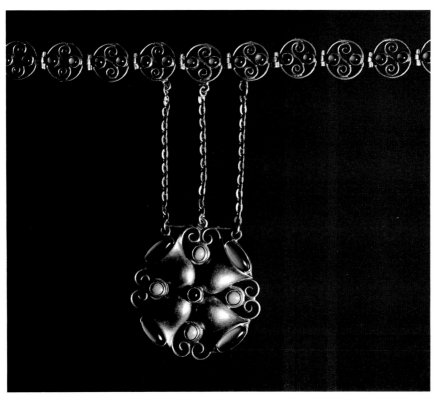

193

191 **Carl Otto Czeschka** (designer) and
Anton Pribil (maker) Gold brooch and
necklace set with black opals. Made by the
Wiener Werkstätte, *c.* 1905.

192 **Otto Prutscher** (designer) and **Theodor
Fahrner** (maker) Silver, *plique à jour* enamel
and pearl brooch, *c.* 1900–02.

193 **Gustav Kalhammer** (designer) and
Oskar Dietrich (maker) Pendant and chain
of silver, partly gilt, set with chrysoprases,
turquoises and a garnet, *c.* 1910.

In *The Studio*'s special supplement in 1901–02, the section on German contemporary jewelry includes illustrations of pieces designed by Olbrich, many executed by Fahrner. The author of the commentary, Christian Ferdinand Morawe, a designer himself, writes that Olbrich's jewels were very characteristic of his architectural style, and that his work was the best in Germany: 'He takes a hammered gold-plate, enriches it with precious stones and enamel and adds a rim set with long pearls. It is easy to see that he is fond of rummaging among the treasures of the old cathedrals and convents; he knows the secret of their effect, and besides this he has an extraordinary talent for inventing new things himself.' Olbrich's work is characterized by a strong simplicity which contrasts with the gentle lilt of gold lines or the silky sheen of mother-of-pearl. In spite of its affinity to modernist design it has rich, medieval-like opulence.

Morawe calls Olbrich's jewels 'pure and thoughtful' works of art. They were made of silver or gold, sometimes with the hammered surface Morawe refers to, set with lapis, pearls, bloodstones and amethysts, deeply coloured stones used with Baroque pearls, which produced the rich and sumptuous effect reminiscent of ancient treasures, at the same time retaining a simplicity of form. Olbrich's designs were also executed by Zerrenner in Pforzheim and by Robert Koch and D. und M. Loewenthal in Frankfurt.

Patriz Huber (1878–1902) was also an architect, and he produced the greatest number of jewel designs of all Darmstadt members; they translated easily into jewelry. Huber's initials (PH) are marked on his pieces, alongside Fahrner's (TF), so his designs can be firmly identified today. His work is simple and strong, distinguished by restrained, dull silver surfaces set with stones of subdued colour or enamels within coils or folds of metal. He used sweeping yet controlled linear movements and a subtle geometry often expressed as triangular motifs or stones, the corners always softened. His abstract designs hint at organic motifs or movement, often in little clusters of cells, an underlying theme in abstract German jewel design. The circular motif, often with a little whiplash cut-out, was a typical Huber feature, and was found also in the colony's architecture and decoration.

Peter Behrens (1868–1940), another leading member of the colony, was a Munich architect, painter and designer of exceptional importance. His jewelry designs were in the same vein as the work of Huber and Moritz Gradl, with concise but sweeping lines and chiselled pleats of metal, but his individual contribution to *Jugendstil* was the use of the image of the eye and tear-drop, which became his motif. His designs were executed by the firm of B. Schreger in Darmstadt and by M.H. Wilckens und Söhne in Hamburg.

Ludwig Habich (1872–1949), a sculptor and medallist, was also a member of the Darmstadt colony, and his designs were executed by Theodor Fahrner. Habich's most distinctive design is figurative: a playful female figure, seated, her legs stretched out in front, and her arms reaching towards a pearl or ivory ball resting at her feet. Brooches made to this design were produced in silver, partly gilt.

The painter Hans Christiansen (1866–1945) was studying in Paris when he was called to join the Darmstadt colony. In Paris he had become well acquainted with the work of Mucha, and his few jewel designs show Mucha's influence. Christiansen designed a head ornament in Mucha's theatrical Byzantine manner, and a necklace of extravagant floral form. He also designed a belt buckle, executed by D. und M. Loewenthal, in German

Design by Peter Behrens from *Die Kunst*, 1901

biomorphic style, with softly undulating silver-gilt outlines encasing pieces of mother-of-pearl.

One of the founder members of the colony was Paul Bürck (1878–1947), an artist and graphic designer. He produced very little jewelry but he was not left out of Fahrner's commissions: one simple, organic-looking brooch executed by Fahrner bears his name. A draped necklace (with loops of chain) from a design by Bürck was made by D. und M. Loewenthal, but otherwise no other jewelry designed by him is known today.

Rudolf Bosselt (1871–1938) had trained as a sculptor and medallist and was called from Paris to join the colony. He made frequent use of bird motifs in his jewel designs, adding enamel to buckles, brooches and haircombs in pierced openwork.

The Darmstadt colony projects had come to an end by 1902, although the colony itself continued to exist until the First World War. Its concentrated force had changed *Jugendstil* jewels from floral designs derived from European styles towards a new abstract geometry.

Throughout the *Jugendstil* period, the Pforzheim manufacturer Theodor Fahrner continued to draw on other designers wherever he saw an exceptional and individual talent. He used designs by Van de Velde and also by Moritz Gradl from Munich and Georg Kleemann from Pforzheim. Gradl (b. 1873) had studied at the Kunstgewerbeschule in Munich and made some excellent designs bought by Fahrner. His work is rare and sought after by connoisseurs. It is sometimes strictly abstract and geometric, like Huber's, but he sometimes makes use of softer outlines executed in gold, introducing a more fluid movement. He sets his pieces with richly coloured cabochon stones amidst swirls of lines, and also uses little clusters of cells of translucent enamel, which have a biomorphic appearance. This feature appears in many other jewels manufactured by Fahrner and it is difficult to establish who first made use of it. It certainly recalls the work of Obrist and Endell, which was based on close observation of nature. The clusters of cells sometimes suggest skeletons, membranes, or coagulating, amoeba-like shapes in a constant state of change.

Another designer used by Fahrner was Georg Kleemann (1863–1932) who had studied in Munich and, from 1887, became a professor in jewelry design at the Pforzheim Fachschule (Technical School). His jewels are stylistically among the most important to come from Pforzheim. In 1900 he put on show at the school over a hundred innovative designs for jewels and haircombs. He initially worked in a gently flowing flower format, but then progressed to a highly stylized geometrical style which he applied to his strange beetle creatures, conceived after 1900, and his winged scarabs with staring eyes. The curved wing shape that he first used in these was developed in more abstract jewels. His extraordinary scarab creations were set richly with opals, emeralds, rubies, topazes, diamonds, and with *plique à jour* enamel wings. They usually had large, bulbous mother-of-pearl or turquoise bodies. His designs were often carried out by craftsmen or students at the school, and his style was therefore widely imitated. Small numbers of his designs were also executed by leading manufacturers such as Fahrner, Zerrenner, Lauer und Wiedmann, C.W. Müller and Victor Mayer. Kleemann's name does not appear on these jewels, however.

After Pforzheim, Hanau was the biggest jewelry-producing centre, but it specialized in diamond-set jewels. Manufacturers could not easily adapt traditional diamond jewels to the new style, which relied for its appeal on

design rather than gemstones, and so had to make drastic changes, both technical and aesthetic. They made use of current floral motifs and, being situated near Darmstadt, also used some geometric designs. These included adaptations of Huber's spiral shapes, copies of Schaper's symbolic pendant 'Frühlingserwachen' and variations and copies of Von Cranach's fish and butterfly creations.

Schwäbisch-Gmünd, a town with a long tradition in jewelry, was another, smaller manufacturing centre for gold and silver, specializing also in inexpensive, popular pieces. In the 1880s manufacturers there tried to raise the quality of design by setting up art schools and a museum. Schwäbisch-Gmünd produced diluted versions of *Jugendstil*, generally cheaper versions of expensive pieces. Work from the town was represented at the Paris Exhibition in 1900.

Many German jewels are made of cheap materials (metal or copper with glass, for example) but in excellent designs. Such jewels may have been models or the work of students, but it seems more probable that they were intended to be sold as inexpensive versions of designs by well-known jewelers. In these pieces a deep blue glass was sometimes used as a substitute for hardstones and was known as 'Swiss lapis', while very strong designs, attributable to Darmstadt artists, were often produced in a silver-coloured metal stamped 'ALPACCA'. This was another name for German silver (*Neusilber*, now known as nickel silver) which was an alloy of copper, nickel and zinc.

Austria

Vienna was the centre of *Jugendstil* in Austria, and the last of the major European cities to adopt the new style. Austria's break with past traditions in the arts came in 1897 when a group of artists and architects 'seceded' or broke away from the Vienna Academy, to set up their own organization called the Wiener Sezession (Vienna Secession). This gave them the freedom to explore new concepts, and to exhibit their art. Their aim, the creation of a contemporary art movement and a unity between architecture and functional everyday objects, was similar to that of like-minded groups in neighbouring countries. The Secession was especially concerned with architecture, but it had an equally great impact on the fine and decorative arts, including jewelry. The geometric style developed by the Secessionists and their followers was the Austrian version of Art Nouveau and became known as *Sezessionsstil* – a term not widely used today.

As in Germany, nineteenth-century Austrian architecture and decorative design had been ruled by historicism, which took the form of a florid, Baroque style. The Secessionists rejected eclectic and historicist ornament, which they felt was stale and not appropriate to the modern way of life. They believed that the design of both buildings and contents should suit their function, and reacted by moving towards a simple, streamlined style, based on geometry and stripped of unnecessary ornament. This had a strong link to the later, abstract phase of German *Jugendstil* design. Olbrich was a founder member of the Vienna Secession, and through his foundation of the Darmstadt colony the styles of Germany and Austria intermingled. The new style was applied first to architecture, then made its way to everyday objects and jewelry.

Poster for the 14th Vienna Secession Exhibition, 1902, designed by Alfred Roller

131

Poster for *Ver Sacrum*, 1903, designed by Koloman Moser

Austrian *Jugendstil* jewels are rare and far more individual than German pieces, with a much starker geometry. There was also only a small group of designers devoted to Austrian *Jugendstil*. Unlike Germany, Austria did not have great jewelry-manufacturing centres like Pforzheim, Schwäbisch-Gmünd or Hanau to absorb modern trends and turn them into popular jewelry designs on a large scale. On the other hand, Austria did have an efficient and productive system of art and technical schools which had been built up over some fifty years. Influences gradually filtered through this system, especially those from England and the Arts and Crafts movement, from Scotland, and from Japan through the many artefacts that were shown in museums. By the mid 1890s, through these influences and the reaction against historicism, the functional, cubic or rectilinear form that was to be the hallmark of Austrian *Jugendstil* emerged. It was inspired by the architect Otto Wagner (1841–1918), and passed on to his talented pupils, among them Joseph Olbrich and Josef Hoffmann. In 1898 Olbrich designed what was to be the Secession headquarters and exhibition hall. The design of the building, inside and out, included many decorative elements central to the work of Austrian *Jugendstil* designers, and also repeated in their jewelry and metalwork: simple geometric outlines, regular curling spirals, arrangements of cubes, and highly stylized, simple leaf patterns. At one side of the entrance to the building were the words 'Ver Sacrum' ('Holy Spring'), which was the name given to the magazine of the Secession. This art journal was to share the work of the new artists and designers with the general public. It was on the pages of *Ver Sacrum* that *Jugendstil* first appeared in Austria.

While the Secession was being established in 1897 and 1898 (and its designs and architecture often treated with ridicule by critics and onlookers), the symbolic French style of Art Nouveau jewel, known as the 'genre Lalique', achieved popularity in fashionable Viennese circles. Because of its ornamental purpose, jewelry was at first of little concern to the Secessionists, but in 1898 and 1899 more jewelers took part in the Secessionist exhibitions, among them Van de Velde and the Frenchmen Henri Nocq (b. 1868) and François Carabin (1862–1932). Carabin was an imaginative sculptor specializing in figurative and organic creations who also showed some items of jewelry. In 1900, some of Ashbee's jewels were added to the exhibition, and jewelry began to play a more significant part in the displays of the new style.

At this stage, the lead in jewel design for the main jewelers and in public taste still came from Paris and was based on Lalique's style. Even some of the avant-garde Secessionists like Koloman Moser and Joseph Olbrich based their early jewelry experiments on this French style. (In 1900, Moser designed a young girl's head, her hair flowing out from behind a chrysanthemum.) It took a while before they adapted their individual geometric style to jewelry design.

One or two leading Viennese jewelers were extremely proficient in the French Art Nouveau style, and received praise in the special supplement to *The Studio* in 1901–02. These were A.D. Hauptmann and Roset und Fischmeister. By the last years of the century, A.D. Hauptmann was using fluid French motifs, and around the same time Roset und Fischmeister began to produce their successful French-style jewels. Fischmeister had gone to Paris to learn with Lalique, and possibly with the medallist and sculptor Frédéric de Vernon, and he came back to Vienna full of ideas for using ivory, coloured glass, tortoiseshell and enamel, especially *plique à jour*, as well as picking up some of Lalique's ideas for compositions. The firm made flying-

swallow brooches, dramatic enamelled butterflies and *plaques de cou*, as well as adapting the more traditional, diamond-set items to delicate Art Nouveau lines. Roset und Fischmeister's brightly coloured *plique à jour* butterfly brooches have gem-set wings and gold bodies. They also produced a range of softly chased gold jewels.

After 1900, the genuinely Austrian modern style began to affect jewelry. New abstract designs were made side by side with French-style jewels, which now developed a more distinctly Viennese look, with richer, deeper enamels, as in the jewels of Roset und Fischmeister, and a purely ornamental rather than allusive interpretation of motifs. Commenting on the new national style in *The Studio's* special supplement in 1901–02, the critic W. Fred recognizes that Austrian jewel design had only just been freed from the dominating influence of France, which had lasted through the entire nineteenth century: 'Now, at last . . . the liberating influence of the modern spirit is making itself felt in the art of jewelry, as in everything else; and every ornament produced, whether in precious stones or in enamel, bears the unmistakable impress of the distinctive psychic character of our capital city, which even foreigners do not fail to recognize. The result of this individuality is that a work of art is indissolubly bound up with the personality of its creator and with the idiosyncrasies of the town which was its birthplace.'

Vienna was a cultured, elegant city, alive with the celebration of beautiful women. The same critic wrote: 'The graceful and witty, yet dreamy and passionate girls and women of Vienna, give to it its distinctive character.' These qualities encouraged jewelers to make exquisite jewels in the ornate French manner, which contrasted greatly with the biomorphic style exemplified by such motifs as clusters of shifting organic cells, of skeletal frames and soft tissue.

The best known and most widely sought-after Austrian jewelry of this period is that made by the Wiener Werkstätte (Viennese Workshop) and most of it is designed by Josef Hoffmann (1870–1956). Hoffmann was among those who firmly believed in the need for a unity in the decorative arts. With his austere and geometric designs, stripped of ornament, Art Nouveau reached the other extreme of its stylistic variations, proving that it was itself a transition towards modernism. Hoffmann had studied painting in Munich and architecture at the Vienna Academy under Otto Wagner. He had been a founder member of the Vienna Secession in 1897, and in 1903 he, together with Koloman Moser and the banker Fritz Wärndorfer as a financial backer, founded the Wiener Werkstätte, inspired by C.R. Ashbee's Guild of Handicraft in England. In some ways, the Werkstätte followed Ashbee's example of a co-operative workshop, but the Austrian craftsmen were highly trained and technically skilled.

The idea for the Wiener Werkstätte developed from the aims of the Secession, one of which was to restore art to everyday life. The satisfaction of handcraftsmanship to both maker and user was one way of achieving this. The workshops specialized in the production of handmade metalwork, including jewelry, and also made furniture, textiles and other decorative objects. Their production of jewelry started from the beginning, with designs by Hoffmann and Moser.

An important feature of the Wiener Werkstätte was the close communication between designer and workers, so that the designer kept in touch with materials and with the technical progress of each piece, instead of losing control once execution had begun.

Illustration for *Ver Sacrum*, 1902, by Leopold Bauer

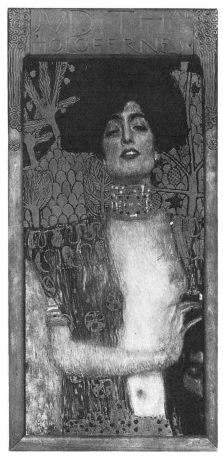

Judith, 1901, painting by Gustav Klimt

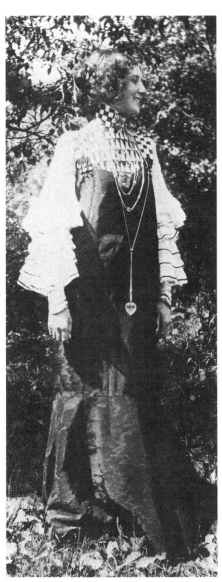

Mathilde Flöge in a dress probably designed by Gustav Klimt and wearing Wiener Werkstätte jewelry by Koloman Moser, c. 1905

Hoffmann designed quite extensively for jewelry. Particularly fond of the square format, he used a chequerboard design, and simple representations of leaves and flowers, always with a thin rectilinear frame. His fine metal lines, echoing the work of Mackintosh, were combined with neat coils of wire, or heart-shaped leaves, and a highly stylized rose or flower, its petals rolled with geometric regularity. He worked in silver and silver gilt, using hammered metal surfaces, semi-precious cabochons of deep unusual colours and mother-of-pearl, all features that became typical of Wiener Werkstätte jewelry. He incorporated a great deal of enamelled metal, also in unusual colours, but he most enjoyed using the contrast of black and white.

Hoffmann's style was greatly influenced by the Scottish architect and designer Charles Rennie Mackintosh (1866–1928). There was a great affinity between the rectilinear designs of Mackintosh and the Glasgow School and emerging Austrian *Jugendstil*. In his architecture and furniture designs Mackintosh had developed a very individual style which was based on rhythmic, elongated lines, sometimes gently curved, contrasting with the rounder, slightly squat decorative motifs, particularly the rose, which became highly stylized and geometric. In 1898, the German periodical *Dekorative Kunst* published an article about the work of Mackintosh and the Glasgow group of designers known as 'The Four'. In 1900 Mackintosh was invited to exhibit with the Vienna Secession and designed a room-setting and furniture for the Scottish section. This was illustrated in the magazine *Die Kunst* in the same year and received rapturous acclaim. After this Mackintosh was better known and appreciated abroad than in England. His work was particularly admired by Josef Hoffmann, and they became close friends and colleagues, sharing in their work a distaste for any kind of unnecessary decorative ornament.

Koloman Moser (1868–1918), the other leading Austrian artist and decorative designer mentioned above, and a founder member of the Wiener Werkstätte, also designed a number of pieces of jewelry. Moser's work was even more stylized than Hoffmann's in his interpretations of natural forms, using a strict geometric linear style, also reminiscent of Mackintosh. His clusters of softly misshapen ovals are similar to elements in Hoffmann's designs. Moser used black and white checks, squares and stripes. He also designed jewels for the firm of Georg Anton Scheidt in Vienna, and for Roset und Fischmeister. He withdrew from the Wiener Werkstätte in 1906.

Versatility was the hallmark of Wiener Werkstätte designers. They could turn their talents to almost any of the decorative arts. Carl Otto Czeschka (1878–1960) was a particularly versatile designer and artist-craftsman who had been a member of the Vienna Secession and joined the Wiener Werkstätte soon after it started in 1904. He worked there until 1908, when he was called back to Hamburg to teach at the Kunstgewerbeschule, although he continued to supply designs, including some for jewelry, for the Werkstätte. Since 1902 he had taught drawing part time, and his jewel designs clearly show a graphic quality. Because of his art-school training, he combined figurative motifs with abstract design, and also made good use of unusual materials – another inheritance from art school, where the cost of precious metals and stones meant that students had to make innovative use of less expensive materials. One important necklace, now in the Österreichisches Museum für Angewandte Kunst, and made around 1905, is very much in the Wiener Werkstätte style and was made to Czeschka's design by Anton Pribil (pl. 191). It has long oval motifs filled with stylized spiky leaves and thin gold

wires, and is set with deeply coloured black opals. He also designed a series of silver brooches for children, using very simple motifs of animals such as a fish, a bird, and a rabbit.

Since the Wiener Werkstätte started only in 1903 and the Art Nouveau style had virtually come to an end by 1910, its time-span for producing goods in the *Jugendstil* manner was short. During this period it drew on several other good designers for jewelry, notably Eduard Wimmer, Bernhard Löffler and Karl Witzmann. For the most part these three worked in the clearly defined style of the Werkstätte, using strong colours of unusual stones and materials, thin straight outlines and stylized, rounded or fluted leaves and wire coils.

Eduard Wimmer (1882–1961) joined the Wiener Werkstätte in 1907, and many of his designs have a strong organic theme. Bernhard Löffler (1874–1960) was mainly a ceramicist, who also joined the Werkstätte in 1907, having founded a separate workshop co-operative exclusively for ceramics, the Wiener Keramic, in 1905. His experiments in ceramics can be traced in his jewel designs. He worked only in silver and added no stones but his applied wirework patterns were reminiscent of the flat simplicity of Czeschka's brooches for children. He used the motif of a little plump child or cherub, on one piece playing with a bird, on another holding a flaming torch. His pieces are rare.

Karl Witzmann was an architect who occasionally designed for the Wiener Werkstätte. For his jewels he used simple flowerhead motifs, coils, and discs covered in black and white checks.

The Wiener Werkstätte style, with its geometric black and white patterns and stylized leaves, was picked up by commercial manufacturers, principally by Oskar Dietrich in Vienna, who executed designs by leading figures, including Hoffmann and Otto Prutscher.

Prutscher (1880–1949) was one of the most important Austrian designers of turn-of-the-century jewels and also designed jewels for the Wiener Werkstätte, although he is not generally considered one of its major designers. He was much influenced by Mackintosh and the Glasgow School, had studied with Hoffmann in Vienna, and in 1909 became a professor at the Kunstgewerbeschule. His work is characterized by a strong use of colour. He worked with deeply coloured enamels and some *plique à jour* on spread wing motifs, and was also fond of using mother-of-pearl, mixed with highly stylized metalwork incorporating the coils and rounded leaf motifs typical of Austrian *Jugendstil*. Some of his designs were made up in Pforzheim by the firm of Heinrich Levinger. His work was praised by W. Fred in *The Studio*'s special supplement in 1901–02, where it was described as remarkable for the 'beauty and harmonious variety' of the colours: 'It would appear as if the artist had in his mind a vision of the women who are to wear his work, who are too tender and frail to carry any weight, so that the use of much metal in ornaments for them would be quite unsuitable.' Prutscher's jewels, he concluded, were made for the 'softly nurtured Mignonne of the present day'.

Gustav Gurschner (1873–1971) was a talented sculptor who occasionally designed jewels, stressing the importance of line and form. His jewels are rare and usually incorporate the female form, particularly a stylized female head. Mostly in silver, they have the modelled look of sculpture in miniature.

Following a similar pattern to that established in England during the Arts and Crafts period, Austrian *Jugendstil* encompasses a group of interesting jewels made by students in the Kunstgewerbeschule in Vienna. Many are very simple enamel plaques of animals and birds, following Czeschka's

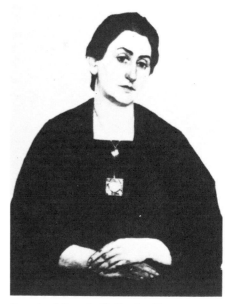

Portrait of Broncia Koller, by Hans Schröder, with jewelry designed by Koloman Moser, 1907

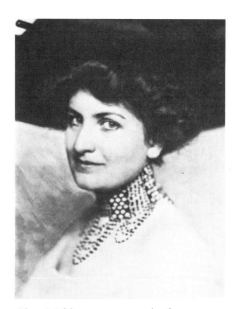

Alma Mahler wearing jewelry by Koloman Moser, 1904, in a photograph by D'Ora, 1909

drawings, and others incorporate typical Viennese motifs, such as wire coils, cells of colour, or more geometric spindly lines. Certainly their work reflects the general Austrian tendency to use colour and line for principal decorative effect, rather than precious stones. *The Studio* praised the work done in the school, where the students 'learn to esteem skill in art craftsmanship as it deserves, and become thoroughly familiar with the materials employed in it. In the course of their training, feeling for true beauty and elegance is mixed, so to speak, with their very blood, becoming part of their natures, so that they cannot go far wrong.'

Else Unger, daughter of William Unger, a professor at the Kunstgewerbeschule, and a pupil there, produced good modern silver jewels. The success of her jewels lay in her understanding and appreciation of the materials she used. She added softly coloured enamels to produce inexpensive Art Nouveau jewels. Another student, Anna Wagner, worked in a similar way, adding soft enamels to her silver jewelry. Franz Mesmer, also at the school, produced popular and inexpensive jewels, integrating organic themes and geometric lines. Both he and Else Unger made good use of beaten silver.

The simple images created by the designers of the Wiener Werkstätte share forward-looking characteristics with the designs of German jewelers such as Fahrner, and both largely overshadow the transitional jewels of the period in these countries: tame, floral ornaments produced in Munich and Berlin, and the 'genre Lalique' popular in Vienna in the earlier years. The presence of two styles, which was unique to Germany and Austria, expresses the divergent nature of Art Nouveau. Both Austrian and German abstract jewels, in their fierce reaction against early Art Nouveau, led to twentieth-century design: they paved the way for the modernist preoccupation with suitability of form and function, the flat stylization which anticipated Art Deco and the streamlined strength of the machine age.

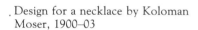

Design for a necklace by Koloman Moser, 1900–03

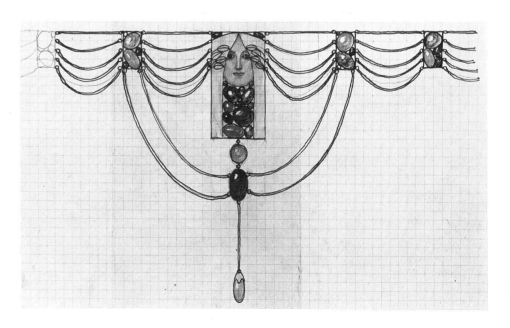

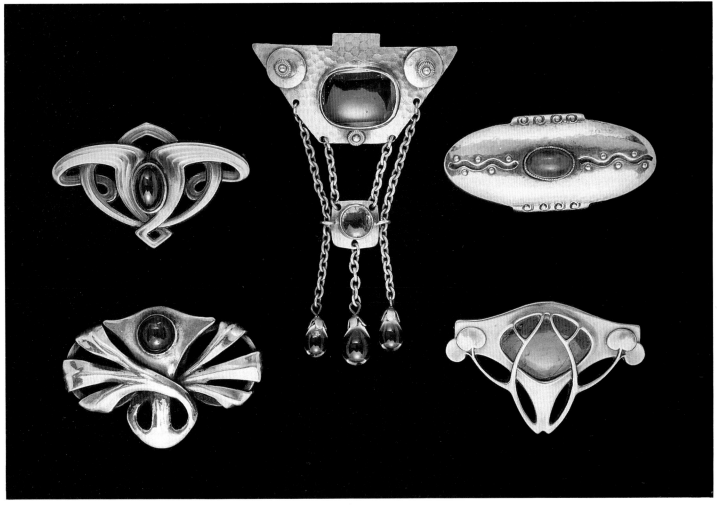

194

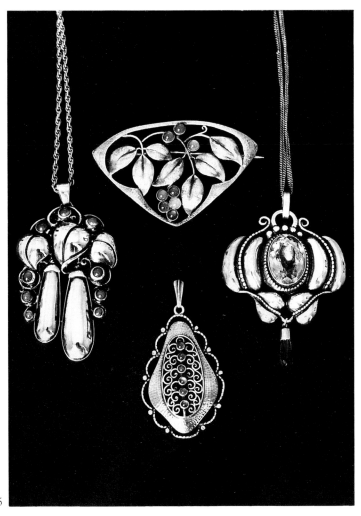

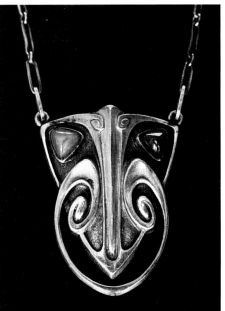

196

194 Five brooches made in Pforzheim: (clockwise from top centre) silvered metal and green glass; Alpacca silver and green hardstone; **Theodor Fahrner** silver and lapis lazuli; silver and chrysoprase; silver and garnet. All *c.* 1900–05.

195 (Above) **Karl Karst** Silver brooch with green chrysoprases; (right) **Theodor Fahrner** silver pendant with topaz and amethyst; (below) **Karl Karst** silver pendant with green chrysoprases; (left) **Theodor Fahrner** silver pendant with chrysoprases. All made in Pforzheim, *c.* 1910.

196 **Patriz Huber** (designer) and **Theodor Fahrner** (maker) Silver pendant set with green chrysoprases, *c.* 1901.

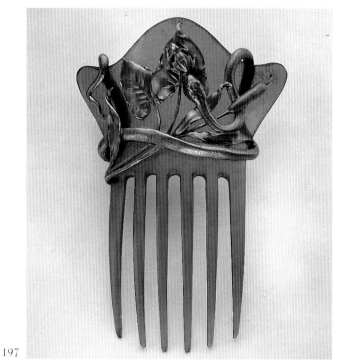

197

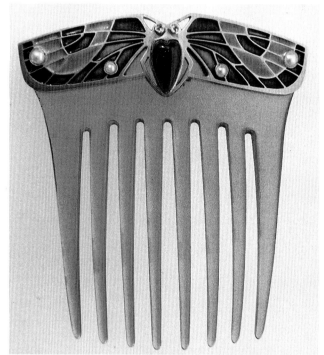

198

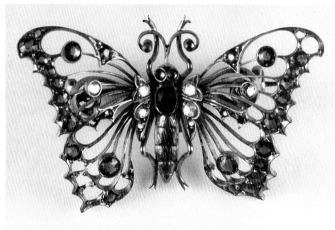

199

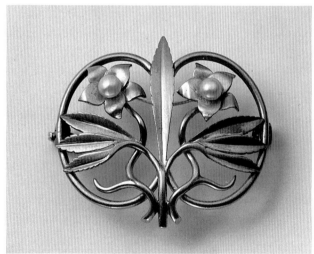

200

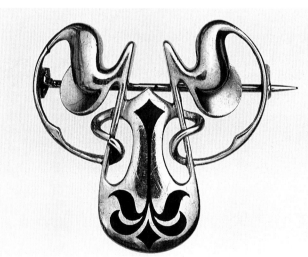

201

197 **F. Zerrenner** Blond tortoiseshell haircomb with gold serpent and plant decoration, c. 1898–1900.

198 **Georg Kleemann** (designer) and **Otto Zahn** (maker) Gold and horn haircomb showing Kleemann's winged scarab motif, set with opals, pearls, rubies and green and violet *plique à jour* enamel. Pforzheim, c. 1900–02.

199 **Emil Riester** (designer) and **Adolf Hauber** (maker) Silver butterfly brooch set with coloured stones. An early Pforzheim piece, 1895.

200 **Hugo Schaper** Gold brooch with simple pearl-set flower motif, illustrating the Berlin style, c. 1898.

201 **Hermann Hirzel** (designer) and **Louis Werner** (maker) Gold and enamel brooch, the dynamic lines showing Van de Velde's influence, c. 1898.

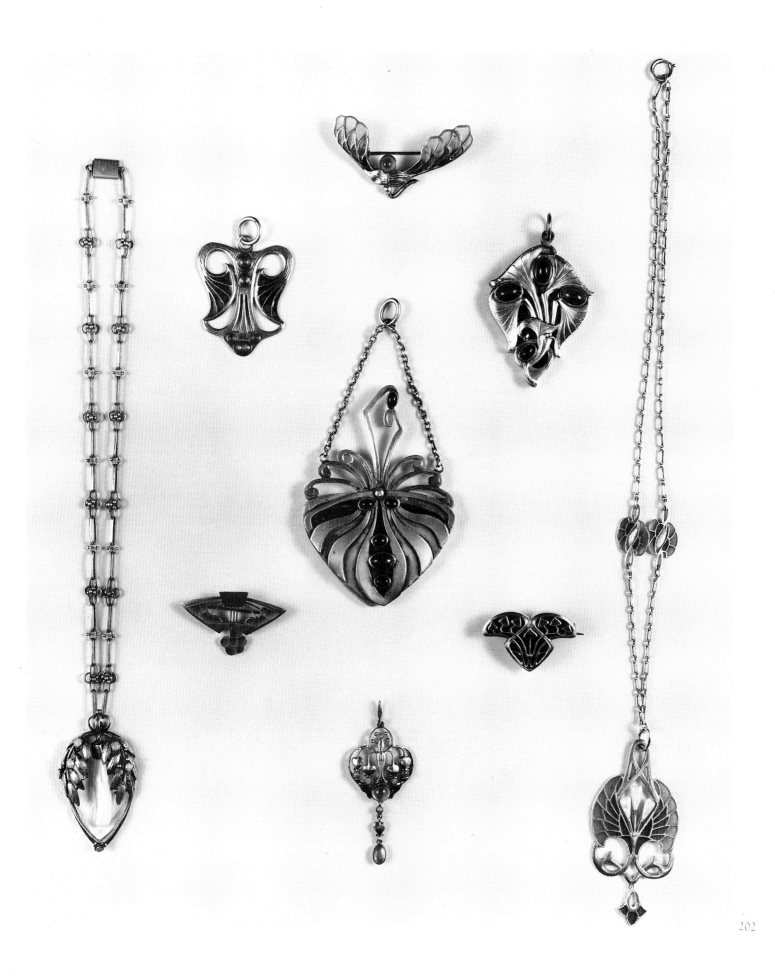

202

202 Jewelry made in Pforzheim. The two pendants with chains: (left) in silver with pearl and turquoise; (right) by **Georg Kleemann** (designer) and **Saver und Wiedmann** (maker) in silver with *plique à jour* enamel and pearls. The other pieces, clockwise from top: silver gilt and *plique à jour* brooch; silver gilt locket with cabochon cornelians; **Patriz Huber** (designer) and **Theodor Fahrner** (maker) silver and enamel brooch; silver pendant with moonstones; **Patriz Huber** (designer) and **Theodor Fahrner** (maker) silver brooch with *plique à jour* enamel and lapis lazuli; silver and enamel pendant; (centre) **Patriz Huber** (designer) and **Theodor Fahrner** (maker) silver pendant locket with lapis lazuli. All c. 1900–02.

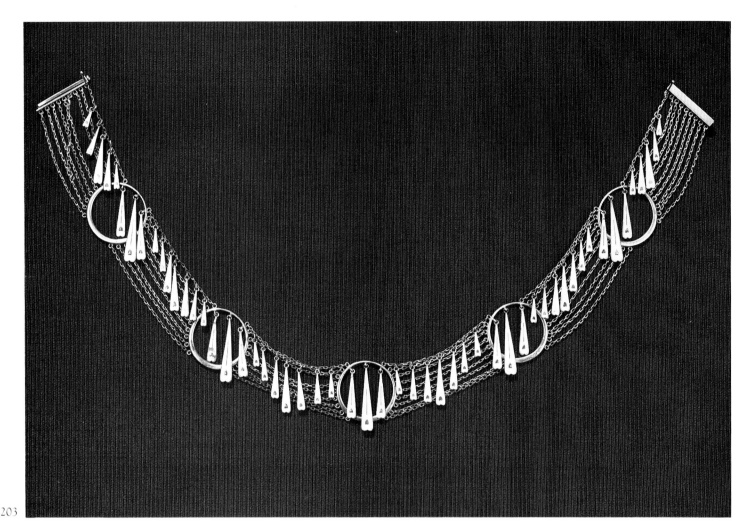

203

204

205

203 **Theodor Fahrner** Silver necklace, partly gilt, decorated with white enamel, c. 1905–06.

204 **Maria von Ortloff** Hand-made silver belt buckle. Munich, c. 1905.

205 **Patriz Huber** (designer) and **Theodor Fahrner** (maker) Silver brooch with violet, green, yellow and orange-brown enamel, with typical spiral and crescent motifs. The same design was made for Murrle, Bennett and Co., and imported to England, c. 1900–02.

206

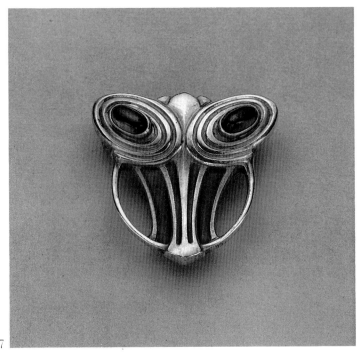

207

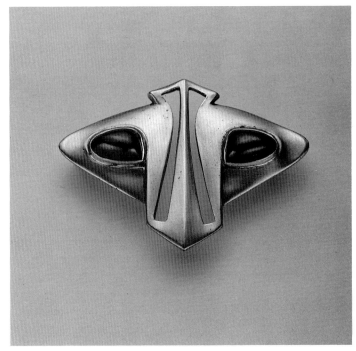

208

206 **Theodor Fahrner** Silver brooch with characteristic linked open circles and a pendant stone, c. 1905.

207 **Theodor Fahrner** Silver brooch with red glass imitation hardstones and violet enamel in coiled lines, c. 1900–02.

208 **Moritz Gradl** (designer) and **Theodor Fahrner** (maker) Silver and haematite brooch, c. 1902.

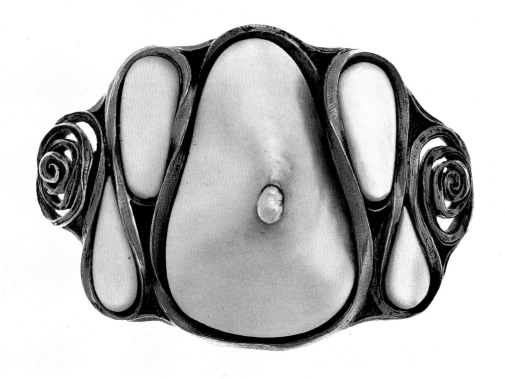

209

210

209 **Hans Christiansen** (designer) and **D. und M. Loewenthal** (maker) Silver belt buckle, partly gilt, with mother-of-pearl, c. 1901.

210 **Moritz Gradl** (attrib.) (designer) and **Theodor Fahrner** (maker) Silver buttons with green chalcedony cabochons showing the motif of clusters of cells, c. 1902.

211 **Theodor Fahrner** Two brooches: (above) in silver and iridescent blue enamel, c. 1902; (below) in silver, chrysoprase and mother-of-pearl, in the Wiener Werkstätte style, c. 1910–12.

212 **Georg Kleemann** (designer) and **Otto Zahn** (maker) Silver gilt brooch set with turquoises, amethysts, emeralds, rubies, pearls and mother-of-pearl. Pforzheim, c. 1907.

213 **Joseph Maria Olbrich** (attrib.) Gold brooch set with Baroque pearls and red enamel c. 1901.

214 **Moritz Gradl** (designer) and **Theodor Fahrner** (maker) Silver gilt brooch with green and light blue enamel, set with sapphires and pearls, c. 1900.

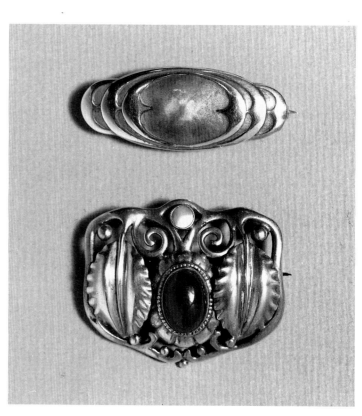

211

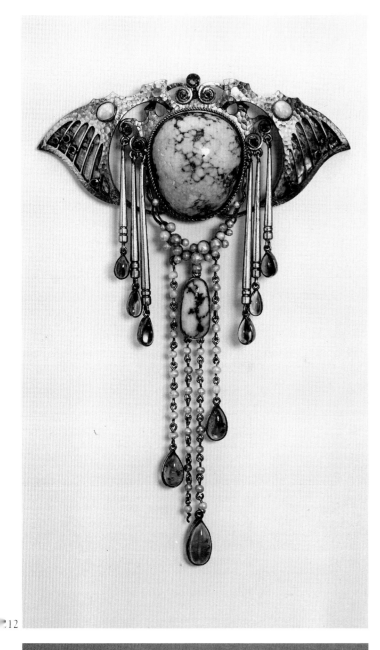

212

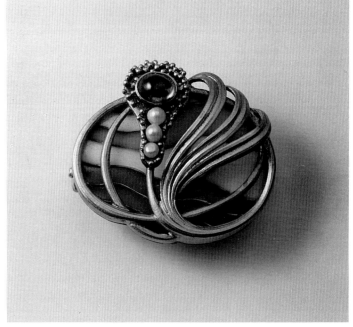

214

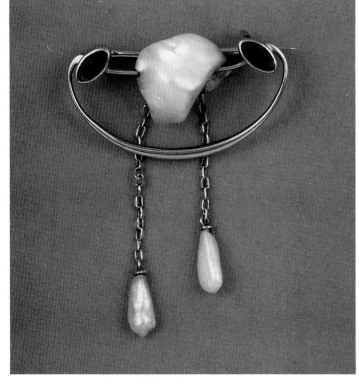

213

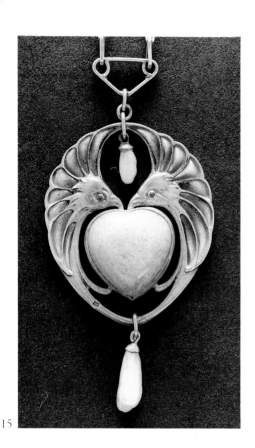

215

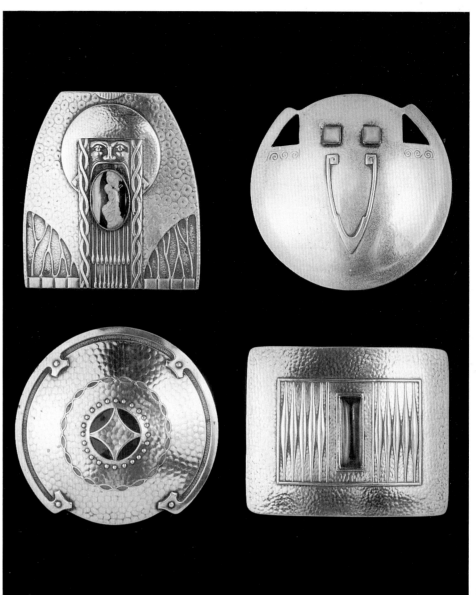

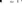

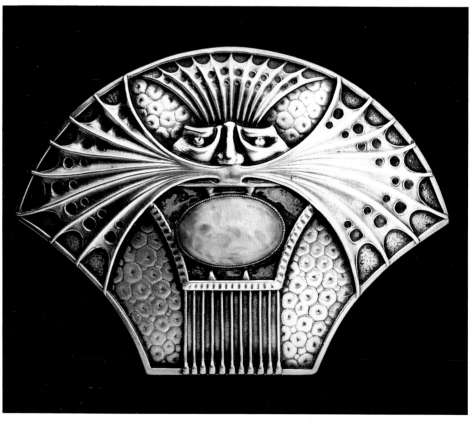

215 Theodor Fahrner Silver pendant with purple glass imitation hardstone, *plique à jour* enamel and stylized bird motif, in the style of Rudolf Bosselt, *c.* 1900.

216 Four buckles of abstract design, all bearing the mark 'Alpacca', set with glass imitation hardstones, by artists of the Darmstadt colony, *c.* 1900.

217 Buckle marked 'Alpacca', with imitation hardstones, probably of Darmstadt design, *c.* 1900–02.

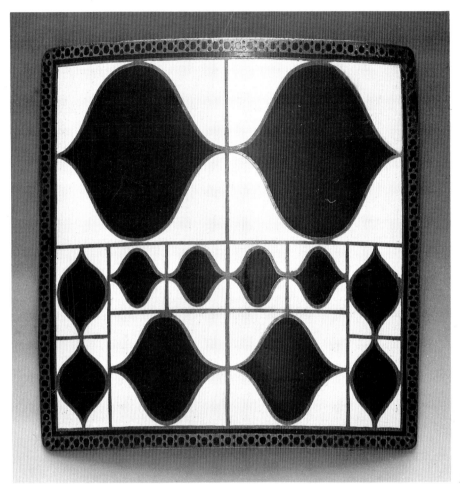

218

218 **Josef Hoffmann** Copper and enamel buckle. Made by the Wiener Werkstätte, 1907.

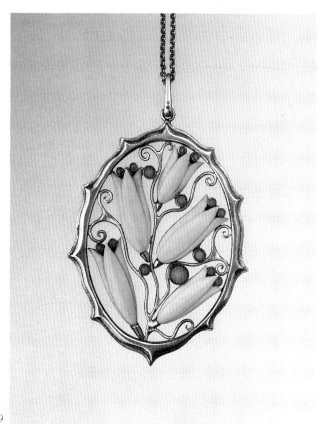

219

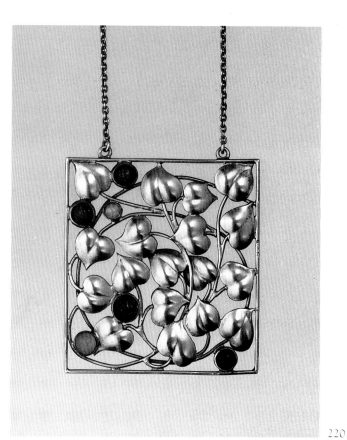

220

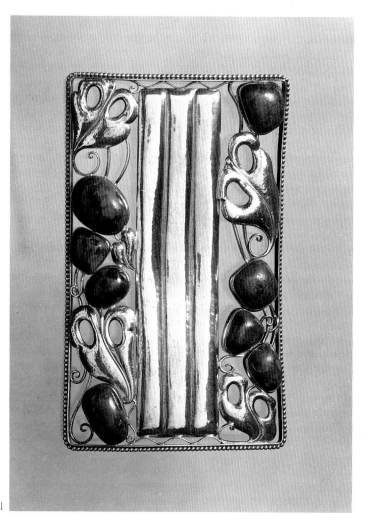

221

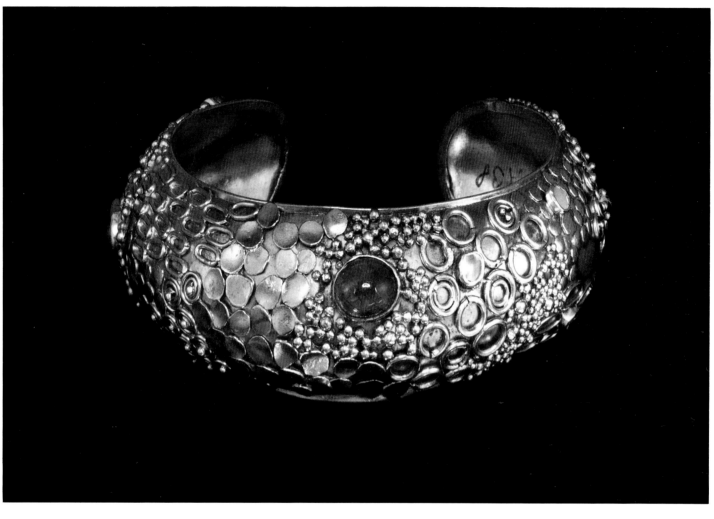

219 **Emanuel Margold** (designer) and **Oskar Dietrich** (maker) Silver gilt pendant set with coral and ivory c. 1910—12.

220 **Franz Delavilla** (designer) and **Oskar Dietrich** (attrib.) (maker) Silver gilt pendant with opals and cabochon emeralds, c. 1911.

221 **Eduard Wimmer** (designer) and **Karl Ponocny** (maker) Belt buckle in silver set with malachite. Made by the Wiener Werkstätte, c. 1910.

222 **Georg Klimt** Silver gilt bracelet set with amethysts and mother-of-pearl, 1904.

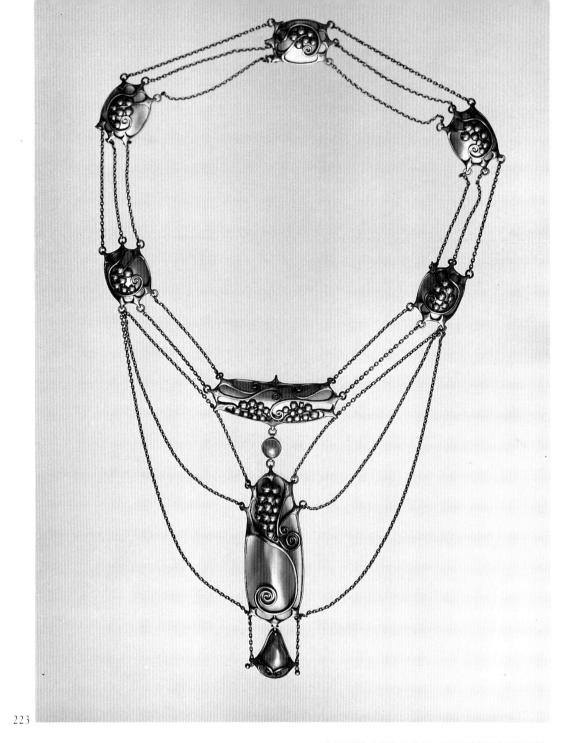

223

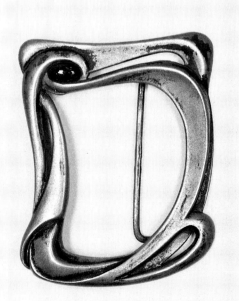

224

225

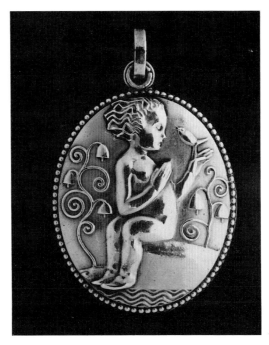

226

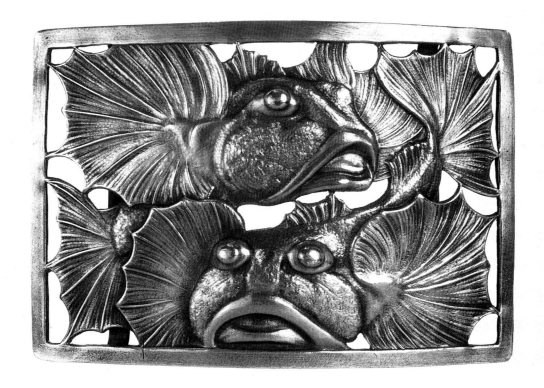

227

223 **Otto Prutscher** Platinum and mother-of-pearl necklace. Made by the Wiener Werkstätte, c. 1905–06.

224 **Otto Prutscher** Platinum and mother-of-pearl earrings. Made by the Wiener Werkstätte, c. 1905–06.

225 **Georg Anton Scheidt** Silver belt buckle set with imitation lapis lazuli, c. 1900.

226 **Bernhard Löffler** Silver locket. Made by the Wiener Werkstätte, c. 1900.

227 **Anna Wagner** Silver belt buckle, 1905.

228 Silver and multicoloured enamel child's pendant, made at the Vienna Kunstgewerbeschule, c. 1904.

229 **Agostino Ghedina** Silver filigree belt buckle, c. 1900.

230 **Franz Messner** (designer) and **Hermann Kappermann** (maker) Silver gilt belt buckle with green and blue enamel, c. 1900.

231 **Otto Prutscher** (designer) and **Heinrich Levinger** (maker) Silver gilt brooch with greenish yellow *plique à jour* enamel and mother-of-pearl, c. 1901–02.

232 **Otto Prutscher** Silver gilt brooch with stylized winged female motif, set with opals. The wings are of blue, green and violet enamel, c. 1901.

233 **Georg Anton Scheidt** Belt buckle of silver gilt, set with lapis lazuli, violet, yellow and blue opaque enamel and dark blue and violet *plique à jour* enamel, c. 1900.

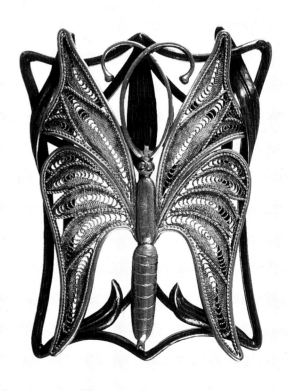

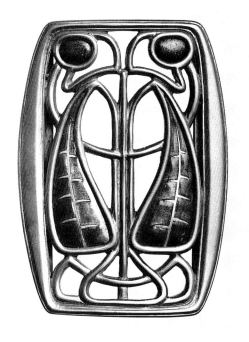

230

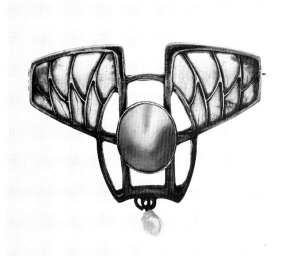

231

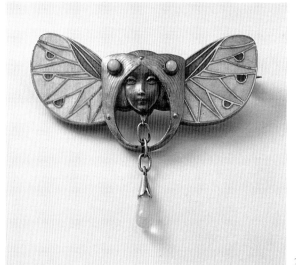

232

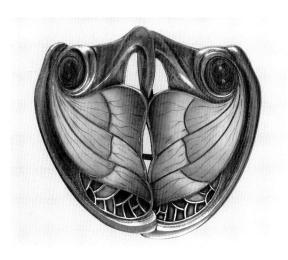

233

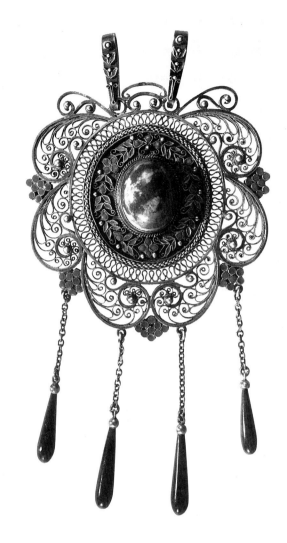

234

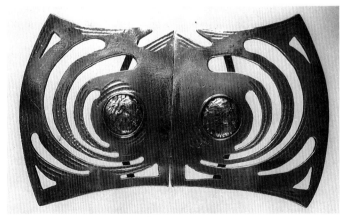

235

234 **Sophie Sander-Noske** Silver filigree pendant, set with lapis lazuli and blue and green enamel, c. 1910.

235 **Turriet und Bardach** Belt buckle of silvered metal with blue glass imitation stones, c. 1902.

3 Great Britain

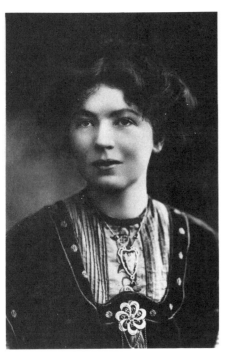

Christabel Pankhurst wearing Arts and Crafts jewelry. Her mother Emmeline Pankhurst was a supporter of the Arts and Crafts movement and had sold jewelry and other crafts in a Liberty-style shop before she became involved full time in Suffragette activities. Some English jewels at the time were made in the Suffragette colours of purple, white and green

Decorations for this chapter: after a design by Archibald Knox (chapter title page); after a painted decoration on the back of a chair by Charles Rennie Mackintosh, *c.* 1902.

In England, the name of Liberty and Co. became synonymous with Art Nouveau and with the modern English jewel. Although his designers did not make wide use of the motifs and symbols outlined in the Introduction, Liberty's venture into jewel design represented a conscious and significant break with the past. Liberty jewels were based on abstract designs, but still concentrated on the importance of line, of movement and of fresh interpretation of materials.

When Liberty launched a new range of jewels in the 1890s, advertisements described them as 'artistic productions in which individuality of idea and execution is the essence of the work.' This individuality came from the talented Arts and Crafts designers whose work was commissioned by Liberty.

The Arts and Crafts movement of the 1880s was a catalyst in the whole European and American artistic revolution, and it was Liberty who translated its esoteric design into popular, fashionable jewels.

The movement originated from an early nineteenth-century reaction against industrialization and the worsening effects of mechanization. By the mid century, the cry over the soul-destroying results of industrial progress grew louder in academic circles. It seemed that there was a total lack of individuality in the lives of factory workers, and that the machine-made goods they were forced to turn out possessed no artistic worth. Ideas for a revival of 'honest' crafts were being formulated by those who bitterly resented the intrusion of the machine. True art, to be shared by all, in everyday life, was seen as the cure to the social and moral sickness.

John Ruskin (1819–1900) was the guiding force behind the movement, and his ideas and writings laid the foundations for the Arts and Crafts principles. By the 1850s his work was read by the young undergraduate William Morris (1834–96), who determined to join his cause. Their case was strengthened by the display of machine-made, showy, and in some views tasteless, goods at the Great Exhibition of 1851. It seemed then that it was impossible to produce a work of art under the present system. Morris turned his sights away from the Church to concentrate on architectural design. He and his associates determined to bring more personal fulfilment and freedom of expression to the individual artist-craftsmen and thus bring an enjoyment of true art to the lives of ordinary people. Art was not to be confined to oil paintings on unapproachable gallery walls. Morris wrote that 'the minor arts were in a state of complete degradation',[1] and he gradually moved from architecture towards these 'minor arts', designing furniture, wallpaper and fabrics. In 1861 he set up his own firm, Morris, Marshall, Faulkner and Co., which was an immediate success.

Morris became the leading figure in the decorative arts in the second half of the nineteenth century, but it was his hatred of the machine that prevented the ultimate success of the Arts and Crafts movement. All jewels were to be hand made, and, as a reaction against increasing specialization in the jewelry trade, the craftsman was to design, make and decorate the jewel from start to finish. In reality this was not so practical. The amateur could rarely attain the all-round skills required. Moreover, a hand-made object was more expensive than the machine-made equivalent, and the jewels made by Arts and Crafts workers were not generally appealing, seeming amateurish, dull and old-fashioned. In fact, very few of the leading designers had any direct experience of jewelry making. The jewels appealed only to a small élite group, educated into this aesthetic approach, and thus defeated the main object of the

movement. Ironically the designs that were most successful were those adapted for the machine, produced cheaply and in large quantities, principally by Liberty.

The formation of guilds and art schools during the 1880s was a feature of the movement. The Middle Ages and the Renaissance were seen as model eras, and co-operative workshops or guilds based on those of the Middle Ages were set up to train and encourage craftsmen to work together to make a wide variety of crafts. The jewelers shunned precious stones and other intrinsically valuable materials, and concentrated on the aesthetic contribution of design. They used humble materials, going so far as, rather pretentiously, including pebbles from the beach.

Ruskin's principles decreed that it was essential not to pervert the material, but to use and translate its natural beauty, altering it as little as possible. Silver was much preferred to gold, diamonds were never used, and faceted stones rarely. Smooth cabochons or uncut stones in medieval taste were most admired, as were the natural imperfections in Baroque pearls or turquoise, and the unevenness of mother-of-pearl. The enamelling revival was central to Arts and Crafts jewelry, both because enamel was a non-precious material and also because it gave the designer the opportunity for self-expression in the creation of designs.

There is not room to look in great depth at Arts and Crafts jewelers, but some designers of the movement were particularly influential. Charles Robert Ashbee (1863–1942) was a self-taught silversmith and jeweler, a former architect, and perhaps the best known and most influential designer of Arts and Crafts jewelry. In 1887 he founded his School of Handicraft followed by the Guild of Handicraft in 1888, in the East End of London. The Guild is best known for its metalwork and jewelry, but furniture was also made. In 1902, the workshops moved to Chipping Campden in Gloucestershire, while retail shops were kept in London. This move, the maintenance of the London shops and ambitious plans to turn the whole village into a community of guildworkers brought financial disaster, and the Guild disintegrated in 1908.

Ashbee was a leading advocate of Arts and Crafts theories and is especially relevant to jewelry as he exerted great influence on developing styles in Europe and in America, and was a great ambassador for the Arts and Crafts movement abroad. Ashbee's work, his theories and his Guild provided guidelines for other groups such as the Wiener Werkstätte. At home, he was instrumental in the development of Liberty jewelry, although he objected to Liberty's alteration of designs and use of the machine. However, after 1900 and a meeting with the architect Frank Lloyd Wright, Ashbee began to alter his views and finally conceded that the machine, if used correctly and with discretion, did have a vital part to play in the diffusion of Arts and Crafts ideals.

Ashbee's jewel designs were close to Continental Art Nouveau in theme: he is famous for his interpretations of the peacock motif, in a soft blend of silver, gold and pearls, and also for his stylized natural motifs, especially leaves and petals. He made extensive use of turquoise enamel.

John Paul Cooper (1869–1933) was perhaps the most professional and successful of the craft revival jewelers, partly because he put all his energies into his work rather than into the social ideology accompanying Arts and Crafts. He is unusual, too, as he worked in the rich-looking 15-carat gold (traditional material of the mainstream jewelry trade) rather than silver,

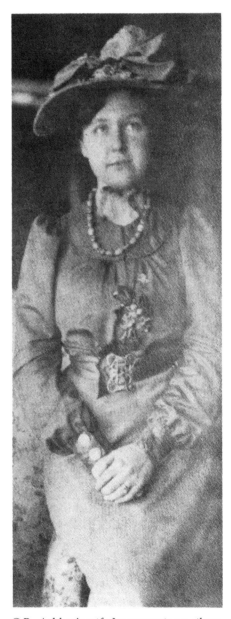

C.R. Ashbee's wife Janet wearing a silver and turquoise belt buckle he designed and made for her, c. 1897, cast and chased with a design incorporating four large fish entwined among seaweed (pl. 242)

155

Margaret Gere, shown in this undated pencil and watercolour portrait by C.M. Gere wearing a necklace made by Arthur and Georgie Gaskin

because he liked its colour and sumptuous effect. He had trained as an architect and had worked with the architect and silversmith Henry Wilson, who stirred his interest in metalworking and remained a close colleague. Cooper collaborated with Ashbee for a while, and in 1906 began experimenting with Japanese mixed metal techniques, combining silver and copper. His pieces are better made than most Arts and Crafts jewelry.

Jewels by Henry Wilson (1864–1934) are important because of their original composition and professional finish, and their unusual combination of medieval and Japanese elements. He was one of the few English designers to use *plique à jour* enamel. A talented architect, he turned to metalworking in about 1890. His work is often very close in style to that of John Paul Cooper. He became a key personality in the movement and is also remembered for his important handbook on design and technique, *Silverwork and Jewellery*, published in 1903. Wilson used professional jewelers to make up his designs, which contributed to their success.

Arthur Gaskin (1862–1928) and his wife Georgie (1868–1934) were leading Arts and Crafts jewelers, metalworkers, enamellists and teachers, involved in the Birmingham group of painters and designers. Their work represents some of the best Arts and Crafts products, and incorporates coils and tendrils of gold and silver wire, little pyramids of silver granules, rope borders, cut-out leaves and simple flowers set with small, coloured stones. The Gaskins also produced designs for Liberty, but generally this arrangement was not a success: the designs did not adapt readily to mass production and Liberty altered them too freely for the Gaskins' liking.

Alexander Fisher (1864–1936) was the foremost Arts and Crafts enamellist, and worked briefly with Henry Wilson. He wrote extensively on the art of enamelling, and was an important influence, both through his work and his teaching and writing, on the Continent. He specialized in layered translucent enamels in deep colours, sometimes with metal or foil inclusions, an influential technique and one used by Etienne Tourette in Paris. Jewels by Fisher are rare; one of his most famous pieces is a large belt composed of painted enamel plaques, each depicting a scene from a Wagner opera, made between 1893 and 1896. He made caskets and enamel plaques framed in silver or bronze.

Nelson Dawson (1859–1942) and his wife Edith (dates unknown) were influenced by Fisher. Nelson Dawson had studied architecture but in 1891 took up metalworking and studied enamelling under Fisher. In 1901 he set up the Artificers' Guild, specializing in metalwork and jewelry. Edith Dawson learnt enamelling from him and produced the painted enamel plaques which characterize their jewelry. These usually depict flowers or birds in deep colours.

The firm of Liberty and Co. achieved success in bringing 'art' jewels to the general public where the Guildsmen had failed by combining an appreciation of artistic innovations with commercial considerations. Such was its success that Liberty production controlled and shaped British and Continental tastes at the turn of the century. In Italy Art Nouveau was even called *Stile Liberty*. The story of Arthur Lasenby Liberty (1843–1917) and the development of the firm is documented in an excellent catalogue, *Liberty Style* (1983). Its author, Victor Arwas, points out that 'since he [Liberty] was also a great merchant, English Art Nouveau developed as a commercial venture, firmly rooted in objects that were of wide appeal, not rarefied, expensive and of limited appeal as it developed in some other countries.'

In 1862, after a two-year apprenticeship to a draper, Liberty had joined the company of Farmers and Rogers' Great Shawl and Cloak Emporium in Regent Street. This was the time of the great mania for Japanese arts and crafts, and the year of the International Exhibition in Kensington, at which the major attraction had been the Japanese section. Farmers and Rogers bought a large proportion of the Japanese exhibits and opened a separate department called the Oriental Warehouse, where Liberty was transferred; within two years, he had become its manager.

Liberty was very much the English counterpart of Samuel Bing, but also in many ways a forerunner. He was led into the new style, like Bing, via Oriental art, and was in an ideal situation to judge the appeal of Japanese arts and crafts and spot new trends. He also had the opportunity to meet such customers as the artists Dante Gabriel Rosetti, William Burges and J.A.M. Whistler. By 1875, having been refused a partnership at Farmers and Rogers, Liberty felt confident enough to open his own shop, also an Oriental emporium, in Regent Street. The shop, opened on 15 May, was called East India House and his initial staff consisted of one girl assistant, a colleague from Farmers and Rogers and one porter, a Japanese boy. The formula and the timing were just right. From the start, Liberty imported Oriental silks and fabrics, and a little later porcelain and other decorative objects. These met with great success, and the shop grew quickly from its small beginnings. He also stocked ornaments in historical styles of continuing popularity. In 1883 he moved further along Regent Street to a new shop, adding novelties to attract the public, including an Arab tearoom. Eventually, Liberty progressed to running his own lines of exclusive design in all areas, commissioned from various craftsmen.

Parallels to developments in France, as well as to Bing's venture, can clearly be seen in the history of Liberty and Co. The new illustrated arts magazine, *The Studio*, started in London in 1893, and did a great deal to publicize Liberty's work. Magazines ran design competitions in various areas of the decorative arts including jewelry, an idea later taken up in France, and these were often organized in conjunction with Liberty, who would then buy and produce the winning designs. Fairly soon, Arthur Liberty had gathered a group of talented freelance designers.

In 1894, Liberty and Co. became a limited company and was able to experiment with avant-garde designs from the best contemporary designers. Like Bing, Liberty kept production very much under his control but, it would seem, for more commercial reasons. He knew what his customers wanted. Liberty was shrewd in spotting the wasted potential of Arts and Crafts designs. He disregarded the Guildsmen's attitudes about hand-craftsmanship and managed to persuade artists to design with the machine and mass production in mind. It was Liberty who introduced the Arts and Crafts style, adapted and diluted perhaps, at affordable prices to the general public. As early as 1890, he opened a Paris branch at 38 Avenue de l'Opéra, which helped to spread English Art Nouveau through Europe.

Around 1897 Liberty decided to import some of the new *Jugendstil* metalware in organic designs from the German firm of Kayser. They proved a great success, and soon after this he conceived the idea of designing his own range of metalwork. Jewelry was launched with a venture in gold and silver that started in the late 1890s under the trade name Cymric. (The name Tudric was given to a parallel range of new pewter wares.) Liberty's hallmark for gold and silver had been registered in 1894, but the first Cymric pieces did not

appear until 1899. It was the first time that gold and silver had been made into such avant-garde designs, and that the work of important designers had been brought within the reach of the general public. In an advertisement in *The Studio* in 1901, Liberty professed that the Cymric range marked 'an original and important departure in gold and silverwork.' This complete break with convention 'in the matter of design and treatment' was 'calculated to commend itself to all who appreciate the note distinguishing artistic productions in which individuality of idea and execution is the essence of the work.' The Cymric style represents another important design influence on English Art Nouveau jewelry: the current Celtic revival.

The Celts were a people inhabiting West Central Europe, gradually making their way across the Continent to invade the British Isles about 250 BC. From the fifth century BC Celtic art displays the distinctive features of curving lines, knots, and linear and geometric interlacing. Ancient and medieval Celtic jewels had been unearthed in England, Ireland and Scotland in the nineteenth century, and had led to a Celtic revival in the last quarter of the century. The whiplash motif, a strong Liberty feature, derives from this source. It worked well in jewel design, the little 'tail' of the line curling around the edge of a brooch or a pendant. Celtic revival jewels are marked also by strong stylization and a consistent discipline and control of line.

Liberty's association with Archibald Knox (1864–1933) is one of the most important aspects of the Cymric range. Knox was one of the finest British designers of metalware and jewels. Arthur Liberty must be credited with an appreciation of Knox's forward-looking ideas and with sharing the work of an important artist whose gifts might otherwise have remained unknown. It was, however, many years before designs were formally credited to Knox, as company policy required that the identities of its designers were kept a close secret.[2]

It was Archibald Knox who was largely responsible for Liberty's successful Celtic revival. He came from the Isle of Man and had been fascinated by the Celtic ornament he found there. He was to make a special study of Celtic art at Douglas School of Art, where he later taught. He had become involved with the principles of design, and as a student he would probably have been familiar with Owen Jones's *Grammar of Ornament* and its examples of Celtic ornament. Knox may well have been first introduced to Liberty while working part time at the offices of the architect M.H. Baillie Scott in the Isle of Man. Baillie Scott is known to have designed fabrics for Liberty from the early 1890s, and Knox also probably began in this way. In 1899, Knox designed the first series of Cymric ware. All the pieces were hand made but, ironically, given a slick, machine-finished appearance. The success of this range helped to promote Knox to the position of Liberty's chief designer.

In his first designs Knox closely followed Celtic sources, but later, after about 1901, began to produce stylized interpretations. He used softened square patterns, bulging boxes all leaning rhythmically to one side, triangles with corners stretched into scrolled tails, again swaying to one side, or heart-shaped leaves. Lines were drawn with a soaring movement, but in a restrained manner rather than with the extravagant curves of French Art Nouveau jewels. Interlacing was a favourite Knox theme, often seen in his cut-out motifs and used with the whiplash line.

Cymric jewels were made in both silver and gold, usually set with turquoise or mother-of-pearl, or decorated with enamel, and hung with little misshapen blister pearls. Knox's designs feature the 'floating' blue and green peacock

enamel so widely imitated and one of the most recognizable features of the English Art Nouveau jewel. This was often incorporated in designs as a pool of enamel behind a cage of silver and gold. Knox also used a kind of opal mosaic, with flat slices of opal juxtaposed into a paved pattern. Silver jewels were often given a hand-hammered appearance, to suggest the hand of the artist.

Within the Liberty repertoire some jewels are more closely linked to Arts and Crafts design than others, as Liberty tended to use designs as he pleased. Some small mass-produced Cymric brooches with touches of enamel, for example, selling for just 7s 6d each, probably represented only a very watered-down version of the original design. Liberty also used one design on several different items, from a button and cloak clasp to a knife-rest or cuff links. As we have seen, his modification of designs was a great bone of contention with Arts and Crafts artists.

Most of the Cymric wares were made by W.H. Haseler and Son of Birmingham, which was the centre for cheap mass-produced jewelry. In 1902 Haseler merged with Liberty, officially registering their joint company with the trade name Cymric. The three Haselers, father and sons, had a large shareholding in the new company, but this did not stop them producing and marketing under their own name pieces that looked just like Liberty's.

Liberty called on other talented designers, such as Oliver Baker (1859–1938), who is best known for his belt-buckle designs commissioned by Liberty. He also designed silverware and some jewelry, combining thin, curling tendrils of silver with heavier, organic-looking shapes. His hammered silver surfaces oozed cabochon stones.

Rex Silver (1879–1955), who ran the Silver Studio, specializing in fabrics and silverware, designed for Cymric, along with Bernard Cuzner, Arthur Gaskin and Jessie M. King (1873–1949). A student at the Glasgow School of Art, Jessie King showed great talent as a graphic designer, and later became a lecturer in book decoration. She is best known for her book designs, but she also designed some attractive and successful jewelry and silverware for the Cymric range, as well as fabric for Liberty. She applied her distinctive hairline circles and lines to jewels, and occasionally used motifs of swooping birds.

Charles Fleetwood Varley (1881–1969) made an interesting addition to Liberty's output. A member of the Varley family of Victorian painters, he painted landscapes and seascapes in deep, strong colours, bathed in sun- or moonlight. Liberty set his hand-painted enamel plaques into lids for silver or pewter boxes, but used them less often in jewelry. His work has a soft, highly characteristic haze. Occasionally a Varley enamel in a jewel is surrounded by little enamelled leaves in complementary colours, the cupped metal filled with translucent enamel to give a rich, gem-like effect.

Liberty's widespread success naturally led to rivalry and competition. There are numerous unmarked or unidentified examples of modern jewels which bear a greater or lesser similarity to Liberty design. Murrle, Bennett and Co. were Liberty's main rivals. There is a range of Murrle Bennett jewels that consists of near or direct copies of Liberty designs, and there are pendants from Knox designs that bear the Murrle Bennett mark. Because of Liberty's reputation, it has always been supposed that Murrle Bennett bought, stole or plagiarized Liberty designs. It now seems likely that the company produced modern-style jewels before Liberty did (they were established in 1884, some years earlier than Liberty's Cymric venture) and may well have supplied Liberty with designs rather than copying them.

159

Proof of the Murrle Bennett relationship with Liberty can be gleaned from a look at the company's stock lists. Fascinating, neatly hand-written pages list Murrle Bennett's many ranges: among these is Cymric, showing that Murrle Bennett produced some of this range for Liberty. Jessie King's name appears in the columns as a designer of some Murrle Bennett jewels, and there is also mention of Cymric plate. It is said that the founder of the firm, Ernst Mürrle, often spoke of doing business with Liberty and, considering the wholesale nature of the company, it is highly likely that he himself sold to Liberty and Co. The firm had a vast range of jewels, from the conventional, still lingering Victorian designs of Scottish or Etruscan, to small gold accessories such as feather-boa fasteners and pencils. They had a large gold chain section. The *Jugendstil* jewels made up just one range which they called 'Modern Art'. The business consisted of many different companies, including Murrle Bennett Export Ltd and Artistic Novelties Ltd. Mürrle, like Liberty, obviously had a gift for spotting good new artistic and commercial lines, and so is unlikely to have found the need to copy Liberty designs.

There was also a link between Murrle Bennett and German *Jugendstil* jewels produced in Pforzheim, and it is in the search for Murrle Bennett's workshops that this connection can be traced. From contemporary advertisements we know that Murrle, Bennett and Co. had premises in London at 13 Charterhouse Street in the City, but this was purely a wholesale operation: there were no workshops in London. In fact Ernst Mürrle, who came from Pforzheim, used workshops there. (The umlaut in his name was dropped for the firm's title.) He travelled to Pforzheim at least six times a year, and worked with Theodor Fahrner and Wilhelm Fühner. As we have seen, Fahrner was a successful jewelry manufacturer who produced inexpensive but fashionable jewelry made from silver or low-carat gold, set with semi-precious stones in the popular *Jugendstil* designs. He drew on the artistic resources of the artist's colony at nearby Darmstadt in the same way that Liberty used the potential of the Arts and Crafts Movement. Through Murrle Bennett's links with Fahrner in Pforzheim, and through Fahrner's links with Darmstadt, some very interesting and modernistic jewels came to England via Murrle Bennett, and were integrated into English Art Nouveau jewelry. About eighty per cent of Murrle Bennett's jewelry came from Pforzheim, from Fahrner and other workshops who were producing similar pieces, often based on the work of very talented designers. The company had a representative, Emmanuel Saacke, in Pforzheim, and also sold widely abroad.

Ernst Mürrle sometimes bought ready-made pieces, in which case they would bear Fahrner's mark, and in some cases also that of the designer. On these ready-made pieces, Murrle Bennett's mark would be added for importation. At other times the firm would order jewels to be made up from sketches, and these might then only carry their own mark, again as importers. There were no hard and fast rules as far as marks were concerned (see p. 232).

The success of Murrle, Bennett and Co. was interrupted by the First World War, and it must surely be their German associations that account for the lack of information until now about the firm and its scope at the turn of the century. In 1915 Mürrle, being a German, was interned and his business confiscated by the British Government. (Interestingly, Mürrle was interned on the Isle of Man, where Archibald Knox also spent the war years, working in the Aliens' Detention Camp.) In 1916, Mürrle was repatriated and returned to Pforzheim. Murrle, Bennett and Co. was renamed White, Redgrove and Whyte.

Continued on p. 177

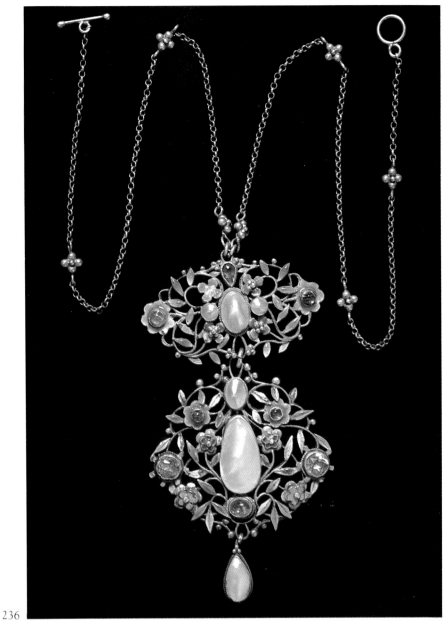

236

237

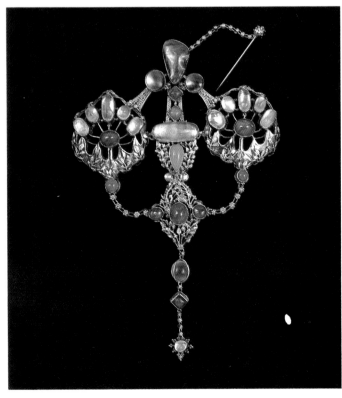

238

236 **Arthur and Georgie Gaskin** Silver, enamel, pearl and gem-set necklace, c. 1900.

237 **Nelson and Edith Dawson** Silver belt buckle set with enamel plaque of deeply coloured flowers and leaves, c. 1900.

238 **John Paul Cooper** Opulent, medieval-style brooch in gold openwork, set with semi-precious stones, including moonstones, garnets, chrysoprases and black mother-of-pearl (abalone shell), c. 1908.

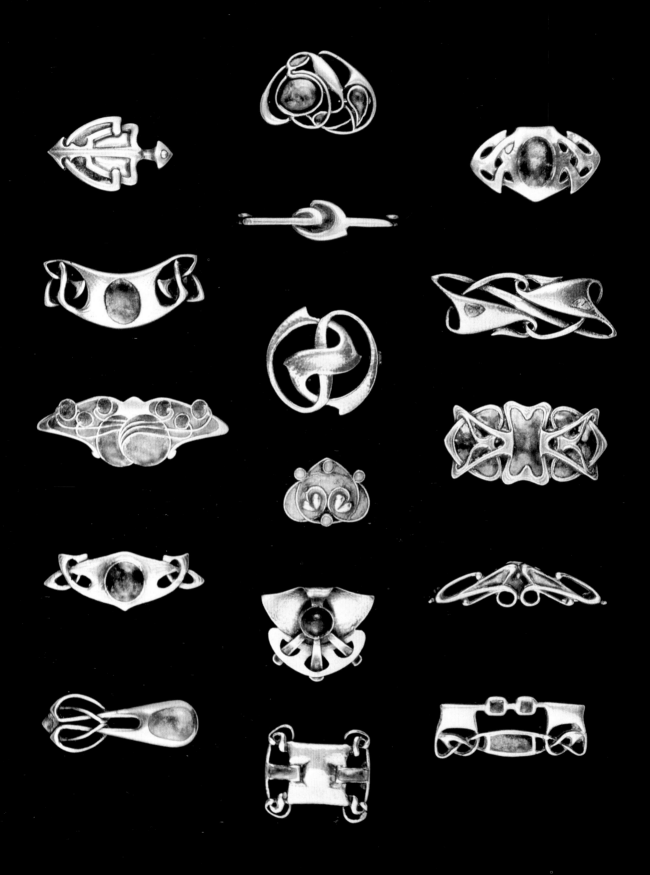

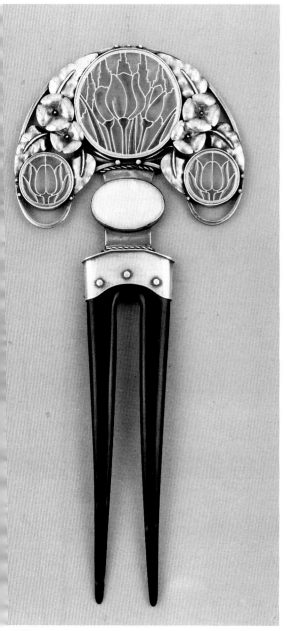

240

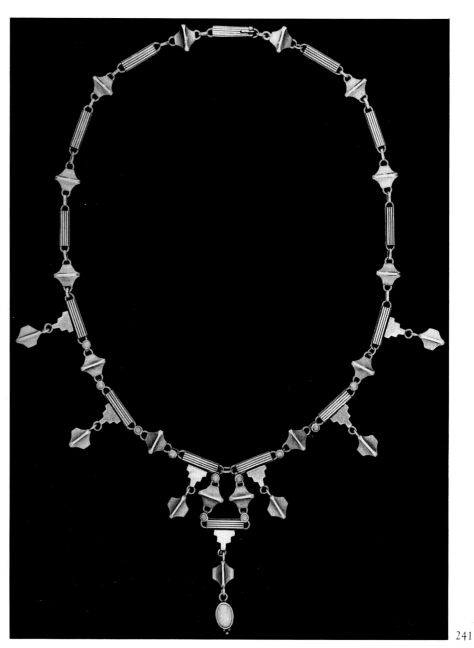

241

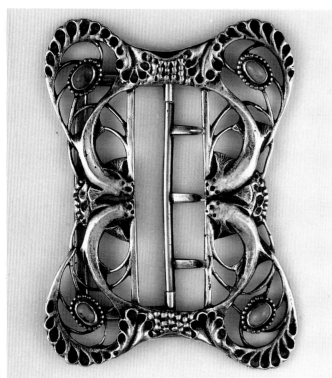

242

239 **Liberty and Co.** Silver and enamel brooches, including pieces attributed to **Jessie M. King** (left-hand row, centre) and **Oliver Baker** (centre row, fifth). The rest are based on designs by **Archibald Knox**. All *c.* 1900–10.

240 **Henry Wilson** (attrib.) Silver, gold and tortoiseshell haircomb set with opals, and decorated with pink, green and turquoise *plique à jour* enamel, *c.* 1906.

241 Silver and opal Arts and Crafts necklace, *c.* 1905.

242 **Charles Robert Ashbee** Silver belt buckle, with a design incorporating four fish among seaweed, set with turquoises. Made by the Guild of Handicraft for Ashbee's wife, *c.* 1897.

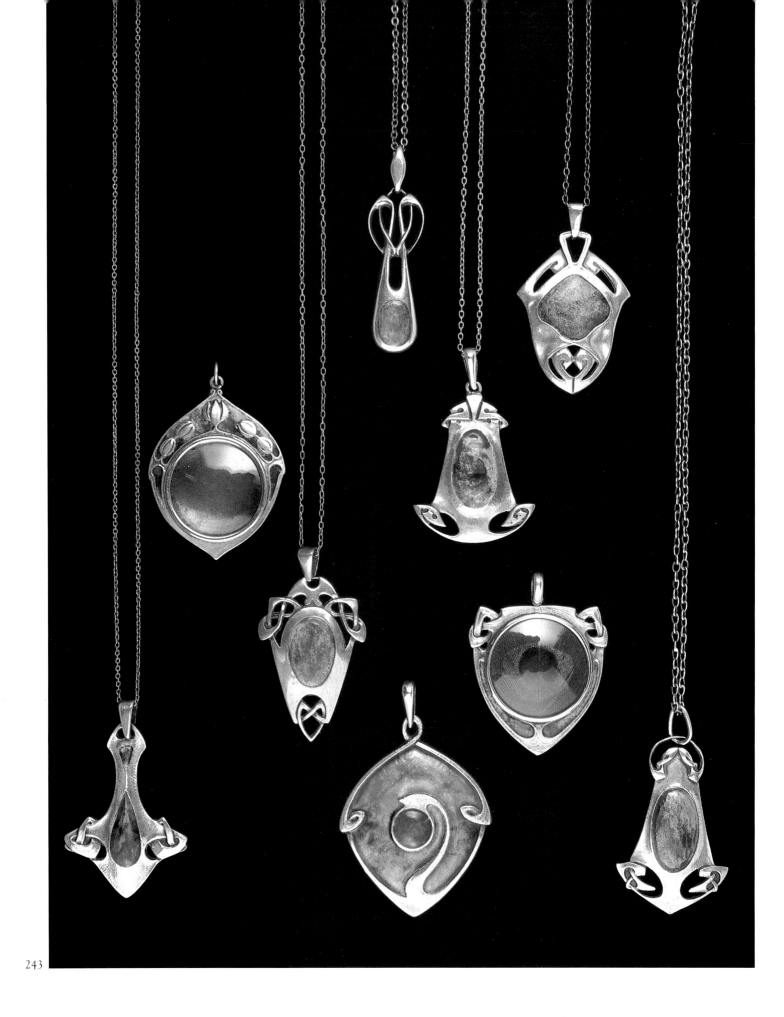

243

243 **Liberty and Co.** Silver and enamel pendants, all except second from left designed by **Archibald Knox**, c. 1900.

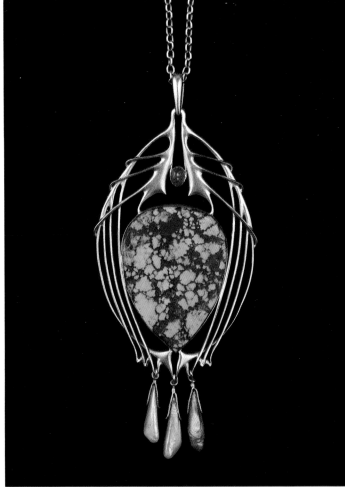

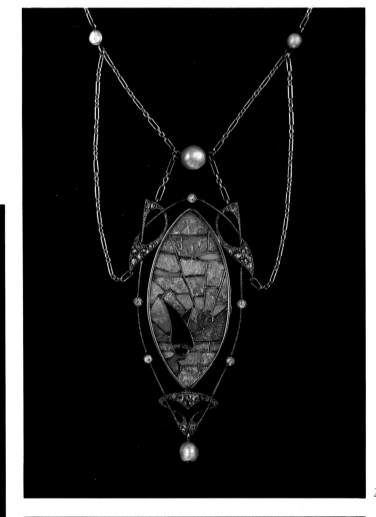

245

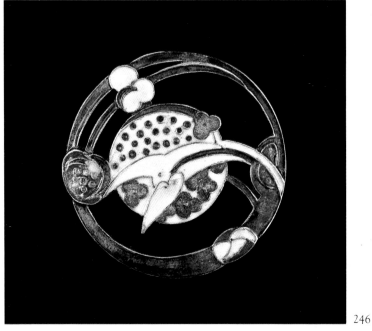

246

44

244 **Archibald Knox** (designer) and **Liberty and Co.** (maker) Gold and turquoise matrix pendant, hung with three large pearl drops, the symmetrical linear wirework similar to that of German *Jugendstil* jewels.

245 **Archibald Knox** (designer) and **Liberty and Co.** (maker) White gold, pearl, diamond and opal mosaic pendant, c. 1902.

246 **Jessie M. King** (designer) and **Liberty and Co.** (maker) Silver and enamel brooch, 1906.

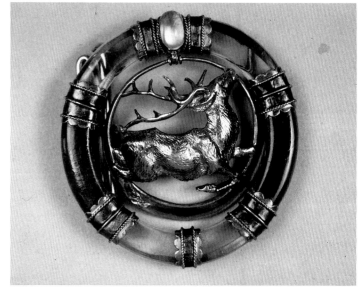

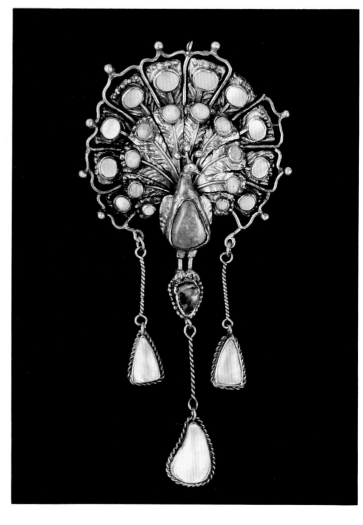

247 **Charles Robert Ashbee** Silver, opal and pearl brooch made by the Guild of Handicraft, c. 1902–05.

248 **Henry Wilson** Gold brooch, with frame of rock crystal, chalcedony and enamel, set with a moonstone, c. 1905.

249 **Charles Robert Ashbee** Silver peacock brooch set with opals and mother-of-pearl, c. 1899–1900.

250 **Sarah Madeleine Martineau** Gold and green enamelled pendant, c. 1910.

251 **John Paul Cooper** Gold pendant enamelled and set with semi-precious stones, depicting a medieval castle in a forest under a starry crescent, 1913.

252 **Sarah Madeleine Martineau** Gold and enamel pendant, c. 1910.

253 **Omar Ramsden** Silver pendant which opens to show an enamelled plaque representing St George, c. 1905.

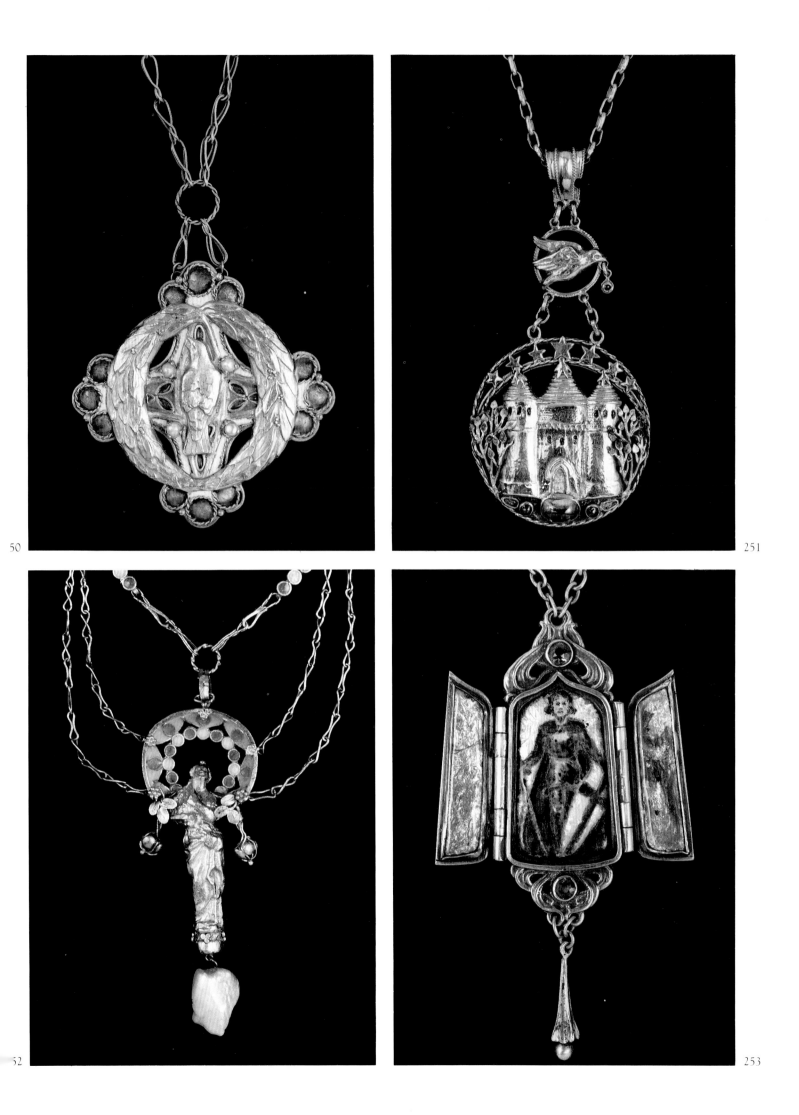

250

251

252

253

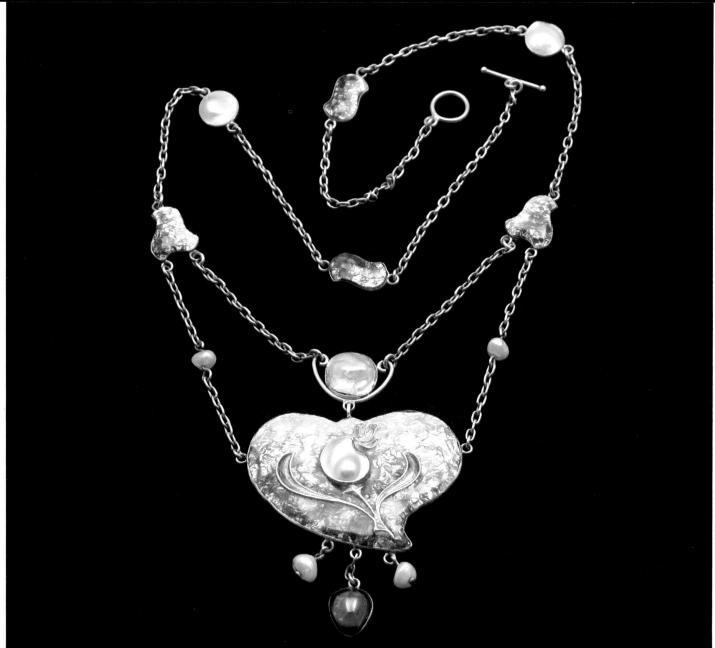

254

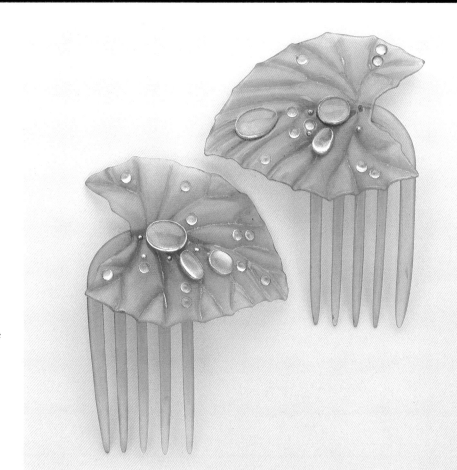

254 **James Cromer Watt** (attrib.) Necklace of stylized heart shape, with iridescent enamel on gold, c. 1900.

255 **Ella Naper** Green-tinted horn lily-pad haircombs with moonstone dewdrops, c. 1900.

255

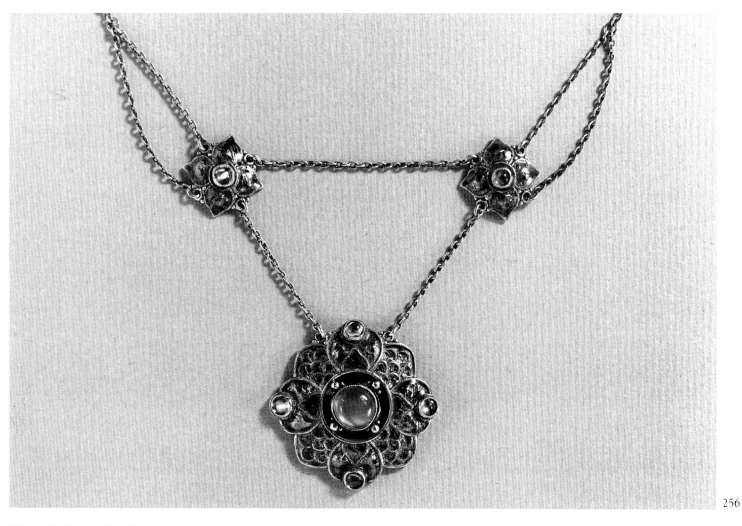

256

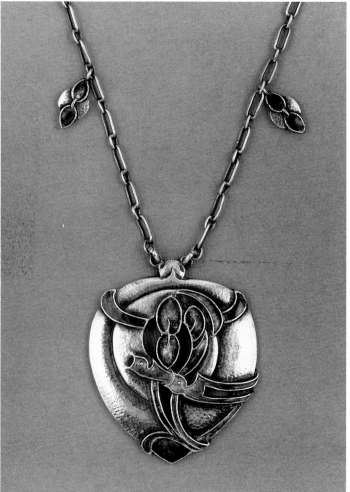

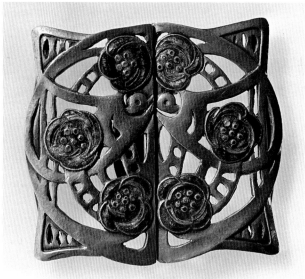

258

256 **Liberty and Co.** Draped silver necklace with flowerhead motifs and silvery-turquoise enamels, set with moonstones, c. 1900.

257 **Jessie M. King** (designer) and **Liberty and Co.** (maker) Hammered silver and green and purple enamel pendant with stylized bird and leaf motifs, c. 1902.

258 **Jessie M. King** (designer) and **Liberty and Co.** (maker) Silver belt buckle with blue and green enamel, 1906.

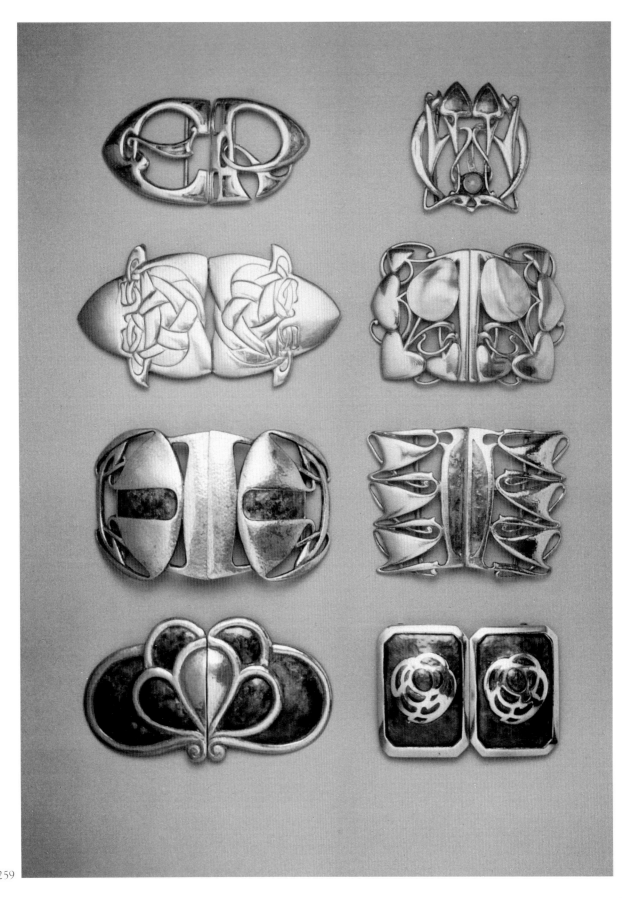

259 **Liberty and Co.** Silver and enamel belt buckles in the style of Archibald Knox, c. 1900–05.

260 **Archibald Knox** (designer) and **W.H. Haseler** for **Liberty and Co.** (maker) Gold *entrelac* and mother-of-pearl necklace, c. 1902.

261 **Liberty and Co.** Gold, diamond and mother-of-pearl brooch/pendant, c. 1902.

262 **Archibald Knox** (designer) and **Liberty and Co.** (maker) Silver and blue-green cufflinks with Celtic *entrelac* design, c. 1900.

263 Three gold and opal brooches showing linear openwork in the Liberty style, the one in the centre by **Murrle, Bennett and Co.** All c. 1900–02.

264 **Archibald Knox** (designer) and **Liberty and Co.** (maker) (Above) gold and opal ring; (centre) gold and citrine brooch; (below) gold brooch. All c. 1903–04.

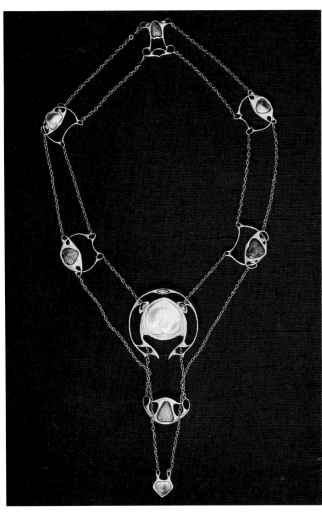

260

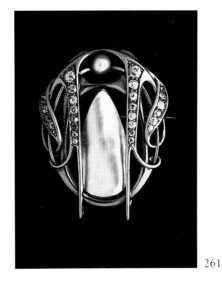

261

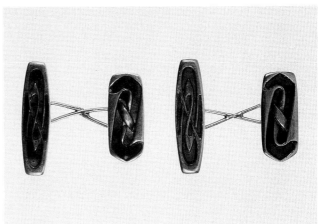

262

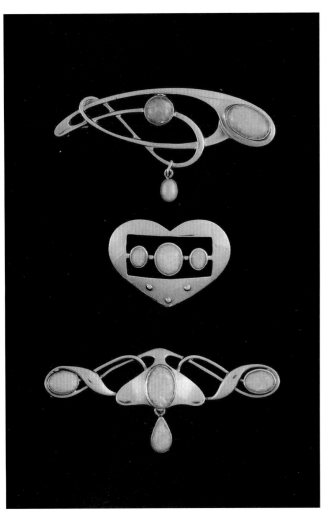

63

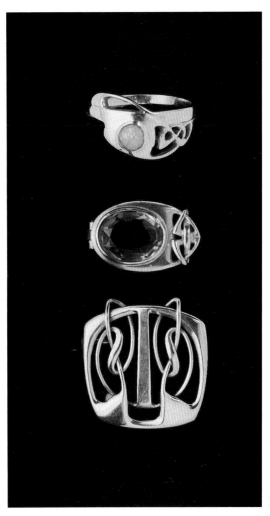

264

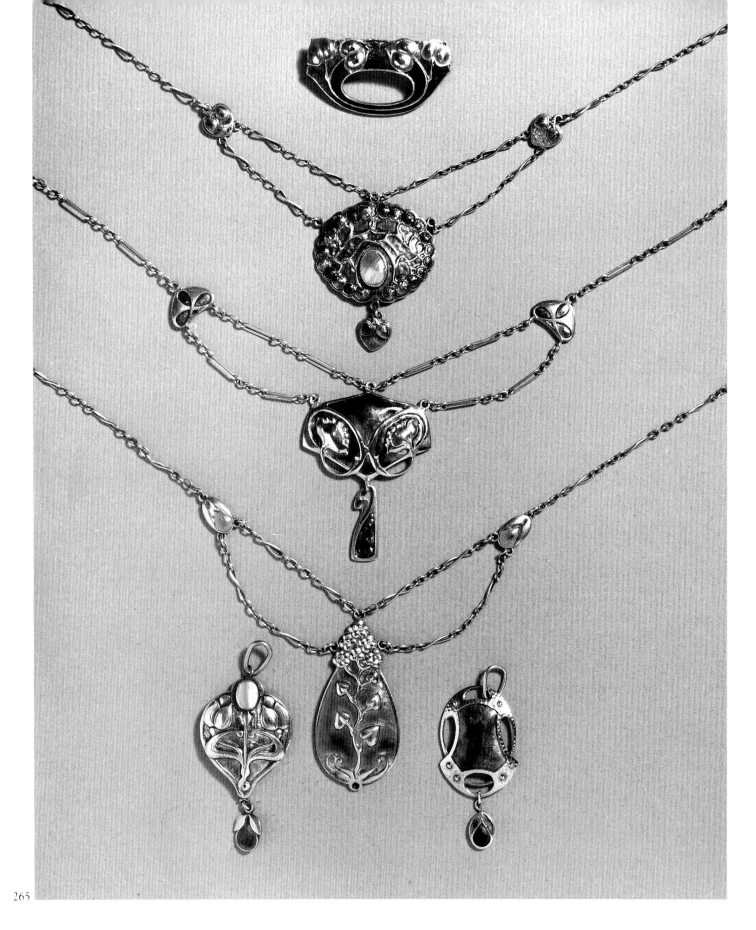

265 **Murrle, Bennett and Co.** Group of silver and blue-green enamelled pendants and necklaces, all but the pendant bottom right in the Liberty style, c. 1900–05.

266 **Murrle, Bennett and Co.** Jewels showing pierced goldwork, set with pearls and turquoise matrix, c. 1900–05.

267 **Murrle, Bennett and Co.** Two silver necklaces: (above) with mother-of-pearl; (below) with citrines, showing the firm's distinctive style of strong outlines, pin-head bumps and stitch motifs. Both c. 1900–05.

268 **Murrle, Bennett and Co.** Hammered silver necklace with mother-of-pearl and blue-green enamelled flowers, c. 1902.

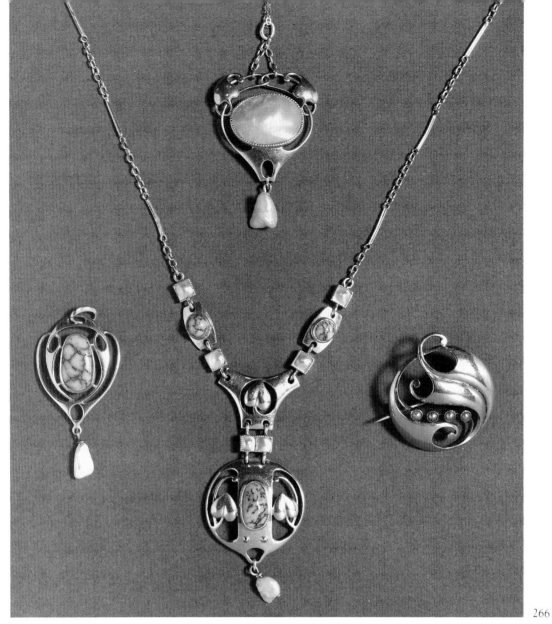

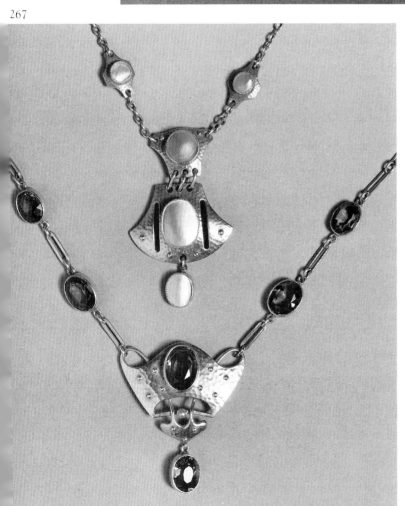

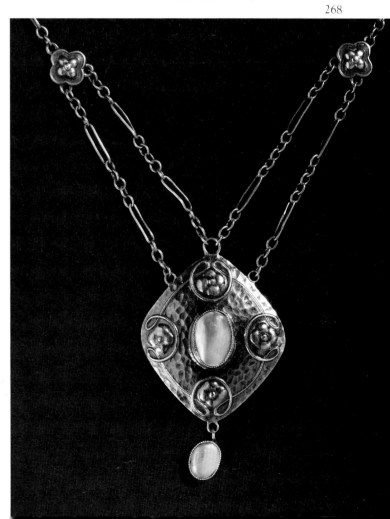

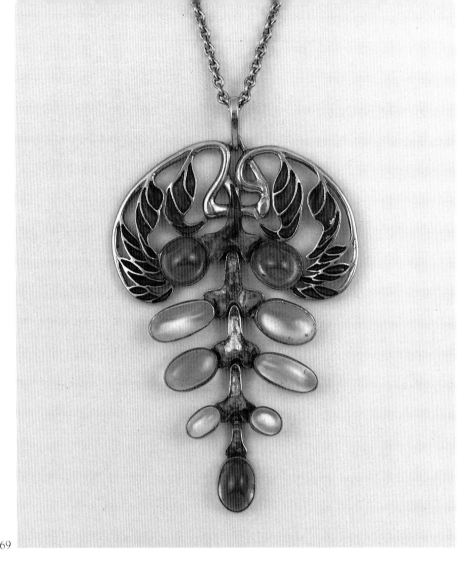

269

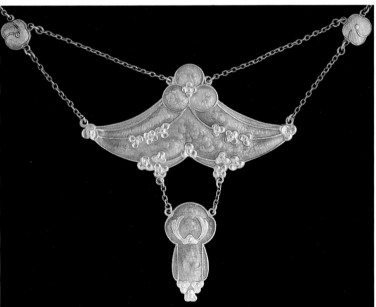

270

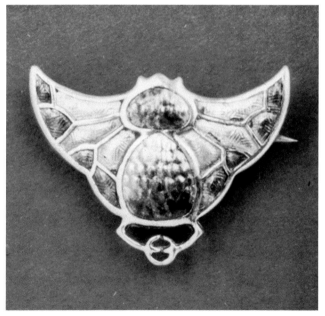

2

269 **Frederick James Partridge** Silver, green enamel, chrysoprase and moonstone pendant, c. 1905.

270 **Jessie M. King** (designer) and **Liberty and Co.** (maker) Necklace of silver and turquoise enamel, with typical circle and flower theme, c. 1902.

271 **Charles Horner** Silver and enamel winged scarab brooch, c. 1905–10.

272 Silver belt showing strong Art Nouveau lines, combined with a Celtic *entrelac* motif, c. 1900.

273 **A.C.C. Jahn** Pendant with silver frame set with pearls, enclosing a mother-of-pearl plaque and girl's head profile in ivory, silver and silver gilt, c. 1900–01.

274 **A.C.C. Jahn** Brooch in the form of an angel. Silver, partly gilt, the ivory bust set with an opal and pearls, c. 1900–01.

275 **Charles Ricketts** (designer) and **Carlo Giuliano** (maker) Renaissance-style gold and enamel pendant, set with emeralds and rubies, and hung with pearls, 1900.

276 Three buttons (part of a set of six), possibly imported from France, c. 1900–08.

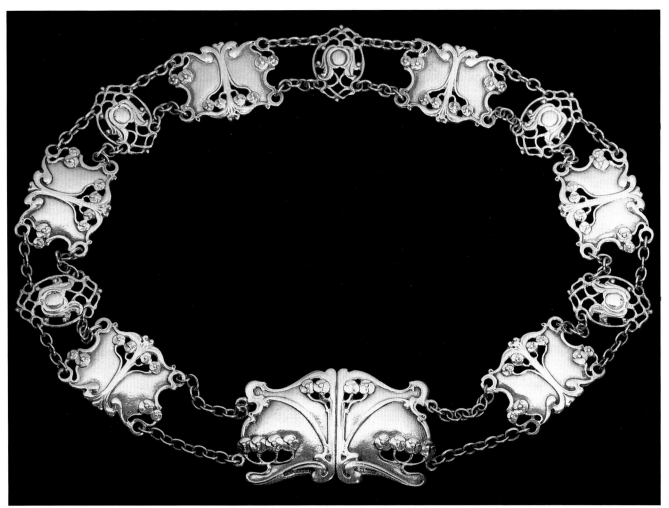

273 274 275

272

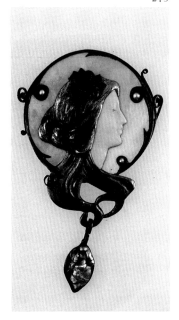

276

277

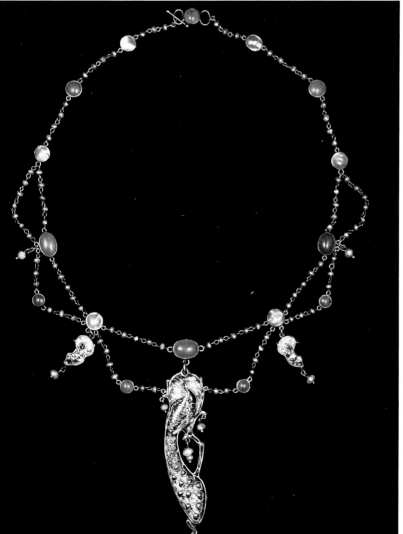

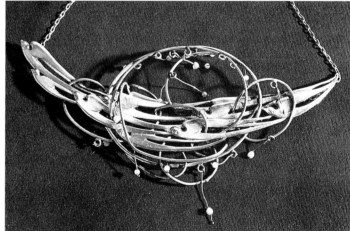

27

277 James Cromer Watt Gold, enamel and opal necklace, the enamels in iridescent shades of red and pink, c. 1900.

278 James Cromer Watt Gold, foiled enamel and mother-of-pearl peacock necklace. The shaded green enamel, with bright blue glints, is matched by green chrysoprases, c. 1900–05.

279 Charles Rennie Mackintosh (designer) and **Margaret MacDonald** (maker) Silver pendant representing a flight of birds through storm clouds, c. 1902.

278

Some silver and enamel pendants designed by Knox which bear the Murrle Bennett mark may have been made by Murrle Bennett, but were sold exclusively by Liberty and Co., who guarded their designers jealously. Murrle Bennett's own range of jewels are distinctive: they made a great many gold jewels with a rich matt sheen, often set with turquoises, amethysts or large mis-shapen pearls. Turquoises were usually large and speckled' with brown or black imperfections. Flawed opal was also used and was carved into curious shapes, for example the head of a Red Indian. The outlines of the jewels were linear but fluid, using Celtic-style interlacing. Gold wires were trailed over a pearl or a piece of turquoise, or formed into a kind of cage with straight lines reminiscent both of Mackintosh and the Wiener Werkstätte. Straight geometric lines on some pendants and brooches very closely follow the new German designs of the time. Pendants borrowed from Arts and Crafts the motif of a stitch that seemed to sew two parts of the pendant together, in imitation of hand workmanship. Some silver jewels were abstract and geometric, others delicate. Draped necklaces were very popular, with stylized Arts and Crafts leaves and blue-green enamels. The stronger, more Continental silver designs had a hammered finish and tiny pin-head bumps like rivets, a feature which was particularly typical of Murrle Bennett jewels. Silver pendants in this style were set with amethysts or mother-of-pearl.

The firm of Connell and Co. are also known to have competed openly with Liberty and may even have sold them some designs. Connell called themselves 'modern artists in jewelry and silverware' and were based in London at 83 Cheapside. They advertised a wide range of silver jewels in the Liberty vogue. One bracelet was also shown in a contemporary Murrle Bennett advertisement. Like Murrle Bennett, Connell were most probably wholesalers, and their jewelry was sold through retailers such as the Goldsmiths' and Silversmiths' Company.

Among independent jewelers, Frederick James Partridge (1877–1942) is a relatively little-known designer-craftsman and rather a special case, since he was not associated with any one firm and since his work is closer than any other to French Art Nouveau. Partridge came from Barnstaple in Devon, a centre of Arts and Crafts designers, and worked with Ashbee at the Guild of Handicraft when it moved to Chipping Campden in 1902. He was a particularly skilled worker in horn, and worked from about 1900 to 1908 in Branscombe in Devon. He was especially influenced by Lalique and Desrosiers, and made very beautiful haircombs, distinguished from French examples only by his signature. He was married to May Hart Partridge, who did some enamelling for Ashbee's jewelry and silverware.

Ella Naper (1886–1972) was a colleague of Partridge, and her work in horn, in French Art Nouveau style, has just come to light. She made a pair of superb haircombs in green-tinted horn with moonstone dew-drops clinging to veined leaves (pl. 255). They look typically French but can now be attributed to her. Ella Naper was part of an artists' colony that gathered around Lamorna, Cornwall, in the early years of the century. Her work shows distinct similarities to that of Partridge, in the carving and especially in the use of cabochon moonstones.

Ella Naper attended Camberwell School of Arts and Crafts from 1904 to 1906, where she was presumably introduced to jewelry making and where she won several prizes. After this training she went to Branscombe for three years and it was during this period that she worked with Partridge. Ella's carving was skilful, artistic and sensitive. She also used natural motifs in an

Frederick James Partridge with Ella Naper, c. 1906–09

Belt buckle design by Ella Naper,
c. 1905–10

imaginative way. Unfinished or practice pieces in horn show themes of succulent purplish berries, linked butterflies and a carved ear of corn – borrowed, it might seem, from Gaillard. The charming green lily-pad motif on the haircombs, however, seems to be entirely Ella's conception. The practice pieces with linked butterfly motifs show that she experimented with overlaying a thin carved slice of mother-of-pearl on top of the horn, to add depth and a luminous sheen. She also worked a great deal in enamel, showing traces of Ashbee's influence which was presumably relayed to her by Partridge. She was especially fond of using deep green enamels.

Ella Naper exhibited her jewelry at the Arts and Crafts exhibitions and also made some pieces for Liberty and Co. A bleached horn tiara, carved with ears of corn and set with oval cabochon moonstones, commissioned by Liberty, could very well be her work.

A.C.C. Jahn was the Headmaster of the Municipal School of Art in Wolverhampton, and, like Partridge, he made jewels in a fluid French manner. Some of his simple gold jewels were similar to those of Colonna, while others tended towards a richer neo-Renaissance style, incorporating carved ivory, sometimes in the form of a girl's head, mounted in gold and set with pearls. Jahn also included Celtic *entrelac* motifs in his designs for buckles of beaten steel or chased silver.

In all countries, the high ideals behind Art Nouveau jewel design were sacrificed eventually to commercial considerations. Outside the new artistic movement, machine-made goods were considered new, exciting and desirable. The Halifax firm of Charles Horner was the pioneer of total mass production.

Horner jewels show a very different face of Art Nouveau jewelry but are nonetheless representative of their era. Most of them were made between 1905 and 1910. Charles Henry Horner's father, Charles Horner senior, was the inventor of the 'Dorcas' thimble, which was an overnight sensation and led to a new factory being built in 1905 at Mile Cross in Halifax. The large family company was joined by the two sons, Charles Henry Horner and James Dobson Horner. It was Charles Horner junior who was the talent behind the jewelry side of the business; he himself had a certain artistic flair and designed most of the pieces now considered typical of the firm. James Dobson Horner looked after the mechanical and commercial side of the business.

The Horner factory was remarkable for its time, because every stage of manufacture was carried out within the factory, from design to the finished product. The silver was melted into ingots and then made into the sheets and strips needed for jewelry production. There was no other firm in the country doing this. Horner even imported the latest machines from Germany to make lengths of fine silver chain on which to hang their pendants.

Considering the huge numbers of pieces produced, the designs are pleasing and the jewelry well produced. Horner took the immensely popular Liberty-style designs and selected the strongest elements that could be simplified successfully, choosing enamel as decoration. The firm are particularly well known for their Art Nouveau-style hatpins, also pendants and brooches. Some pieces of gold jewelry were produced but not frequently; rings are extremely rare and not very exciting. Horner jewels often featured a simple silver twist or knot design – this worked particularly well as a hatpin. Necklaces copied rather stiffly the openwork designs of Liberty and the whiplash or geometric triangle. Another well-known Charles Horner motif is

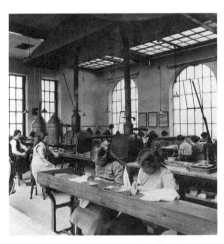

The enamelling room at the Charles Horner factory, 1913. The girls in the foreground, wearing the firm's Art Nouveau pendants, are enamelling silver pieces, while those in the centre are waiting to remove finished jewelry from the kilns. Specimen cases are hanging on the back wall

the winged scarab, usually with outspread wings, sometimes curled into a more rounded shape. The scarabs are invariably enamelled in blue and green, with a touch of purple, and were used as brooches, pendants or to sit on top of a hairpin. Horner jewelry often features deep peacock-blue enamel, or a blend of yellow and green.

The quality of other English Art Nouveau jewels varies enormously and there must have been many unknown jewelers working in a similar way to account for the large numbers of indifferent jewels, with weak whiplash curves and pools of insipid enamel. Most common were little openwork pendants with swirls of enamel. In England, as in France, jewel design around 1900–10 became a widespread pastime. The system of improved art education was turning out very able designers who undertook freelance work for manufacturers and who were only too happy to keep up with modern trends. Among the best of these artists were Annie McLeish, Kate Harris and Kate Allen.

Annie McLeish came from Liverpool and was recommended in Aymer Vallance's critique of British jewelry in *The Studio*'s special supplement, 'Modern Design in Jewellery and Fans' (1901–02). Her work, he said, was curiously suggestive of the pierced iron guards of Japanese sword handles or *tsuba*, in the way several parts were connected to produce an ornamental feature. She also made use of the human figure, as did two of her colleagues, Ethel Larcombe and Winifred Hodgkinson. In 1901, William Hutton and Sons Ltd, silver manufacturers in Sheffield and London, employed the young designer Kate Harris to give their production a modern Art Nouveau image. Silver and buckles, often with the motif of a young girl wearing a close-fitting hat, like a Dutch girl, were a speciality. Kate Allen worked in a bold, swirling style, also using the motif of a Dutch girl, as well as the typical Arts and Crafts motif of a galleon in full sail.

Child and Child, a London firm of silversmiths and jewelers, worked primarily in what was to become known as the Edwardian style. Some of their jewels, however, have great affinity with Art Nouveau, especially in their use of peacock motifs and their speciality of enamelling. They were active mainly between 1880 and 1916. They were established in 1880 at Seville Street in Knightsbridge and moved in 1891 to 35 Alfred Place West, off Tottenham Court Road. A silver mark was registered at the Goldsmith's Company on 21 February 1888, which recorded the partnership of Walter Child and Harold Child as 'workers in plate' (silversmiths). When they moved to Alfred Place West, they began trading as manufacturing jewelers and it was after this that they developed their emphasis on enamels. They made up some jewelry designed by the painter Edward Burne-Jones (1833–98). Their enamelwork is best known for its plump wing motifs which bore little resemblance to the gossamer creations usually associated with Art Nouveau. The enamels, frequently in lurid grass-green or turquoise blue, tend to be crudely executed, but have a charm of their own. They frequently use the motif of a peacock or peacock's feather. The partnership ended in 1899, and Harold Child continued on his own as a gold and silver worker until 1915 or 1916.

There are one or two examples of Art Nouveau jewels made by the leading London jeweler Carlo Giuliano (1831–95), who worked mostly in his own version of the neo-Renaissance style. Giuliano also received commissions from Edward Burne-Jones and also from the English painter, sculptor and decorative artist Charles Ricketts (1866–1931). Ricketts' main love was theatre design, but he designed a small number of jewels for his friends, and

these were made by Carlo Giuliano (pl. 275). The jewels still exist (in the Ashmolean Museum, Oxford), and drawings for a number of them are in a sketchbook, dated 1899, now in the British Museum. They have a rich Renaissance tinge mixed with Art Nouveau lines and motifs.

Scotland

Scotland had an important influence on European Art Nouveau in general but produced little jewelry itself. The architect and designer Charles Rennie Mackintosh (1868–1929) was the leading light of the Glasgow School, which developed a forward-looking, rectilinear style much admired in Austria for its emphasis on suiting form to function. As far as jewelry is concerned, Mackintosh was most important as a formative influence on the designs of the Wiener Werkstätte (see p. 134). He himself designed only a few pieces of jewelry, the best known being based on the design of birds flying through storm clouds with raindrops. These were made by Margaret MacDonald and have been much copied.

Mackintosh was also the leader of the group of designers called 'The Four' which was made up of J. Herbert McNair and the sisters Margaret and Frances MacDonald. (Mackintosh married Margaret and McNair married Frances.)

J. Herbert McNair (1868–1955) designed jewelry which may have been made by his wife, who was a teacher of metalwork and enamelling at Glasgow School of Art. He exhibited at the 1896 Arts and Crafts Exhibition and again at the Turin International Exhibition in 1902. His designs incorporate eerie female figures and faces, and he often uses the motif of a silver wire cage. Both the MacDonald sisters designed and made a small number of pieces in a similar style.

More prolific in jewel design was Talwyn Morris (1865–1911). He too trained as an architect and became a member of the Glasgow School. He made jewels of beaten copper and aluminium. He also used silver with enamel and coloured glass. Bird motifs such as a peacock's eye or head often appear in Talwyn Morris's designs.

Jessie M. King, mentioned earlier in connection with her designs for Liberty jewels, was also a member of the Glasgow School.

Outside the Glasgow School, some fine and attractive jewelry in Art Nouveau style was made by James Cromer Watt, who worked in Aberdeen. He was an expert enamellist in the Arts and Crafts tradition and was famed for his use of 'foiled' enamels, the intense colour laid over a swirling iridescent background. He used the voluptuous female figure, and also the peacock, as vehicles for his luminous enamels. His pendants and sweeping, exotic-looking necklaces with little pearl and gold festoons are well made and usually set in gold.

4 The United States

Throughout the nineteenth century, America had followed European fashions in costume and jewelry. Large quantities of inexpensive, fashionable jewels were imported from London and Birmingham. Cameos, the most popular items of jewelry in America, came from Italy, along with other fashions such as coral or mosaics. To prevent the loss of potential earnings, the American government had imposed a duty on imported jewelry in 1850, and from this time cheap and fashionable accessories began to be produced by the silversmithing centres fast growing up in the United States. Real gems were still rare in America by the mid century, and semi-precious stones like the turquoise or garnet were considered valuable treasures. By the 1860s there were traces of a distinctly American style in gold jewelry, with fringes of chain, engraving and delicate black enamel.

The American Arts and Crafts movement of the 1890s corresponded to England's attempts at a renewal of the arts and crafts and worked along similar lines, with craft workshops, societies and co-operatives. The Art Workers' Guild in Providence was established in the mid 1880s, the Boston and Chicago Arts and Crafts Societies in 1897, and the New York Guild of Arts and Crafts in 1900. Very little American Arts and Crafts jewelry remains, as the movement focussed primarily on ceramics, furniture and other crafts.

Florence Koehler (1861–1944) was one of the leading exponents of the American crafts revival, and one of the few to produce jewels. She lived and worked in Chicago, which was a thriving centre for the new artistic interest. Her jewelry, made after 1900, was, like its English counterpart, destined to appeal only to an élite group.

The Americans had been quick to embrace Oriental styles of decoration, perhaps because Commodore Perry, instrumental in negotiating the vital treaty with Japan in 1858, was an American. Japonisme had spread to America by the 1870s and 1880s and there were many silver, gilt or mixed-metal jewels in the Japanese taste produced in America, for the popular end of the market. American laws were different from those in England, and permitted craftsmen to mix gold and silver with non-precious or less precious metals. American metalworkers made the most of techniques such as inlay and damascening, to produce attractive jewels and trinkets in Japanese taste. Tiffany and Co. were the leading New York jewelers at this time, and they made some of their most successful pieces in this style. The firm had a special link with the Oriental fashion through Edward C. Moore, Tiffany's chief designer, who was a keen and knowledgeable collector of Japanese art. In the 1880s, Tiffany had produced some very fine Japanese-style gold jewels, made from coloured gold in imitation of mixed metalwork techniques, with motifs of birds and flowers.

In the last years of the century, the jewelry industry took its lead from Paris and adopted the fashionable French Art Nouveau style. Two main centres for mass production flourished in the latter part of the nineteenth century: in Newark, New Jersey, and in Providence, Rhode Island. Both had begun in the opening years of the century and by the late 1890s were highly practised, ready to launch commercial, inexpensive Art Nouveau jewels for the new fashion-conscious middle or merchant classes.

America's individual contribution to Art Nouveau, however, lay mainly in the realm of architecture, with the work of Louis Sullivan (1840–1924) and in that of glass and jewelry, with the work of Louis Comfort Tiffany (1848–1933).

Decorations for this chapter: detail of *The Serpentine Dancer* (Loie Fuller) by William H. Bradley (chapter title page); detail from a book plate decoration by William H. Bradley, 1896.

There are two kinds of jewels produced by Tiffany and Co.: one conventional and gem-set, relying on important stones, the other artistic, hand-wrought and very much part of the Art Nouveau movement. Relatively little is known of Tiffany's 'art' jewelry, although this was apparently of great importance to him.[1]

It was into a well-established firm of jewelers, founded by his father, that Louis Comfort Tiffany was born. He did not inherit his father's business sense and never had total control of the firm, even when his father died in 1902. He was an artist, sensitive and aesthetically inclined, and his ideas for the diffusion of art to the public were very much in tune with those of the Arts and Crafts movement in England. As a teenager, Tiffany had studied with the landscape artist George Innes. He blossomed in this milieu, then travelled in Europe, spending time in Paris and Spain from 1868 to 1869. After his training in the fine arts, he was unsure of his talent as a painter, and eventually decided to concentrate on the decorative arts. He was convinced of the principles of the Arts and Crafts movement but objected to the amateurish side of their doctrine. In 1878 he formed an interior decorating firm called Louis C. Tiffany and Associated Artists, with Samuel Colman and Lockwood de Forest, both painters, and Candace Wheeler, founder of the Society of Decorative Art in New York. The firm enjoyed great success, particularly in Society circles – they were commissioned to decorate the White House in 1882. Louis Comfort Tiffany inherited the company's preoccupation with Oriental art, and was encouraged in this by Edward C. Moore, now director of the silver department. It is significant that the greatest exponent of Art Nouveau in America, like Bing in France and Liberty in England, should have begun his career with a close involvement with Japanese art. His exotic interiors, for example, showed a strong Japanese influence. At the same time his interest in glassmaking was developing and also showed Oriental inspiration.

Gradually his ideas for stained glass and his famous *favrile* glass evolved. In 1889 he began a close business association with Bing, whom he had met some years previously and who became his agent in Paris. Tiffany's glass was by now widely admired and by the late 1880s he was made a Director of Design at Tiffany and Co. In his workshops at the Tiffany and Co. building in New York, he occupied himself with his own designs, which included 'art' jewelry, very different from the firm's mainstream production. This was known as Tiffany Studios jewelry, and is now extremely rare.

In 1914, Louis Comfort Tiffany commissioned a special biographical publication called *The Art Work of Louis Comfort Tiffany*, written by his friend Charles Dekay. The book provides an insight into Tiffany's interest in developing the 'art' jewel in America: 'One may say that the quality, the artistic quality of the jewelry which is found among a people goes far to measure that people's level in art. Hence the importance of having artists instead of untrained artisans to supply jewelers with designs; hence the value to the people . . . to supply a class of jewelry not only original and individual, but often very beautiful. Each piece acts as a little missionary of art and tries in its own dumb way to convert the Philistine.'

It is generally thought that Tiffany began to produce his hand-made jewels after 1900, when he was influenced by Lalique's display at the International Exhibition in Paris, but Bing had exhibited Lalique's jewels when he opened his gallery, L'Art Nouveau, in 1895, and Tiffany must surely have come under Lalique's influence around this time. Tiffany and Co. exhibited at the

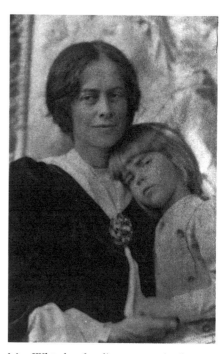

Mrs Whitehead, who was involved in the Arts and Crafts movement in America and whose husband founded the artistic colony of Byrdcliffe, wearing Arts and Crafts jewelry

1900 Paris Exhibition, with gem-set jewelry and also some 'art' jewels which were illustrated in *La Revue de la bijouterie*. These were, ironically, criticized by the French for their lack of artistry. Tiffany and Co. had organized important displays at earlier exhibitions in America, notably the Chicago World's Fair in 1893.

It is probable that Tiffany 'art' jewelry based on naturalistic, sometimes weird, organic forms was included in their display in Paris as early as the 1889 Exhibition.[2] Secret experiments in jewelry techniques, it seems, had been carried out for two years before this. But generally the Tiffany Studios jewels date from 1902 onwards, when a special department was opened for individually designed jewelry. These pieces were an unusual mixture of handwrought Arts and Crafts and the organic motifs of Art Nouveau, with an emphasis on unusual materials chosen for colour and effect rather than intrinsic value. Tiffany mixed metals and enamels, precious and semi-precious stones; he drew on his favourite Oriental and Byzantine motifs and was dedicated to fine workmanship in all aspects of the jewelry, making the back of each piece as attractive as the front. The back of the famous Peacock Necklace is decorated with enamelled flamingos (pl. 294). It has a very strong Byzantine flavour, and at the same time is reminiscent of Oriental *cloisonné* work. The necklace was a prize Tiffany display item; it was shown at St Louis in 1904, at the Paris Salon of 1906 and continued to be exhibited even after Tiffany's death in 1933. His use of the peacock motif may have come from his admiration of C.R. Ashbee's work. Ashbee made several visits to the United States, visiting crafts communities and Tiffany's glassworks.

Tiffany was also influenced by Alphonse Mucha, who had a great following in the United States. There was a great similarity between the work of the two artists in their preference for a Byzantine opulence. They knew each other personally, having met in Paris in the 1890s, and in New York.

Like Tiffany's opulent interiors and glass, the jewelry made in the studios was exotic. Other items were described in Dekay's biography: 'A dragonfly hatpin enamelled and set with opals in a platinum base. A marine motif, half crab, half octopus, with the writhing feet split in two, is arranged as a brooch and set with opals, sapphires and rubies. A girdle of silver, ornamented with enamels, has berries formed of opals . . . a decoration for the head is a branch of blackberries, the berries clusters of dark garnets.'

The concentration on art, materials and naturalistic motifs in Tiffany Studios pieces makes them the most important of American Art Nouveau. He made great use of Baroque pearls and unusual coloured stones, including the grass-green demantoid garnet. His goldwork was fluid and sinuous, often with coiled spirals, and was decorated with rich, iridescent enamels. The jewels, however, did not sell well. Their subtlety was not appreciated by New York society, which preferred the status value of precious stones and the firm's usual brand of glamour. Like English Arts and Crafts jewelry, Tiffany Studios jewels were very expensive and not conventionally beautiful.

Julia Munson (1875–1971) was largely responsible for the production of Tiffany Studios jewelry, yet her name has remained virtually unknown. This is probably because anonymity was a prerequisite for any designer who worked with Tiffany. A New Jersey doctor's daughter, she was attracted to nature and to the arts, and had followed with great interest the writing and theories of William Morris. In her early twenties, she came to New York to be an apprentice to Louis Comfort Tiffany, an unusual position for a woman at that time.

184

Continued on p. 193

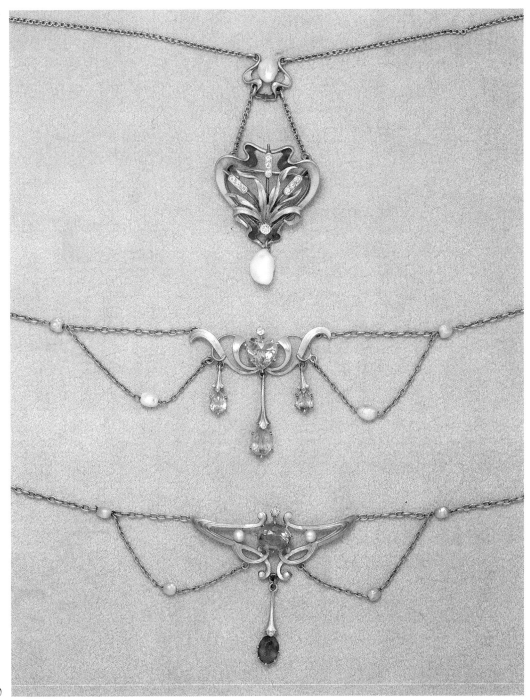

280

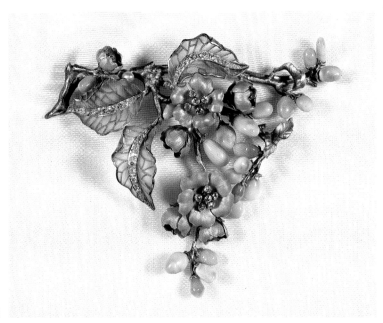

281

280 Three gold and gem-set enamelled necklaces with festoons of gold chain in the Edwardian manner, set with amethysts and peridots, and decorated with shaded satin enamel, c. 1900.

281 **Marcus and Co.** Gold, coral, satin enamel and *plique à jour* brooch in French style, c. 1900.

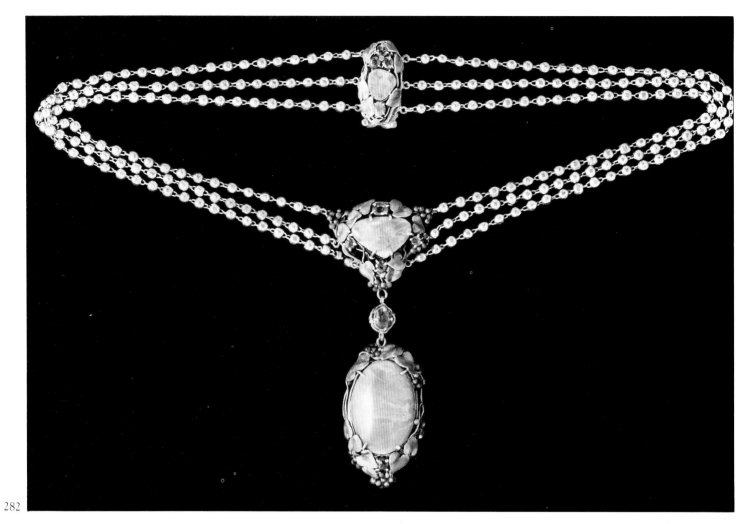

282

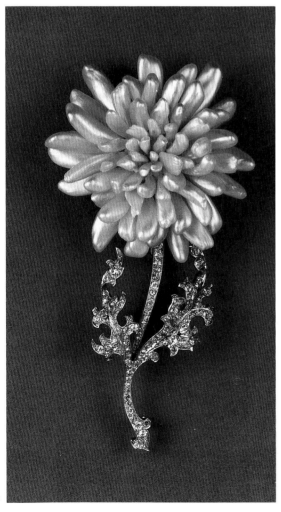

283

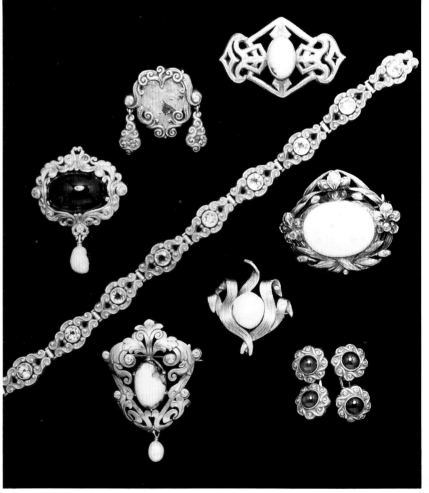

28

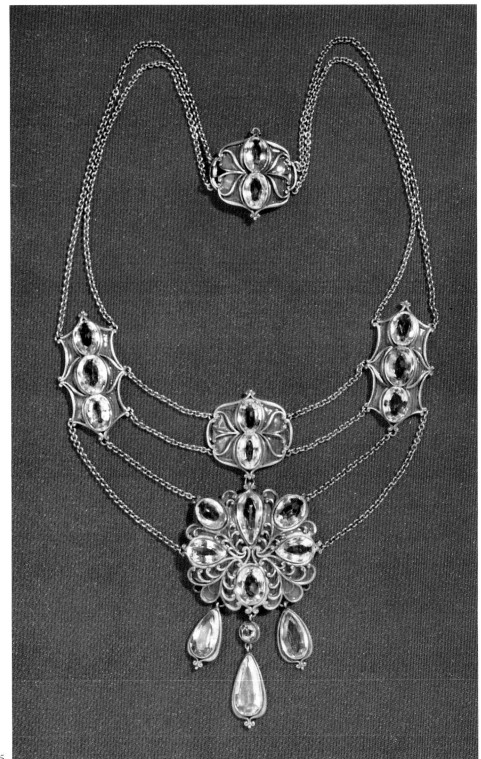

85

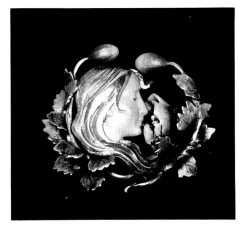

286

287

282 **Tiffany Studios** Gold, opal and enamel necklace. The enamelled flowers encircling the stones reflect the blue-green colours of the opals, c. 1902.

283 **Tiffany and Co.** Gold, diamond and Mississippi pearl chrysanthemum brooch, c. 1898.

284 Engraved gold and gem-set jewels, c. 1900.

285 **Marcus and Co.** Necklace with aquamarines matched by blue *plique à jour* enamel, set in gold, c. 1905.

286, 287 Two gold and enamel brooches, c. 1900.

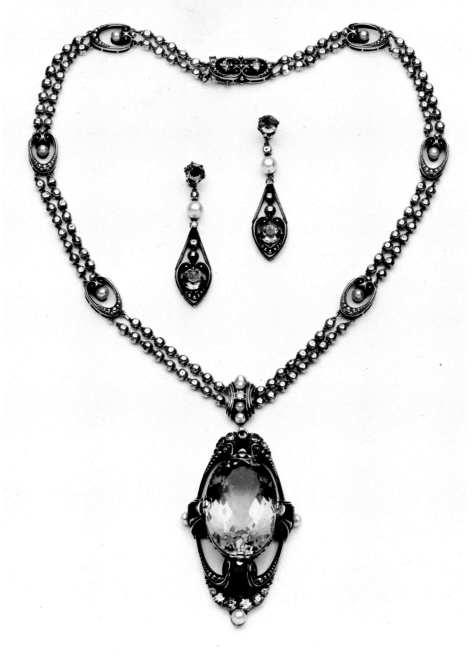

288 **Tiffany Studios** Necklace and matching earrings, the green gold complementing the chrysoberyls and coloured diamonds, and contrasting with the pearls and onyx, c. 1902–05.

289 **Tiffany Studios** Gold and *plique à jour* enamel pendant and chain, set with a fiery black opal. The tiny coils and sweeping wirework are characteristic of Tiffany jewels, c. 1902.

290 **Tiffany and Co.** Gold, enamel and diamond orchid brooch, c. 1898.

291 **Marcus and Co.** Two gold and enamel brooches, one set with a cabochon sapphire and diamonds, the other of black enamel set with rubies, c. 1900.

292 Four gold and gem-set rings including one by **Marcus and Co.** (above left) and **Peacock and Co.** (above right), c. 1900.

293 **Tiffany Studios** Gold bracelet set with fire opals and small green demantoid garnets, the goldwork showing Byzantine inspiration, c. 1902–05.

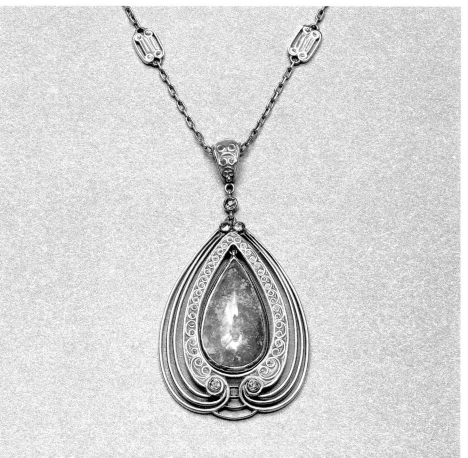

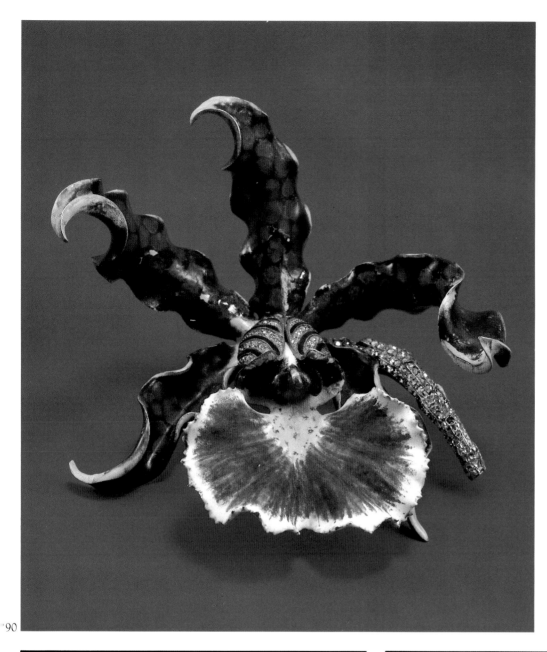

90

291

92

293

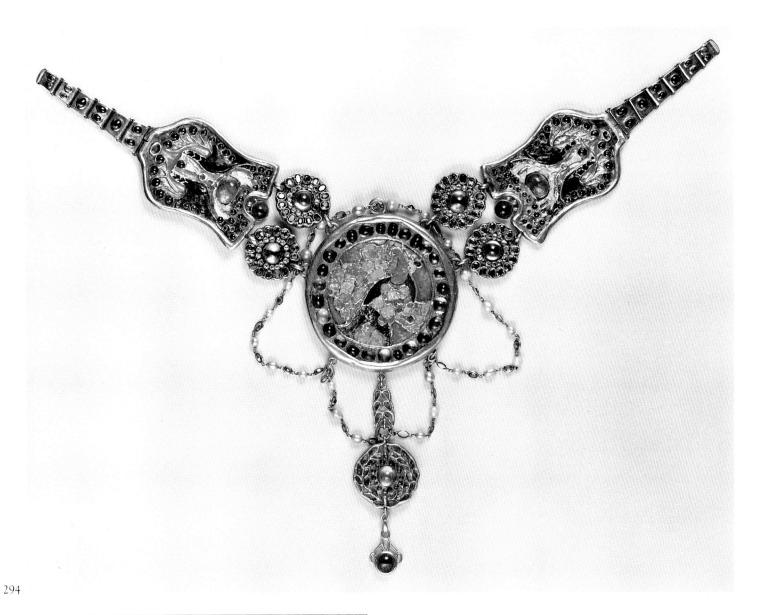

294

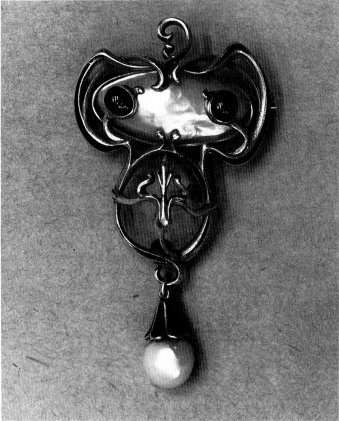

295

294 **Tiffany Studios** The Peacock Necklace, in gold, pearls, enamel, and a mosaic of semi-precious stones in the Byzantine taste. Two bell-shaped plaques depicting peacocks are joined to the central medallion by twin rosettes, the looped chain set with pearls and demantoid garnets, c. 1902.

295 **Marcus and Co.** Gold and enamel brooch set with a Baroque pearl and cabochon emeralds. A direct copy of a Colonna jewel, c. 1901–10.

296 **Ladislas Zental** Silver and ivory haircomb, c. 1905–10.

297 Mass-produced silver jewelry by commercial firms, the playful nymphs by Gorham after a French design by **C. Duguine** (see 27), the girl's head brooch by **William B. Kerr**, and the pearl and silver rings unmarked. All c. 1900.

298 Gold lorgnette with iris motif, the handle formed by the long woven leaves, c. 1900.

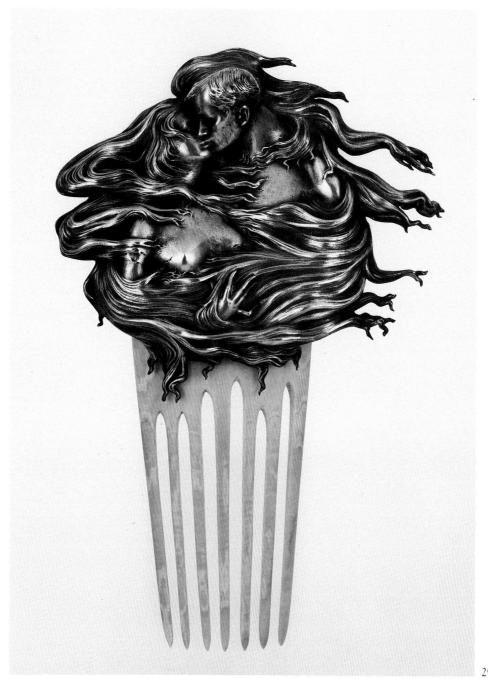

296

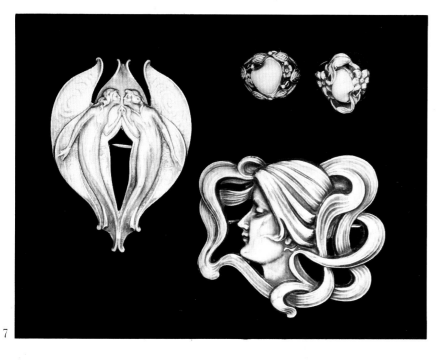

7

298

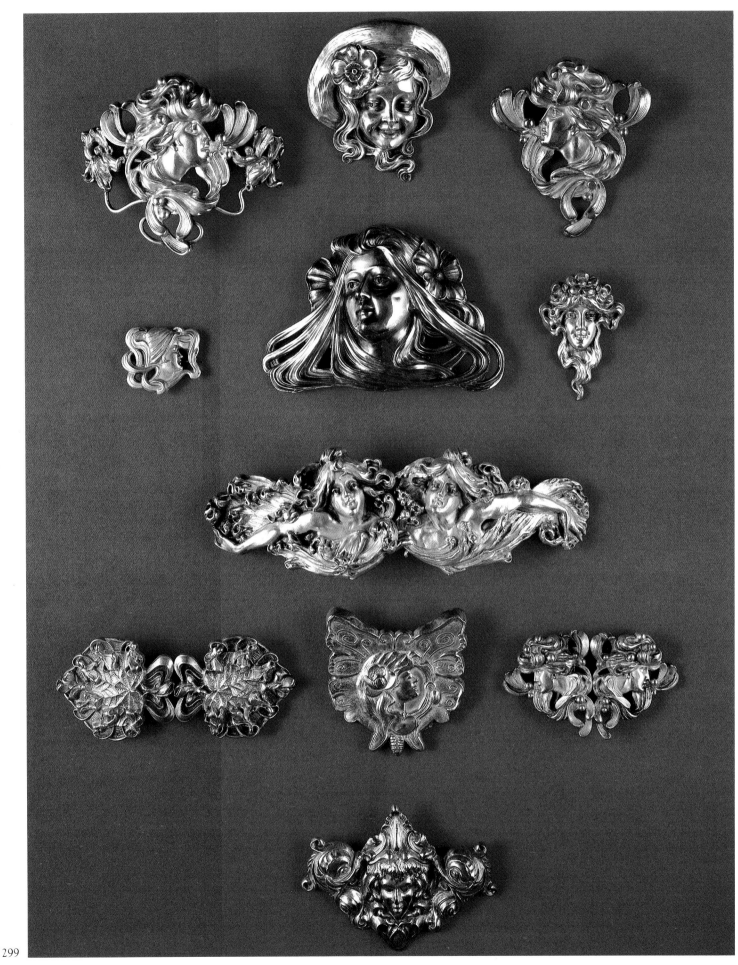

299 Mass-produced silver jewels by **Unger Brothers** (top two and bottom two in centre row) and **William B. Kerr**, showing the exuberant use of the female face with wildly flowing hair and flowers, c. 1900.

Tiffany's interest in glass led him to experiment with enamels for jewelry, and it was Julia Munson who helped him work out techniques, plans and designs. She became head of Tiffany's enamelling division and in 1903 head of the jewelry department. The jewelry output from the Tiffany Studios was small, and production stopped in 1916.

Marcus and Co. were also leading New York jewelers, but little is known of them. They worked in a very individual, colourful style, drawing on the current trends of the new crafts revival. Necklaces often have coils of metalwork and mother-of-pearl and look as if they have been copied from Tiffany Studios designs. One piece, a pendant, on the other hand, is clearly a direct imitation of a Colonna brooch, using free gold outlines with a mother-of-pearl centre (pl. 295). Several Marcus jewels incorporate either a softly meandering gold line or ribbed coils, or were imitations of French floral Art Nouveau. They feature a great deal of enamel, often in remarkably strong colours, like deep ruby pink, dark green or aquamarine, even on *plique à jour* enamel (in which soft colours usually emphasize the translucency), and often to complement the stones set in the pieces. The workmanship may appear somewhat crude and the colours overpowering, compared to the subtleties of French Art Nouveau jewelry, but the finished Marcus product has a robust confidence of its own.

American mass-produced silver jewels have a distinctive boldness with clearly delineated, lively motifs, and are extremely effective decorative ornaments. They appealed to the middle market, who wanted the latest fashion at reasonable cost. The Gorham Corporation Inc. was the largest firm of silversmiths and jewelers in Providence, Rhode Island, and had been established in about 1815. They made jewelry and specialized in chain, gradually gleaning much knowledge and experience from visits to silver manufacturers in England.

Gorham were among the earliest firms to introduce mass-production methods to silver making and were experienced and professional by the time Art Nouveau had become fashionable. From about 1900, they produced a special range of Art Nouveau silverwork and jewelry called Martelé, from the French *martelé*, or 'hammered'. One of the directors, Edward Holbrook, had gathered a group of specialist silversmiths, and the design of the Martelé wares was co-ordinated under the supervision of William C. Codman, an Englishman who had worked with the silversmiths Cox and Son in London before he moved to Providence in 1891. Gorham based designs on those of the American Arts and Crafts revival. They used mixed metals, or silver, silver gilt and copper, with either no stones or very few, such as agates or freshwater pearls, in accordance with craft revival ideas.

The Gorham building in New York was located at Fifth Avenue and 36th Street, and their full-page advertisements in the trade paper, the *Jeweler's Circular*, listed branches in Chicago, New York, San Francisco and London.

William B. Kerr and Co. of Newark, New Jersey, were also manufacturers of popular jewels. Their pieces were based more directly on typical French Art Nouveau motifs than those of Gorham. Kerr is best known for silver brooches with the profile of a girl's head surrounded by flowing hair. The firm was founded by William B. Kerr in 1855 and made tableware and gold and silver jewelry. They used a special technique to produce jewels, stamping them out of sheets of metal to imitate *repoussé* work. The hollow back was covered by a thin plate of silver to add the illusion of weight and substance.

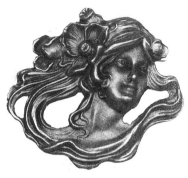

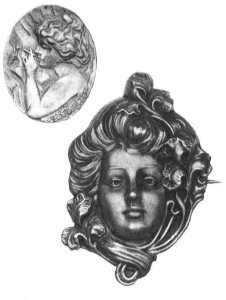

Three mass-produced silver jewels from an advertisement for Averbeck and Averbeck in *Jeweler's Circular*, February 1903, including (top) a buckle based on the musical comedy 'Flor-a-Dora', popular at the time in London and New York, and (below right) a 'Gibson Girl' brooch

Detail of an illustration by Charles Dana Gibson of 'Gibson Girls', 1907. The 'Gibson Girl', created by the caricaturist Charles Dana Gibson, represented the American celebration of femininity and was frequently depicted in jewelry

The designs are always strong, with a great deal of movement in the silverwork, and relied on variations of a few motifs in the French Art Nouveau manner. The pieces are often quite large and have a strength and purposeful appearance that compensates in some way for the lack of originality.

Unger Brothers, founded in 1878, produced low-cost silver Art Nouveau jewels in the popular French style, similar to those of Kerr and Co., also using the technique of imitation *repoussé*. Like their competitors, they were thrilled by the French jewels at the Paris Exhibition in 1900, and in 1903 took out patents for designs under the name of Philomen Dickinson, their chief designer. These designs incorporated chased flowers and leaves, or tilted dreamy female faces with flowing hair. Like Kerr's production, most of the pieces were made of silver, occasionally partly gilt or set with semi-precious stones. The firm continued to make Art Nouveau silver until 1910.

Apart from silver jewelry, American manufacturers excelled in making enamelled flower brooches, delicate draped gem-set pendants, and enamelled or gem-set stickpins in 14-carat gold or gold plate. The numerous floral brooches commonly represented pansies or violets, with gold stamens, and the enamel was usually hand painted, often opalescent or matt. The opalescent effect was produced by applying translucent enamel to gold, so that the gold gleamed through, giving a satin-like sheen.

Another common form of cheap American Art Nouveau jewelry is the matt-finish, gold-plated buttons, or 'blouse sets'. Sets of buttons were accompanied by very slim, oval bar brooches to be worn as tie or cravat pins, all stamped with flowers or motifs imitating French medal-jewels.

American manufacturers used European art journals as inspiration for designs, and their own trade magazines carried articles about top European Art Nouveau jewels and the progress of new fashions, as well as advertisements. These remain an invaluable source of information on designs and makers for collectors today.

Judging from such sources and the numbers of jewels still available, there were many American firms based in Rhode Island and New England turning out fashionable jewels in watered-down Art Nouveau mood in the early years of this century. The School of Design at Providence, Rhode Island, had thriving jewel-design and die-cutting departments to supplement the industry.

The extent of European influence fluctuated, and while some pieces could be mistaken for German and French, others are clearly American. Theodore W. Foster and Brother, of Providence, sold gem-set pendants and brooches with little curving lines. Ostby and Barton was another Providence company who adopted the Art Nouveau style. Blackington and Co. of North Attleborough, Massachusetts (another large manufacturing community), made copies of French jewels, which could be ordered in a rose, green or grey finish.

By 1900 Averbeck and Averbeck of 19 Maiden Lane, New York, were offering an extensive range of flower brooches, buckles and sash clasps in silver, gold plate or German silver, all beginning to show the Art Nouveau influence. Later, by 1903, they were featuring female themes, including a 'Gibson Girl' brooch in heavy silver and a buckle with an Art Nouveau lady surrounded by flowing locks, called 'Flor-a-Dora'.

5 The International Impact of the Art Nouveau Jewel

Belgium Holland
Scandinavia Russia Eastern Europe
Switzerland Italy Spain

The Art Nouveau style influenced design across the world: it was imitated in most European countries in varying degrees, with emphasis on one or other of the decorative arts according to the talents and leanings of the individual designers. The international nature of Art Nouveau meant that designers often moved from their native countries to work elsewhere: as we have seen, the German-born Edward Colonna and the Czech artist Alphonse Mucha both came to work in Paris, which was undoubtedly the centre of Art Nouveau jewelry, and jewels by designers such as Obiols, who came from Spain, are considered to be French.

In some countries such as Belgium, Holland and Scandinavia, jewelry design was rethought along the lines of the general renewal of the arts which took place at the turn of the century; elsewhere, notably in Spain and Switzerland, jewelry designers adopted and created variations on the original French Art Nouveau jewel, after its triumphant emergence in Paris in 1900. But the impact of the Art Nouveau jewel, almost as a separate phenomenon from the style as a whole, was felt even in countries such as Russia or Hungary, where Art Nouveau did not take such a firm hold.

Belgium played a leading part in the growth of the Art Nouveau movement, producing some fine masters of the style, particularly the young architects Victor Horta (1861–1947) and Henry van de Velde (1863–1957), and the jeweler and goldsmith Philippe Wolfers (1858–1929) who created some of the most remarkable Art Nouveau jewelry.

In the 1880s and 1890s, Brussels was gripped by the new ideas of avant-garde art. The intense artistic atmosphere of the Belgian capital stemmed from the strong rejection of historicism. At this time Brussels was susceptible to the English influence, acting as a go-between for England and the Continent, but also successfully fusing the two styles. In 1881 a new art review, L'Art moderne, was published in Brussels, paving the way for innovative ideas, and in 1884 'Les Vingt' ('The Twenty') was formed, a society of progressive artists and designers including numerous leading foreign painters like Toulouse-Lautrec, Whistler, Gauguin and Rodin. Van de Velde joined Les Vingt in 1889. The society was re-formed into La Libre Esthétique which lasted from 1894 to 1914, organizing annual exhibitions of arts and crafts, concerts and lectures. French symbolism and the English Pre-Raphaelite movement inspired Belgian art and literature.

Perhaps the most important figure in Belgian Art Nouveau was the architect Victor Horta. In terms of the decorative arts, though, the main figure was Van de Velde, whose main concern was with a synthesis and unity within the applied arts. His influence on the evolution of an abstract, linear Art Nouveau style was felt throughout Europe and was greatest in Germany where he worked after 1899. Having trained as an architect and painter, Van de Velde made his debut as a decorative artist in 1893. In 1895 he built a controversial house, Bloemenwerf, at Uccle near Brussels, to which he invited eminent guests including Samuel Bing and Julius Meier-Graefe. He designed its furniture, silver, cutlery and suitable clothes for his wife to wear in it. (He even ensured that the colour-texture combinations of the food served when Toulouse-Lautrec came to visit were aesthetically pleasing.) Van de Velde was asked to design furniture for Bing's new gallery L'Art Nouveau and interiors for Meier-Graefe's La Maison Moderne. His designs met with mixed criticism in France and Belgium, but when he exhibited furniture in Dresden in 1897 he received great acclaim. It was through Meier-Graefe and the periodical Pan that Van de Velde became so well known in Germany.

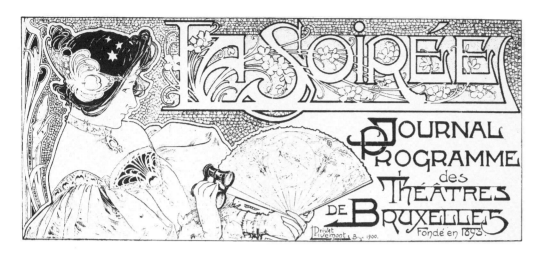

Title page of *La Soirée* designed by Privat Livemont, 1900

Van de Velde was perhaps at his best when working on small pieces of metalwork and jewelry in which he could concentrate his dynamic curvilinear designs in a small area for maximum effect. His jewels are exceptional: they are deceptively simple and lyrical, of abstract form, based on a very smooth, controlled flowing line. His first jewel designs were done in 1898. Working both in silver and gold, he used semi-precious stones such as amethyst, and occasionally cabochon sapphires or emeralds. His designs succeeded in bringing together in jewelry and metalwork ideas derived from the architectural style developed by Victor Horta, and were also instrumental in exploring and encouraging the later abstract stages of Art Nouveau and *Jugendstil*, bridging the two phases by his use of a rhythmic softness of line.

The designer most closely associated with Belgian Art Nouveau jewelry is Philippe Wolfers (1858–1929), who worked in the French Art Nouveau style rather than in the linear manner of Van de Velde. Wolfers' jewels are rare but their breathtaking and original, often eerie, beauty labels this designer as one of the greatest masters of Art Nouveau jewelry. Like Lalique, he designed a series of exceptional jewels in high Art Nouveau mood and, also like Lalique, thereafter turned his attention away from jewelry, in his case to sculpture.

Wolfers was born in Brussels, and his father, Louis Wolfers, was head of the family business of Wolfers Frères, Court Jewelers. Working in his father's workshop, he learnt all the different skills required of a goldsmith and jeweler in the nineteenth-century tradition. He was a modeler, founder, engraver, setter and mounter. He also travelled in Europe as a repesentative of his father's firm, picking up commissions and designing silverware and jewels, at first in the neo-Rococo taste.

Wolfers was impressed by the tide of Japanese art that swept European exhibitions in the 1870s and 1880s, and in the 1880s his style changed from fussy ornament to simple, sweeping outlines, following the drive towards a realistic interpretation of nature. Wolfers' jewels of the 1890s are transitional, made during a period of gestation in which he created, with diamonds and pearls, plants with sinuous and sensuous forms: orchids, irises, fuchsias, freesias, cyclamens.

In 1892 the first elephant tusks from the Belgian Congo arrived in Belgium, just at the time when Art Nouveau was becoming noticed in the capital. King Leopold II wanted to see better use made of this magnificent material, and the use of ivory was suggested to principal Belgian artists and sculptors, Wolfers among them; he carved the ivory skilfully in designs based on floral forms.

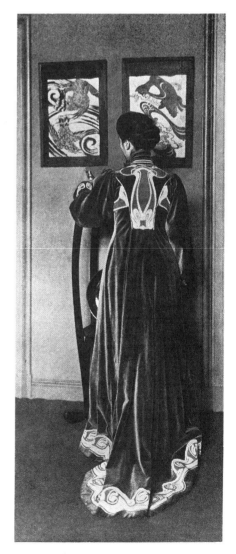

Maria Sethe, Henry van de Velde's wife, wearing a dress designed by him, 1898

The results of the artists' experiments were shown at the International Exhibition at Antwerp in 1894, and at the exhibition of Les Vingt in Brussels in 1895. More ivory was then given to the best craftsmen in Brussels, including Wolfers, in preparation for the International Exhibition in Brussels in 1897, which was a wonderful showcase for the decorative arts generally. As a gift to the Commissioner General of the Congo and a token of the success of the Congo pavilion, Wolfers was commissioned to make a sumptuous bookcover, in gem-set ivory and silver, for an album of photographs showing all the exhibits. At this time, Wolfers was concentrating on sculpture and decorative objects, using bronze and silver, in the Japanese style, and was gradually finding his way towards Art Nouveau.

From the early 1890s, Wolfers set up his own workshop in the Square Marie-Louise, in Brussels. He gathered a team of skilled specialist workers, and together they created Art Nouveau objects and jewels, characterized by supple goldwork enriched with translucent enamels. They produced ivory figures and masks, statuesque birds made of cornelian, tourmaline, opals and other semi-precious stones of unusual colours.

In 1889, he had an Art Nouveau villa built at La Hulpe, and his team went with him, staying in the next village. The garden at La Hulpe enabled him to spend a great deal of time studying flowers and insects, and also peacocks, turkeys, swans and even bats. His most fruitful period came after the 1897 Exhibition. From 1897 to 1905 he made a series of 109 jewels, part of a group of 136 Art Nouveau objects. These were his individual creations, as distinct from the production of Wolfers Frères, and were marked with his monogram and 'ex[emplaire] unique'. By this time, he was also directing designs and productions for the firm. The spectacular jewels made during this period were symbolic, expressive and each given a title. They were considered compositions rather than accumulations of established motifs, and their haunting, often sinister originality and superb craftsmanship makes them some of the greatest pieces of Art Nouveau jewelry. From 1902 to 1904 he concentrated on stylized insects: dragonflies, butterflies, scarabs, praying mantises, using gold and *plique à jour* enamel set with gems. Wolfers exhibited in Munich in 1898 and 1899. He did not exhibit in Paris in 1900 but presented an important collection at the Galerie Aublanc, and a further collection of jewels at the Salon des Beaux-Arts in the showcase of Paul Hankar, the designer of furniture and interiors. The jewels here caused a sensation, and the *Revue des arts décoratifs* in 1901 referred to them as 'ultra-modern'. In 1902 and 1906 he exhibited in Turin, in Liège in 1905, in Milan and Frankfurt in 1906 and in Venice in 1907. He turned increasingly from jewelry to decorative sculpture and by 1908 he had more or less given up jewelry design.

Wolfers' work is extravagant and quite unmistakable. Flowers and insects are carefully selected for their individual characteristics and their suitability to composition and materials. He used a studied interplay of motifs that work on the Art Nouveau theme of metamorphosis: an iris turns out to contain a female mask in carved ivory, serpents' coils are entwined with menacing crab's claws. His repertoire of symbols, animals and flowers is narrower than Lalique's but his output was proportionally smaller. He made good use of the female form in his work, while faces, in carved ivory and hardstone, are often depicted as masks, with unseeing opal eyes, a feature which produces a distinctly ethereal effect (pl. 300). He was especially adept at suiting colour and material to his subjects. An owl, for example, creature of the night, would

be made of dark, dusky amethyst. Many of his jewels, like Lalique's, strive for shock effect and often have a sinister, surreal quality. Others evoke the soft, fresh and innocent beauty of flowers, leaves, wings, in goldwork and exquisite shaded *plique à jour*.

Wolfers' contribution to Belgian Art Nouveau jewelry overshadows the work of other Belgian designers and craftsmen. Jewelry by lesser known or unknown makers is generally characterized by its close association with sculpture, a suppleness of line or flower form, together with the flowing dynamism taken from Horta's architecture.

Leopold van Strydonck was another jeweler who made an original and individual contribution to Art Nouveau jewelry. He was Jeweler and Goldsmith to the Belgian court, and had premises at 79 Montagne de la Cour and 14 Place du Musée. He exhibited with Les Vingt. His work was characterized by the use of oxidized metals, producing contrasts of colour and texture. He worked in coloured gold and patinated silver. He veered away from enamel, using only some translucent colours to emphasize the beauty of his coloured gold. His work is also characterized by a fluid use of goldwork with dainty flower motifs.

Paul Dubois was a jeweler and silversmith who emphasized the sculptural nature of Belgian Art Nouveau. He produced well-modelled silver belt-buckles and clasps, some incorporating flower forms, others tending towards the linear abstract style of Van de Velde.

Holland had its own movement towards the renewal of the arts and, perhaps because of the influences from its Indonesian colonies and its own national craft traditions, it focussed primarily on ceramics and textiles among the decorative arts. Here, as in the rest of Europe, artists fought to free themselves from the ties of earlier nineteenth-century academic traditions, and welcomed the example of English reform in the arts and crafts. In the case of Holland, the essential ingredient of exoticism came from Java, rather than Japan, and it was Javanese batiks that inspired experiments in textile design. Fine art showed the impact and influence of Symbolism, particularly in the work of Jan Toorop (1858–1928) the most important Dutch artist of the period, who was also a member of the Belgian Les Vingt. Toorop's paintings incorporated Art Nouveau elements which were also characteristic of the jewelry of other countries: the sweeping, curvaceous lines with strong rhythmic movement, the depiction of mystical women, probably borrowed from the Pre-Raphaelites, with an air of suffering and longing, the use of gliding swans and rippling water, and, most significantly, the obsession with hair, stylized strands dressed to form a linear Art Nouveau pattern. All this was not, however, carried through to Dutch jewelry design, which developed rather late in the Art Nouveau period, after 1905, and was more closely related to the German abstract *Jugendstil*. It rejected the flamboyant flourish of neighbouring France and Belgium, yet was not as rigorously and starkly geometric as Austrian design.

Lambert Nienhuis (1873–1960) is the only significant Dutch jewel designer in the Art Nouveau style known to date. He was a ceramic artist who turned to jewel design and particularly to enamels, which he taught in Haarlem and then in Amsterdam and The Hague. He is known to have designed a number of jewels for the Amsterdam silversmiths W. Hoeker. These are in the abstract *Jugendstil* manner, with enamel decoration and geometrical outlines that are softened into slight curves, with the occasional tempered swirl. His jewels, late examples, were made between 1905 and 1918.

E. Voet was another silversmith who also designed some jewelry for W. Hoeker. He specialized in belt-buckles, of complex interlaced linear designs influenced by Van de Velde, while other designs showed a definite neo-Renaissance influence.

Scandinavian countries reflected and adapted international trends of European Art Nouveau without actually shaping the development of the style. In the same way that Toorop in Holland shared Art Nouveau's affinity with the Symbolist movement, the Norwegian artist Edvard Munch (1863–1944) was also, to some extent, touched by these influences. Munch spent his formative years in Paris and Berlin and exerted a great influence on German painting. Munch was also preoccupied with the female, and his tormented images are echoed in the struggling female of French Art Nouveau jewels. And yet none of these trends affected Scandinavian jewelry of the period.

Generally speaking, jewel styles were abstract, unemotional, or tending towards a streamlined stylization of organic shapes and traditional folk art. In Norway, for example, there was a revival of medieval *entrelac* ornament, reminiscent of Viking decoration, which, as with Celtic design in England, blended well into Art Nouveau.

During the second half of the nineteenth century, the Scandinavian countries of Denmark, Norway and Sweden had been caught up in the wave of historicism. Samuel Bing had included Scandinavian jewels in his opening exhibition at L'Art Nouveau in 1895, but these were traditional in design and only hinted at the beginning of an artistic revolution. At the Paris International Exhibition in 1900, the Scandinavian section showed revivalist jewels. A new style did not really evolve in these countries until after the turn of the century, and it was not until the 1920s and 1930s that Scandinavia made its mark in decorative design with the Danish jeweler Georg Jensen (1866–1935).

During the Art Nouveau period Jensen was beginning to develop his ideas for jewelry and metalwork. He had trained as a goldsmith and silversmith in Copenhagen, and had studied sculpture at the Royal Academy, a skill which is evident in his silver jewels of the Art Nouveau period and later years. He used the motifs of nature – flowers, animals and fruit – represented in a precise and stylized way which emphasized and flattered the qualities of the materials. These motifs showed a plump, curvy softness that was very different from the attenuated lines of Art Nouveau forms in other countries. Some designs were based on organic themes, skeletal bone-like motifs of sculpted silver, but were almost always figurative. Silver was sometimes set with amber and tortoiseshell. His rounded, shapely forms restored an element of calm to the feverishness of much Art Nouveau jewelry design.

In the late 1890s, Jensen met Mogens Ballin (1871–1914), one of the most innovative Danish painters and metalworkers in the Art Nouveau style. In his jewelry designs Ballin worked in a simple abstract manner, but using softly rounded, sculptural forms and outlines. He made combs, clasps and buckles in silver and bronze. Around the turn of the century Jensen worked with Ballin and together they produced pewter and silverware. It was with Ballin in 1901 that Jensen started to make silver jewelry.

In 1904 Jensen opened his own shop selling jewelry and silverware. In the following year he exhibited at The Hague, very successfully, and in 1907 began working on designs with the painter Johann Rohde. It was during this collaboration that Jensen developed his highly individual style associated with the 1920s, very simple and stylized.

Continued on p. 209

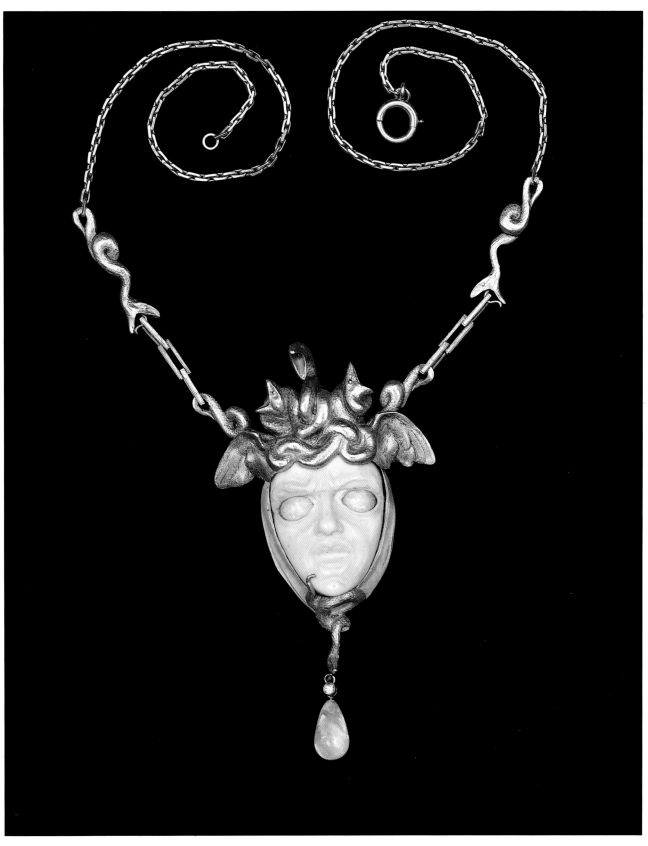

300 **Philippe Wolfers** Medusa-head pendant, the grimacing ivory mask set with opal eyes, the hair formed by chased gold serpents with enamel decoration. Belgium, 1898.

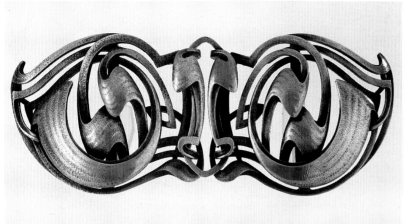

301

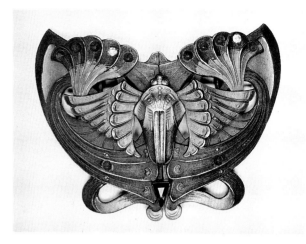

302

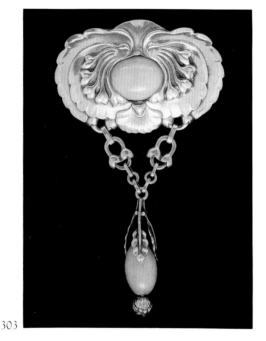

303

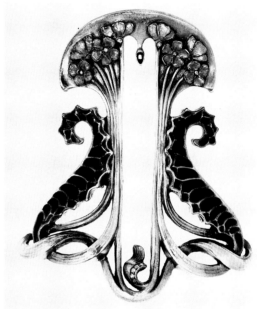

304

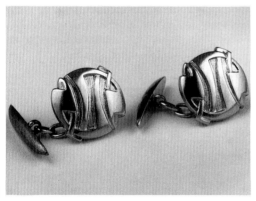

305

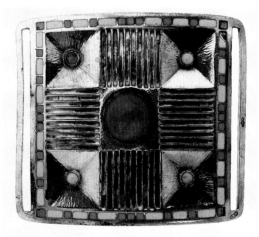

306

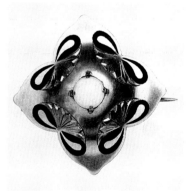

301 **Henry van de Velde** Belt buckle of silver, partly oxidized, showing Van de Velde's compact but dynamic lines. Belgium, c. 1898–1900.

302 Silver-plated belt buckle set with amethysts and imitation citrines, made in Gablonz. Bohemia, c. 1900.

303 **Georg Jensen** Silver brooch set with amber. Denmark, c. 1900.

304 **Paul Liénard** (designer) and **K.S. Bolin** (maker) Gold and enamel buckle. Russia, 1903.

305 **Henry van de Velde** Gold cufflinks. Belgium, c. 1900.

306 **Jan Eisenloeffel** Silver and enamel buckle set with hardstones. Holland, c. 1900.

307 **Lambert Nienhuis** Silver and enamel brooch set with an opal. Holland, c. 1910.

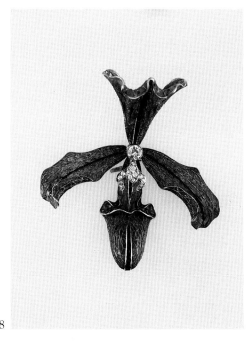

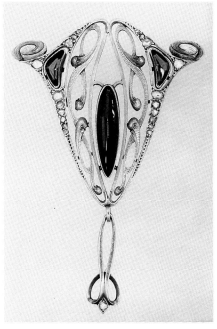

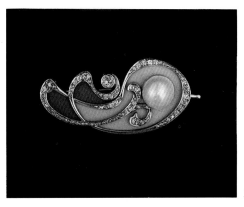

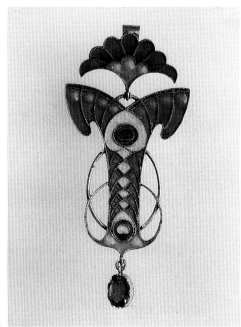

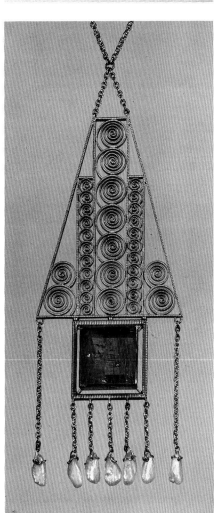

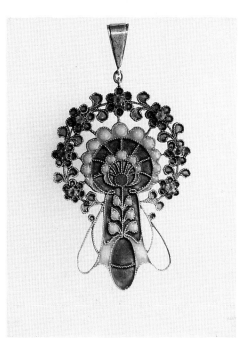

312

308 Philippe Wolfers Gold hair ornament enamelled in blue *plique à jour*, set with diamonds and rubies. Belgium, 1902.

309 L. Pompe Gold pendant set with peridots and diamonds, the fluid outlines in the style of Leopold van Strydonck. Belgium, c. 1900

310 Peter Carl Fabergé Gold brooch set with a pearl and diamond and decorated with pink and green enamel. Russia, c. 1900.

311 Oskar Huber Silver gilt pendant with characteristic bright enamelwork in strong sky-blue, light grey-blue and red, hung with a garnet. Hungary, c. 1902.

312 Maria Křivánková (designer) and **M. Schober** (maker) Gold pendant set with an emerald. Czechoslovakia, c. 1910.

313 Oskar Huber Silver gilt pendant, enamelled in deep blue, green and red, and set with amethysts. Hungary, c. 1902.

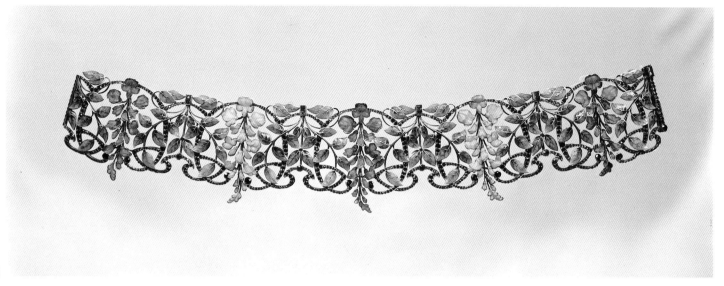

314

315

31

314 **Philippe Wolfers** 'Glycines' ('Wisteria'). Dog collar with densely clustered flowers in shaded enamel on gold, set with carved tourmalines and opals, rubies, garnets and Baroque pearls. Belgium, 1902.

315 **Leopold van Strydonck** Pendant of delicate leaf design, in gold, diamonds, emeralds, agates and enamel. Belgium, c. 1900.

316 **L. Bozza** Gold bracelet of pearl-set vine leaves and tendrils, reflecting the lingering classicism in Italian jewels. Italy, c. 1890–1900.

317 **Philippe Wolfers** 'La Nuit.' Pendant showing winged nude female body sculpted in cornelian, the wings of *plique à jour* enamel, standing on a curled opal leaf. The branch-like setting is of gold and enamel, and the whole set with diamonds and cabochon rubies. Belgium, 1899.

318 **Christian Thomsen** (designer) and **A. Michelsen** (maker) Painted porcelain buckle made by the Royal Copenhagen Porcelain Factory and mounted on silver by Michelsen. Denmark, 1905.

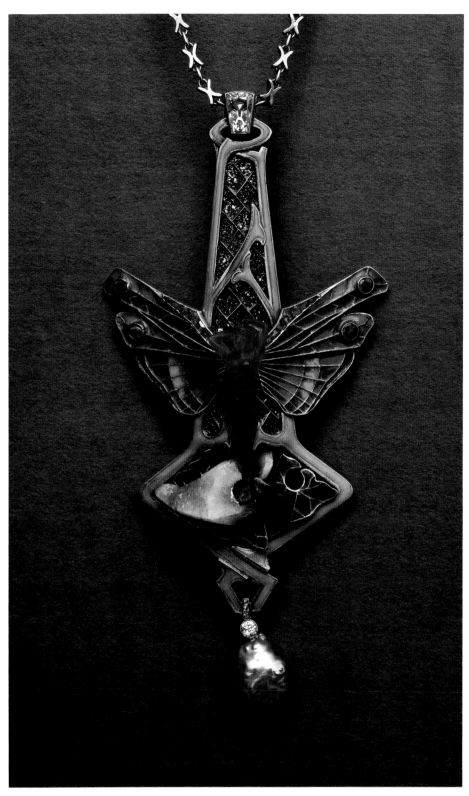

317

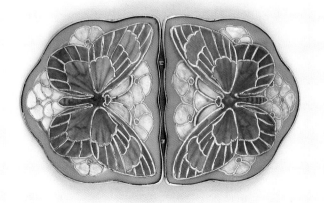

318

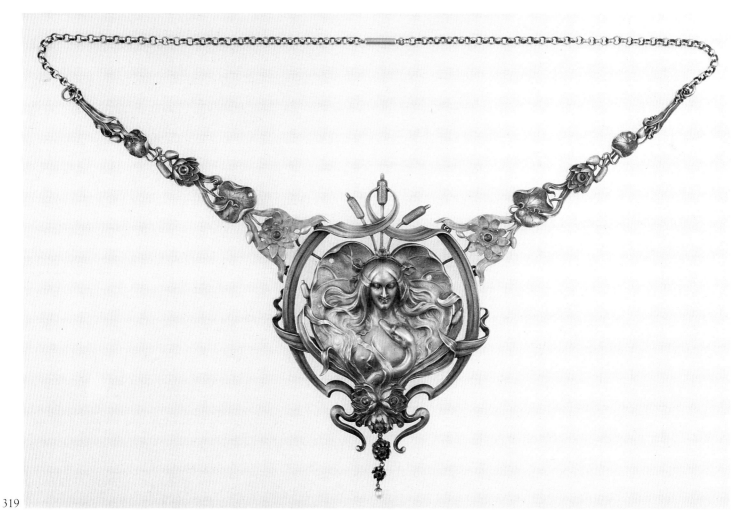

319

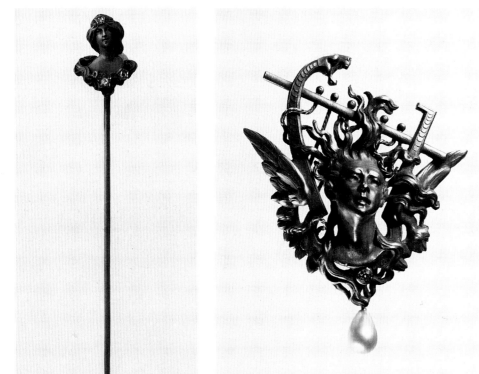

320

321

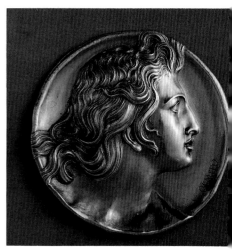

322

319 **Alfred Jacot-Guillarmod** Necklace representing Leda and the Swan, in oxidized silver, partly gilt in two colours, and set with diamonds, rubies, and an emerald. Switzerland, c. 1905.

320 **Vallot** Gold tie-pin, with female motif, her hair and neckline set with diamonds. Switzerland, c. 1900.

321 **Pochelon et Ruchonnet** Chased gold brooch, with a diamond and a pearl drop, representing the head of Orpheus, with lyre, wing and serpent motifs, Switzerland, c. 1900.

322 **Vincenzo Gemito** Circular plaquette of gold with a profile head of Alexander the Great. Italy, c. 1900.

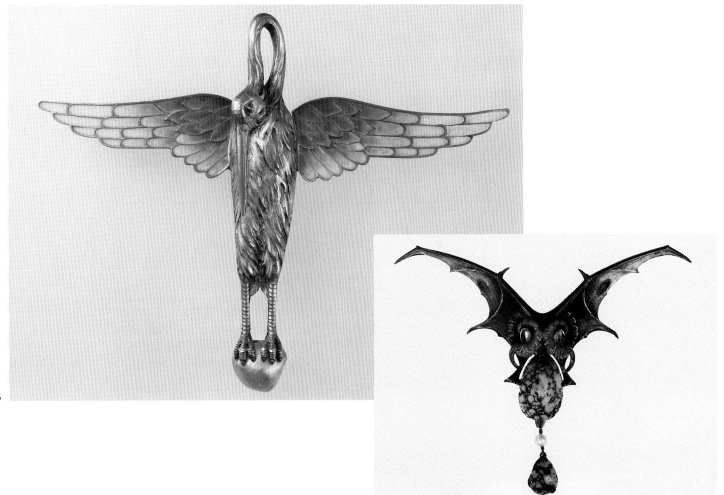

23

324

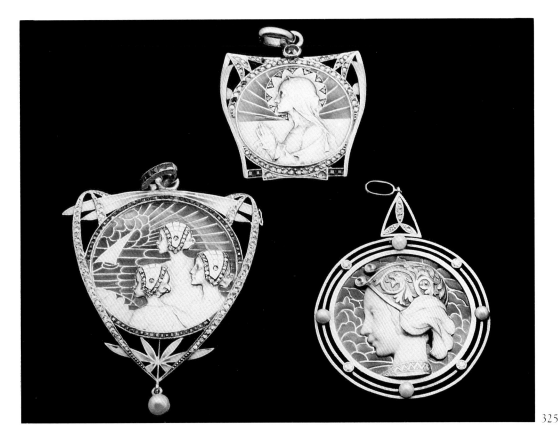

325

323 Gold brooch in the form of a pelican, with outstretched wings, in *plique à jour* enamel, set with a Baroque pearl. Spain, *c.* 1900.

324 **Pochelon Frères** Pendant of silver and gold, in the form of a stylized owl's head, flanked by bat's wings, the body a large turquoise. Switzerland, *c.* 1900.

325 **Luis Masriera** Three small gold and blue *plique à jour* enamel pendants, with motifs of Dutch girls, a madonna and a girl in a medieval headdress. Spain, *c.* 1900.

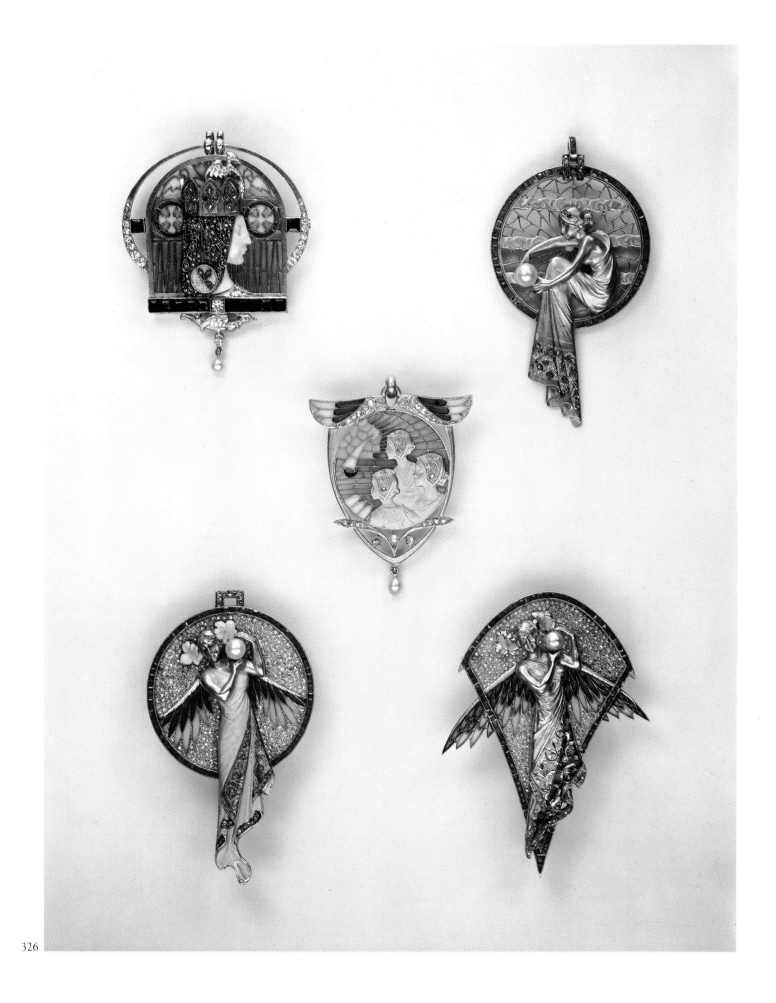

326 **Luis Masriera** Group of gold jewels set with *plique à jour* enamel and gems, c. 1900–05.

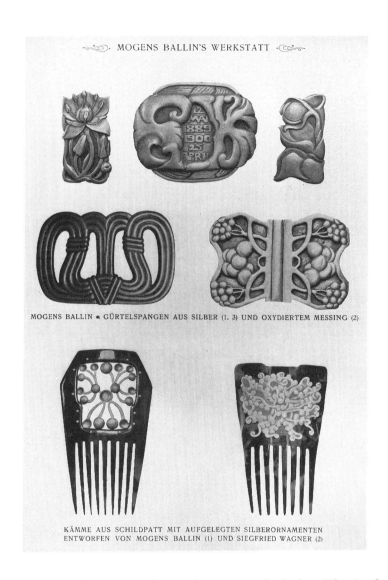

Belt buckles and haircombs from the
workshops of Mogens Ballin

An article on modern Danish jewelry was included in *The Studio's* special
supplement in 1901–02. It is interesting to note that this began by pointing
out that designers had devoted little attention to jewelry, and had concentrat-
ed on other crafts. Harald Slott-Möller's work was discussed in particular,
and his name, it was said, took the place of honour among modern Danish
jewelers. In his designs, which were often made up by Michelsen, the Danish
Court Jeweler, there was more than a trace of English influence, especially in
his enamelled silver jewels which frequently had a narrative quality or were
allegorical. These often reflected the folk art element in Scandinavian design,
with motifs such as a Viking galleon, a mermaid or a fish.

Other Danish jewelers mentioned in the supplement included Thorvald
Bindesbøll (1846–1908) who developed a simple abstract style. Bindesbøll
was an architect who turned his attention to the decorative arts and helped to
develop the streamlined Danish style that was so popular in the 1920s. His
work is very similar to that of Jensen and Ballin.

New linear abstract designs affected domestic metalware in Sweden, but do
not appear to have reached jewelry design at this stage.

In Russia, late nineteenth-century craftsmen had also turned to traditional
folk art for inspiration, and this signalled the start of a renewed interest in the
arts. Around the turn of the century, Carl Fabergé (1846–1920), Goldsmith to
the Russian Imperial Court, was creating legendary jewelled and enamelled

trinkets, exquisitely made in the manner of French eighteenth-century styles. Fabergé had a lively and enquiring mind and was always receptive to new ideas. He exhibited for the first time at the Paris International Exhibition in 1900, showing a diamond diadem and his treasured bibelots and Easter eggs. In the previous year, however, he had changed moods and created one of the annual Imperial Easter eggs in the Art Nouveau style, with opaque enamelled pansies, the base designed as a swirling twist of silver-gilt leaves and twigs. Fabergé was not interested in creating a Russian Art Nouveau, but used the decorative elements of the style to create fashionable objects such as cigarette cases. Only occasionally did he venture to use the new style for his jewels, which generally lacked the originality and vitality of his objects. They incorporate fluid, ribbon-like but somewhat formal gold outlines, combined usually with typical Fabergé enamels such as silky pink or elegant blue-grey *guilloché* (translucent enamel on a mechanically engraved background), and sometimes motifs of leaves or plants in gold. Fabergé's craftsmen did occasionally use *plique à jour* enamel, in a colourful but rather formal style.

W.A. Bolin, another firm of goldsmiths, were also jewelers to the Imperial Court, at the turn of the century, with premises in St Petersburg and Moscow. The company, which had been founded by a Swedish family in 1845, moved to Sweden in 1914. During the Art Nouveau period they were noted for their execution of a design by the leading French Art Nouveau jeweler Paul Liénard: a buckle with a flower and seahorse motif stamped 'Bolin 1903', which was illustrated in René Beauclair's *Neue Ideen für Modernen Schmuck* (1901) (pl. 304).

The powerful attraction of the new style reached into Eastern Europe, where the manufacturing centres such as Turnau and Gablonz in Bohemia (now part of Austria and Czechoslovakia) took their lead in fashions and designs from Paris and other European capitals. There was a wealthy and fashion-conscious clientele for Art Nouveau jewels almost everywhere in Europe, and manufacturers were eager to cater for this demand. Bohemian pyrope garnets, the little blood-red, rose-cut stones so popular in the nineteenth century, were now used in small, seductively curving settings. In Gablonz, the goldsmith and teacher Eugen Pflaumer, who had worked with the Wiener Werkstätte, brought the Austrian geometric style to Bohemia, while in Prague designers and students followed the celebrated lead of Mucha, creating jewels based on the female motif with luxuriant hair. Styles from France, Germany and Austria were absorbed by the jewelry industries and translated into fashionable, attractive jewels, exported from the mass-manufacturing centres in Eastern Europe all over the world. In Hungary, Oskar Huber of Budapest made an individual contribution to jewel design with his pendants in colourful enamels, which he exhibited at Turin in 1902. Solid shapes of textured colour contrasted with thin, curling or draped outlines.

In Switzerland, individual artists adapted their work to accommodate Art Nouveau lines and characteristics, without establishing a strong national identity. Geneva, especially, as an important jewelry and watchmaking centre, adapted to Art Nouveau with flair and style, in the French taste. Pochelon et Ruchonnet were leading Swiss Art Nouveau jewel makers, and others included Fleuret, Vallot, Golay Fils et Stahl and Henri Preysler. Fleuret and Vallot, both Geneva firms, used the winged female motif, while Pochelon et Ruchonnet and Preysler often used the image of flying birds or bats with outstretched wings, giving the impression of swift movement. Such

jewels were well executed in chased gold and silver, or were decorated with enamels. Preysler also used the insect and winged scarab motifs. Vallot preferred undulating seaweed, also borrowed from Parisian designers like Maurice Dufrène. Watchmakers from Geneva decorated fashionable pocket watches and brooch-watches, again in the French Art Nouveau style.

Italy was too deeply entrenched in classical traditions to create a national style of its own. As we have seen, the Italians called Art Nouveau *Stile Liberty*, borrowing the name from the English firm. The eclectic historicism of the nineteenth century still governed Italian decorative design through the turn of the century. Italian jewelry shown at the Paris International Exhibition in 1900 was in the archaeological revival taste, which had been born in Italy in the mid nineteenth century. This 'ancient-looking' style was still much in demand by visitors to Italy's ancient monuments and it was to this market that the jewelry trade was geared. One firm, however, called Vincento Miranda of Naples, exhibited in Paris in 1900 with a gold buckle in fine French Art Nouveau style decorated with flower motifs. At the Turin Exhibition in 1902 a Turin jeweler called Musy exhibited simple French-style jewels.

It was the floral emphasis of Art Nouveau that was most appreciated in Italy – *Stile Floreale* was one alternative Italian name for the new style – along with the principals of English Arts and Crafts, and both influences were reflected in the work of a handful of designers and architects such as Carlo Bugatti (1856–1940) and Ernesto Basile (1857–1932) who were searching for a fresh artistic direction. Little attention, however, was focussed on jewelry. This may have been because the Italians had already taken the lead, world-wide, in jewelry design and manufacture in the second half of the nineteenth century, with the exceptional skills and talents of goldsmiths like Castellani, and jewelry was therefore not in the state of degradation bemoaned in other countries. Innovative, modern designs were not made in Italy until after the First World War.

Cameos had been among the most popular items of jewelry in Europe and America from about 1800 to the late 1880s, and Italian production of these, especially in shell, had become very important in the nineteenth century. Some cameos were carved in the Art Nouveau manner but these are extremely rare. It is significant that *The Studio*'s special supplement did not include a chapter on Italian jewelry.

In Spain, Art Nouveau (or *Arte Joven*, 'New Art', after a periodical of that name; or *Modernista*) was confined almost entirely to architecture in Barcelona, and the creative genius of Antonio Gaudí. When it came to jewelry, 'modern' design was based primarily on French examples. Luis Masriera (1872–1958) made the only significant contribution known to date to Art Nouveau jewelry.

Masriera was born in Barcelona, a thriving artistic centre from 1890 to 1900, where the Art Nouveau movement found its foothold. He was the son of a painter and goldsmith and with his brother he took over the family jewelry firm, which specialized in making traditional Spanish ornaments. At the age of seventeen, he went to study at the Geneva Académie des Beaux Arts, under the famous enamellist Lossier, who based his teaching on seventeenth-century painted Limoges enamel. Masriera's name was first mentioned in the same year, 1889, as an exhibitor at the International Exhibition in Paris, which featured an enamel vase by Masriera that was offered as a gift to the President of the Exhibition.

An important turning point was Masriera's discovery of Lalique's work. He had met the artist at various exhibitions but it was Lalique's astonishing display at the International Exhibition in 1900 that persuaded Masriera to change his style completely. It is said that he came home to Barcelona, melted down his entire stock, closed his shop for six months and reopened with a display of his own versions of Art Nouveau jewels. They had immediate success and he sold out within a week.

Many of Masriera's themes are the same as those of French Art Nouveau, particularly nymphs with floral aureoles, and bird brooches strongly influenced by Japanese art and a variety of flower themes, from well-observed, realistic depictions to more symbolic, organic representations. Perhaps his most distinctive works were the religious jewels using Catholic motifs such as the Virgin Mary with a halo.

Small gold pendants by unidentified designers also made at this time, using a motif of the veiled Virgin Mary set against a background of *plique à jour* enamel, were probably influenced by Masriera. They show the Art Nouveau influence in their use of softly shaded *plique à jour* and the gently undulating goldwork of their outlines.

One of the best of Masriera's jewels is the Isolde pendant, made during the height of the popularity of Wagner's operas in Barcelona around 1900. It is a highly allusive work, depicting the profile of the medieval Queen set against a *plique à jour* Gothic window (pl. 326, top left).

Art Nouveau touched the decorative identities of most countries. Because of its role in fashion and because of the large manufacturing centres in Germany and Eastern Europe, jewelry more than any of the decorative arts was subject to an interchange of designs, a process which was augmented by the increasing number of periodicals, and which makes nationality very often hard to pinpoint.

If Art Nouveau jewelry was the most extreme expression of the style, it was also in the end the most commercialized. Gradually the style spread through Europe from its ideological centre in Paris where designers had devoted their attention to the re-creation of the jewel as a work of art. After 1900 the Art Nouveau jewel became high fashion and, as the motifs and themes were copied, often indiscriminately, the style became diluted, its initial force undermined. This popularization, ironically the aim of Arts and Crafts exponents, finally led to the eclipse of the Art Nouveau jewel.

The excesses of French Art Nouveau had left early expectations for a new and lasting style largely unfulfilled. Although striving to break away from the past, Art Nouveau designers were still constricted by their bonds with the nineteenth century; their interpretations were new, but the emphasis was still on surface ornament, figurative forms and the representation of nature. The impact of the style, however, succeeded in drawing the attention of architects, sculptors and painters to the decorative arts, including jewelry, by offering them fresh opportunities for self-expression.

Art Nouveau left a two-fold legacy to twentieth-century jewel design. In Paris a group of young designers including Charles Boutet de Monvel and Charles Rivaud offered hope for the future of the 'art' jewel. They worked at the end of the period, around 1910, making full use of materials and concentrating on line and form rather than on melodramatic representations of flowers and females, while in Germany and Austria, it was the abstract version of *Jugendstil*, based on crisp, geometrical lines, which was to lead to the styles of the machine age and the Modern Movement.

Decorations for pp. 213–40: designs by Henry van de Velde.

212

Notes to the Text

Introduction (pp. 7–24)

1. Munn, Geoffrey, *Castellani and Giuliano, Revivalist Jewellers of the Nineteenth Century*, London, 1984.
2. *Art et décoration*, vol. III, Paris, Jan.–June 1898.
3. Quoted in *Art Nouveau*, ed. Peter Selz, Museum of Modern Art, New York, 1959.
4. Peter Selz (ed.) *Art Nouveau*, Museum of Modern Art, New York, 1959.
5. 'Modern Design in Jewellery and Fans', special supplement to *The Studio*, London, 1901–02.
6. *La Revue de la bijouterie, joaillerie, orfèvrerie*, vol. I, Paris, 1900.
7. *Art et décoration*, vol. I, Paris, Jan.–June 1897.
8. *Artistic Japan*, vol. 5, London, Sep. 1888.
9. Peter Selz (ed.), *Art Nouveau*, Museum of Modern Art, New York, 1959.
10. Robert Melville, 'The Soft Jewellery of Art Nouveau', *Architectural Review*, London, May 1962.
11. Henri Vever, *La Bijouterie française au XIXe siècle*, Vol. III ('Conclusions'), Paris, 1908.
12. Walter Crane, from a lecture entitled 'Transaction of the Art Congress', Edinburgh, 1889.
13. Alphonse Fouquet, *Histoire de ma vie industrielle*, Paris, 1899.
14. Philippe Jullian, *The Triumph of Art Nouveau. The Paris Exhibition 1900*, New York, 1974.
15. Robert Schmutzler, *Art Nouveau*, New York, 1962, London 1964.
16. 'Modern Design in Jewellery and Fans', special supplement to *The Studio*, London, 1901–02.
17. Robert Melville, 'The Soft Jewellery of Art Nouveau', *Architectural Review*, London, May 1962.
18. For details of techniques of working horn, see Cathryn Vaughan, 'Art Nouveau Horn Jewellery', *Antique Collector*, London, Nov. 1982.

Chapter 1: France (pp. 41–96)

1. Samuel Bing, *Artistic Japan*, vol. I, London, May 1888.
2. Samuel Bing, 'L'Art Nouveau', *The Architectural Record*, vol. 12, New York, 1902.
3. Ibid.
4. Dr Martin Eidelberg in *E. Colonna*, Dayton Art Institute, 1983.
5. In his essay on Colonna in the catalogue to the exhibition organized by the Dayton Art Institute (see note 4, above), Dr Martin Eidelberg warns against describing the broom corn designs as Art Nouveau, for he feels they belong firmly in the 1880s. They are, he says, organic in inspiration, but there is no unity yet between the object and its ornament.
6. L. Jouvance, 'Les Bijoux de l'Art Nouveau Bing', *La Revue de la bijouterie, joaillerie, orfèvrerie*, vol. II, Paris 1901. The article tells of Colonna's arrival at L'Art Nouveau, and Bing's apparent surprise at finding just what he was looking for in the young artist's portfolio, but it does not give any dates or factual details.
7. Ibid.
8. Ibid.
9. In his essay on Colonna for the catalogue to the exhibition at the Dayton Art Institute (see note 4, above) Dr Eidelberg points out that Colonna's friend, Brainerd Thresher of Dayton, Ohio, designed jewelry and objects that owe much to Colonna's influence. The New York firm of Marcus and Co. made a pastiche of a Colonna pendant (pl. 295).
10. L. Jouvance, 'Les Bijoux de l'Art Nouveau Bing', in *La Revue de la bijouterie, joaillerie, orfèvrerie*, vol. II, Paris, 1901.
11. Dr Martin Eidelberg, *E. Colonna*, Dayton Art Institute, 1983.
12. 'Modern Design in Jewellery and Fans', special supplement to *The Studio*, London, 1901–02.
13. The life and work of Lalique is covered in great detail in the standard work on the artist by Sigrid Barten, *René Lalique, 1890–1910*, Munich, 1977. Sketchy details of Lalique's life are given in Henri Vever, *La Bijouterie française au XIXe siècle*, vol. III, Paris, 1908.
14. Léonce Bénédite, 'Le Bijou à l'Exposition Universelle', *Art et décoration*, Paris, 1900.
15. 'René Lalique', *Art et décoration*, Paris, Jul.–Dec. 1899.
16. The bronze figures had been given a black encrusted coating.
17. Henri Vever, *La Bijouterie française au XIXe siècle*, vol. III, Paris, 1908.
18. *Art et décoration*, Paris, Sep. 1900.
19. A comprehensive exhibition called 'Les Fouquet' was held in 1984 at the Musée des Arts Décoratifs, Paris, under the direction of Marie-Noël de Gary. The accompanying catalogue, *Les Fouquet*, Paris, 1984, provides the widest coverage to date of the history of the firm.
20. Jul.–Dec.
21. Ibid.
22. Henri Vever, *La Bijouterie française au XIXe siècle*, vol. III, Paris, 1908.
23. *La Revue de la bijouterie, joaillerie, orfèvrerie*, vol. I, Paris, Sep. 1900.
24. Vol. III, Paris, 1908.
25. Roger Marx, *Les Médailleurs français depuis 1789*, Paris, 1897.
26. *Art et Décoration*, vol. I, Paris, 1897.
27. *La Revue de la bijouterie, joaillerie, orfèvrerie*, vol. I, Paris, Sep. 1900.
28. Ibid.
29. Ibid.
30. *La Revue de la bijouterie, joaillerie, orfèvrerie*, vol. 5, Paris, Sep. 1900.
31. Henri Vever, *La Bijouterie française au XIXe siècle*, vol. III ('Conclusions'), Paris, 1908.
32. Ibid.
33. *Art Nouveau*, ed. Peter Selz, Museum of Modern Art, New York, 1959.
34. Henri Vever, *La Bijouterie française au XIXe siècle*, vol. III, Paris, 1908.

Chapter 2: Germany and Austria (pp. 105–36)

1. Robert Schmutzler, *Art Nouveau*, New York, 1962, London, 1964.
2. Henri Vever, *La Bijouterie française au XIXe siècle*, vol. III ('Conclusions'), Paris, 1908.
3. Illustrated in Walter Lochmüller, *100 Jahre Schmuck Design*, Pforzheim, 1973.
4. Illustrated in Henri Vever, *La Bijouterie française au XIXe siècle*, vol. III, Paris, 1908.
5. Hermann Bahr, *Ein Dokument Deutscher Kunst*, Munich, 1901.
6. Issued by the Darmstadt architect and publisher, Alexander Koch, in 1897 and 1889 respectively.

Chapter 3: Great Britain (pp. 153–80)

1. Philip Henderson, *Letters of William Morris to His Family and Friends*, London, 1950.
2. Knox was given his first major showing at the Liberty centenary exhibition at the Victoria and Albert Museum, London, 1975.

Chapter 4: The United States (pp. 181–94)

1. Charles Dekay, *The Art Work of Louis Comfort Tiffany*, New York, 1914.
2. Dora Jane Janson, *From Slave to Siren*, Duke University Museum of Art, Durham, North Carolina, 1971. Katherina Harlow, 'A Pioneer Master of Art Nouveau, the Hand-wrought Jewellery of Louis C. Tiffany,' *Apollo*, London, Jul. 1982.

Biographies of the Jewelers

Aguttes, Georgette
Exhibitor at the Paris Salons in 1902 and 1903, where she was praised for her intelligent interpretation of nature.

Archambaut
French jeweler mentioned by Gabriel Mourey in *The Studio*'s special supplement of 1901–02. He continued to work in the Art Nouveau style until the end of the decade.

Ashbee, Charles Robert (1863–1942)
Architect, silversmith and jeweler, and the most influential designer of Arts and Crafts jewelry. He studied history at Cambridge, and from 1883 was articled to the architect G.F. Bodley. He lived at Toynbee Hall, a philanthropic settlement in London's East End, and in 1887 founded the School of Handicraft there. In 1888 he founded the Guild of Handicraft, a cooperative group of craftsmen, and became its chief designer. In 1890 the Guild moved to Essex House in the Mile End Road, and later acquired two retail shops in the West End: in Brook Street and Bond Street. In 1902, when the Essex House lease expired, the Guild, its workshops and craftsmen moved to Chipping Campden in Gloucestershire. From 1905, the Guild encountered financial problems, and in 1907 it failed completely and went into voluntary liquidation the following year. Ashbee showed with the Arts and Crafts Exhibition Society from 1888, and at several Vienna Secession Exhibitions. His designs were much copied by Liberty and Co. After the failure of the Guild, Ashbee returned to architecture. The Guild of Handicraft was the main inspiration for the Wiener Werkstätte.

Aucoc, Louis (b. 1850)
Son of a well-known goldsmith, Louis Aucoc was an important Paris jeweler and Lalique's teacher and first employer. In 1877 he took over the firm of Lobjois, and founded La Maison Aucoc which produced chased gold Art Nouveau jewels as well as gem-set pieces. Aucoc himself was extremely active in the committees and societies of the jewelry trade. His brother André was also a jeweler.

Augé, Mathilde
French jewelry designer and maker who exhibited at the Salon des Artistes Français in Paris in 1903. She showed an enamel mirror and a brooch made from designs by Mlle Ely Vial, with whom she regularly collaborated.

Auger, Alphonse (1837–1904)
The founder of the well-known Parisian firm of jewelers, La Maison Auger, Alphonse Auger began his career as a gem-setter, and in 1862 set up on his own as a manufacturing jeweler. He worked for major retailers, in partnership with Gabriel Falguières from 1864 to 1870. Until 1878 he worked by himself, when he went into partnership with Guéret, who left in 1889. Auger's son Georges (b. 1864), joined him in 1895, and took over the business in 1900. A new mark for the firm was entered under his name on 29 May 1900. Apart from fine jewels, La Maison Auger made presentation objects, including swords, trophies and album covers. Their premises were at one point in the Place des Victoires, Paris.

Averbeck and Averbeck
American firm of jewelers specializing around 1900 in the mass manufacture of fashionable jewels in the Art Nouveau style. Their premises were at 19 Maiden Lane, New York.

Baker, Oliver (1859–1938)
English silversmith and designer best known for his belt-buckle designs commissioned by Liberty and Co. He also designed silverware and jewelry.

Ballin, Mogens (1871–1914)
Danish painter and Art Nouveau metalworker with whom Georg Jensen worked in the late 1890s.

Basset et Moreau
French jewelry firm mentioned by Vever as producing good 'modern'-style jewels.

Bastanier, Georg
German goldsmith, enamellist and jeweler who worked at Pforzheim in the French style.

Beauclair, René
French designer who compiled a book of designs for Art Nouveau jewels called *Neue Ideen für Modernen Schmuck* ('New Ideas for Modern Jewelry') in 1900–01, in conjunction with several other designers.

Becker, Edmond-Henri (b. 1871)
French medallist, jeweler, woodcarver and sculptor. His sculptures and designs were widely used by many Art Nouveau jewelers. He is known particularly for his work with Boucheron and for his designs for medal-jewels, some produced by Ferdinand Verger and chased by Paul Richard, others in cheap gilt metals which bear his signature and the mark FIX or FIXE. He exhibited at the Paris Salons from 1898 onwards, and his work around 1901 and 1902 won him much praise in art journals.

Beetz-Charpentier, Eliza
Dutch-born sculptress who worked in Paris and designed jewels for Samuel Bing. These were exhibited in 1899 at the Grafton Galleries in London. She married the sculptor Alexandre Charpentier, her teacher.

Behrens, Peter (1868–1940)
German architect, illustrator, artist-craftsman, graphic artist and founder (in 1893) of the Munich Secession. He designed some jewelry while at the Darmstadt artists' colony from 1899 to 1903. He was head of the Düsseldorf Kunstgewerbeschule from 1903 to 1907. In 1906 he designed publicity material for the AEG electrical plant in Berlin and was the firm's architect from 1907 to 1914, designing some of its products as well as its buildings. In 1908 he designed four typefaces. He was a prolific and versatile designer and a pioneer of the Modern Movement and of industrial design, from about 1901 until the 1930s. From 1922 to 1936 he taught architecture at the Vienna Academy.

Belville, Eugène
French jeweler who exhibited regularly at the Paris Salons, and who was noted for his skill in translucent enamels. A pendant exhibited at the Salon of 1904, for example, incorporated the motif of a bleeding heart flower.

Bindesbøll, Thorvald (1846–1908)
Danish architect who became the most influential of Danish decorative designers. He designed silver and jewelry which was executed by the Danish Court Jewelers, A. Michelsen, and exhibited by them at the Paris 1900 International Exhibition.

Bing, Marcel (1875–1920)
The son of Samuel Bing, Marcel Bing worked as a designer at his father's gallery, and studied at the Ecole du Louvre. His designs for bronzes and jewelry were exhibited in Samuel Bing's pavilion at the International Exhibition of 1900. After his father's death in 1905 he took control of the gallery.

Bing, Samuel (1838–1905)
Not a designer, but the key figure in bringing together avant-garde designers and in providing the name for the movement, from that of his Paris gallery, L'Art Nouveau. Born in Hamburg, he moved to Paris in 1871 and opened a shop selling Oriental art and objects. His success led him to travel to the Far East in 1875 and to open a second shop. He exhibited at the Paris International Exhibition of 1878 where he met Edward C. Moore, chief silversmith for Tiffany and Co. Bing became

Tiffany's agent in Paris in 1889. In the 1880s he opened a New York branch and in 1888 launched a monthly illustrated journal called *Le Japon artistique* (*Artistic Japan*). After a visit to America in 1893 to investigate American decorative art for the French government, Bing decided to change his Oriental gallery into a gallery for modern art. L'Art Nouveau was opened on 26 December 1895 with an international exhibition of Art Nouveau. Bing had his own pavilion, 'Art Nouveau Bing', at the International Exhibition in Paris in 1900, with interiors designed by Georges de Feure, Eugène Gaillard and Edward Colonna, who also designed jewels for Bing. His display was widely influential, but L'Art Nouveau was not a financial success. Bing's son Marcel took over the gallery and by 1905 had reverted to selling Oriental art.

Bocquet, F.
French jeweler who exhibited rings and brooches at the Paris Salon of 1903. These were described as well designed and well made.

Bolin, W.A.
Russian firm of goldsmiths, and Jewelers to the Imperial Court, founded in 1845 in St Petersburg by a Swedish family. Branches were later opened in Moscow and in Germany in Bad Homburg-an-der-Höhe. At the start of the First World War the firm moved to Stockholm and have remained Swedish Court Jewelers to the present day. They produced some Art Nouveau jewels around 1900, one of which is signed K.S. Bolin.

Bonny, Louis
Inventive French jeweler, who worked with floral themes and used precious stones. At the Paris Salon of 1902 he exhibited a necklace of vine leaves and succulent hanging clusters of grapes made of enamel, diamonds and emeralds. He also made a diadem with the Gallic motif of cockerels fighting for a topaz.

Bonté, Mme
French designer and maker who specialized in decorative horn jewelry, especially pendants. Her workshops were merged (exact date unknown) with those of her main rival George Pierre (GIP), and they worked together in the Art Nouveau style until 1936.

Bonval
French craftsman who was praised in art journals for a haircomb exhibited at the 1902 Paris Salon.

Bosselt, Rudolf (1871–1938)
German sculptor and medallist and member of the Darmstadt artists' colony from 1899.

Bottée, Louis Alexandre (1852–1941)
French sculptor and medallist, who had been a pupil at the Paris Ecole des Beaux Arts. He made medal-jewels from about 1890 and in 1900 designed jewels for Sandoz and Vever.

Boucheron
Jewelry firm founded in Paris in 1858 by Frédéric Boucheron (1830–1902). They rapidly gained a high reputation for lavish gem-set jewels and in the 1860s moved from the Rue Royale to the Place Vendôme. Boucheron adapted to Art Nouveau designs in both *joaillerie* and *bijouterie*, commissioning work from contemporary artists, notably the sculptor and woodcarver Edmond-Henri Becker. Boucheron's display of diamond jewels in softly curving Art Nouveau lines at the International Exhibition in 1900 was much praised in art journals. Designers who worked for Boucheron included Louis Rault (1847–1903), Michel Menu and Comte d'Epinay de Briort.

Boutet de Monvel, Charles (b. 1855)
Highly original French jeweler. He was born in Paris and attended the Ecole des Beaux Arts from 1874, later studying medal engraving there under Ponscarme. He only started making jewelry in about 1898 and went on to exhibit regularly at the Paris Salons, winning critical acclaim after 1900. He used unusual symbolic-organic motifs combined with an imaginative use of materials. His favourite motifs included marine plants, dragonflies, pea pods, spiders, lizards, shells and seahorses. In 1901 he exhibited at the first Studio International Exhibition in London. He was referred to in *The Studio* in 1901 as one of the 'friendly rivals from Continental ateliers' and his jeweled snakes, lizards and 'other uncanny beings' were described as 'strikingly fanciful'. He was one of several young designers who worked in a forward-looking style, less opulent and glamorous than early Art Nouveau.

Bouvet, R.
French jeweler who participated in the 1908 exhibition of jewels at the Musée Galliera in Paris.

Brandt, Edgar (1880–1960)
French metalworker who showed a series of jewels at the exhibition of jewels at the Musée Galliera in 1908. These were in gold and silver, wrought and *repoussé*, and were described in *Art et décoration* as well-made, sober and subtle. He used simple leaf motifs, set with 'discreet' stones such as pearls and opals. He became much more famous in the 1920s.

Brandt, Paul Emile
Swiss Art Nouveau jewelry designer who studied in Paris and set up in the Rue des Saints Pères. He made watches and jewels in floral Art Nouveau forms.

Bricteux, Antoine
Founder of the Paris jewelry firm of the same name. He used designs by the young designer and competition winner Landois, and produced Art Nouveau jewels around 1899 and 1900. The address of the firm was 29 Rue des Petits-Champs.

Brindeau
French iron worker who made cloak clasps and belt buckles which were much praised when they were exhibited at the Musée Galliera in 1908. He added attractive patinas to the metal.

Brunet, Georges (1847–1904)
Mentioned by Vever as a skilful jeweler who had formerly been an armourer in Reichshoffen.

Bucher, André
French designer and jeweler working in a fluid, linear style, who was praised particularly for his exhibits at the Paris Salons of 1902 and 1903. He designed parasol handles, to be made of carved, tinted wood. He also produced designs for precious metals, set with mother-of-pearl and ivory. His themes were unusual: among the pieces he showed at the Salon of 1902 was one representing a fisherman battling with an octopus.

Bürck, Paul (1878–1947)
German artist and graphic designer, and founder member of the Darmstadt artists' colony. His few jewelry designs were executed by Theodor Fahrner in Pforzheim and D. und M. Loewenthal in Frankfurt.

Burne-Jones, Sir Edward (1833–98)
English painter and designer associated with the Pre-Raphaelites. Born in Birmingham, Burne-Jones studied at evening classes at the Birmingham School of Design from 1848. He met William Morris at Oxford and they became close colleagues. Burne-Jones took up painting in 1855 and became Rossetti's pupil the following year. From 1857 he began to design stained glass, followed by embroideries, ceramic designs, mosaics and jewelry from about 1880. He is famous for his tapestries made by William Morris's firm (1881–94). Burne-Jones's designs for jewelry were made up by Carlo Giuliano in London, and occasionally by Child and Child.

Carabin, François Rupert (1862–1932)
French sculptor, medallist, graphic artist and decorative designer, principally of furniture. Together with Georges Seurat, Paul Signac and Albert Dubois-Pillet, he founded the Société des Artistes Indépendants in Paris in 1884. He modelled statuettes for reproduc-

tion in bronze and pottery, and is known to have designed jewelry, some sculpted from bone in organic designs, incorporating the female face.

Cartier
Internationally famed jewel house founded in Paris in 1847 by Louis François Cartier (1819–1904). In 1872 he was joined by his son Alfred and in 1898 the firm moved to 13 Rue de la Paix. In 1902 Cartier opened a branch in London, and in 1908 Alfred's son Pierre established the New York branch. Cartier persisted with their conventional, gem-set jewels right through the fashion for Art Nouveau, but drew on certain Art Nouveau designers such as Louis Aucoc, Philippe Wolfers, Georges Le Turcq, Louis Zorra and the Charpentier workshop. Cartier excelled in restrained, 'Edwardian'-style diamond and platinum jewels, and later in opulent Art Deco jewelry.

Casaulta
French firm of jewelers who were praised in art journals for their combs, rings and pendants shown at the Salon of 1902.

Chaumet
Paris jewelry firm founded in about 1780 by Etienne Nitot when he opened a small jeweler's shop in the Rue St Honoré. He became jeweler to Napoleon I after he rescued the Emperor from a carriage accident. In 1815 the firm was taken over by Fossin who ran it until 1862 and was succeeded by Prosper Morel, son of the silversmith J.V. Morel who had worked for Fossin. Joseph Chaumet (1854–1928), Prosper Morel's son-in-law, took control in 1889. The Chaumet family has run the business since then. The firm adapted their gem-set jewels successfully to Art Nouveau lines. They exhibited for the first time at the Paris International Exhibition in 1900, and received much praise for jewels using fine stones.

Chéret, Jules (1836–1932)
French poster artist working in the 1880s and 1890s who was famous for his portrayals of *fin de siècle* Paris and women in frivolous and exuberant moods. He was commissioned to translate his typically 'Parisian' designs into gold medal-jewels in the 1880s.

Cherrier
French jeweler who displayed an original range at the Paris Salon in 1902, including a *plaque de collier* representing a landscape of weeping willows reflected in a river.

Child and Child
London jewelry firm flourishing around 1880–1916, noted for their enamelwork, usually on silver. They were established in 1880 at Seville Street and moved in 1891 to Alfred Place West. In 1888 the silvermark registered at Goldsmiths' Company recorded the partnership of Walter Child and Harold Child as plate workers, and they began trading as manufacturing jewelers when they moved to Alfred Place West. They were given a Royal Warrant for Queen Alexandra and executed some designs for jewels by Edward Burne-Jones. The firm was best known for their enamels. The partnership ended in 1899 and Harold Child continued manufacturing gold and silverwares until 1915 or 1916.

Chopard
French jeweler inspired especially by Gallo-Roman jewels but working in the Art Nouveau style, with ivory, silver and enamels, often using animal motifs.

Christiansen, Hans (1866–1945)
German painter, decorative designer and graphic artist who had studied in Hamburg and Munich in the 1880s. He left studies in Paris to join the Darmstadt artists' colony in 1899. His jewel designs were executed by D. und M. Loewenthal in Frankfurt.

Coeylas
Young French jeweler who began working after 1900 and showed promise with jewels exhibited at the Paris Salon of 1902. He received praise for a haircomb with an Art Nouveau motif of a rosebud. He collaborated with René Aucoc in 1902.

Colonna, Edward (1862–1948)
German-born decorative artist and designer, best known for his work for Samuel Bing's gallery in Paris. His father (whose name was Klönne) was a book dealer in Wesel. In 1877 Colonna went to Brussels to study architecture, left Europe in 1882 and settled in New York, where he worked for Louis Comfort Tiffany during 1883 and 1884, in his interior design firm, Associated Artists, on luxurious projects. For the next two years he worked with the fashionable New York architect Bruce Price. Through Price he became chief designer for the Barney Smith Manufacturing Company of Dayton, Ohio, who made railroad cars, a thriving business in the Mid West at that time. In 1887 Colonna published a small book, *Essay on Broom Corn*, a collection of architectural designs. In 1888 he moved to Montreal to work as an independent architect, and he designed for the Canadian Pacific Railway. His jewel designs were first exhibited in Montreal in 1890. He returned to New York in 1893, and later the same year sailed to Europe. Presumably with an introduction from Tiffany or William van Horne (one of Bing's customers for Oriental art whom Colonna met in Montreal), he worked with Samuel Bing from 1898 to 1903. His work was first shown at L'Art Nouveau in 1898, and subsequently at the Paris Salon in 1899 where he won an honourable mention, in London at the Grafton Galleries, at La Libre Esthétique in Brussels and at the Munich Secession, all in 1899. The high point in his career was a much-praised display at Bing's Pavilion at the 1900 Paris Exhibition. He also designed furniture, textiles, silver and small objects. When L'Art Nouveau collapsed in 1903 Colonna returned to Canada. He travelled extensively, returned to New York in 1913, and retired in 1923 to the South of France, where he earned a meagre living as an antique dealer.

Connell and Co.
Manufacturing silversmiths, working in the Liberty style, with premises at 83 Cheapside, London. William George Connell was Director until his death in 1902, and was succeeded by his son, George Lawrence Connell.

Cook, Thomas A.
British jeweler who came from West Ham, London, and who worked in mosaics of small slabs of coloured stone.

Cooper, John Paul (1869–1933)
English architect and silversmith, and one of the most successful Arts and Crafts jewelers. In 1887 he was articled to the architect J.D. Sedding and in 1891 moved to Henry Wilson's practice. While working with Wilson, Cooper became interested in metalworking, which he started in 1897. He taught at the Birmingham School of Art and was head of the metalwork department from 1904 to 1907. In 1906 he started experimenting with Japanese mixed metal techniques. In 1907 he moved to Kent and set up a workshop in Westerham in about 1910.

Coudray, Marie Alexandre (b. 1864)
French sculptor and medallist who studied at the Ecole des Beaux Arts in Paris under Ponscarme, and who produced medal-jewels in the 1890s.

Coulon et Cie, L.
Jewelry firm founded by Léon Coulon and Jules Debût in 1879. They had both been employees of Boucheron, and set up on their own at 12 Rue de la Paix, taking over premises previously owned by the jeweler Samper. The firm were noted for the glamour and quality of their jewels, notably an eye-catching dog collar of peacock-plume motifs in precious stones. They achieved rapid success with their display at the International Exhibition of 1889, where they won a gold medal, and subsequently specialized in fine stones and engraving. Debût left in 1890, and in 1895 Coulon was joined by a Monsieur Deverdun and the firm was named L. Coulon et Cie. At the 1900 International Exhibition

they showed exceptionally fine pieces, using aluminium for extra lightness and whiteness.

Cranach, Wilhelm Lucas von (1861–1918)
German painter, designer and jeweler who studied in Weimar and Paris and claimed to be a descendant of the artist Lucas Cranach. In 1893 he settled in Berlin as a landscape and portrait painter, and started designing jewels during the 1890s. Pieces executed by Louis Werner to his designs were shown at the International Exhibition of 1900. In 1903 the critic Wilhelm Bode made a collection of Von Cranach's designs, which was published in 1905: *Werke Moderner Goldschmiedekunst von W. Lucas von Cranach.*

Cuzner, Bernard (1877–1956)
English silversmith and jeweler who trained with his father as a watchmaker. He left after two years, and turned to silversmithing, working in a Birmingham silver firm and studying at evening classes. He was much influenced by Arthur Gaskin, and began designing for Liberty around 1900. In 1910 he became Head of the Metalwork Department at Birmingham School of Art. In 1935 he published a book called *A Silversmith's Manual.* He retired from teaching in 1942 but continued to make silver until his death.

Czeschka, Carl Otto (1878–1960)
Painter, graphic artist and decorative designer who studied at the Vienna Academy and taught at the Kunstgewerbeschule there from 1901 to 1907. He joined the Wiener Werkstätte in 1904, soon after it started. In 1907 he moved to the Hamburg Kunstgewerbeschule, but continued to send designs to the Wiener Werkstätte. He retired in 1943.

Dabault, E.
Imaginative French jeweler who worked in chased gold and silver, using highly symbolic and romantic themes. At the 1902 Paris Salon he displayed chased gold rings and a jewel showing a nymph perched between two wing motifs. He is most famous for a jewel of silver, enamelled and gilt, again based on the theme of a nymph, but this time entwined with two enamelled serpents, one of which reaches up to her lips for a kiss (pl. 13). It is signed and dated 1901.

Dawson, Nelson (1859–1942) and Edith (n.d.)
Nelson Dawson was an English painter, designer and metalworker who trained as an architect and then studied painting at the South Kensington School. In 1891 he took up metalwork and studied enamelling under Alexander Fisher. He married Edith Robinson in 1893, and taught her enamelling, which she used on his jewelry and silver. In 1900 the Dawsons exhibited 125 pieces of jewelry at the Fine Art Society in London, and in 1901 Nelson Dawson founded the Artificiers' Guild, specializing in metalwork and jewelry. He worked exclusively for the Guild until 1903 but continued to produce jewelry and silverwork, usually with enamels, until 1914.

Debschitz School
Munich school of decorative art, including jewelry design and manufacture, founded in 1902 by William von Debschitz and Hermann Obrist. Pupils were required to design and make the jewels by hand, working in avant-garde, abstract motifs. They included Friedrich Adler (1878–1943), who was active from 1898 to 1906, and Marie Herberger.

Debût, Jules (1838–1900)
French jeweler and goldsmith who worked for Boucheron from 1858 until 1879. He had trained with the Paris jewelers of Téterger and Rouzé, and was made head of the Boucheron workshop in 1866. Debût designed most of the jewelry shown by Boucheron at the 1878 International Exhibition in Paris and some of the pieces made for Sarah Bernhardt. Debût left in 1879 to set up in business with Coulon but they parted in 1890 and Debût opened a jewelry shop at 1 Rue de la Paix. It was not a success and Debût took a job with Froment-Meurice, where he stayed until his death.

Delavilla, Franz (b. 1884)
Austrian painter, sculptor, graphic and decorative designer. He studied at the Kunstgewerbeschule in Vienna and worked in Hamburg from 1909. His jewel designs, in the style of the Wiener Werkstätte, may have been made up by Oskar Dietrich of Vienna.

Deraisme, Georges-Pierre (1865 – after 1930)
Parisian engraver who worked with Lalique until 1908 or 1909, and then independently. He employed twenty workers to deal with Lalique's orders alone. Deraisme used more abstract, spiky lines when he produced his own jewels, one of which was illustrated in *Art et décoration* in July 1912.

Desbazeille, Louis
Parisian jeweler who first went into business with Derouen, taking over the Maison Bourgeois at 24 Rue des Petits-Champs. In 1877 he set up his own firm in the Rue Monsigny. The Desbazeille firm went through three different kinds of manufacture: cameos (1872–82), a varied range of jewels (1882–89) and medal-jewels from 1889 onwards. The latter were their main contribution to Art Nouveau jewelry. In 1881 Louis Desbazeille was joined by his son Germain, who took over the business in 1886. From 1882 to 1885 they made a series of jewels using translucent enamels. Under the direction of Germain Desbazeille, the firm began producing medal-jewels and became early exponents of the art, commissioning work from Oscar Roty and enjoying great success with brooches, buttons and cuff-links. These were all well made, often produced by mechanical stamping methods, then decorated with various patinas. Some were embellished with enamels or diamonds.

Desbois, Jules
French goldsmith and jewelry designer whose jewels are sculptural in form. He concentrated on jewel design around 1902 and 1903, using the female figure in voluptuous attitudes, often sleeping on a carpet of thick flowing hair, against a background of gold or mother-of-pearl. His buckles and brooches were praised at the Salon of 1903.

Descomps, Emanuel-Jules Joë (1872–1948)
Important Paris sculptor, medallist and engraver, who adapted particularly well to Art Nouveau. Little is known about him, except that he had trained thoroughly, specializing in goldwork, with the firm of Falguières. His main skill lay in sculpted and engraved goldwork, which he combined with enamels. He also produced a variety of objects, including goblets and boxes, often incorporating sculpted ivory.

Desprès
Paris jewelry firm founded by Felix Desprès. They were noted for their many small, delicate, diamond-set jewels influenced by the Art Nouveau style in their use of soft swirls and feathery, ribbon-like lines of diamonds. Their jewels were neat and elegant, often set with pearls, and were praised at the 1900 International Exhibition. Felix Desprès was made a Chevalier of the Légion d'Honneur in 1897.

Desrosiers, Charles
French designer who worked for Fouquet and was responsible for the firm's success in the Art Nouveau style. He studied under Eugène Grasset and Luc-Olivier Merson, and then became a teacher himself. He began working with Fouquet around 1895. At the Salon of 1901 his jewels were accused of looking too flat, the enamel being likened to varnished painting and the metal to tooled leather or thin tin. Jewels designed by Desrosiers and made by Fouquet were also exhibited at the Salons of 1899, 1902 and 1903.

Dietrich, Oskar
Commercial jewelry manufacturer in Vienna who executed designs by leading Wiener Werkstätte designers, including Josef Hoffmann and Otto Prutscher.

Dropsy, Jean-Baptiste-Emile (1858–1923)
French medallist who designed popular medal-jewels in the 1890s. His

display at the 1898 Paris Salon won a third class medal. He designed religious medals and plaques, and brooches incorporating the female face, for the firm of L. Chalin among others.

Dubois, Fernand
Belgian medallist, sculptor and jeweler, who had studied natural sciences and later sculpture. He exhibited with La Libre Esthétique in 1894, 1895, 1897 and 1899.

Dubois, Paul
Belgian jeweler and silversmith who worked in a sculptural style.

Dufrène, Maurice (1876–1955)
French decorative designer who was born in Paris and studied at the Ecole des Arts Décoratifs. While still a student he began to work for Julius Meier-Graefe's gallery, La Maison Moderne. In 1902 he was a founder member of the Société des Artistes Décorateurs. He designed interiors as well as objects (fabrics, ceramics, and glass) and jewelry. As early as 1906 he rejected the curvilinear excesses of Art Nouveau and worked in a simple, progressive style anticipating Art Deco. He was a successful and important designer of the 1920s and 1930s.

Duguine, C.
French jeweler or designer, little known. The design of one of his jewels, a gold pendant incorporating two playful water nymphs made in about 1900, was later copied in silver by the American firm of Unger Brothers (pl. 297).

Durand-Leriche
French Art Nouveau jeweler and prize-winner of design competitions. At the International Exhibition of 1900 he exhibited a Loïe Fuller pendant enamelled by Tourette.

Duval, Julien (b. 1856)
Parisian jeweler known for his medal-jewels of sculpted gold, principally designed by Frédéric de Vernon. He had been a pupil at the Ecole des Arts Décoratifs, where he met Georges Le Turcq, who became his partner from 1885 to 1894. Duval continued to produce medal-jewels designed by Vernon.

Eisenloeffel, Jan (1876–1957)
Dutch silversmith and jeweler who studied in Amsterdam and produced silverware for the Amsterdam firm of W. Hoeker around 1896. In 1908 he began working with the Vereinigte Werkstätten in Munich. His style was abstract and geometric.

Endell, August (1871–1925)
German architect and designer, and a protégé of Hermann Obrist. He was born in Berlin but worked in Munich where he was a leading exponent of *Jugendstil*. In 1898 he was involved with the Munich Vereinigte Werkstätten, and designed textiles, graphics and jewelry (although there is no record of what this was like). From 1904 to 1914 he ran a school of design in Berlin and wrote on design and architecture. In 1918 he was appointed Director of the Breslau Academy.

Epinay de Briort, Prosper, Comte d' (b. 1836)
French sculptor and jeweler, who was born in Mauritius and studied in Paris and Rome before settling in 1880 in Paris. He made figurative jewelry, and was an accomplished engraver, translating his sculptural themes into gold medal-jewels. He worked for Boucheron.

Erhart, Ferdinand
French jeweler who adapted well to Art Nouveau and is best known for chased silver belt buckles in floral designs.

Erler-Samaden (Erich Erler)
German jewelry designer working in Munich around 1905–06.

Fabergé, Peter Carl (1846–1920)
Celebrated goldsmith to the Russian Imperial Court and creator of jeweled 'objects of fantasy', notably the annual Imperial Easter eggs.

He specialized in varied enamelling techniques and coloured gold decoration, working mainly in the eighteenth-century French style. Fabergé was twenty-four when he took control of the family jewelry business in St Petersburg, which produced fashionable, traditional jewelry. He changed the emphasis of the business, adding decorative objects remarkable for their design and craftsmanship rather than their value. The first Imperial Easter egg was presented to the Empress Marie Feodorovna in 1884 and led to the famous series of Easter gifts. Fabergé received a Royal Warrant from the Czar in 1884 or 1885. He exhibited his objects of fantasy at the Paris International Exhibition in 1900. They were well received and Fabergé was made a Chevalier of the Légion d'Honneur. In 1903 a branch of the firm was opened in London, and King Edward VII and Queen Alexandra were enthusiastic patrons. After the Revolution of 1917, the Bolsheviks closed the Fabergé workshops. Fabergé escaped and died in Switzerland.

Fahrner, Theodor (1868–1929)
Son of the founder of the firm (also called Theodor, 1823–83), Theodor Fahrner was the most innovative jeweler in Pforzheim. He designed inexpensive, high-fashion jewelry for mass-production in silver or low-carat gold, set with semi-precious hardstones. He collaborated with the London-based firm of Murrle, Bennett and Co., and made up designs by several important German artists around 1900, particularly those at the Darmstadt artists' colony, among them Patriz Huber and Joseph Maria Olbrich. Fahrner also made some jewels designed by Van de Velde, and drew on a very wide range of designs and designers. The firm continued to make fashionable jewels, specializing in marcasite, through the 1920s and 1930s. The firm exhibited in Paris in 1900.

Falguières, Gabriel
Firm of Paris jewelers, based at 23 Rue Notre Dame de Loretta, who changed from conventional, diamond-set pieces to a dramatic Art Nouveau style. Their work was considered highly artistic, although not as original as that of Lalique, and was more regular in composition. They exhibited at various Paris Salons.

Falize, Lucien (1838–97)
The son of Alexis Falize (1811–98), who founded the Falize jewelry firm around 1850, Lucien Falize was instrumental in applying a Japanese style of decoration to jewel design and leading other designers towards Art Nouveau, in an effort to improve standards of jewel design in general. He concentrated especially on the use of *cloisonné* enamel and a fresh interpretation of nature. Lucien took over the family firm in 1876. His father had started the revival of *cloisonné* techniques but had concentrated on technical perfection, while Lucien became a serious student of art and design. In 1862 he went to the International Exhibition in London and was impressed by the jewels he saw at the Crystal Palace, by the Japanese objects on view there and also by the South Kensington Museum. On his return to Paris he was influenced by the collection of the Campana ancient jewels on show at the Louvre. Falize was overwhelmed by the influx of Japanese art and artefacts to Paris, and particularly by the serene designs, colourful enamels and metal alloys. He was discouraged from making a journey to Japan by his parents, and instead worked in Paris with the enamellist Tard, developing a distinctive style of *cloisonné*. He exhibited at the Paris Exhibition in 1878, and in 1880 went into partnership with the Bapst firm, French Court Jewelers. Germain Bapst left Bapst et Falize in 1892. Lucien was succeeded by his son André (1872–1936) who, with his two brothers Jean and Pierre, ran the firm under the name Falize Frères. They made fashionable if rather stiff and formal Art Nouveau jewels around 1900.

Falk, Gebrüder
German jewelry manufacturers in Pforzheim, founded in 1897 by the brothers Fritz and Heinrich Falk. They produced good quality gold and silver gilt jewels in Art Nouveau style, using floral and female motifs. The firm closed in 1926.

Fannière Frères
The brothers Auguste (1819–1901) and Joseph Fannière were nephews of the goldsmith Fauconnier. They became famous in the second half of the nineteenth century for their fine goldwork. Joseph's son continued the business, which at the turn of the century made gold jewels with motifs of mythological animals and creatures.

Feucht, Wilhelm
Pforzheim manufacturer who made up jewels designed by Emil Riester.

Feuillâtre, Eugène (1870–1916)
French goldsmith, sculptor and important enamellist. He was born in Dunkirk and began working and experimenting with enamels at the age of eighteen. He worked with other designers, notably Lalique, until around 1898 when he exhibited at the Paris Salon of the Société des Artistes Français. His enamels were immediately successful, and the Musée des Arts Décoratifs bought one of his pieces, called 'Poppies'. He was working on his own by 1899 and exhibited at La Libre Esthétique in Brussels and at the New Gallery in London in 1898, along with Fouquet and Lalique. He showed jewelry at the Paris International Exhibition in 1900 and at that of Turin in 1902. In 1899 he became a member of the Société des Artistes Français, and exhibited with them until 1910.

Feure, Georges de (1868–1943)
Painter and designer who worked a great deal with Samuel Bing at L'Art Nouveau and exerted a considerable influence on the evolution of Art Nouveau. In 1903 he exhibited small personal accessories at the Paris Salon.

Fiessler, Louis
Pforzheim firm of jewelers working in the French style. The firm was founded in 1857 by Louis Fiessler. After his death the firm was sold by Fiessler's widow to V. Boss and E. Friedrich in 1892. In 1919 the firm was taken over by Fuhrmann and Schaible, who still own it today.

Fisher, Alexander (1864–1936)
Principal English Arts and Crafts enamellist. Jewelry by Fisher is rare, but he exerted a powerful influence on jewelers both in England and on the Continent. He trained as a painter at the South Kensington Schools from 1881 to 1884 before studying enamelling in Paris. In 1887 he set up a studio for enamelled decorative objects and jewelry. He taught enamelling at the Central School of Arts and Crafts from 1896 to 1899 and set up his own school in Kensington in 1904. He wrote extensively on enamelling, including the book *The Art of Enamelling upon Metal* (1906), and exhibited regularly with the Arts and Crafts Exhibition Society. His work was shown at many International Exhibitions.

Fleury, O. de
French jeweler praised for work exhibited at the Paris Salon in 1903.

Foisil
French medallist who applied his skill to jewelry design and in 1899 produced the first medal-jewel to be set with rose-cut diamonds.

Follot, Paul (1877–1941)
French sculptor and decorative artist, and former pupil of Grasset, who is best known as a designer for La Maison Moderne in Paris. He worked in a linear, abstract style, stripped of any figurative or fantastic elements. Art critics praised his work in 1902, pointing out that it did not convey the air of fantasy or nervousness of the age. He first exhibited at the Salon des Artistes Français in 1901, and in 1904 for the first time as an independent artist (La Maison Moderne having closed down). Follot continued to design jewels until 1910–14.

Fonsèque et Olive
Paris jewelry firm founded in 1885 by Emile Olive and a Monsieur Fonsèque. Olive trained at the Ecole des Arts Décoratifs and worked as a designer for his uncle who was a jeweler. His work for the Vienna Exhibition of 1873 led to his becoming a designer for Falize. With Falize, he concentrated on enamelling and goldwork. In 1885 he left to become a partner with Fonsèque, a longstanding friend. Olive was the creative partner. Vever exhibited some of their pieces at the International Exhibition in Paris in 1889. Fonsèque et Olive were particularly successful with their unusual brooches designed as coffee beans (1885) and as clusters of grapes (1889). These were early representations of unusual organic subjects. Fonsèque et Olive were early exponents of the medal-jewel, and they also produced many simple, diamond-set pieces in gentle, modern or Art Nouveau designs which were very successful.

Fontana
Well-known firm of Paris jewelers, which was founded in 1840 in the Palais Royal by Thomas Fontana (1813–61), a Swiss. Success followed and his firm expanded steadily. On his death, his nephews Joseph Fontana (1840–97) and Alexandre Templier, together with other relatives, ran the business until 1871 when his son Charles took over. In 1896 they moved to the Rue Royale. The firm had a reputation for classic, gem-set jewels, which were adapted to some Art Nouveau designs and were exhibited in 1900. Joseph Fontana stayed with the firm until 1881. When he left, he started his own company with his brother, Giacomo Fontana (1847–99), who had also worked with Charles. They kept their shop in the Palais Royal until 1893, when Joseph's son Pierre Fontana (b. 1870) took over the business and it moved to the Rue de la Paix.

Fouquet
Leading Parisian jewelry firm of three generations, the second of which excelled in Art Nouveau jewels. Alphonse Fouquet (1828–1911) founded the firm in about 1860, having worked as a designer with Jules Chaise and Léon Rouvenat. Alphonse's son Georges (1862–1957) took over the business (based at 35 Avenue de l'Opéra) in 1895 and was responsible for the firm's success with Art Nouveau jewels. Fouquet won great acclaim at the Paris International Exhibition of 1900 with jewels designed by Alphonse Mucha. Mucha also designed the new shop when Fouquet moved in 1900 to 6 Rue Royale. Fouquet, together with his chief designer at this period, Charles Desrosiers, continued to make fine Art Nouveau jewels until about 1910–14. Fouquet's first Art Nouveau jewels were exhibited at the 1898 Salon des Artistes Français and continued to be shown annually until 1904 when the firm concentrated on International Exhibitions, including Liège in 1905 and Milan in 1906. In 1919 Georges Fouquet was joined by his son Jean, who excelled in the Art Deco style.

Fourain, A.
Jeweler who participated in the jewelry exhibition at the Musée Galliera in Paris in 1908.

Foy, René
Important Paris Art Nouveau jeweler who made a much-praised contribution to the International Exhibition of 1900, and exhibited subsequently at the Salons. His studio was in the Parc Monceau. Little is known about him, but pieces attributed to him are well made. His work was considered very modern and spectacular. He often used sculpted ivory, translucent enamels and gemstones chosen to harmonize with each other, frequently with the motif of a peacock. In 1900 he exhibited dramatic diadems, one incorporating an enamelled peacock's feather that spread out over the hair, and another of gold mimosa with densely set emerald leaves. He also made small objects. Foy's jewels continued to show great fantasy in subject and materials in the following years.

Frey, Paul (b. 1855)
French jewel designer and manufacturer, who was noted for his novel ideas, original compositions and immaculate production. He had learnt his trade with the Paris jewelers Hamelin and Antoine Touyon, where he made a wide variety of fashionable jewels and personal accessories. He became well known for his innovative ideas, such as a lady's purse which was designed as an owl and made in tooled leather

with a gold frame. He won a silver medal at the 1900 International Exhibition and a gold medal in Milan in 1906.

Froment-Meurice, Emile (1837–1913)
French goldsmith and jeweler and the son of the famous François-Désiré Froment-Meurice (1802–55), who had worked in the neo-Renaissance style. Emile continued this tradition, but made some Art Nouveau jewels for the Paris International Exhibition in 1900. These were still influenced by the neo-Renaissance style.

Fühner, Richard (1875–1921)
German designer of jewels and objects at Pforzheim. After studying in Paris, he became a junior partner in the firm of his father Wilhelm, a manufacturing jeweler who worked closely with Theodor Fahrner and with Murrle, Bennett and Co. of London. One of Richard Fühner's closest friends was Ernst Mürrle, who was also a relative. Fühner himself produced designs in both modern and traditional styles, and the firm made Art Nouveau jewelry, silverware and vases.

Gaillard
One of the most innovative Paris jewelers dedicated to Art Nouveau, and especially influenced by Japanese art and design. The firm was founded in 1840 by Amédée Gaillard at 101 Rue du Temple, with a workshop for gilt copper jewels. In 1860 Amédée's son Ernest (b. 1836) took over the business and concentrated on silver jewels rather than copper. After 1869 he made jewels in niello (the first to be made outside Russia, Germany and Austria). In the 1870s, Gaillard started making unusual trinkets and personal accessories with a hint of Japanese taste. He experimented with mixed metal ornamentation, for which he won a silver medal in 1878, and exhibited his Japanese-style objects at Paris International Exhibitions in 1878 and 1889, and was awarded the cross of the Légion d'Honneur.

Lucien Gaillard (b. 1861), Ernest's son, took over the firm in 1892, although he had been apprenticed in his father's workshop since 1878. He concentrated on alloys and patinations and won a gold medal for his metalwork at the International Exhibition of 1889. In 1900 he moved to 107 Rue la Boétie and soon had Japanese craftsmen brought over to his workshop from Tokyo. After 1900 he embarked on making jewelry, encouraged by Lalique's fantastic repertoire of jewels. He worked extensively in horn and enamels, and his jewels were much praised when they were exhibited at Paris Salons in 1903 and 1904, the height of his creativity.

Gariod, Léon
Important Paris jeweler who specialized in jewels with fine chasing and enamel work. Pendants often featured a diamond in a sunburst setting above the main pendant. The firm was founded in 1859 by Gaucher and Tonnellier. By 1869 Tonnellier had left; in 1875 Gaucher went into partnership with Gariod, but left in 1884, when Gariod became the head of the firm. In the 1880s Gariod specialized in gold chains and bracelets set with stones, and then progressed to jewels in the Art Nouveau style, although continuing to produce classic settings. Léon Gariod worked with Gautrait around 1900.

Garnier, Alfred
French enamellist who exhibited regularly with Paul Grandhomme. The two were introduced in 1877; Garnier had inherited a great deal of money, and Grandhomme, who had virtually nothing, needed his collaboration to produce fine works of art. They exhibited together at the Paris Salons from 1891 to 1898, when they parted company. Grandhomme continued to exhibit alone.

Gaskin, Arthur (1862–1928) and Georgie (1868–1934)
Leading English Arts and Crafts metalworkers and jewelers. Arthur studied at the Birmingham School of Art where he later taught, and both he and his wife Georgie were involved in the Birmingham group of painters and designers. They married in 1894, and exhibited regularly with the Arts and Crafts Exhibition Society, and with the Birmingham group until about 1915. Arthur Gaskin produced some designs for Liberty. Their pieces are not usually marked.

Gautrait, Lucien
Major Paris jeweler noted for his peacock motifs and expert enamels. Little is known about him except that he worked for Léon Gariod as a modeller and chaser.

Gemito, Vincenzo (1852–1929)
Italian sculptor who exhibited at the Paris Salon and International Exhibition in 1900. His sculptural style was translated into small gold plaques for medal jewels.

GIP (Georges Pierre)
Maker of popular horn jewels who became a partner of Bonté.

Giuliano, Carlo (1831–95)
An employee of Castellani, the famous Italian archaeological revival jewelers, Giuliano came to London around 1860 to manage the London branch. In 1874 Giuliano opened his own retail shop at 115 Piccadilly, calling himself an 'Art Jeweler'. He was a skilful worker in the archaeological manner, and his distinctive enamelwork was inspired by Renaissance jewels. He was instrumental in developing the idea of the jewel as a work of art irrespective of its intrinsic value. Giuliano made up jewels designed by Edward Burne-Jones and Charles Ricketts. Giuliano's two sons Carlo and Arthur continued to run the business after 1895, also specializing in delicate enamelled jewels.

Godet, E.
Paris jeweler and enameller whose work shows the influence of Mucha, in its deep colours, often purple and yellow. He is much mentioned in journals around 1900.

Gorham Corporation Inc.
American manufacturers of silver, plate and jewelry founded in Providence, Rhode Island, in about 1815 by Jabez Gorham (b. 1792). At first they specialized in making chain. In 1842, after Jabez Gorham had gone into partnership with his son, the firm was called the Gorham Manufacturing Company. Their range of Art Nouveau silverwork and jewelry was called Martelé. The headquarters was at Fifth Avenue and 36th Street in New York and they also had branches in Chicago, San Francisco, and in London (at Ely Place).

Gosen, Theodor von (1873–1943)
German designer from Munich who worked for the Vereinigte Werkstätten around 1900 in a figurative manner, using dancers or mermaid motifs.

Gradl, Moritz (b. 1873)
German designer of abstract jewels. He studied from 1888 to 1892 at the Kunstgewerbeschule in Munich, and many of his designs were made up by Theodor Fahrner.

Grandhomme et Brateau
Firm founded by the enamellist Paul Grandhomme and the engraver Jules Brateau. Paul Grandhomme was one of the foremost French enamellists in the second half of the nineteenth century, and he continued to work through the Art Nouveau period, sometimes with Alfred Garnier (also an enamellist). Some of the firm's Art Nouveau jewels, based on intricate pierced and chased goldwork, were exhibited at the Salon of 1903.

Grasset, Eugène (1841–1917)
Swiss-born architect and decorative artist who exerted considerable influence on French Art Nouveau jewelry design. He went to Paris in 1871, working as a textile designer and by the 1880s had widened his field to include ceramics, glass and graphic design. He was a leading figure in the development of Art Nouveau and an early devotee of Japanese art. His illustrations for *Les Quatre Fils d'Aymon* (1883), strongly reflecting the Japanese influence, won him recognition and respect. He designed posters, graphics and stained glass which was made by Tiffany for Bing's opening exhibition in 1895. In 1896 Grasset published the first volume of *La Plante et ses applications ornamentales*, a book of plant motifs. A second volume appeared in 1900. Grasset was

commissioned by Vever to design an important group of jewels for the Paris International Exhibition in 1900.

Gross, Karl (1869–1934)
German designer who worked in Dresden as an art teacher, but who originally came from Munich. He designed jewels for the Vereinigte Werkstätten in Munich in 1898 and for the Dresden firm of A. Berger in 1900.

Gross et Langoulant
Paris jewelers known in the late nineteenth century for gold chain, but who also made jewels in the Art Nouveau style.

Guérin, J.
French jeweler from Marseilles who exhibited at various Paris Salons. By 1902 his work, although traditional, incorporated motifs of scrolled outlines, flowers and girls' heads. In 1903 he exhibited a necklace representing a classical scene of ivory figures, decorated with enamel, coral and pearls.

Gueyton, Camille
Son of Alexandre Gueyton, founder of the Gueyton jewelry house. He took over the business in 1833 when Alexandre's nephew died. Camille Gueyton had no knowledge of the jewelry trade, but luckily had a good eye. His jewels are characterized by the use of palm-leaf motifs and also daisies or marguerites, showing the Japanese influence. He made *bijouterie* rather than *joaillerie*, and exhibited regularly at the Paris Salons from 1896.

Gurschner, Gustav (1873–1971)
Austrian sculptor who designed some jewelry. He studied in Munich, in Paris in 1887, and in Vienna from 1884 to 1894.

Habich, Ludwig (1872–1949)
German designer, sculptor and medallist. Having studied in Frankfurt and Munich, he joined the Darmstadt artists' colony in 1899. He left in 1906 to teach in Stuttgart but returned to Darmstadt in 1937. His figurative designs were often made up by Theodor Fahrner.

Hamelin, Paul
Paris jeweler who was known for using very fine precious stones, and who worked in the Art Nouveau style around 1900.

Hamm
One of the most successful French workers, in horn and tortoiseshell after 1900. He produced very simple, almost geometric, shapes and designs, and exhibited regularly at Paris Salons. By 1908 he was accused of being derivative and drawing on Assyrian forms.

Harris, Kate
English designer known for her Art Nouveau silverware and buckles which were made around 1901 by the firm of William Hutton.

Harvey, Agnes Bankier
British jeweler and member of the Glasgow School, who worked in enamels and non-precious metals.

Hauptmann, A.D.
Viennese jeweler who worked in the French style around 1900.

Heiden, Theodor
Munich firm of jewelers and silversmiths founded in 1880. They produced well-designed *Jugendstil* jewels.

Henry, George (b. 1859)
Scottish painter and designer and member of the Royal Academy, he designed a small number of jewels in the Art Nouveau style.

Hesbert, Paul
French jeweler whose horn haircombs were exhibited at the Paris Salon of 1903.

Heurtebise, Lucien Eugène Olivier (b. 1867)
Paris sculptor and jeweler who worked with diamonds.

Hirné
Firm of Paris jewelers who carried out work by the enamellist Fernand Thesmar. Thesmar and Hirné exhibited at various Salons, showing an enamelled orchid in 1902.

Hirtz, Lucien (b. 1864)
Important designer and enamellist who worked with Falize and then with Boucheron from 1893. He was largely responsible for Boucheron's great success at the International Exhibition in 1900, creating both jewels and objects, and using strongly coloured enamels. He continued to exhibit at the Paris Salons.

Hirzel, Hermann Robert Catumby (1864–1939)
Jewelry designer based in Berlin. He attended the Berlin Academy School in 1893, and from about 1897 designed jewelry for Louis Werner. He also worked with the Vereinigte Werkstätten in Munich.

Hoeker, W.
Amsterdam firm of silversmiths who commissioned jewels by leading designers including Lambert Nienhuis and Jan Eisenloeffel.

Hoffmann, Josef (1870–1956)
German-born architect and decorative designer, whose work is associated with Austrian design. He studied in Munich, at the Vienna Academy, and with the architect Otto Wagner. He was a founder member of the Vienna Secession in 1897. In 1903, along with Koloman Moser, he founded the Wiener Werkstätte, backed by Fritz Wärndorfer, a banker. He was the architect and designer of the Palais Stoclet in Brussels (1905–11), working on this project with Gustav Klimt and Carl Otto Czeschka. Hoffmann also designed the Austrian pavilions at several exhibitions including Cologne in 1914, Paris in 1925 and Stockholm in 1930. By the 1920s Hoffmann had changed to a curvilinear style in his metalwork. He designed for the Wiener Werkstätte until 1931, in various media including jewelry, furniture and glass. He was much influenced by the austere rectilinear style of Charles Rennie Mackintosh.

Hoffstätter, J.
Austrian jeweler who worked in silver and horn, mostly in organic designs.

Holbein, Albert (1869–1934) and **Binhardt, Georg** (b. 1876)
German mass-manufacturers of *Jugendstil* jewels around the turn of the century in Schwäbisch-Gmünd. They worked together until 1903. After this Holbein continued to design jewelry in Schwäbisch-Gmünd, working in an austere linear style. Binhardt left Schwäbisch-Gmünd and took up teaching in Solingen and then in Altona.

Horner, Charles
English firm of jewelers and silversmiths, based in Halifax, which pioneered total mass production. Charles Horner Senior was the inventor of the Dorcas thimble, and he was joined by his two sons Charles Henry and James Dobson. The factory was highly mechanized and produced simple versions of Liberty jewels, specializing in hatpins.

Houillon, Louis
French enamellist who contributed to the revival of *plique à jour* enamels. He was the teacher of famous enamellists and jewelers including Etienne Tourette and Philippe Wolfers.

Huber, Oskar
Hungarian jeweler working in Budapest. His gold and enamel jewels were exhibited at the Turin International Exhibition in 1902.

Huber, Patriz (1878–1902)
German architect and designer who was a member of the Darmstadt colony. Born in Stuttgart, he studied in Munich and went to Darmstadt in 1899. His jewel designs were made up by Theodor Fahrner. He committed suicide in Berlin at the age of twenty-four.

Husson, Henri (1852–1914)
French goldsmith and designer of jewelry and flatware.

Hutton and Sons Ltd, William
English firm of silversmiths in Sheffield and London, who in 1901 employed the young designer Kate Harris to give their production an Art Nouveau look.

Ihm
French jeweler and engraver who exhibited haircombs and buckles at the Paris Salon of 1901.

Jacot-Guillarmod, Alfred
Swiss firm of jewelers, medallists and watch-case engravers in Geneva.

Jacquin, Georges
French jeweler who worked in an organic style, concentrating on non-precious materials. At the Paris Salon of 1902 he exhibited a *cloisonné* landscape pendant.

Jacta
Jewelry firm founded in Paris by Eugène Jacta (1815–93), who had been apprenticed to the firm of Crouzet, manufacturing jewelers. In 1848 Jacta took a small shop of his own in the Rue de la Paix, which failed when his financial backer died suddenly. His son Georges (b. 1848) was also apprenticed to a jeweler, and after the Franco-Prussian war of 1870 spent four years in London working with the Italian jeweler Ernesto Rinzi. On his return to Paris in 1875, he became workshop manager for the jeweler Lefebvre. He moved to the firm of Jarry as a designer and eventually took over in 1879 when the firm became known as Maison Jacta. He continued to make fine jewels, mostly of gold, and also personal accessories.

Jahn, A.C.C.
English jewelry designer and maker, who was also Headmaster of the Municipal School of Art in Wolverhampton.

Janvier, Lucien Joseph René (b. 1878)
Parisian jeweler, sculptor and medallist who had been a pupil of Falguières and Antonin Mercié. He specialized in *tour à réduire*, the technique of reducing the designs of engravings or sculptures for use on medals and medal-jewels (see p. 65).

Jensen, Georg (1866–1935)
Danish jeweler and metalworker, born near Copenhagen, who was first apprenticed as a goldsmith and then studied sculpture at the Copenhagen Royal Academy. With the avant-garde painter and metalworker Mogens Ballin, whom he met in the late 1890s, he produced silverware and pewter, later jewelry. He opened his own shop in 1904, selling jewelry and silverware, and participated in the International Exhibition in 1905 at The Hague. His collaboration with the painter Johann Rohde began in 1907 and resulted in Jensen's distinctive sculptural style that was to win him success in the 1920s.

Joindy
French medallist who designed medal-jewels.

Kalhammer, Gustav
Austrian designer whose jewelry designs, in the Wiener Werkstätte style, were executed by Oskar Dietrich in Vienna.

Karst, Karl
Jewelry designer at Pforzheim.

Katrina
French metalworker who also produced medal-jewels and painted porcelain jewels in the Art Nouveau style.

Kerr and Co., William B.
American firm of silver- and goldsmiths and jewelers in Newark, New Jersey, founded by William B. Kerr in 1855. They initially made tableware and gold and silver jewelry. Their mass-produced silver Art Nouveau jewels, in imitation of *repoussé* work, were based on French

designs. In 1906 the firm was purchased by the Gorham Corporation and moved to Rhode Island.

King, Jessie M. (1876–1949)
Scottish decorative designer and member of the Glasgow School. As a student at the Glasgow School of Art she showed talent as a graphic designer. She later lectured in book decoration, in which she specialized. As well as jewelry, she designed fabrics and wallpapers for Liberty from about 1902.

Kleemann, Georg (1863–1932)
Leading German jewelry designer and professor at the Pforzheim Fachschule from 1887. He had studied at Munich, where he had completed an apprenticeship in general decorative design. In 1900 he exhibited at Pforzheim over a hundred designs for jewels and haircombs. His designs were often made up by his students, as well as by firms such as Fahrner, Zerrenner, Lauer und Wiedmann, C.W. Müller and Victor Mayer.

Klimt, Georg (1876–1931)
Austrian sculptor and medallist, the brother of the painter Gustav Klimt. He studied and worked in Vienna, designing and making jewels in gem-encrusted gold and silver.

Knox, Archibald (1864–1933)
Painter and designer of jewelry and metalwork for Liberty. The son of an engineer, he was born in Cronkbourne on the Isle of Man and was educated at Douglas Grammar School. From 1878 to 1884 he studied at Douglas School of Art, where he then taught until 1888. From 1892 to 1896 Knox was probably employed part time in the offices of architect M.H. Baillie Scott in the Isle of Man. In 1897 he took a teaching post at Redhill in Surrey. In 1897 or 1898 Knox contacted Liberty and began to design for his Cymric range of silver and jewelry, which was launched in 1899. Knox returned to the Isle of Man in 1900 and stayed there until 1904 when he started teaching at Kingston School of Art. He continued to submit designs to Liberty, including ideas for silver, pewter, carpets, pottery and textiles as well as jewelry. In 1912 Knox stopped working for Liberty and travelled to America but in 1913 returned to the Isle of Man to teach. He spent the war years there working in the Aliens' Detention Camp. In 1917, when Liberty died, he designed his memorial stone. From 1920 he taught art in Douglas.

Koch, Max Friedrich (1859–1930)
Berlin manufacturing jeweler who produced Art Nouveau jewels in the French style.

Koch, Robert (1852–1902)
German jeweler based in Baden-Baden and Frankfurt. He is best known for his French-style Art Nouveau jewels, although he also executed designs by Joseph Olbrich.

Koehler, Florence (1861–1944)
American Arts and Crafts jeweler and metalworker based in Chicago.

Kolb, Georg
Pforzheim jeweler who helped to develop German *Jugendstil*, using floral patterns in goldwork with enamels.

Křivánková, Maria
Czech designer whose jewel designs were executed by the firm of Max Schober in Prague.

Kuppenheim, Louis
German firm of jewelers in Pforzheim who participated in the Paris International Exhibition in 1900 and who produced jewels from designs by artists of the Darmstadt colony, notably Hans Christiansen.

Lafitte, Gaston
Important French Art Nouveau jeweler noted for his strong motifs and *plique à jour* enamels. Little is known of Lafitte, but he was working

well after 1900, creating some very fine winged female jewels, the wings in unusual, deeply coloured *plique à jour*. He often worked in association with the designers Fourié and Wasley. He exhibited regularly at the annual Paris Salons. In 1902 he exhibited small silver accessories to be hung on chains, including match-boxes and mirrors, all in *repoussé* work and finely engraved, and a pair of lorgnettes decorated in floral Art Nouveau style, similar to his *plaques de cou*. In 1904 he was still producing winged female pendants and brooches, the year in which his album of designs, *Documents du bijou art moderne*, was published.

Lalique, René (1860–1945)
Leading Art Nouveau designer of jewelry and glassware. He was born in Ay on the River Marne, the only son of a Parisian merchant. While still at school in Paris, he studied design with Justin-Marie Lequien Père. He was apprenticed at the age of sixteen to the jeweler Louis Aucoc, and in 1878 went to England, where he spent two years at Sydenham College. While in England he entered numerous design competitions. He returned to Paris in 1880 and spent the following year working for the jeweler Auguste Petit. At this time he also designed fans, fabrics and wallpapers and contributed to the monthly magazine *Le Bijou*, which had been founded in 1874. Lalique contributed two pages of watercolour jewel designs each month for about a year. In the early 1880s he went into business with a Monsieur Varenne. Their designs were signed 'Lalique et Varenne, rue de Vaugirard 84'.

In 1884 Lalique exhibited his own jewels for the first time at the Louvre. In the following year he took over the workshops of the jeweler Jules Destape, and by 1890 the business had expanded and moved to larger premises at 20 Rue Thérèse. From 1891 to 1894 Lalique made a series of dramatic jewels for the actress Sarah Bernhardt which brought him much publicity.

In 1894 he exhibited for the first time under his own name, at the Salon of the Société des Artistes Français. At this time he was also developing both his glassmaking interest and the *tour à réduire* method of reducing a design (see p. 65). Having exhibited at the Société's Salons of the next three years, Lalique triumphed at the Paris International Exhibition in 1900 with a breathtaking display of jewels which sealed his reputation.

In 1902 Lalique moved his workshops and offices to 40 Cours la Reine and in 1905 opened another shop at 24 Place Vendôme. He took part in International Exhibitions in Turin in 1902, Berlin in 1903, St Louis in 1904 and Liège in 1905. He exhibited in London at the Grafton Galleries in 1903, and again at Agnews in 1905. From 1895 to 1912 Lalique was occupied with his most prestigious order of 145 pieces from the Armenian banker Calouste Gulbenkian. In 1906 he was commissioned to produce scent bottles for François Coty and, after 1908, devoted his energies exclusively to glassmaking.

Lambert, Théodore (b. 1857)
French architect and artist-craftsman who designed jewelry as well as interiors. In jewelry he is best known for modernist designs executed by the Paul Templier company. These were linear, symmetrical designs in metal, sometimes in red or green tones, relieved only occasionally by pearls and pierced openwork emphasizing the swirling lines.

Landois
French designer who worked for Louis Aucoc and also designed Art Nouveau jewels for Bricteux. He was a prizewinner in jewelry design competitions organized by the Chambre Syndicale de la Bijouterie around 1900.

Landry, Abel
French Art Nouveau architect and decorative designer. He designed interiors for La Maison Moderne, and made some designs for jewels.

Laporte Blairsy, Léo (1865–1922)
French sculptor and craftsman who specialized in bronze statuettes for lighting fixtures but who also created some jewel designs. His pieces at the Paris Salon of 1903 included a haircomb and a butterfly pendant.

Lauth Sand, Mme
French designer who exhibited objects and jewels in enamel and goldwork at the Salon of 1903.

Le Couteux, Lionel
French designer whose exhibits at the Paris Salons of 1901, 1902 and 1903 were praised by critics. In 1902 he showed horn haircombs with motifs of birds, leaves and sirens, and in 1903 a jewel with a shimmering bird motif, of softly chased gold, and pieces with marine motifs like shells, crabs and seaweed.

Lecreux, Marguerite
French designer who exhibited at the Musée Galliera in Paris in 1908.

Lefebvre
Watchmaking firm founded in Paris by François Lefebvre (1820–90). His eldest son Eugène (1848–1907) took over the firm in 1874 and began to produce jewelry, winning a gold medal at the 1889 International Exhibition. The firm expanded, and in 1898 set up a special workshop at 118 Rue du Temple. Eugène's sons, Charles (b. 1874) and Eugène (b. 1876), went into the business in the 1880s. Charles looked after the original Rue de Rivoli premises and Eugène, together with his father's colleague Desmarquet, began to produce stamped gold jewels in Art Nouveau style in the Rue du Temple. The firm continued to produce popular jewels which were exhibited at the Paris Salons.

Lelièvre, Eugène (b. 1856)
French sculptor and designer whose work was mentioned after the Paris Salon of 1902.

Le Saché, Georges (b. 1849)
Important jewelry designer and manufacturer who came from a family of artists and engravers. He went to Germany and then to London to study, but returned to France at the outbreak of the Franco-Prussian war in 1870. After a brief period in London he worked for Lucien Falize as a designer from 1872 to 1877. He became one of the most sought-after manufacturers in Paris, supplying all the best jewel houses with their prime exhibits at the various International Exhibitions. He worked in both *bijouterie* and *joaillerie*, producing a rather formal version of Art Nouveau.

Le Turcq, Georges (b. 1859)
Paris jeweler who studied at the Paris Ecole des Arts Décoratifs, and went into partnership with Julien Duval in 1885. From 1890 they were leading manufacturers of medal-jewels. They parted in 1894 and Le Turcq continued to produce medal-jewels, in conjunction with the medallist Vernier. Around 1900 Le Turcq began to make highly original Art Nouveau jewels with organic motifs, using enamels. He is known especially for elegant rings (illustrated in Vever, *La Bijouterie française au XIXe Siècle*), and for a versatile range of Art Nouveau jewel designs, calling on popular designers.

Levinger, Heinrich
German firm of jewelers in Pforzheim, founded during the nineteenth century by Heinrich Levinger who died in 1899. In 1903 the firm was renamed Levinger und Bissinger, but reverted to the name of Heinrich Levinger after 1909. They produced *Jugendstil* designs in stylized floral forms, using silver and *plique à jour* enamel, and also some purely linear designs. They executed jewels designed by Otto Prutscher.

Liberty and Co. Ltd
Famous London shop founded in 1875 by Arthur Lasenby Liberty (1843–1917). He started his working life in his uncle's lace warehouse in Nottingham, and came to London in 1859. After a two-year apprenticeship to a draper in Baker Street, he joined the company of Farmers and Rogers' Great Shawl and Cloak Emporium in Regent Street in 1862. In 1864 he became manager of their new Oriental Warehouse, and opened his own shop, also an Oriental Emporium, called East India House, in Regent Street in 1875. In 1883 he moved

further along Regent Street to a shop which he named Chesham House after his birthplace. In 1889 a Paris branch was opened, at 38 Avenue de l'Opéra. Soon Liberty started selling his own ranges of designs in all areas of the decorative arts. He launched his first range of jewelry and silverware in the late 1890s under the trade name 'Cymric', from Celtic-style designs by Archibald Knox. In 1909, when the taste for the Celtic style began to fade, Liberty sold this range to Connell and Co. Liberty used many talented British designers but insisted on their remaining anonymous. He ran his company successfully until his death. He was knighted in 1913.

Liénard, Paul (b. 1849)
French sculptor, jeweler and designer who was a regular exhibitor at the annual Paris Salons. Liénard worked in a strong, organic style, incorporating movement and life into his designs. He designed a border of seaweed motifs for the jewelry magazine, *La Revue de la bijouterie, joaillerie, orfèvrerie*, and was a promising designer during the Art Nouveau period. He does not appear to have been active, at least not under his own name, until after the Paris International Exhibition of 1900, but came to the forefront of critical attention after about 1905, some of his best pieces being made around 1908. He is known to have designed jewels for the firm of Bolin in Moscow. In 1908 he exhibited a range of beautifully light jewels, using sprays of Baroque pearls for flowers, crystal and amethysts for flowerheads and adding enamels and insect motifs. His mark was registered at the Paris assay office in 1905, his address being given as 7 Rue Joubert.

Linzeler
French firm of jewelers founded in 1840 by Eugène Linzeler (1808–88) who was a goldsmith making jeweled accessories. He was followed into the business by his two eldest sons, Eugène and Frédéric in 1864, and then by his other two sons. Frédéric's son was Robert Linzeler, a famous goldsmith of the 1920s.

Löffler, Bernhard (1874–1960)
Austrian ceramicist who also designed jewels. He joined the Wiener Werkstätte in 1907, having founded the Wiener Keramic (Ceramic Workshops) in 1905. He worked only in silver, and used flat, childlike designs.

Louchet, Paul
Metalworker and jeweler who exhibited Art Nouveau-style jewels at the Paris Salons. At the Salon of 1903 he and his brother Albert were praised for their *cloisonné* enamels, so fine that they looked like porcelain. These may in fact have been done in their workshops by Japanese artists.

MacDonald, Frances (1874–1921)
Sister of Margaret MacDonald Mackintosh. In 1899 she married Herbert McNair whom she had met at the Glasgow School of Art. She taught enamelling and metalwork at the School, and participated in the Arts and Crafts Exhibition in 1869, in the Vienna Secession Exhibition in 1900, and in the International Exhibition in Turin in 1902. Although she made little jewelry, her designs exerted an influence on her Glasgow pupils.

MacDonald Mackintosh, Margaret (1865–1933)
Scottish decorative designer who made some pieces of jewelry with her sister Frances. She married Charles Rennie Mackintosh in 1900. Margaret had studied at the Glasgow School of Art, and as one of 'The Four' she showed at the Arts and Crafts Exhibition in London in 1896.

Mackintosh, Charles Rennie (1868–1928)
Scottish architect and decorative designer of outstanding talent, and a major influence on twentieth-century design. Born in Glasgow, Mackintosh was apprenticed in 1884 to the architect John Hutchison. In 1889 he moved to the architectural firm of Honeyman and Keppie, where he met J. Herbert McNair. At evening classes at the Glasgow School of Art they met two sisters, Margaret and Frances MacDonald.

Margaret married Mackintosh in 1900 and Frances married McNair. Together they formed the group known as 'The Four'. Mackintosh was also the leader of the Glasgow School, a group of designers and architects associated with the Glasgow School of Art. He exhibited in 1900 at the Secession Exhibition in Vienna, became a close friend and colleague of Josef Hoffmann and was an important influence on Wiener Werkstätte design. Thereafter he continued to work as an architect, and concentrated on painting at the end of his life.

McNair, J. Herbert (1868–1955)
Scottish architect and designer, and one of 'The Four' (see Mackintosh). He showed jewelry at the Arts and Crafts Exhibition in London in 1896. His jewel designs were probably executed by his wife, Frances MacDonald.

Mangeant, E. Paul
French painter, decorative designer and jeweler working in the Art Nouveau style, who produced ornaments from non-precious materials. He was known for using mother-of-pearl, gold, oxidized silver, silver with a dark patina, which he set 'discreetly' with stones. In *The Studio*'s special supplement of 1901–02, Gabriel Mourey points out that Mangeant made jewels in which all the 'constructive parts' have been intentionally left visible. This was very much in the English Arts and Crafts tradition, as were his hammered silver surfaces and humble organic motifs.

Marcus and Co.
Leading New York firm of jewelers located at the corner of 5th Avenue and 45th Street, specializing in deeply coloured *plique à jour* enamels and expensive, fashionable versions of American Arts and Crafts jewels and Tiffany Studios designs.

Margold, Emanuel (b. 1889)
Austrian craftsman who studied at the Kunstgewerbeschule in Vienna with Josef Hoffmann and worked in Germany after 1913. His designs, in the style of the Wiener Werkstätte, were often made up by Oskar Dietrich of Vienna.

Marie, Charles
Firm of Paris jewelers founded in 1858 by Auguste Marie (1821–98), who had been workshop manager for Alexis Falize. From 1869 to 1877 his partner was Lamargot, and they produced fashionable, well-made jewels for the major retail houses. In 1887, Auguste's son Charles took over the business and expanded the range of jewels, adding tie-pins and other jewels to their speciality of gem-set rings. During the Art Nouveau period, the firm made gem-set jewels in designs based on butterflies, insects, frogs and shrimps, as well as more classic designs using coloured stones cut to standard sizes for setting in clusters (*calibré*).

Marret, Frères
Well-established firm of Paris jewelers, with an exceptionally long pedigree (see Vever, *La Bijouterie française au XIXe siècle*, vol. III). They specialized in conventional gem-set jewels for a rich clientèle. Under the direction of Charles and Paul Marret, they took part in the Paris International Exhibition in 1900, adapting their range to the lines of Art Nouveau, and won a prize for their display. They were praised for the delicacy and precision of their settings, with some stones being set on fine, 'knife-edge' wires. Some jewels made definite concessions to the new style, especially their less expensive range of chased and enamelled jewels.

Martilly, de
French designer who exhibited at the Salon of 1903. His work was much praised and he was introduced as a promising future talent. His jewels were light and feminine, yet emphatically modern, making use of the decorative vocabulary of Art Nouveau such as peacock, dragonfly and flower motifs, in gold and enamel.

Martineau, Sarah Madeleine (b. 1872)
English goldsmith, silversmith and jeweler. She studied at the

Liverpool School of Art and made only a small amount of gold and enamelled jewelry, around 1908–19.

Masriera, Luis (1872–1958)
The son of a painter and goldsmith, he and his brother ran the family jewelry firm in Barcelona, which had been founded by his grandfather in 1839. The firm was called Masriera y Hijos (Masriera and Sons) in 1872, but became Masriera Hermanos (Masriera Brothers) in 1886. In 1889 Luis went to the Geneva Academy to study under the enamellist Lossier. His name is first mentioned as an exhibitor at the Paris International Exhibition of 1889. Lalique's display at the 1900 Exhibition inspired Masriera to work in the Art Nouveau style, which he often adapted to religious themes, using gold, diamond, and *plique à jour* enamels. The firm continued to work in the Art Nouveau style for many years.

Mayer, Victor
German jewel manufacturers in Pforzheim, working around 1902 –05. They produced some designs by Georg Kleemann.

Mayrhofer, Adolf von (1864–1929)
German goldsmith and engraver, working in Munich. His jewels, made around 1906–10, incorporate fine wire coil motifs.

Mellerio
Well-established Paris firm of goldsmiths and jewelers who made dramatic gem-set jewels in modified Art Nouveau style. They often used the motif of a peacock feather set with precious stones, notably in one *plaque de cou*, which represents two peacocks fighting over the fruit of a laurel, the prize for their beauty. The jewel could be taken apart so that one feather could be worn on the shoulder and the other in the hair. The feathers themselves were made of green gold, set with very fine diamonds, the edges in red gold, delicately chased.

Menu, Michel (b. 1857)
The son of the Paris goldsmith Alfred Menu (b. 1828), he served his apprenticeship with his father. He is best known for the jewelry he made for Boucheron's display at the Paris International Exhibition in 1900, and for producing gold mounts for the woodcarvings of E.-H. Becker.

Mère, Clément (b. 1870)
French painter and decorative designer who worked for La Maison Moderne around 1900, but is better known for his wood- and ivory-carving in the 1920s and 1930s.

Messner (or Mesmer), Franz
Austrian jewelry designer who trained at the Vienna Kunstgewerbeschule during the Art Nouveau period and produced inexpensive pieces in popular styles.

Michelsen, A.
Firm of goldsmiths, silversmiths and Jewelers to the Danish Court. It was founded in Copenhagen in 1841 by Anton Michelsen, who was succeeded in 1877 by his son Carl.

Miranda, Vincento
Italian jeweler from Naples who exhibited at the Paris International Exhibition in 1900.

Moche
French firm of goldsmiths, known for their mesh purses, which they adapted around 1900 to current fashions – for example by adding a frame of sculpted gold with a female head and flower motifs.

Möhring, Bruno (1863–1929)
German architect and designer from Berlin who designed jewels for the firm of J.H. Werner. He participated in the Paris International Exhibition in 1900.

Montigny, Jeanne de
French designer and jeweler notable for her use of *cabochonné* enamelling, in the manner of Comte du Suau de la Croix (see p. 24).

Morawe, Christian Ferdinand (b. 1865)
German jewelry designer and critic, whose designs were made up by Theodor Fahrner.

Morris, Talwyn (1865–1911)
Scottish designer and metalworker from Glasgow, and member of the Glasgow School (see Mackintosh).

Moser, Koloman (1868–1918)
Viennese painter, graphic artist and designer of jewelry, furniture, glass and textiles. He studied painting and design at the Vienna Academy and there met Joseph Olbrich and Josef Hoffmann. He was a founder member of the Vienna Secession in 1897. Having turned down an invitation from Olbrich to move to the artists' colony at Darmstadt, he taught at the Vienna Kunstgewerbeschule from 1899 to his death. In 1903 he founded the Wiener Werkstätte with Josef Hoffmann. He designed a number of pieces of jewelry for the Wiener Werkstätte, in a strictly geometric and austere manner. He also designed for the Viennese jewelers Roset und Fischmeister and Georg Anton Scheidt. Moser left the Wiener Werkstätte in 1906 and thereafter concentrated on painting.

Mucha, Alphonse (1860–1939)
Art Nouveau graphic artist and designer, originally from Czechoslovakia, whose best work was done in Paris. He worked in Vienna and Munich before moving to Paris in 1888, where he became well known as a decorative artist and designer of posters. His first poster for Sarah Bernhardt as Gismonda in 1894 made him an overnight success, and brought him to the attention of Paris jeweler Georges Fouquet. Their short but fruitful collaboration resulted in a dramatic series of jewels shown at the 1900 International Exhibition in Paris, and also in Mucha's exotic designs (1900–01) for Fouquet's new shop in the Rue Royale. Some of the most opulent Mucha-Fouquet jewels were made for Sarah Bernhardt. In 1902 Mucha's *Documents décoratifs* was published, a book of decorative designs including several pages of jewelry. These were widely influential and much copied. During his later years he devoted his attention to painting and returned to Czechoslovakia in 1910.

Müller-Salem, Julius
Pforzheim designer whose designs were made up by Theodor Fahrner.

Munson, Julia (1875–1971)
American designer and craftswoman, who in her early twenties was apprenticed to Louis Comfort Tiffany, and became his chief jewelry designer. She also became head of Tiffany's enamelling division and in 1903 head of the jewelry department. She was largely responsible for Tiffany Studio jewels.

Murat
French firm of jewelers working in the Art Nouveau style around 1900. One of their pieces, a belt buckle with an iris motif, is illustrated in Vever, *La Bijouterie française au XIXe siècle*, vol. III.

Murrle, Bennett and Co.
London-based firm of wholesale jewelers specializing in Art Nouveau designs, often in the German style. They were established in 1884, and probably collaborated with Liberty and Co., possibly supplying them with jewels made in Pforzheim. They produced a vast and varied range of popular jewels, including some Knox designs identical to those made by Liberty and Co. Ernst Mürrle was a German born in Pforzheim. Mr Bennett was the English partner. Mürrle came to London around 1880 and worked first with a Mrs Siegele, a cousin and fellow Pforzheimer, in the jewelry trade. Murrle, Bennett and Co. often collaborated with Theodor Fahrner on certain designs (Fahrner had been a school-friend of Mürrle's, and their marks may often be found together on the same piece. Murrle, Bennett and Co. sold widely abroad and had a large range of styles, conventional and modern. During the First World War Mürrle was repatriated and the company was renamed White Redgrove and Whyte.

Musy
Italian jeweler in Turin who exhibited French-style Art Nouveau jewels at the Turin International Exhibition in 1902.

Naper, Ella (1886–1972)
English craftswoman and jeweler, and colleague of Fred Partridge. She was born in New Cross, London, and attended the Camberwell School of Arts and Crafts from 1904 to 1906. She then went to Branscombe in Devon for three years and worked with Partridge, producing horn jewelry and enamelwork. In 1910 she married Charles Naper, a landscape painter, and they lived at Looe in Cornwall. In 1912 they moved to the artists' colony at Lamorna. Ella Naper exhibited with the Arts and Crafts Exhibition Society and also made some jewelry designs for Liberty. She founded and ran the Lamorna pottery and worked closely with the artist Laura Knight.

Nau, Robert
French designer and jeweler who used strange animal motifs, including the octopus, vulture and pelican.

Nics Frères
French firm of metalworkers who made delicate jewels after 1900 in wrought metal, minutely worked.

Nienhuis, Lambert (1873–1960)
Dutch ceramicist and jewelry designer. He taught enamelling in Haarlem and later in Amsterdam and The Hague. From 1905 to 1918 he designed *Jugendstil* jewels for the Amsterdam firm of W. Hoeker.

Nocq, Henri (b. 1868)
French sculptor, medallist and jeweler, who used organic, marine motifs. In 1896 and 1897 he exhibited at the Galerie des Artistes Modernes in the Rue Caumartin in Paris, and later became a critic and historian.

Obiols, Gustave
Sculptor and jeweler of Spanish origin, born in Barcelona and working in Paris. He was well known for his belt buckles using the motif of an iris, lily, chestnut leaves or poppy, usually with a female head.

Ofner, Hans
Austrian architect and decorative designer who was a pupil of Josef Hoffmann.

Olbrich, Joseph Maria (1867–1908)
Important avant-garde Austrian architect and designer who worked in Germany. Olbrich studied architecture at the Vienna Academy and briefly worked as an assistant to Otto Wagner where he was joined by Josef Hoffmann. Together with Moser and Hoffmann, Olbrich founded the Vienna Secession in 1897. In 1899 Olbrich set up the artists' colony at Darmstadt, at the invitation of the Grand Duke of Hesse. He designed the major buildings and interiors, and also jewelry which was made up by D. und M. Loewenthal and Theodor Fahrner.

Orazzi, Manuel
Designer for La Maison Moderne in Paris, known for his poster advertising the gallery and for curious organic jewels.

Partridge, Frederick James (1877–1942)
English Arts and Crafts jeweler working in the French style, and specializing in horn. He studied at the Birmingham Municipal School of Art from 1899 to 1901, and joined Ashbee at the Guild of Handicraft when it moved to Chipping Campden in 1902. Partridge exhibited in 1903 with the Arts and Crafts Exhibition Society, together with the Guild of Handicraft. He set up a workshop in Soho, London, and made some jewelry for Liberty. From 1900 to 1908 he also spent time working at Branscombe in Devon. He married May Hart in 1906, who did some enamelwork for Ashbee. He worked with, taught and influenced Ella Naper.

Peche, Dagobert (1887–1923)
Austrian architect and decorative designer who joined the Wiener

Werkstätte in 1915 and was director of its Zürich branch from 1917 to 1919, when he returned to Vienna. He designed silver and jewelry as well as textiles, ceramics, glass, graphics and wallpapers. His style was ornamental and figurative, in contrast to the early geometric designs of the Wiener Werkstätte.

Péconnet
French firm of jewelers. Vever illustrates a group of their diamond- and pearl-set rings made around 1898–1900.

Pflaumer, Eugen
Austrian goldsmith who worked as a teacher and designer in Gablonz. He had worked in Vienna with the Wiener Werkstätte, and in 1906 visited London, where he became influenced by Henry Wilson. On his return to Gablonz he continued to design jewels in the style of the Wiener Werkstätte.

Piel Frères
Paris jewelry firm (at 31 Rue Meslay) which caused a sensation at the Paris International Exhibition in 1900 with its fashionable but inexpensive 'art' jewels. The head of the firm was Alexandre Piel, who worked with the sculptor Gabriel Stalin as artistic director. In their jewels, sculpted ivory was replaced by the new plastic material, celluloid, while copper and silver replaced gold. Critics approved of these substitutes, since the aim was to present art at an affordable price. Piel Frères' jewels were often gilt or enamelled, which they accomplished successfully on the difficult media of copper and silver. The designs were excellent, and they are known particularly for their range of buckles and for an impressive gilt and enamelled peacock feather buckle, illustrated in *La Revue de la bijouterie* in 1901.

Pillet, Charles Philippe Germain Aristide
French medallist working in Paris around 1900.

Plisson et Hartz
Important French firm of jewelers who made good Art Nouveau pieces, and also specialized in gold chimerical or animal jewels. The firm was run by Bottentuit and Plisson from 1872 to 1886, by Plisson alone until 1898, and by Plisson and Hartz until Plisson's death in 1904. Hartz had long been an associate of Plisson, and he was the creative force behind their novel designs. The firm was the first to produce chimerical jewels: chased gold griffins or mythical monsters. These were not initially well received, but later became enormously popular. They also made a speciality of diamond animal jewels, and baskets of flowers.

Ponocny, Karl
Designer for the Wiener Werkstätte.

Ponscarme, Hubert (1827–1903)
Sculptor and medallist. From 1871 he was a teacher at the Ecole des Beaux Arts in Paris and inspired younger French medallists such as Charpentier and Coudray to produced medal-jewels.

Printemps, Georges
Pupil of Eugène Grasset, a French jeweler who worked in a linear Art Nouveau style.

Prouvé, Victor Emile (1858–1943)
French sculptor, painter, designer and medallist. He was born in Nancy, and became a member of the School of Nancy, led by Emile Gallé, the famous Art Nouveau glassworker. Prouvé studied drawing at Nancy and at the Academy of Paris, but returned to Nancy to work with Gallé, closely following his style and adapting it to furniture and jewelry. In 1918 he became Director of the Ecole des Beaux Arts in Nancy. His design of an embroidered dress exhibited at the Paris Salon of 1901 was compared by critics to the great corsage ornaments created by Fouquet. He also exhibited objects, sculpted metalwork, book-bindings and sculptures. He designed medal-jewels for Rivaud. His jewels were exhibited in London at the Grafton Galleries in 1899.

Prutscher, Otto (1880–1949)
Austrian jewelry designer who was a pupil of Josef Hoffmann and worked with the Wiener Werkstätte shortly after it was founded in 1903. His designs were sometimes executed by the Pforzheim firm of Heinrich Levinger.

Rambour, André
French jeweler who specialized in enamelled landscape and sunset jewels.

Ramsden, Omar (1873–1939)
English silversmith and goldsmith who was born in Sheffield. He was apprenticed to a firm of silversmiths, and attended evening classes at Sheffield School of Art where he met his future partner Alwyn Carr (1872–1940). In 1897 he came to London and set up a workshop with Carr, gradually taking on a large number of assistants. Their first commission was a mace for the City of Sheffield, Ramsden having won first prize in a competition for its design. Their silverware and jewelry shows the influence of the Arts and Crafts movement and also incorporates Art Nouveau motifs, particularly flowers. Neither Ramsden nor Carr themselves took a leading part in design or production. The partnership ended in 1919 and Ramsden continued to produce silverware.

Reinitzer
French jeweler whose designs were sometimes made up by La Maison Arnould, 6 Rue Racine, Paris.

Ribeaucourt, Georges de (1881–1907)
French designer who studied under Hector Lemaire at the Ecole des Arts Décoratifs in Paris, and also trained as an industrial artist before turning his attention to jewel design. In 1902 he won first prize in the design contest sponsored by *La Revue de la bijouterie, joaillerie, orfèvrerie*. He did his best work after 1900 and was frequently mentioned in art journals, particularly for his displays at the Paris Salons of 1902 and 1903. In 1903 he was praised for his entry for the annual competition organized by the Chambre Syndicale de la Bijouterie. At the 1902 Salon his exhibits included a collection of *objets d'art* in various precious materials and also some drawings lent by Sarah Bernhardt, who was one of his customers.

Ribeaucourt developed a personal style of gold jewelry based on natural themes, creating spiky gold fronds and clusters of pine needles. he worked with the designer Camille Sturbelle, probably around 1902, and together they produced jewels in precious stones as well as 'art' jewels.

Richard, Paul
French jeweler and engraver who worked independently and for manufacturing jewelers. He exhibited finely chased jewels and objects at various Paris Salons.

Ricketts, Charles de Sousy (1866–1931)
English painter and decorative artist. He was the founder, together with Charles Shannon, of the Vale Press in 1896. In the 1890s he designed bookbindings and after about 1906 concentrated on theatre design. In 1899 and 1900 he designed some jewelry for friends, made up by Carlo Giuliano.

Riester, Emil (d. 1925/26)
German jewelry designer and teacher in Pforzheim. He started teaching there from about 1877, and is thought to have introduced Art Nouveau designs to the town, starting with an exhibition of innovative jewel designs in Pforzheim in 1880. Later his jewels were often made by the firm Wilhelm Feucht.

Rivaud, Charles (1859–1923)
French decorative artist and jewel designer, who is best known as the creator of fine medal-jewels, commissioning designs from Roty, Dampt and Prouvé among others. The simplicity of his designs made him one of the most lasting figures of the period.

Rivet
French engraver and medallist.

Robin
Paris firm of goldsmiths and jewelers known from the 1860s to the 1880s for their sculpted gold jewels in animal forms, many designed as serpents and lizards. They made highly chased chimerical jewels in the 1880s and 1890s.

Roset und Fischmeister
Firm of Viennese jewelers, working in the French style, around 1900. Fischmeister had gone to Paris to study with Lalique and possibly also with the sculptor/medallist Vernon. When he returned to Vienna, the firm started using a wide range of materials mixed with diamonds, and *plique à jour* enamel in deep colours.

Rothmüller, Karl (1860–1930)
German goldsmith in Munich who created *Jugendstil* jewels with lingering traces of the neo-Renaissance style. He exhibited at the Paris International Exhibition in 1900.

Roty, Louis Oscar (b. 1846)
The chief exponent of the medal-jewel. He studied at the Paris Ecole des Beaux Arts in 1864, and also studied painting and sculpture with Dumont. He spent three years in Rome, won a Grand Prix in Paris in 1889 and became a Chevalier of the Légion d'Honneur in 1885. In 1888 he became a professor at the Académie des Beaux Arts in Paris, and President in 1897. His work was much praised in contemporary art magazines, and he was considered the first medallist to realize the potential of the medal in jewels.

Rouzé
Jewelry firm which was noted for its display at the 1900 Paris Exhibition of a collection of jewels made in copper, skilfully gilded. Their range included buttons, many of them enamelled, brooches with various textured backgrounds, floral ornaments, buckles and medal-jewels.

Saint-Yves
French jewelry designer who was commissioned by La Maison Moderne.

Sander-Noske, Sophie
Austrian goldsmith and designer who worked in Paris and Amsterdam, specializing in gold and silver filigree.

Sandoz, Gustave-Roger
Son of Gustave Sandoz (1836–91), he succeeded to his father's jewelry and watchmaking business in Paris in 1891. The firm was initially based in the Palais Royal and made gem-set and gold jewels, for which Gustave-Roger maintained its reputation. He moved his shop to the Rue Royale in 1895, but retained premises in the Palais Royal. He adopted the Art Nouveau style of jewel design, mostly in goldwork, and was on the jury at the International Exhibition of 1900, where he exhibited attractive, modern jewels and interesting objects. He also devised a chased gold medal-jewel in Art Nouveau style incorporating a watch, which was hung on a necklace.

Savard, A.
Paris jewelers with premises at 22 Rue St Gilles. They were known for their portrayal of a female head with flowers, from a design by Dropsy (pl. 139). They participated in the Paris International Exhibition of 1900 with a series of medal-jewels based on designs by famous sculptors.

Schaper, Hugo (d. 1915)
German Court Goldsmith who adapted his neo-Renaissance style to Art Nouveau, and was much influenced by French figurative work. He founded a jewelry firm in Berlin in 1875 and participated at the International Exhibition of 1900.

Scheidecker, Paul Frank
Paris-based jeweler, born in England, who was much praised for his jewels displayed at the Musée Galliera in 1908.

Scheidt, Georg Anton
Austrian jeweler based in Vienna, working in a linear style, and using designs from Koloman Moser among others.

Schenck, E.
Jeweler who probably worked in Paris. At the Paris Salon of 1903 he was praised for a cloak clasp based on the motif of flying ducks. This was described as being highly decorative, yet realistic, and incorporating a great deal of movement. The birds held the ends of the chain in their beaks. He also exhibited a belt buckle on the theme of a woman holding out her arms to catch a wave.

Schoenthoner, V.
Austrian painter who also designed Art Nouveau jewels.

Selmersheim, Jeanne
Wife of the decorative designer and artist Pierre Selmersheim. She designed jewelry, exhibiting at various Paris Salons.

Siess, Joseph
Austrian jewelry manufacturer in Vienna who worked in the abstract style.

Silver, Rex (1879–1955)
Manager of the Silver Studio, a design studio responsible for many of Liberty's designs. These included some in silver for the Cymric range. The Studio had been started in 1880 by Rex's father Arthur Silver (1853–96). Rex took over in 1901, continuing to run it until his death. It closed in 1963.

Simpson, Edgar (fl. 1896–1910)
English designer and metalworker, who was very much influenced by the work of C.R. Ashbee. His jewelry is illustrated in *The Studio*'s special supplement on 'Modern Design in Jewellery and Fans' (1901–02). He designed for manufacturers such as Charles Horner.

Slott-Möller, Harald
Danish decorative designer, metalworker and jeweler who produced enamelled jewels, which were usually allegorical. His designs were often made by Michelsen, Danish Court Jeweler.

Solié, Henri-Auguste
Paris jeweler who was known for his use of female motifs. For the Paris International Exhibition of 1900 he produced a Loïe Fuller buckle incorporating draped ribbons and showing a great deal of movement.

Soufflot, Paul
Son of the jeweler François Soufflot (1821–1902), Paul Soufflot went into partnership in the family firm with his brother-in-law Henri Robert, in 1872. In 1878 Soufflot and Robert won a gold medal for their gem-set flower jewels, and in 1889 they were praised for a magnificent bunch of begonias, set in diamonds. In 1892 Paul Soufflot took over the firm. At the International Exhibition in 1900 Soufflot, based in the Rue Quatre Septembre, adapted these themes to Art Nouveau and exhibited jewels that maintained the firm's high standards of workmanship. He also wrote reports on jewels at the Exhibition. Soufflot retired in 1901 and left the business to René Boivin, who was to become a talented Art Deco jeweler.

Soulens, Eugène (1829–1906)
Paris jeweler who produced Art Nouveau pieces in the 1890s. He had begun his apprenticeship with Alexis Falize when he was ten, and later trained with La Maison Robin before setting up his own business in 1864.

Stöffler, Wilhelm
Jewelry designer who founded a firm of the same name in Pforzheim. He was one of the first to explore the new style and to work in the French manner, in the late 1890s.

Strathmann, Carl (1866–1939)
German jeweler known for his gold medal-jewels, which were sometimes set with gems.

Strydonck, Leopold van
Belgian Court Jeweler and goldsmith working in Brussels, at 79 Montagne de la Cour and 14 Place du Musée. He exhibited at the Brussels Salons of 'Les Vingt'. He specialized in oxidized metalwork.

Sturbelle, Camille Marc (b. 1873)
Belgian jeweler working in the French Art Nouveau style, known for bizarre motifs. He worked with the designer Georges de Ribeaucourt in Paris, probably around 1902.

Suau de la Croix, Comte E. du
French jeweler and enamellist who developed *cabochonné* enamelling, a variation of *plique à jour* (see p. 23). He used this for pendants and necklaces, sometimes with traditional motifs like cherubs' heads or wings, or else birds, butterflies and flowers. His pupil Jeanne de Montigny was one of the few other jewelers who employed this technique.

Tard, Antoine
Leading French enamellist of the middle and late nineteenth century, known especially for his work with Falize in copying Japanese *cloisonné* enamels.

Templier
Firm of jewelers founded in 1848 by Charles Templier (1821–84). A hard worker and shrewd businessman, he ran a thriving business. He had two sons, Hippolyte and Paul (b. 1860). The latter succeeded his father in 1885, and became an important figure in the Paris jewelry trade. In 1907 he was elected to succeed Louis Aucoc as President of the Chambre Syndicale de la Bijouterie. Paul Templier is known for his production, around 1900, of abstract designs by Théodore Lambert. Many of these jewels – brooches, buckles and pendants made in silver – were exhibited at the 1901 Paris Salon. Raymond, Paul's son, became a leading Art Deco jewel designer.

Téterger, Henri (b. 1862)
Leading Paris Art Nouveau jeweler, of whom little is known. He was the son and pupil of the well-established jeweler Hippolyte Téterger, and had premises at 250 Rue de Rivoli. He exhibited a Loïe Fuller bracelet, of linked dancers, at the International Exhibition in 1900. The Téterger firm continued to make jewels in the Art Nouveau style, but veered towards the more conventional 'Edwardian' style around 1910. They were still making innovative and fashionable jewels in the 1920s.

Thallmayr, Nikolaus (fl. c. 1900)
German goldsmith and jeweler working in Munich. He worked in a gentle, naturalistic style, using motifs of softly undulating leaves and petals.

Thesmar, André Fernand (1843–1912)
Enamellist who is credited with the rediscovery of *plique à jour* enamel. Born at Châlons-sur-Saône, Thesmar was the son of a banker. In 1860, after an apprenticeship in a textile factory, he went to Paris and entered a workshop for industrial design and then a studio for theatre design. He worked at the tapestry factory at Aubusson and then at the Barbédienne foundry. From 1872 he took his own studio at Neuilly and there began to specialize in the study of *cloisonné* enamel on precious metals. He participated in the Vienna International Exhibition in 1873, and at the Exposition de l'Union Centrale des Arts Appliqués á l'Industrie in 1874. Two exhibits shown at the 1878 International Exhibition in Paris were bought by the Japanese Government. In 1888 he showed his first work in *plique à jour* enamel and in 1891 exhibited various gold *cloisonné* enamelled works at the Salon of the Société Nationale des Beaux Arts. In 1895, after two years in London, he developed a new technique of translucent *cloisonné* enamel on soft paste porcelain, produced by the Sèvres factory.

Thomsen, Christian (1860–1921)
Danish designer known for the design of six belt buckles in 1901, all with insect motifs. These were produced in painted porcelain by the

Royal Copenhagen Porcelain Factory and mounted in silver by A. Michelsen, Danish Court Jewelers.

Tiffany, Louis Comfort (1848–1933)
Eldest son of Charles Louis Tiffany (1812–1902) who had founded the New York jewelry shop, Tiffany and Co., Louis Comfort Tiffany was the leading exponent of Art Nouveau in America and produced important 'art' jewels around 1900 in his Tiffany Studios. Tiffany studied painting in the New Jersey studio of the landcape artist George Innes in 1868/69, but turned to the decorative arts in the late 1870s. In 1878 he founded an interior design firm called Louis C. Tiffany and Associated Artists, which gathered many prestigious commissions. Around this time he also took a keen interest in stained glass and in Oriental art. Tiffany's visit to the 1889 Paris Exhibition led to Samuel Bing becoming Tiffany's agent in Europe. At his gallery L'Art Nouveau in 1895 Bing showed Tiffany stained glass designed by artists such as Bonnard and Vuillard, and also the new *favrile* glass patented in 1894. Tiffany won a Grand Prix at the Paris International Exhibition of 1900. It was in 1900, or even earlier, that Tiffany began to produce his Tiffany Studios jewels under the direction of Julia Munson. He exhibited at International Exhibitions in Turin in 1902, in St Louis in 1904, and at various Paris Salons. His work also included furniture, lighting, wallpapers and fabrics. He became artistic director of the firm after his father's death in 1902, and concentrated thereafter on jewelry.

Tonnellier, Georges
French sculptor and goldsmith working in the Art Nouveau style.

Topf, Erhard
German jeweler working in Nurnberg in the abstract version of *Jugendstil*.

Tourette, Etienne
Important French enamellist known for his inclusion of gold *paillons*, which produced an iridescent effect. He trained with Louis Houillon and worked for Fouquet, among others. In 1875 and 1884 he exhibited at the Paris Salons with Houillon, and from 1893 to 1912 independently, showing *objets d'art* in *cloisonné* enamel on gold. His display of 1897 included jewels.

Turriet und Bardach
Austrian firm of manufacturing jewelers who participated in the Turin International Exhibition in 1902.

Unger Brothers
American firm of silverware and jewelry manufacturers who made commercial, popular jewels. The firm was founded in 1878 (when it was called H. Unger and Co.) by three brothers, Herman, Eugene and Frederick. Frederick died in the following year and the business was then renamed Unger Brothers. Having visited the International Exhibition in Paris in 1900, the firm took out patents for French-style jewel designs in 1903, under the name of Philomen Dickinson, their chief designer.

Unger-Holzinger, Else
Jeweler who trained at the Vienna Kunstgewerbeschule during the Art Nouveau period and who worked mostly in silver.

Ungerer, Alfons
Goldsmith and jeweler born in Pforzheim, where he attended the Kunstgewerbeschule. He developed an individual style of jewelry, delicate yet modern, which he produced in Berlin.

Vaguer, Léon
Founder of the jewelry firm of Vaguer, which concentrated on *joaillerie* and participated in the 1900 International Exhibition. Most of the jewels were set in platinum, their designs a compromise between conventional elegance and Art Nouveau line.

Vallot
Jewelry firm based in Geneva which produced organic-style jewels around 1900. It may well have been founded by Henri Vallot (see below).

Vallot, Henri
Described by Vever as a talented designer, Henri Vallot worked for Vever around 1899.

Varley, Charles Fleetwood (1881–1969)
One of the Varley family of Victorian painters, and best known for his painted enamel plaques of landscapes and seascapes, which were used by Liberty and Co., mainly for box lids but occasionally for jewelry.

Velde, Henry van de (1863–1957)
Belgian-born architect and designer who was one of the most important figures in the development of Art Nouveau and the Modern Movement. He travelled around Europe and spent a great deal of time working in Germany. He produced a few jewelry designs, which have more affinity with German *Jugendstil* in their abstract modernism than with organic, symbolic French or Belgian Art Nouveau. After training as a painter and studying in Paris, where he was a member of Les Vingt, he turned his attention to the decorative arts after 1893. In 1894–95 he built a house for himself at Uccle, near Brussels, and also designed furniture, silver cutlery, and clothes for his wife to wear in it. He also designed furniture for Bing, and interiors for Meier-Graefe's La Maison Moderne. In Dresden in 1897 he exhibited furniture which launched his success in Germany. In the same year he founded the Société van de Velde, with workshops for furniture and metalwork at Ixelles, near Brussels, and from 1898 worked in Berlin and elsewhere in Germany. In 1902 he was appointed artistic adviser to the Kunstgewerbeschule in Weimar and in 1904 became Director. After this he concentrated on architecture and design theory, travelling to Switzerland in 1917 and to Holland in 1920. In the 1920s his designs became sharper and more austere than those of the Art Nouveau period. He was widely influential through his writings and theories, promoting a synthesis of the arts, and anticipating the importance of the machine, although he always preferred hand craftsmanship.

Verger, Ferdinand
French manufacturer of medal-jewels, who produced designs by Edmond-Henri Becker and Paul Richard, among others, around 1900.

Verneuil, Maurice Pillard (b. 1869)
French poster artist and decorative designer who produced some designs for jewels.

Vernier, Séraphin Emile (1852–1927)
Parisian engraver and medallist who worked for major Paris jewel houses, including Bapst et Falize (1877–87), Froment-Meurice (1882–85) and Vever (1888–92) and also for Sandoz and Fonsèque et Olive. Vernier is credited with first applying medal-engraving techniques to jewelry, in 1887. His compositions were initially used as brooches and pendants. In 1896–97 he visited Cairo to study Egyptian jewelry.

Vernon, Frédéric Charles Victor de (1858–1912)
Leading Paris medallist and engraver who attended the Ecole des Beaux Arts in Paris, and from 1892 exhibited every year at the Salons. In 1895 he was awarded a first class medal.

Vever
Leading Paris jewelry firm, second only to Lalique. The firm was founded in 1821 by Pierre Vever in Metz, and moved to Paris in 1871. In 1881 Pierre Vever's grandsons Paul (1851–1915) and Henri (1854–1942), took over the firm. In the late 1880s and 1890s they exhibited in Paris, Moscow, Chicago and Brussels, and won a Grand Prix at the Paris International Exhibition in 1900. They commissioned designers such as Eugène Grasset, Henri Vollet, Lucien Gautrait, the sculptor René Rozet, and the enamellist Etienne Tourette. The firm was run by Paul's sons André and Pierre after 1915.

Henri Vever was also a prolific writer, critic and historian, and author of the standard work on nineteenth-century French jewelry, *La*

Bijouterie française au XIXe siècle (1908). The third volume of this provides biographical details of the leading Art Nouveau jewelers.

Vigan, Albert
French jeweler whose work is characterized by rich enamels. He collaborated with Cherrier in 1900.

Voet, E.
Dutch silversmith and designer whose jewelry designs were made up by the Amsterdam firm of W. Hoeker.

Vogeler, Heinrich (1872–1942)
German painter who designed some Art Nouveau jewelry.

Vollet, Henri
Designer who worked for Vever.

Wagner, Anna
Jeweler who trained at the Vienna Kunstgewerbeschule during the Art Nouveau period, producing silver and enamel jewelry.

Wagner, Raoul
French jeweler who exhibited at the Paris Salons in the opening years of the century. He was praised for his exhibits at the 1903 Salon, where he showed a *plique à jour* enamel cup with butterfly motifs, and a light and graceful *plaque du cou* with flowers and leaves.

Wagner, Siegfried
Danish silversmith who worked with Mogens Ballin, in a similar style.

Walter, Almeric-V. (1859–1942)
French glassmaker and designer in Nancy who produced *pâte-de-verre* objects and pendants in the Art Nouveau style, continuing production into the 1920s and 1930s.

Watt, James Cromer
Scottish jeweler working in Aberdeen, who specialized in foiled enamels on gold.

Werner, J.H.
Berlin jewelry firm founded by J.H. Werner (d. 1912). They executed designs by the architect Bruno Möhring and O. Max Werner (the owner's son), and showed at the International Exhibition in 1900.

Werner, Louis
Berlin jewelry firm who executed designs by Wilhelm Lucas von Cranach and Hermann Hirzel.

Werner, O. Max
See J.H. Werner.

Wiener Werkstätte
Craft studio in Vienna, founded by Josef Hoffmann and Koloman Moser in June 1903, with financial backing from Fritz Wärndorfer. It was properly called Produktiv-Gemeinschaft von Kunsthandwerkern in Wien. Although based on C.R. Ashbee's Guild of Handicraft, the workers were highly trained professionals rather than amateurs. The Wiener Werkstätte produced a variety of craftwork including jewelry, some of which was designed by Hoffmann and Moser. They were later joined by C.O. Czeschka in 1904, by Bernhard Löffler and Eduard Wimmer in 1907, and by Otto Prutscher in 1908. The workshops closed in 1932.

Wièse, Jules (1818–90)
German-born goldsmith and jeweler who worked in Paris in the medieval sculptural style of the 1860s. He was employed by Froment-Meurice until about 1860 when he set up on his own. In the 1870s he produced highly chased gold jewels which preceded Art Nouveau.

Wilson, Henry (1864–1934)
English architect, metalworker and jeweler. He studied at the Kidderminster School of Art and was then articled to an architect in Maidenhead. Later he became chief assistant to the architect J.D. Sedding, and took over on Sedding's death in 1891. Wilson turned to jewelry and metalwork around 1895 and became a major figure in the Arts and Crafts Movement. He exhibited regularly with the Arts and Crafts Exhibition Society from 1889, and became President of the Society in 1915. He taught at the Central School of Arts and Crafts, and from 1901 at the Royal College of Art. In 1903 his handbook on design and techniques, *Silverwork and Jewellery*, was published.

Wimmer, Eduard J. (1882–1961)
Austrian craftsmen who worked with the Wiener Werkstätte from 1907 to 1932. His jewels were typical of the Wiener Werkstätte style.

Witzmann, Karl
Austrian architect and designer who designed jewelry for the Wiener Werkstätte around 1907–08.

Wolfers, Philippe (1858–1929)
Leading Belgian jeweler who worked in an extravagant French style. He was born in Brussels, the son of the goldsmith Louis Wolfers (1820–92), who was the head of Wolfers Frères, Court Jewelers, a firm founded in 1812. He studied at the Académie Royale des Beaux Arts in Brussels with the sculptor Isidore de Rudder and in 1875 entered his father's workshop. He designed silverware and jewelry from 1880, at first in Rococo style and then, in the 1890s, adapting to the influences of naturalism and Japanese art. He set up an Art Nouveau villa at La Hulpe in Belgium in 1889, with furniture designed by Paul Hankar. In the early 1890s Wolfers set up his own workshop in the Square Marie Louise with a team of craftsmen. His work in ivory was shown at the International Exhibition in Brussels in 1897. His major series of 109 jewels, made between 1897 and 1905, were marked 'ex [emplaire] unique' to distinguish them from the production of the Wolfers firm. Wolfers exhibited at various International Exhibitions including those of Munich in 1898 and 1899, Turin in 1902, Liège in 1905 and Milan in 1906. After 1908 he turned his attention to sculpture.

Yencesse, Ovide
French medallist and engraver who produced designs for medal-jewels.

Zental, Ladislas
Hungarian silversmith working in New York during the Art Nouveau period.

Zerrenner, F.
Leading Pforzheim jewelry manufacturer who participated in the Paris International Exhibition in 1900 and made jewels in the French style.

Zorra, Louis
Jeweler working in Paris who produced jewels with strong Art Nouveau motifs. The Museum für Kunst und Gewerbe in Hamburg, which was active in buying Art Nouveau jewels from Paris at the turn of the century, acquired some pieces from Zorra, probably from one of the Paris Salons. (There is no mention of him at the International Exhibition of 1900.) He registered in the Paris assay office only in 1901, and his address was given as 30 Rue Volta, a street of small manufacturers. He may well have been of Italian origin.

Checklist of Other Notable Jewelers

Austria

Ghedina, Agostina
Hauptmann, Franz
Pribil, Anton
Zimpel, Julius

Belgium

Altenloh
Bronckère, de
Feys, Jacques
Morren, Georges
Pompe, L.
Rousseau, Victor

Czechoslovakia

Schober, M.

Denmark

Magnussen, Erick

France

Bataille, J.
Blanchot
Brateau, Jules (engraver and medallist)
Bréant et Coulbaux
Chalon, Louis
Chambin, Albert
Charlot (enamellist)
Charpentier, Alexandre (1856–1909;
　engraver, sculptor and medallist)
Chaveton
Courcy, de (enamellist)
Dampt, Jean (1854–1946; sculptor and
　medallist)
Debacq
Deberghe
Démaré, Victor
Dubret, Henri (d. 1934)
Duchemin
Durbec

Écalle, Charles
Fleuret
Haas Neveux
Héglas, Mme
Jean, Charles (enamellist)
Lecas, Edmond
Lelièvre, Eugène (b. 1856)
Lemaire
Lemeunier et Cauvin
Mandre, de
Marchand
Marionnet
Martincourt
Noufflard, Annie
Olivier
Oran, Robert (medallist)
Pégoux
Perrault, H.
Pospisil
Quénard
Quené
Rasumny, Félix (1869–1940)
Ruffe, Léon
Soyer
Stoll
Vallgren (medallist)
Wollès, Benjamin

Germany

Braun, Carl
Gebrüder Friedländer (Berlin
　manufacturers)
Loewenthal, D. und M. (Frankfurt
　manufacturers)
Nolde, Emil (1867–1956)
Weber, Otto

Great Britain

Alabaster, Annie
Alabaster, M.
Davidson, Peter Wyler (d. 1933)

Dick, Reginald
Fisher, Kate
Goldsmiths' and
　Silversmiths' Co.
　(London retailers)
Hart, Dorothy
Hodgkinson, Winifred
Larcombe, Ethel
McLeish, Annie
McLeish, Minnie
Pickett, Edith
Robinson, Fred
Stabler, Harold
Veazey, David

Holland

Amstelhoek
Eersten, van den, and
　Hofmeijer
Straten, Jacob von (b. 1877)

Italy

Bozza, L.

Switzerland

Pochelon Frères
Pochelon et Ruchonnet
Preysler, Henri

Watchmakers:
Braillard
Ditisheim, Paul
Ferrero
Patek Philippe

United States

Foster Brothers
Kohn
Krementz
Ostby and Barton
Peacock and Co.
　(Chicago manufacturers)

Guide to Identification

Marks

The subject of marks on jewelry is a highly complex topic and one that cannot be dealt with fully within the confines of this book.

Where they existed, systems of marks and assaying gold and silver jewelry and objects in Europe and the United States during the Art Nouveau period are complicated, confusing and largely undocumented; rules or registers of marks are for the most part unpublished, and the subject as a whole is still in a very early stage of research. Each country had different gold and silver standards, and these changed at various times, and marks altered accordingly. Most marks on Art Nouveau jewelry consist of a standard or quality mark indicating the quality of metal and a maker's or designer's mark. As each country used a different mark to guarantee that the metal met the required standard, this can also be an indication of the country of origin. The most distinctive is the French eagle's head mark, which has been in use in Paris since 1838, and guarantees that the gold is 18 carat. A number

 French eagle's head mark

might also be used to specify the quality of the metal, e.g. 9, 12 or 15 carat gold in England, or 800 or 850 (800 or 850 parts of silver per thousand) for silver in Germany. Various other marks were used in different countries: the date letter in the English system, import marks in France and England, and often a design registry mark indicating that the design had been registered.

In spite of the existence of such systems, manufacturers in all countries could sidestep rules and avoid marking their wares. The fact that a gold Art Nouveau jewel does not bear the eagle's head mark, for instance, does not necessarily mean that the piece is not French. Perhaps the most important examples of this omission of marks are the French jewels made by Fouquet and Boucheron and others specifically for display at the Paris International Exhibition in 1900. The belt buckle (pl. 144), for example, bears no marks but can be easily identified as it was extremely well documented in contemporary journals. The Mucha-Fouquet jewels, likewise, bear no marks — presumably being exempt as they were for display only. Certainly in the case of fragile enamelled Art Nouveau jewels, manufacturers often avoided having their jewelry marked, since the process could seriously damage the item.

Marks on Art Nouveau jewelry are unfortunately very often incomplete. French jewels frequently bear only the eagle's head, and English jewels only a carat mark. Even if a national mark is present, this does not firmly establish the country of origin as pieces were often commissioned from abroad, and the piece would then bear the mark of the country in which it was commissioned rather than that of the country of origin. French manufacturers, for example, often had jewelry made in Pforzheim in Germany, and some Liberty jewels were produced in German factories.

In contrast, some Art Nouveau jewels are thoroughly marked: those of the Wiener Werkstätte, for example. Some bear several marks: pieces by Theodor Fahrner may bear a silver quality mark, a maker's monogram, a designer's monogram, and an importer's mark (that of the English firm of Murrle, Bennett and Co.). Other items, although attributable stylistically to Fahrner, bear no marks at all. There is not necessarily any consistency within the production of a given maker.

A full German mark, including the quality number (950), the maker's mark (TF), the designer's mark (PH), the importer's mark (MBCo), and REGD to indicate a registered design

For the collector of Art Nouveau jewelry, French marks are the ones to concentrate on, as being the most systematic, and because Art Nouveau jewelry was a predominantly French phenomenon. In

France, the eagle's head was and still is the standard mark for gold, indicating that the piece meets the minimum quality of 18 carat. Gold items imported into France from other countries bear the mark of an owl in an oval, which was in use from 1893. Gold items intended for export carried the mark of the winged head of Mercury, used since 1879. The wild boar's head was the standard mark for silver (which had to be 950 parts out of a thousand) and had been in use since 1838. From 1905, the double symbol of an eagle's and a boar's head was used for jewels made of mixed metals (gold and silver).

 French import mark

 French export mark

 French standard mark for silver

 French mark for jewels of mixed metals

There are no published records of French makers' marks for the Art Nouveau period. The French maker's mark, or *poinçon de fabricant*, in the form of a lozenge, consists of the maker's initials and a tiny symbol. These symbols, however, can be very tricky to read. Examining hallmarks in general, and especially these *poinçons*, is often frustrating and a strain on the eyesight. The devices are usually very hard to decipher, and may be worn smooth. Initials tend to be slightly easier to read, but as several goldsmiths had the same initials, the presence of the emblem is necessary for positive identification. In some cases makers and designers did not use their own initials, but used the mark of the firm which produced their work. These marks often took the form of the founder's initials, and when a son or other successor took over, the mark would not necessarily be changed. Emblems were often puns or references to the maker's name; a firm called Mouton, for example, used a sheep motif. Some emblems are particularly difficult to photograph or reproduce, and for these I have given a verbal description in the list overleaf.

The British hallmarking system has served as a safeguard to purchasers of gold and silver articles since 1300. The hallmark shows that the item has been tested by an official assay office and that it complies with the legal standard of quality. British hallmarks consist of the maker's mark (the initials of the person or firm), the standard mark indicating the type of metal (the lion for silver, the crown for gold), the carat number indicating its purity, the assay office mark indicating the particular office at which the article was tested and marked, and the date letter representing the year in which the article was hallmarked.

British hallmark used by Liberty and Co., showing the maker's mark (L&Co); the anchor representing the Birmingham assay office; the lion passant standard mark for sterling silver; and the date letter C for 1902

During the Art Nouveau period letters varied from office to office, but each office used the same letter for gold and silver during a given year. Gold and silver pieces imported to England had to be assayed and marked, and from 1884 to 1903 the letter 'F' for foreign, in an oval, was added to the standard mark. Many English Art Nouveau jewels are

fully hallmarked, and can be dated with the use of a book of hallmarks. It is important to remember, however, that the maker's mark does not always identify the person who made the piece. It can also be the mark of the importer or retailer, or simply the person or firm who submitted the item for assay. In the late nineteenth century and during the Art Nouveau period it was not always obligatory for jewelry to be marked in the same way as larger objects. There were exemptions if the jewel was especially flimsy or set with stones. This accounts for the fact that many Liberty gold jewels for example, especially delicate gold gem-set necklaces, bear no marks. Some gold jewels only carry the quality mark of 9, 12 or 15 carat.

Austrian gold jewels frequently bear the standard mark of the head of Apollo facing left. The head of Diana was used for silver. Many popular French-style jewels were imported to Austria, and these may also bear two crossed 'A's as an import mark. An Imperial eagle was added to the right of this symbol on imported pieces between 1901 and 1921.

Austrian standard mark for gold; the head of Apollo

Austrian standard mark for silver; the head of Diana

Austrian marks for imported gold wares and jewelry, the one on the left used from 1891 to 1901, the one on the right from 1901 to 1921

The contemporary systems in most other European countries are even less satisfactory, and have yet to be studied in any depth. In Germany, for instance, there is no equivalent of the French or English hallmarking systems. Regulations for marking metals were formalized only in 1884 and did not come into force until 1888. After this date jewels very often bear a standard mark, in figures (for example 800 or 850 for silver) and sometimes a maker's mark. The German standard emblem is a crown and crescent, again only occasionally found. The French word *dépose* was used in Germany, as in France and Austria, to signify a registered design. Sometimes the German equivalent *geschützt* was used and meant the same thing.

German quality mark for silver

DÉPOSÉ *Déposé* mark

GESCHÜTZT *Geschützt* mark

In most European countries (apart from France) and in America, marking was probably organized on a spot-check system, with no central assay office, which explains the spasmodic use of marks. In America during the Art Nouveau period, the English sterling standard for silver (925 parts) was used and silver jewelry was sometimes marked 'Sterling'. Lower quality gold than 18 carat was probably used, and such pieces are unmarked. For details of marks in other countries collectors should consult the book of marks by Tardy (see Recommended Reading, below).

American mark of the Gorham Corporation, incorporating their symbol of an anchor surmounted by an eagle, a Gothic G, the trademark 'Martelé' (for their Art Nouveau range of hammered jewels) and 'FINE', indicating high quality silver. This mark imitates the style of British hallmarks.

It is undoubtedly of interest to collectors to know the name of the maker of a particular piece, even if nothing is known about that maker. As yet, however, there is no recognized list of Art Nouveau makers' marks.

Signatures

Many Art Nouveau makers and designers chose to engrave their signatures or monograms as well as, or instead of, stamping them with the official mark, possibly to prevent damaging the jewels, or to label the piece as the work of a particular designer, as the artistic value of jewelry gained in importance during this period. Sometimes these signatures could be made part of the cast, and so part of the design. Makers or firms often used more than one mark: Lalique, for instance, used either an engraved facsimile signature, LALIQUE stamped in block lettering, or his initials.

As prices and demand for Art Nouveau jewels have increased, so too have fake signatures, especially where simple block letters were used. It is also possible to transfer a mark from a damaged piece by a known maker to an unmarked jewel. The best way of detecting such forgeries is by keen observation and experience, and by handling as many authentic signed pieces as possible.

A knowledge of marks is important to the serious student or collector, but the value of marks or signatures should not be over-emphasized: simply because a piece is marked by a good maker does not mean it is a good piece. A good piece signed by a good maker is of course more valuable than an unsigned piece, but each jewel must be judged on its individual merits of design, quality and craftsmanship.

Recommended Reading

Barten, Sigrid, *René Lalique: Schmuck und Objets d'art*, Munich, 1977. Gives details of Lalique's marks.

Blakemore, Kenneth, *The Retail Jeweller's Guide*, London, 1976. Includes a section on marks and facsimile signatures.

Bott, G., *Kunsthandwerk um 1900: Jugendstil*, Darmstadt, 1973.

Gere, Charlotte, *European and American Jewellery, 1830–1914*, London, 1975.

Hase, Ulrike von, *Schmuck in Deutschland und Österreich 1895–1914*, Munich, 1977. Gives details of German and Austrian marks.

Haslam, Malcolm, *Marks and Monograms of the Modern Movement 1875–1930*, London, 1977.

Jeweller's Circular: Trademarks of the Jewelry and Kindred Trades, Radnor (Pennsylvania), 1896. Gives American makers' marks.

Neuwirth, W., *Lexikon der Wiener Gold- und Silberschmiede*, Vienna, 1976–77.

Rainwater, Dorothy T., *American Silver Manufacturers, Their Marks, Trademarks and History*, Hanover (Pennsylvania), 1966.

Sataloff, Joseph, *Art Nouveau Jewelry*, Dorrance (Pennsylvania), 1984.

Tait, H. (ed.), *The Art of the Jeweller: A Catalogue of the Hull Grundy Gift to the British Museum*, London, 1984. Information about French makers' marks taken from the registers of the Garantie des Métaux Précieux in Paris (the French assay office) was published here for the first time.

Tardy, *International Hallmarks on Silver*, Paris, 1981.

Makers' Marks and Signatures

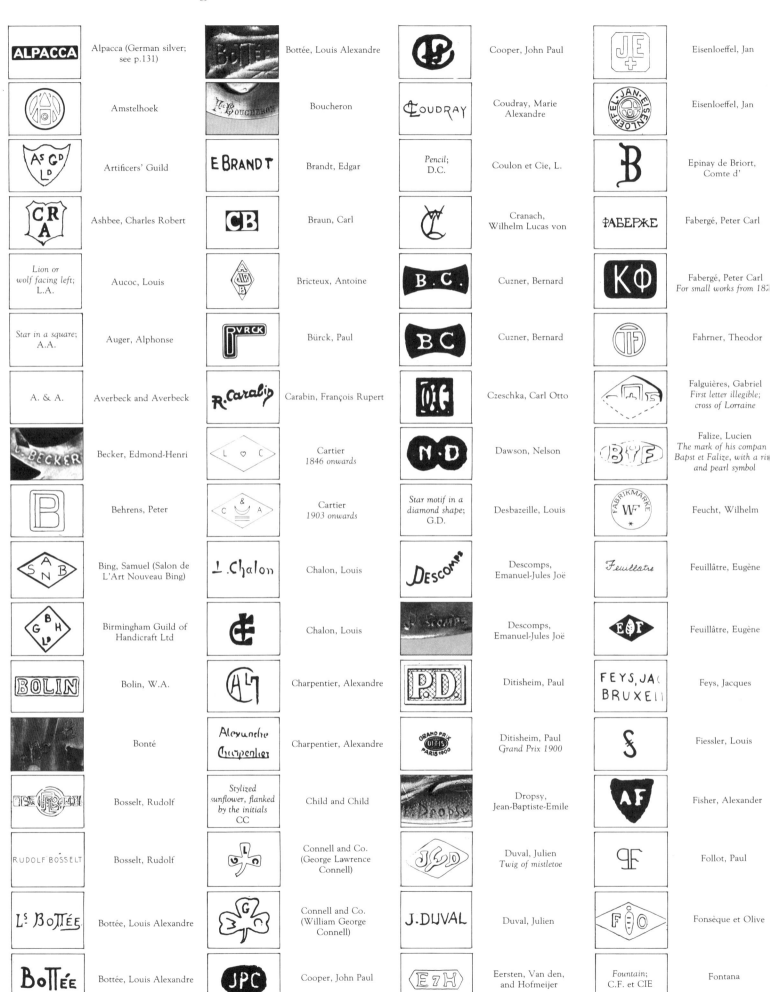

Mark	Maker	Mark	Maker	Mark	Maker	Mark	Maker	
ALPACCA	Alpacca (German silver; see p.131)	BOTTÉE	Bottée, Louis Alexandre	℗	Cooper, John Paul	JE	Eisenloeffel, Jan	
Amstelhoek	Amstelhoek	L.o.B BOUCHERON	Boucheron	COUDRAY	Coudray, Marie Alexandre	JAN·EISENLOEFFEL	Eisenloeffel, Jan	
AS GD LD	Artificers' Guild	E BRANDT	Brandt, Edgar	*Pencil;* D.C.	Coulon et Cie, L.	B	Epinay de Briort, Comte d'	
CR A	Ashbee, Charles Robert	CB	Braun, Carl	C	Cranach, Wilhelm Lucas von	ФАБЕРЖЕ	Fabergé, Peter Carl	
Lion or wolf facing left; L.A.	Aucoc, Louis	AB	Bricteux, Antoine	B. C.	Cuzner, Bernard	KФ	Fabergé, Peter Carl *For small works from 18?*	
Star in a square; A.A.	Auger, Alphonse	BVRCK	Bürck, Paul	BC	Cuzner, Bernard	TF	Fahrner, Theodor	
A. & A.	Averbeck and Averbeck	R. Carabin	Carabin, François Rupert	DIG	Czeschka, Carl Otto	A 15	Falguières, Gabriel *First letter illegible; cross of Lorraine*	
L. BECKER	Becker, Edmond-Henri	L ♡ C	Cartier *1846 onwards*	N·D	Dawson, Nelson	BYF	Falize, Lucien *The mark of his compan Bapst et Falize, with a ri and pearl symbol*	
B	Behrens, Peter	C & A	Cartier *1903 onwards*	*Star motif in a diamond shape;* G.D.	Desbazeille, Louis	FABRIKMARKE WF *	Feucht, Wilhelm	
SANB	Bing, Samuel (Salon de L'Art Nouveau Bing)	L. Chalon	Chalon, Louis	DESCOMPS	Descomps, Emanuel-Jules Joë	Feuillatre	Feuillâtre, Eugène	
GBH LD	Birmingham Guild of Handicraft Ltd	CFC	Chalon, Louis	J. Scomps	Descomps, Emanuel-Jules Joë	E F	Feuillâtre, Eugène	
BOLIN	Bolin, W.A.	CAL7	Charpentier, Alexandre	P.D.	Ditisheim, Paul	FEYS, JA(BRUXEI		Feys, Jacques
Bonté	Bonté	Alexandre Charpentier	Charpentier, Alexandre	GRAND PRIX Dtfs PARIS 1900	Ditisheim, Paul *Grand Prix 1900*	S	Fiessler, Louis	
Bosselt, Rudolf	Bosselt, Rudolf	*Stylized sunflower, flanked by the initials* CC	Child and Child	L. Dropsy	Dropsy, Jean-Baptiste-Emile	AF	Fisher, Alexander	
RUDOLF BOSSELT	Bosselt, Rudolf	LO	Connell and Co. (George Lawrence Connell)	JCD	Duval, Julien *Twig of mistletoe*	PF	Follot, Paul	
Lᵉ BOTTÉE	Bottée, Louis Alexandre	G C	Connell and Co. (William George Connell)	J. DUVAL	Duval, Julien	FIO	Fonsèque et Olive	
BOTTÉE	Bottée, Louis Alexandre	JPC	Cooper, John Paul	E 7 H	Eersten, Van den, and Hofmeijer	*Fountain;* C.F. et CIE	Fontana	

234

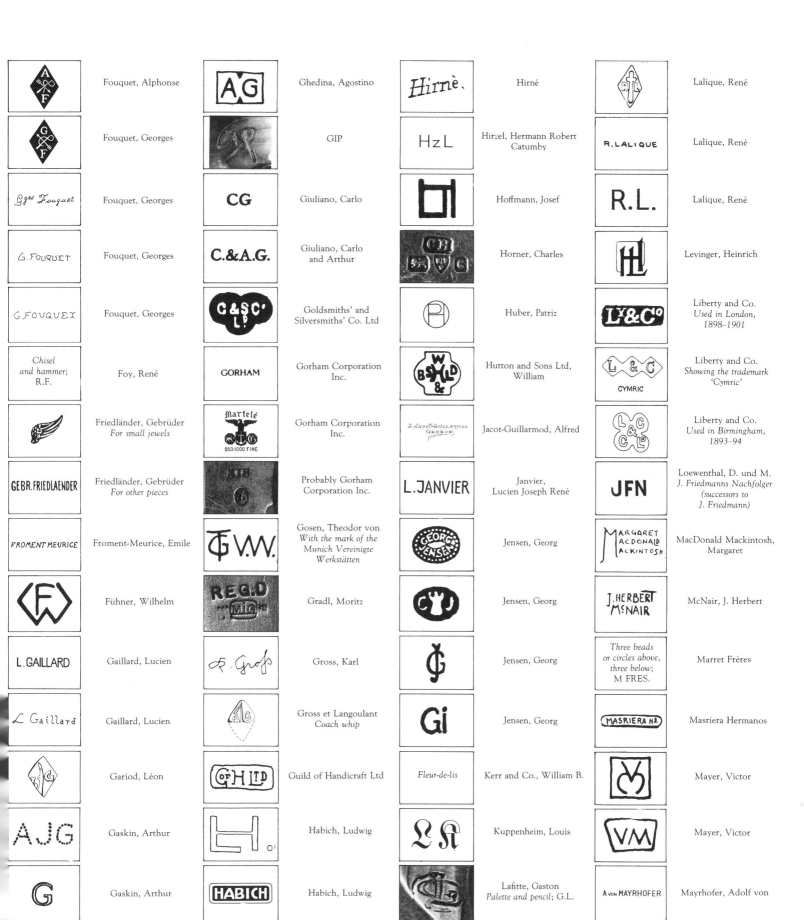

	Fouquet, Alphonse	AG	Ghedina, Agostino	Hirnè.	Hirné		Lalique, René
	Fouquet, Georges		GIP	HzL	Hirzel, Hermann Robert Catumby	R.LALIQUE	Lalique, René
Gges Fouquet	Fouquet, Georges	CG	Giuliano, Carlo		Hoffmann, Josef	R.L.	Lalique, René
G. FOUQUET	Fouquet, Georges	C.&A.G.	Giuliano, Carlo and Arthur		Horner, Charles		Levinger, Heinrich
G FOUQUET	Fouquet, Georges	C&SC° L?	Goldsmiths' and Silversmiths' Co. Ltd		Huber, Patriz	L Y & C°	Liberty and Co. Used in London, 1898–1901
Chisel and hammer; R.F.	Foy, René	GORHAM	Gorham Corporation Inc.		Hutton and Sons Ltd, William	L & C CYMRIC	Liberty and Co. Showing the trademark 'Cymric'
	Friedländer, Gebrüder For small jewels	martelé 950-1000 FINE	Gorham Corporation Inc.	A.Jacot-Guillarmod GENEVE	Jacot-Guillarmod, Alfred	L & C °D	Liberty and Co. Used in Birmingham, 1893–94
GEBR.FRIEDLAENDER	Friedländer, Gebrüder For other pieces		Probably Gorham Corporation Inc.	L.JANVIER	Janvier, Lucien Joseph René	JFN	Loewenthal, D. und M. J. Friedmanns Nachfolger (successors to J. Friedmann)
FROMENT MEURICE	Froment-Meurice, Emile	V.W.	Gosen, Theodor von With the mark of the Munich Vereinigte Werkstätten	GEORG JENSEN	Jensen, Georg	MARGARET MACDONALD MACKINTOSH	MacDonald Mackintosh, Margaret
FW	Führner, Wilhelm	REG.D M°IG	Gradl, Moritz	CYJ	Jensen, Georg	J.HERBERT McNAIR	McNair, J. Herbert
L. GAILLARD	Gaillard, Lucien	R. Groß	Gross, Karl	JG	Jensen, Georg	Three beads or circles above, three below; M FRES.	Marret Frères
L Gaillard	Gaillard, Lucien	AG	Gross et Langoulant Coach whip	Gi	Jensen, Georg	MASRIERA H?	Masriera Hermanos
	Gariod, Léon	CofH LTD	Guild of Handicraft Ltd	Fleur-de-lis	Kerr and Co., William B.	M	Mayer, Victor
AJG	Gaskin, Arthur	H .o	Habich, Ludwig		Kuppenheim, Louis	VM	Mayer, Victor
G	Gaskin, Arthur	HABICH	Habich, Ludwig		Lafitte, Gaston Palette and pencil; G.L.	A VON MAYRHOFER	Mayrhofer, Adolf von
L GAUTRAIT	Gautrait, Lucien		Hartz et Cie (successors to Plisson et Hartz in 1904)	LALIQUE	Lalique, René	M	Michelsen, A.
V. GEMITO	Gemito, Vincenzo	W·H·H	Haseler, William H.	LALIQUE	Lalique, René	(MICHELSEN)	Michelsen, A.

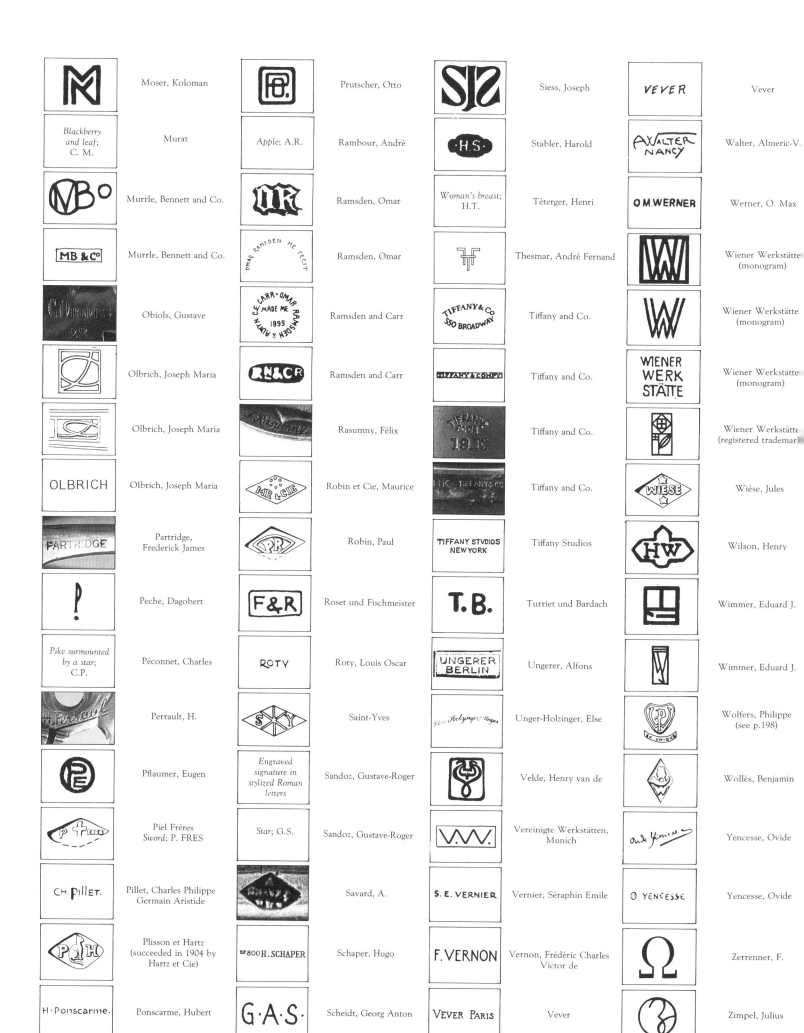

Mark	Name	Mark	Name	Mark	Name	Mark	Name
	Moser, Koloman		Prutscher, Otto		Siess, Joseph	*VEVER*	Vever
Blackberry and leaf; C. M.	Murat	*Apple*; A.R.	Rambour, André	·H·S	Stabler, Harold	A.WALTER NANCY	Walter, Almeric-V.
	Murrle, Bennett and Co.		Ramsden, Omar	*Woman's breast;* H.T.	Téterger, Henri	O.M.WERNER	Werner, O. Max
MB & Cº	Murrle, Bennett and Co.	OMAR RAMSDEN ME FECIT	Ramsden, Omar		Thesmar, André Fernand		Wiener Werkstätte (monogram)
	Obiols, Gustave	CARR·OMAR RAMSDEN & ALWYN CE MADE ME 1899	Ramsden and Carr	TIFFANY & Co 550 BROADWAY	Tiffany and Co.		Wiener Werkstätte (monogram)
	Olbrich, Joseph Maria	RN&CR	Ramsden and Carr	TIFFANY & COMPY	Tiffany and Co.	WIENER WERK STÄTTE	Wiener Werkstätte (monogram)
	Olbrich, Joseph Maria		Rasumny, Félix	TIFFANY 8469 18.K	Tiffany and Co.		Wiener Werkstätte (registered trademark)
OLBRICH	Olbrich, Joseph Maria	MR & CIE	Robin et Cie, Maurice	14K TIFFANY & Co	Tiffany and Co.	WIESE	Wièse, Jules
PARTRIDGE	Partridge, Frederick James	PR	Robin, Paul	TIFFANY STVDIOS NEW YORK	Tiffany Studios	HW	Wilson, Henry
!	Peche, Dagobert	F&R	Roset und Fischmeister	T.B.	Turriet und Bardach		Wimmer, Eduard J.
Pike surmounted by a star; C.P.	Péconnet, Charles	ROTY	Roty, Louis Oscar	UNGERER BERLIN	Ungerer, Alfons		Wimmer, Eduard J.
	Perrault, H.	S·Y	Saint-Yves	*Else Holzinger-Unger*	Unger-Holzinger, Else	P SZ UNIQUE	Wolfers, Philippe (see p.198)
PE	Pflaumer, Eugen	*Engraved signature in stylized Roman letters*	Sandoz, Gustave-Roger		Velde, Henry van de		Wollès, Benjamin
P FRES	Piel Frères *Sword*; P. FRES	*Star*; G.S.	Sandoz, Gustave-Roger	V.W.	Vereinigte Werkstätten, Munich	*ovde fiencesse*	Yencesse, Ovide
CH. PILLET.	Pillet, Charles Philippe Germain Aristide		Savard, A.	S. E. VERNIER	Vernier, Séraphin Emile	O YENCESSE	Yencesse, Ovide
PH	Plisson et Hartz (succeeded in 1904 by Hartz et Cie)	800 H.SCHAPER	Schaper, Hugo	F.VERNON	Vernon, Frédéric Charles Victor de	Ω	Zerrenner, F.
H·Ponscarme.	Ponscarme, Hubert	G·A·S·	Scheidt, Georg Anton	VEVER PARIS	Vever		Zimpel, Julius

236

Bibliography

Periodicals

Art et décoration, Paris, 1897–1939.
L'Art décoratif, Paris, 1898–1914.
Artistic Japan, London, 1888–91. French edition: *Le Japon artistique*, Paris, 1888–91. German edition: *Japanischer Formenschatz*, Leipzig, 1888–91.
Deutsche Kunst und Dekoration, Darmstadt, 1897–1934.
Jugend, Munich, 1896–1933.
Pan, Berlin, 1895–1900.
La Revue des arts décoratifs, Paris, 1897–1902.
La Revue de la bijouterie, joaillerie, orfèvrerie, Paris, 1900–05.
The Studio, London, 1893 onwards, and special supplement, 'Modern Design in Jewellery and Fans', ed. C. Holme, 1901–02.

Books and Articles

Album d'art: le bijou, Collection de l'Art Décoratif, Paris, 1904.
Amaya, Mario, *Art Nouveau*, London, 1966.
——, 'Liberty and the Modern Style', *Apollo*, London, vol. 77, 1963.
Anscombe, Isabelle, and Charlotte Gere, *Arts and Crafts in Britain and America*, London, 1978.
Arwas, Victor, *Art Deco*, London, 1980.
Bairati, Eleanora, et al., *La Belle Epoque*, New York, 1978.
Barten, Sigrid, *René Lalique 1890–1910*, Munich, 1977.
Beauclair, René, *Neue Ideen für Modernen Schmuck*, Stuttgart, 1901.
Becker, Vivienne, 'Arts and Crafts Jewellery', *Antique Collector*, London, Jun. 1979.
——, *Antique and Twentieth Century Jewellery*, London, 1980.
——, 'Murrle, Bennett & Co.', *Antique Collector*, London, Nov. 1980.
——, 'Art Nouveau Jewellery Made in Germany', *Antique Collector*, London, Sep. 1982.
Bing, Samuel, *La Culture artistique en Amérique*, Paris, 1896.
Black, J. Anderson, *A History of Jewels*, London, 1981.
Blakemore, Kenneth (ed.), *The Retail Jeweller's Guide*, London, 1976.
Bott, G., *Kunsthandwerk um 1900: Jugendstil*, Darmstadt, 1973.
Bury, Shirley, *Jewellery Gallery Summary Catalogue*, Victoria and Albert Museum, London, 1983.
——, 'The Liberty Metalwork Experiment', *Architectural Review*, London, 1963.
Crane, Walter, *Line and Form*, London, 1900.
Culme, John, 'Nineteenth Century Silver', *Country Life*, London, 1977.
Dekay, Charles, *The Art Work of Louis Comfort Tiffany*, New York (privately printed), 1917.
Falk, Fritz, *Schmuckmuseum Pforzheim* (catalogue to collection), Pforzheim, 1980.
Fisher, Alexander, *The Art of Enamelling upon Metal*, London, 1906.
Flower, Margaret, *Victorian Jewellery*, London, 1967.
Forrer, L., *A Biographical Dictionary of Medallists*, London, 1919.
Fouquet, Georges (ed.), *La Bijouterie de fantaisie au XXe siècle*, Paris, 1934.
Gere, Charlotte, *Victorian Jewellery Design*, London, 1972.
——, *European and American Jewellery, 1830–1914*, London, 1975.
Guérinet, A. (ed.), *L'Art décoratif aux expositions des beaux-arts*, Paris, 1902.
Harlow, Katherina, 'A Pioneer Master of Art Nouveau: The Hand-wrought Jewellery of Louis C. Tiffany', *Apollo*, London, Jul. 1982.
Hase, Ulrike von, *Schmuck in Deutschland und Österreich 1895–1914*, Munich, 1977.
Haslam, Malcolm, *Marks and Monograms of the Modern Movement, 1875–1930*, London, 1977.
Hinks, Peter, *Nineteenth-century Jewellery*, London, 1975.
——, *Twentieth-century British Jewellery, 1900–1980*, London, 1983.
Hughes, Graham, *Modern Jewellery*, London, 1964.

Jewelry Ancient to Modern, Walters Art Gallery, Baltimore, 1979.
Jullian, Philippe, *The Triumph of Art Nouveau: The Paris Exhibition 1900*, New York, 1974.
Koch, R.A., 'Art Nouveau Bing', *Gazette des Beaux-arts*, Paris, Mar. 1959.
Latham, Ian, *Joseph Maria Olbrich*, New York, 1980.
Leidelmeijer, F., *Art Nouveau and Art Deco in Nederland*, Velsen 1983.
Lochmüller, Walter, *100 Jahre Schmuck Design*, Pforzheim, 1973.
Madsen, Stephan Tschudi, *Sources of Art Nouveau*, New York, 1975.
Melville, Robert, 'The Soft Jewellery of Art Nouveau', *Architectural Review*, London, May 1962.
Meusnier, G., *La Joaillerie française en 1900*, Paris, 1901.
Munn, Geoffrey, *Castellani and Giuliano, Revivalist Jewellers of the Nineteenth century*, London, 1984.
Nadelhoffer, Hans, *Cartier: Jewelers Extraordinary*, London and New York, 1984.
Novas, Himilce, 'A Jewel in his Crown', *Connoisseur*, New York, 1983.
Purtell, Joseph, *The Tiffany Touch*, New York, 1976.
Sataloff, Joseph, *Art Nouveau Jewelry*, Bryn Mawr (Pennsylvania), 1984.
Schmutzler, Robert, *Art Nouveau*, New York, 1962, London, 1964.
Schweiger, Werner, J., *Weiner Werkstätte, Kunst und Handwerk*, Vienna, 1982.
Smith, H.C., *Jewellery*, London and New York, 1908.
Snowman, A.K., *Carl Fabergé*, London, 1980.
Tait, H., and Charlotte Gere, *The Jeweller's Art: An Introduction to the Hull Grundy Gift to the British Museum*, London, 1978.
Tait, H. (ed.), *The Art of the Jeweller: A Catalogue of the Hull Grundy Gift to the British Museum*, London, 1984.
Tilbrook, Adrian, *The Designs of Archibald Knox for Liberty & Co.*, London, 1976.
Vaughan, Cathryn, 'Art Nouveau Horn Jewellery', *Antique Collector*, London, Nov. 1982.
Vever, Henri, *La Bijouterie française au XIXe siècle*, Paris, 1908.
Waddell, Roberta (ed.), *The Art Nouveau Style*, New York, 1977.
Wolfers, Marcel, *Philippe Wolfers*, Brussels, 1965.

Exhibition Catalogues

1896 *Salon de l'Art Nouveau*, Hôtel Bing, Paris.
1899 *Exhibition of L'Art Nouveau: Collection of Samuel Bing*, Grafton Galleries, London.
1905 *Works by René Lalique*, Agnew and Sons, London.
1959 Peter Selz (ed.), *Art Nouveau*, New York (revised 1975).
1961 *International Exhibition of Modern Jewellery 1961*, Worshipful Company of Goldsmiths, London.
1962 *Jugendstil Sammlung K. A. Citroen*, Hessisches Landesmuseum, Darmstadt.
1965 *Le Bijou 1900*, Hôtel Solvay, Brussels.
1967 *Die Wiener Werkstätte 1903–1932*, Österreichisches Museum, Vienna.
1971 Dora Jane Janson, *From Slave to Siren*, Durham (North Carolina), 1971.
1975 *Jewellery and Jewellery Design 1850–1930*, The Fine Art Society, London.
John Paul Cooper, 1869–1933, The Fine Art Society, London.
1976 *Art Nouveau Belgium/France*, Houston Rice University.
1979 *Loïe Fuller, Magician of Light*, Virginia Museum.
1980 *Anderson Collection*, University of East Anglia, Norwich.
1981 *Arthur and Georgie Gaskin*, Birmingham City Museum and Art Gallery.
1982 *La Belle Epoque*, Metropolitan Museum of Art, New York.
1982 *Bijoux Art Nouveau*, Musée d'Art et d'Histoire, Geneva.
1983 *Les Fouquet*, Musée des Arts Decoratifs, Paris.
1983 Victor Arwas, *Liberty Style*, Tokyo.
1983 *Colonna*, Dayton Art Institute.

Index

Page numbers in italic refer to illustrations in the text.

Aguttes, Georgette 214
Alabaster, Annie 231
Allen, Kate 179
Altenlöh 231
Amstelhoek 231, 234
Archambaut 214
Art Deco 7, 136, 216, 218, 219, 228
Art Nouveau, L' (gallery) 42–46, 234
Artificers' Guild 156, 217, 234
Arts and Crafts Movement 12, 17, 43, 154–56, 159, 160, 177, 178, 180, 182, 184, 212, 214, 216, 220, 222, 224, 226, 230
Ashbee, C.R. 17, 111, 132, 133, 155–56, 214, 234; pls 1, 4, 242, 247, 249
Aucoc, André 90
Aucoc, Louis 47, 90–91, 214, 234; pls 18, 100, 102, 120, 152–54
Augé, Mathilde 214
Auger, Alphonse 214, 234; pls 9, 130
Averbeck and Averbeck 194, 214, 234

Baillie Scott, M.H. 111, 158
Baker, Oliver 159, 214; pl. 239
Ballin, Mogens 200, 209, 214
Basset et Moreau 214
Bastanier, Georg 110, 214
Bataille, J. 231
Beauclair, René 214
Beaudouin pl. 135
Becker, Edmond-Henri 89, 91, 94, 214, 234; pls 106, 127, 146, 151
Beetz-Charpentier, Eliza 46, 214
Behrens, Peter 107, 112, 129, 129, 214, 234
Belville, Eugène 214
Bernhardt, Sarah 17, 21, 21, 45, 65, 71, 89, 93; pl. 24
Bindesbøll, Thorvald 209, 214
Bing, Marcel 45–46, 45, 214; pls 47, 48
Bing, Samuel 42–46, 157, 200, 214, 216, 219, 220, 234, 237
Binhardt, Georg 221; pl. 167
Birmingham Guild of Handicraft 234
Blanchot 231
Bocquet, F. 215
Bolin 210, 215, 234; pl. 304
Bonny, Louis 215
Bonté 22–23, 215, 234; pl. 12
Bonval 215
Bosselt, Rudolf 112, 130, 215, 234
Bottée, Louis Alexandre 69, 94, 215, 234
Boucheron 10, 48, 89–90, 94, 215, 232, 234; pls 106, 144
Boutet de Monvel, Charles 16, 22, 212, 215; pl. 110

Bouvet, R. 215
Bozza, L. 231; pl. 316
Braillard 231
Brandt, Edgar 215, 234
Brandt, Paul 215
Brateau, Jules 89, 231
Braun, Carl 231, 234
Bréant et Coulbaux 231
Bricteux, Antoine 215, 234; pls 105, 141
Brindeau 215
Bronckere, de 231
Brunet, Georges 215
Bucher, André 215
Bürck, Paul 112, 130, 215, 234
Burges, William 8, 157
Burne-Jones, Edward, 179, 215

Carabin, François 132, 215, 234
Cartier 47, 48, 90, 216, 234
Casaulta 216
Castellani family 8
Cavalieri, Lina 21
Chalon, Louis 231, 234
Chambin, Albert 231
Chardon 67
Charlot 92, 231
Charpentier, Alexandre 90, 231, 234
Chaumet 90, 216
Chaveton 231
Chéret, Jules 92, 216
Cherrier 216
Child and Child 179, 216, 234; pl. 9
Chopard 216
Christiansen, Hans 112, 129, 216; pl. 209
Codman, William C. 193
Coeylas 216
Colonna, Edward 44–45, 216, 237; pls 44, 49–50
Connell and Co. 177, 216, 234
Cook, Thomas A. 216
Cooper, John Paul 155–56, 216, 234, 237; pls 238, 251
Coudray, Marie Alexandre 216, 234
Coulon et Cie, L. 90, 216, 234
Courcy, de 92, 231
Cranach, Wilhelm Lucas von 108, 131, 217, 234; pls 157–58
Crane, Walter 15
Cros, Henri 24
Cuzner, Bernard 159, 217, 234
Cymric 157–60
Czeschka, Carl Otto 134, 135–36, 217, 234; pl. 191

Dabault, E. 217; pl. 13
Dampt, Jean 231
Darmstadt (artists' colony) 109, 110, 111–12, 129–30, 131, 160, 214, 215, 216, 218, 221, 222, 225, 226; pls 216, 217
Davidson, Peter Wyler 231
Dawson, Edith 156, 217; pl. 237
Dawson, Nelson 156, 217, 234; pl. 237
Debacq 231
Deberghe 231
Debût, Jules 89, 90, 217
Delavilla, Franz 217; pl. 220

Démaré, Victor 231
Deraisme, Georges-Pierre 217
Desbazeille, Louis 93, 217, 234
Desbois, Jules 217
Descomps, Emanuel-Jules Joë 217, 234; pls 85, 107, 115
Desprès 217
Desrosiers, Charles 68, 70, 71, 217
Destape, Jules 47, 48
Deverdun 90
Dick, Reginald 231
Dickinson, Philomen 194
Dietrich, Oskar 135, 217; pls 219–20
Ditisheim, Paul 231, 234
Dresser, Christopher 10, 12
Dropsy, Jean-Baptiste-Emile 217, 234; pls 139, 151
Dubois, Fernand 218
Dubois, Paul 199, 218
Dubret, Henri 231; pl. 122
Duchemin 231
Dufrène, Maurice 46–47, 211, 218; pl. 121
Duguine, C. 218; pls 9, 27, 125, 297
Durand-Leriche 218; pl. 114
Durbec 231
Duse, Eleonora 21
Duval, Julien 93, 218, 234; pl. 147

Écalle, Charles 231
Eckmann, Otto 8ff, 106, 106ff
'Edwardian' style 71, 89, 110, 179, 216, 228; pl. 280
Eersten, van den, and Hofmeijer 231, 234
Eisenloeffel, Jan 218, 234; pl. 306
Enamel 14, 15, 17, 18, 23, 24, 67, 68, 69, 70, 72, 89, 110, 130, 133, 135, 136, 155, 156, 158–59, 177, 178, 179, 184, 193, 194, 210, 216–30; pls 5, 136, 165, 254, 280, 281, 311; cabochonné 23, 24, 225, 228; pls 119, 133; champlevé 24; cloisonné 13, 23, 91, 184, 218, 222, 224, 228, 229; pl. 94; paillons 24, 69, 70, 91, 180, 229, 230; pls 8, 11, 65; pâte de verre 24, 72, 230; pl. 15; plique à jour 16, 17, 23, 44, 45, 69, 70, 91, 92, 132, 198, 212, 221–25, 227, 228, 230; pls 8, 124, 178
Endell, August 106, 107, 218
Epinay de Briort, Comte d' 94, 218, 234; pls 145, 149
Erhart, Ferdinand 218
Erler, Erich 107, 218

Fabergé, Peter Carl 209–10, 218, 234; pl. 310
Fahrner, Theodor 111, 112–30, 136, 160, 218, 234; pls 167, 169, 177, 192, 194–96, 202–03, 205–08, 210–11, 214, 215, 232, 232
Falguières, Gabriel 18, 218, 234
Falize, Alexis 13; pl. 97

Falize, Lucien 10, 13, 43, 218, 234; pl. 97
Falk, Gebrüder 111, 218; pl. 175
Fannière Frères 219
Ferrero 231
Feucht, Wilhelm 219, 234
Feuillâtre, Eugène 91–92, 219, 234
Feure, Georges de 45, 219
Feys, Jacques 231, 234
Fiessler, Louis 111, 219, 234; pl. 173
Fisher, Alexander 24, 156, 219, 234
Fisher, Kate 231
Fleuret 210, 231; pl. 126
Fleury, O. de 219
Foisil 93, 219
Follot, Paul 46, 47, 219, 234
Fonsèque et Olive 92, 219, 234; pl. 137
Fontana 219, 234
Foster Brothers 231
Foster, Theodore W. 194
Fouquet, Alphonse 19, 19, 69, 235; pl. 103,
Fouquet, Georges 17, 19, 21, 21, 68, 69–70, 219, 232, 235, 237; pls 78, 81–82, 91–94
Fourain, A. 219
Foy, René 219, 235; pl. 119
Frey, Paul 219
Friedländer, Gebrüder 231, 235
Froment-Meurice, Emile 220, 235
Froment-Meurice, François-Désiré 19
Fühner, Richard 111, 220
Fühner, Wilhelm 160, 235
Fuller, Loïe 20–21, 20, 181, 237

Gaillard, Eugène 45
Gaillard, Lucien 9, 16, 22, 46, 68, 72, 220, 235; pls 7, 34, 72, 83, 87–90
Gallé, Emile 11, 24
Gariod, Léon 47, 69, 89, 109, 220, 235; pl. 115
Garnier, Alfred 92, 220
Gaskin, Arthur 156, 156, 159, 220, 235, 237; pl. 236
Gaskin, Georgie 156, 156, 220; pl. 236
Gautrait, Lucien 17, 68, 89, 220, 235; pls 32, 108–09
Gemito, Vincenzo 220, 235; pl. 322
Ghedina, Agostino 231, 235; pl. 229
Gilbert, Alfred pl. 2
GIP (Georges Pierre) 22, 220, 235
Giuliano, Carlo 8, 179–80, 220, 235
Godet, E. 118
Golay Fils et Stahl 210
Goldsmiths' and Silversmiths' Co. Ltd 231, 235
Gorham Corporation Inc. 193, 220, 233, 235
Gosen, Theodore von 220, 235
Gradl, Moritz 108, 129, 130, 220, 235; pls 208, 210, 214

Grandhomme et Brateau 92, 220
Grasset, Eugène 10–11, 12, 13, 41, 69, 70, 220; pls 56, 62
Gross, Karl 221, 235
Gross et Langoulant 221, 235
Guérin, J. 221
Gueyton, Camille 221; pl. 112
Guild of Handicraft Ltd 133, 155, 214, 226, 230, 235
Guimard, Hector pl. 25
Gurschner, Gustav 135, 221

Haas Neveux 231
Habich, Ludwig 112, 129, 221, 235
Hamelin, Paul 47, 221
Hamm 221
Harris, Kate 179, 221
Hart, Dorothy 231
Harvey, Agnes Bankier 221
Haseler, W.H. 159, 235
Hauber, Adolf 199
Hauptmann, A.D. 132, 221
Hauptmann, Franz 231
Haweis, Mary 16
Héglas, Mme 231
Heiden, Theodor 221
Henry, George 221
Hesbert, Paul 221
Hesse, Ernst, Duke of 111–12
Heurtebise, Lucien 221; pl. 111
Hirné 221, 235
Hirtz, Lucien 89, 221
Hirzel, Hermann Robert Catumby 108, 221, 235; pl. 201
Hodgkinson, Winifred 179, 231
Hoeker, W. 199, 221
Hoffman, Josef 130–31ff, 132, 133–34, 135, 221, 235; pls 179–84, 187, 190, 218
Hoffmann, N. 67
Hoffstätter, J. 221
Holbein, Albert 221; pls 162, 167
Hooseman, H. 46
Horn 16, 22–23, 66, 70, 72, 91, 177, 178, 215, 220, 221, 223; pls 7, 12, 40, 51, 88–91, 123, 255
Horner, Charles 178–79, 178, 221, 235; pl. 271
Horner, James Dobson 178
Horta, Victor 187, 198
Houillon, Louis 91, 221
Huber, Oskar 210, 221; pl. 311
Huber, Patriz 108, 112, 129, 131, 221, 232, 235; pls 196, 202, 205
Husson, Henri 222
Hutton and Sons Ltd, William 179, 222, 235

Ihm 222

Jacot-Guillarmod, Alfred 222, 235; pl. 319
Jacquin, Georges 222
Jacta 47, 222
Jahn, A.C.C. 178, 222; pls 273–74
Janvier, Lucien 222, 235; pls 30, 132

Japonisme 10, 12–14, 16, 18, 42, 44, 72, 95, 106, 110, 156, 157, 182, 183, 197, 198, 216, 218, 220, 221, 224, 230; pl. 5
Jean, Charles 92, 231
Jensen, Georg 200, 214, 222, 235; pl. 303
Joindy 222
Jones, Owen 10, 10, 13, 158

Kalhammer, Gustav 222; pl. 193
Kappermann, Hermann pl. 230
Karst, Karl 222; pl. 195
Katrina 222
Kerr and Co., William B. 193, 222, 235; pls 297, 299
King, Jessie M. 159, 160, 180, 222; pls 239, 246, 257–58, 270
Kleemann, Georg 16, 130; pls 198, 202, 212
Klimt, Georg 222; pl. 222
Knox, Archibald 15, 153, 158–59, 160, 222; pls 239, 243–45, 260, 262–63
Koch, Max Friedrich 222
Koch, Robert 107, 129, 222
Koehler, Florence 182, 222; pl. 145
Kohn 231
Kolb, Georg 110, 222
Krementz 231
Křivánková, Maria 222; pl. 312
Kuppenheim, Louis 222, 235

Lafitte, Gaston 222, 235; pls 22, 124
Lalique, René 8, 10, 16, 17, 18, 20, 21, 22, 23, 24, 43, 44, 47, 47–48, 48, 65–68, 66, 67, 72, 91, 92, 212, 223, 233, 235, 237; pls 10, 16–17, 39–42, 45, 51–55, 58–60, 64–77
Lambert, Théodore 14, 223
Landois, G. 91, 223; pl. 100
Landry, Abel 223
Laporte Blairsy, Léo 223
Larcombe, Ethel 179, 231
Lauer und Wiedmann 130
Lauth Sand, Mme 223
Le Couteux, Lionel 223
Le Saché, Georges 223
Le Turcq, Georges 90, 93, 223; pls 120, 150, 155–56
Lecas, Edmond 231
Lecreux, Marguerite 223
Lefebvre 18, 223
Lelièvre, Eugène 223, 231
Lemaire 231
Lemeunier et Cauvin 231
Levinger, Heinrich 135, 223, 235
Liberty, Arthur Lasenby 156–59
Liberty and Co. 154–80, 223–24, 232, 232, 233, 235, 237; pls 239, 243–46, 256–64, 270
Liénard, Paul 42ff, 68, 210, 224; pls 6, 95
Linzeler 224
Lobjois 90
Loeuillard 10
Loewenthal, D. und M. 129, 130, 231, 235; pl. 209
Löffler, Bernhard 135, 224; pl. 226
Louchet, Paul 224; pl. 128

MacDonald, Frances 180, 224
MacDonald Mackintosh, Margaret 180, 224, 235; pl. 279
Mackintosh, Charles Rennie 15, 134, 135, 154ff, 177, 180, 224; pl. 279
McLeish, Annie 179, 231
McLeish, Minnie 231
McNair, J. Herbert 180, 224, 235
Magnussen, Erick 231
Maison Moderne, La 22, 46–47, 196, 218, 219, 226
Mandre, de 231
Mangeant, E. Paul 224
Marchand 19, 231
Marcus and Co. 193, 213, 224; pls 281, 285, 291–92, 295
Margold, Emanuel 224; pl. 219
Marie, Charles 224
Marionnet 231
Marret Frères 224, 235
Martelé 193, 233, 235
Martilly, de 224
Martincourt 231
Martineau, Sarah Madeleine 224; pls 250, 252
Masriera, Luis 211–12, 225; pls 325, 326
Masriera Hermanos 211, 225, 235
Massin, Oscar 10, 19, pl. 111
Mayer, Victor 130, 225, 235
Mayrhofer, Adolf von 225, 235
Medal-jewels 92–94, 194, 214–20, 222, 223, 226–30; pls 145, 146, 151
Meier-Graefe, Julius 46, 106
Mellerio 225
Menu, Michel 89, 225
Mère, Clément 46, 225
Mérode, Cléo de 46
Messner (Mesmer), Franz 136, 225; pl. 230
Meusnier, Georges 95
Michelsen, A. 209, 225, 235; pl. 318
Miranda, Vincento 211, 225
Moche 225
Möhring, Bruno 108, 225
Montigny, Jeanne de 24, 225
Moore, Edward C. 42, 183
Morawe, Christian Ferdinand 129, 225
Morren, Georges 46, 231
Morris, Talwyn 180, 225
Morris, William 12, 14, 111, 154, 184
Moser, Koloman 7, 105, 132, 132, 133, 134, 134, 135, 136, 225, 236; pls 185, 186
Mucha, Alphonse 11, 21, 21, 70–71, 71, 184, 225, 232; pl. 103
Müller-Salem, Julius 225; pl. 167
Munch, Edvard 200
Munson, Julia 184, 193, 225
Murat 225, 236
Murrle, Bennett and Co. 159–77, 225, 232, 232, 236; pls 263, 265–68
Mürrle, Ernst 160
Musy 211, 226

Naper, Ella 177–78, 177, 178, 226; pl. 255
Naturalism 9, 10, 11, 69, 71, 94, 106, 197, 230
Nau 226
Neo-Renaissance style 8, 8, 13, 19, 19, 23, 24, 65, 69, 94, 107, 109, 131, 178, 179, 180, 200, 220; pls 28, 174, 275
Nics Frères 226
Nienhuis, Lambert 199, 226; pl. 307
Nocq, Henri 132, 226
Nolde, Emil 231
Noufflard, Annie 231

Obiols, Gustave 226, 236; pls 138, 140
Obrist, Hermann 106, 106
Ofner, Hans 226
Olbrich, Joseph Maria 107, 108–09, 112–29, 131, 132, 226, 236; pl. 213
Olivier 231
Oran, Robert 231
Orazzi, Manuel 46, 47, 226
Ortloff, Maria von pl. 204
Ostby and Barton 194, 231

Pankhurst, Christabel 154
Partridge, Frederick James 22, 177, 177, 226, 236; pl. 269
Partridge, May Hart 177
Patek Philippe 231
Peacock and Co. 231; pl. 292
Péan, René pl. 137
Peche, Dagobert 226, 236
Péconnet 226, 236
Pégoux 231
Perrault, H. 231, 236; pl. 26
Pflaumer, Eugen 210, 236
Pforzheim 95, 96, 109–11, 129, 130, 135, 160, 214, 218–20, 222, 223, 225, 227–30, 232; pls 165, 167, 170, 171, 177, 194, 195, 198, 199, 202, 212
Picard, Georges 67, 226
Pickett, Edith 231
Piel Frères 17, 226, 236; pls 39, 129
Pillet, Charles Philippe Germain Aristide 226, 236
Plisson et Hartz 18, 226, 236; pl. 131
Pochelon et Ruchonnet 210, 231; pl. 321
Pochelon Frères pl. 324
Pompe, L. 231, pl. 309
Ponocny, Karl 226; pl. 221
Ponscarme, Hubert 226, 236
Pospisil 231
Pougy, Liane de 21, 22, 23
Pradier 19
Preysler, Henri 210–11, 231
Pribil, Anton 134, 231; pl. 191
Printemps, Georges 226
Prouvé, Victor 21, 46, 93, 226; pl. 149
Prutscher, Otto 135, 227, 236; pl. 192, 223–24, 231–32

Quénard 231
Quené 231

Rambour, André 227, 236
Ramsden, Omar 227, 236; pl. 253
Rasumny, Félix 231, 236
Rault, Louis 89
Reinitzer 227
Ribeaucourt, Georges de 21, 227
Richard, Paul 93, 227; pl. 127
Ricketts, Charles 179, 227; pl. 275
Riester, Emil 109, 227; pl. 199
Riquet 92
Rivaud, Charles 93, 212
Rivet 227; pl. 151
Robin 18, 227, 236
Robinson, Fred 231
Roche, Pierre 20
Rohde, Johann 200, 209
Roset und Fischmeister 132–33, 134, 227, 236; pl. 178
Rothmüller, Karl 107, 227
Roty, Louis Oscar 93, 227, 236
Rousseau, Victor 231
Rouvenat, Léon 10
Rouzé 227
Rozet, René 69
Ruffe, Léon 231
Rühle 110; pl. 165
Ruskin, John 10, 12, 154, 155

Saacke, Emmanuel 160
Saint-Yves 227, 236
Sander-Noske, Sophie 227; pl. 234
Sandoz, Gustave-Roger 227, 236; pl. 96
Sattler, Joseph 107
Savard, A. 227, 236; pl. 139
Saver und Wiedmann pl. 202
Schaper, Hugo 107, 131, 227, 236; pls 168, 200
Scheidecker, Paul Frank 227
Scheidt, Georg Anton 134, 228, 236; pls 225, 233

Schenck, E. 228
Schober, M. 231
Schoenthoner, V. 228
Schreger, B. 129
Selmersheim, Jeanne 228
Selz, Peter 96
Siess, Joseph 228, 236
Silver, Rex 159, 228
Simpson, Edgar 228
Slott-Möller, Harald 209, 228
Solié, Henri-Auguste 228
Soufflot, Paul 228
Soulens, Paul 228
Soyer 92, 231
Stabler, Harold 231, 236
Stöffler, Wilhelm 110, 228
Stoll 231
Straten, Jacob von 231
Strathmann, Carl 228
Strydonck, Leopold van 199, 228; pl. 315
Sturbelle, Camille Marc 228
Suau de la Croix, Comte du 24, 228; pls 117, 133

Tard, Antoine 13, 92, 228
Templier 228
Téterger, Henri 20, 110, 113, 228, 236; pls 99, 116
Thallmayr, Nikolaus 107, 228; pl. 172
Thesmar, André 23, 91, 228, 236; pl. 5
Thomsen, Christian 228; pl. 318
Tiffany, Charles Louis 42
Tiffany, Louis Comfort 44, 182–93, 229
Tiffany and Co. 183–93, 236; pls 283, 290
Tiffany Studios 184–93, 236; pls 282, 288–89, 293–94
Tonnellier, Georges 229
Toorop, Jan 199–200
Topf, Erhard 229

Tour à réduire 65, 92, 93, 222, 223
Tourette, Etienne 69, 70, 91, 110, 229; pl. 11
Turriet und Bardach 229, 236; pl. 235

Unger Brothers 194, 229; pl. 299
Ungerer, Alfons 229, 236
Unger-Holzinger, Else 136, 229, 236

Vaguer, Léon 229
Vallgren 231
Vallot, Henri 210, 229; pl. 320
Varenne, M. 48
Varley, Charles Fleetwood 159, 229
Veazey, David 231
Velde, Henry van de 21, 46, 106, 108–09, 130, 132, 196, 197, 197ff, 198, 229, 213–40; pl. 305
Vereinigte Werkstätten, Munich 106, 218, 220, 221, 236
Verger, Ferdinand 94, 229
Verneuil, Maurice Pillard 229
Vernier, Séraphin Emile 92–93, 229, 236
Vernon, Frédéric Charles Victor de 93, 132, 229, 236; pl. 147
Vever, Ernest 68
Vever, Henri 8, 14, 19, 42, 67, 68–69, 92, 95–96, 214, 215
Vever, Maison 48, 68, 94, 215, 229, 236; pls 21, 63, 79–80, 84, 86
Vienna Secession 111–12, 131, 132, 133, 134, 177, 214, 221, 224, 225, 226
Vigan, Albert 230; pl. 121
Voet, E. 199–200, 230
Vogeler, Heinrich 230
Vollet, Henri 69, 230

Wagner, Anna 136, 230; pl. 227
Wagner, Otto 132, 133
Wagner, Raoul 230
Wagner, Siegfried 230
Walter, Almeric-V. 230; 236; pl. 15
Walther, Ernst H. 4
Watt, James Cromer 180, 230; pls 254, 277–78
Weber, Otto 231
Werner, J.H. 108, 230
Werner, Louis 108, 230; pl. 201
Werner, O. Max 108, 230, 236
Whistler, J.A.M. 17, 157
White, Redgrove and Whyte 160
Wiener Werkstätte 133–36, 180, 210, 236; pls 179–87, 189–91, 211, 214, 217, 218, 221–27, 230, 232, 237
Wièse, Jules 18, 230, 236
Wilckens und Söhne, M.H. 129
Wilson, Henry 156, 230, 236; pls 240, 248
Wimmer, Eduard J. 135, 230, 236; pls 189, 221
Witzmann, Karl 135, 230
Wolfers, Philippe 16, 90, 197–99, 230, 236; pls 8, 300, 308, 314, 317
Wollès, Benjamin 231, 236; pl. 138

Yencesse, Ovide 93, 230, 236

Zahn, Otto pls 198, 212
Zental, Ladislas 230, pl. 296
Zerrenner, F. 110, 129, 130, 230, 236; pls 176, 197
Zimpel, Julius 231, 236
Zorra, Louis 90, 230; pls 134, 148
Zumbusch, Ludwig von 107

Sources of the Illustrations

Figures in italic refer to the plates.

The author and publishers are grateful to the following institutions and individuals for permission to reproduce illustrations: *Antique Collector* 177, 271; **Baltimore**, The Walters Art Gallery 72, 73, 75; **Berlin**, Kunstgewerbemuseum 158; N. Bloom and Son (Antiques Ltd.), London 281; Verlag Brandstätter, Vienna p.135 below; Eric Bruton Associates/N.A.G. Press, London, from V. Becker, *Antique and Twentieth-century Jewellery* (1980) 7, 89; Christie's, London 40, 52, 128, 326, p.23; Cobra and Bellamy, London SW1 161, 162, 241, 245; John Culme p.194 above; **Darmstadt**, Hessisches Landesmuseum 24, 46, 79, 95, 96, 97, 100, 109, 110, 111, 112, 122, 125, 137, 147, 150, 152, 153, 154, 155, 156, 174, 201, 209, 231, 233, 235, 304, 306, 307, 309; Dr Beate Dry, v.Zeschwitz, Munich 163, 195, 196, 204, 205; Editions Graphiques, London W1 101, 202, 259, 299; Ferrers Gallery, London p. 47 above right; Fischer Fine Art, London p.134; **Frankfurt am Main**, Museum für Kunsthandwerk 38; H.J. Fühner p.111; **Gablonz an der Neisse** (Jablonec nad Nisou) Glass and Jewelry Museum (Muzeum Skla A Bižutérie) 225, 302; **Geneva**, Musée d'Art et d'Histoire 12, 14, 113, 114, 116, 126, 320, 321, 324; Worshipful Company of Goldsmiths, London 294; Collection of Peter and Debbie Gooday 194, 217, 239, 243, 246, 264; **Hamburg**, Museum für Kunst und Gewerbe 36, 67, 80, 148; Hancocks and Co., London 20, 55, 105, 115, 236; Nicholas Harris, London W1 145, 146, 285, 288, 298; Brian and Lynn Holmes, Grays Antique Market, London 23, 28, 151, 170, 255, 272, 276; Pamela Klaber p.178 below; John Jesse and Irina Laski Gallery (photographs by Mick Bruce, except 277) 1, 3, 4, 29, 31, 32, 41, 91, 98, 129, 141, 143, 159, 160, 164, 169, 171, 215, 216, 226, 237, 238, 244, 247, 248, 249, 250, 251, 252, 253, 258, 261, 270, 277, 278, 296, 303; Collection of Sydney and Frances Lewis 16, 53, 71, 81, 118, 142, 305;

Lisbon, Calouste Gulbenkian Foundation 59, 60, 61, 65, 69, 70; **London**, Trustees of the British Museum 26, 104, 127, 138, 139, 140, 144, 319, 322, 323; and makers' marks on pp.234–36, reproduced from H. Tait (ed.), *The Art of the Jeweller: A Catalogue of the Hull Grundy Gift* (1984); The Museum of London p.154; Victoria and Albert Museum 2, 87, 133, 260, 273, 274, 308, pp.14 above, 15; Macklowe Gallery Ltd, New York 22, 34, 44, 49 below, 119, 121, 167, 280, 282, 284, 286, 287, 289, 292, 297; N. Manoukian, Paris 11, 13, 186; I.J. Mazure and Co. Ltd, London 99; **Munich**, Staatsmuseum 301, p.106; **New York**, Collection Museum of Modern Art, Gift of Mme Hector Guimard 25; **Norwich**, The Anderson Collection of Art Nouveau, University of East Anglia 10, 78; **Oxford**, the Visitors of the Ashmolean Museum 275; **Paris**, Bibliothèque Nationale pp.20, 22 below; Musée des Arts Décoratifs 47, 48, 54, 56, 58, 62, 63, 64, 66, 76, 84, 88, pp.19, 21 below; Marlen Perez 17, 51; **Pforzheim**, Schmuckmuseum (photographs by Gunter Meyer) 18, 21, 27, 39, 42, 45, 90, 108, 135, 157, 165, 166, 172, 173, 175, 176, 182, 197, 198, 199, 200, 203, 206, 207, 208, 212, 214, 232, 311, 313; Phillips Auctioneers, London 15, 123, 240; Richard W. Pollard 49, 50; **Prague**, Museum of Decorative Arts (Uměleckoprumyslové Muzeum) 312, private collections 5, 6, 8, 9, 17, 49 above, 50, 51, 57, 77, 83, 92, 93, 94, 106, 117, 120, 130, 131, 132, 134, 136, 178, 179, 180, 181, 184, 192, 210, 213, 218, 222, 254, 257, 269, 279, 290, 291, 293, 295, 300, 314, 315, 316, 317, 318, 325, p.22 above, 156, 177, 178 above, 183; The Purple Shop, Antiquarius, London 211, 256, 265, 266, 267, 268; John Skau 132, 184, 192; Sotheby's, London 19, 30, 33, 35, 37, 43, 68, 74, 82, 85, 102, 103, 107, 124, 149, 183, 188, 242, 262, 263, 310, p.155; **Stuttgart**, Württembergisches Landesmuseum 168, Laurent Sully-Jaulmes 11, 54, 56, 62, 63, 84, 92, 93, 94, 186; V.E.B. Verlag der Kunst, Dresden p.132; **Vienna**, Albertina p.131; Österreichisches Museum für Angewandte Kunst (photographs by Isolde Luckert) 185, 189, 190, 191, 193, 219, 220, 221, 227, 228, 229, 230, 234, pp.133 below, 136; Wartski, London 86, 283; Eva Shutze Watson p.183; John Webb 211, 256, 265, 266, 267, 268, 276, 277; **Zürich**, Museum Bellerive p.197 below.